Los Angeles is a city on the Pacific Rim where things appear on edge, for they lack a permanent footing even while occupying a specific locale. The city's *genius loci* produces this dual vision of fixed place in a state of constant dislocation.

It is only appropriate for the edge-bound Getty Center to initiate a series of publications that aim to expose the historical study of artifacts to the oscillation of rigorous debate. Each of these books proceeds from a specific body of historical material, not because that material is in itself inherently imbued with controversy but because its exposure to different disciplinary approaches raises new questions of interpretation. In the realm of historical studies, issues often emerge at the intersection of the various perspectives scholars have constructed for the examination of their subjects. As their debate refracts and refocuses the material under scrutiny, it also invites reflection upon itself and thereby exposes the assumptions and tendencies of scholarship to no less assiduous criticism than it does the underpinnings of its subjects.

Volumes in the series ISSUES & DEBATES will result from symposia and lecture series, as well as from commissioned writings. Their scholarly editors are invited to frame highly focused essays with introductions, commentaries, and/or sources, documents, and illustrations that further contribute to their usefulness.

ISSUES & DEBATES
A Series of the Getty Center Publication Programs
Julia Bloomfield, Kurt W. Forster, Thomas F. Reese, Editors

American Icons

The Getty Center for the History of Art and the Humanities

Distributed by the University of Chicago Press

ISSUES & DEBATES

American Icons

Transatlantic Perspectives on Eighteenth- and
Nineteenth-Century American Art

Edited by Thomas W. Gaehtgens and Heinz Ickstadt

American Icons: Transatlantic Perspectives on Eighteenth- and Nineteenth-Century American Art

Edited by Thomas W. Gaehtgens and Heinz Ickstadt
Ursula Frohne, Editorial Liaison

This volume, the second in the series ISSUES & DEBATES, evolved from an international symposium entitled "Relations between European and American Art and Artists during the Eighteenth and Nineteenth Centuries," which was held at the Aspen Institute Berlin, 18–21 January 1989.

The Getty Center Publication Programs
Julia Bloomfield, Kurt W. Forster, Thomas F. Reese, Editors
Lynne Kostman, Michelle Ghaffari, Benedicte Gilman, Manuscript Editors

The Introduction by Thomas W. Gaehtgens and Heinz Ickstadt and the essays by Barbara Gaehtgens and Ursula Frohne were translated from the German by David Britt.

Cover: George Caleb Bingham, The Trappers' Return, 1851. Detroit, The Detroit Institute of Arts, Gift of Dexter M. Ferry, Jr., no. 50.138.
 Paving stones, bricks, and other heavy, salable items were used as ballast on ships making transatlantic voyages during the eighteenth century.

Published by the Getty Center for the History of Art and the Humanities, Santa Monica, CA 90401-1455

98 97 96 95 94 93 92 7 6 5 4 3 2 1

Library of Congress Cataloging-in-Publication Data

American icons : transatlantic perspectives on eighteenth- and nineteenth-century American Art / edited by Thomas W. Gaehtgens and Heinz Ickstadt.
 p. cm. – (Issues & debates)
 Includes bibliographical references and index.
 ISBN 0-89236-246-4 (hard) : $55.00. – ISBN 0-89236-247-2 (soft) : $29.95
 1. Painting, American. 2. Painting, Modern–17th–18th century–United States. 3. Painting, Modern–19th century–United States. 4. Nationalism and art–United States. I. Gaehtgens, Thomas W., 1940- . II. Ickstadt, Heinz.
III. J. Paul Getty Center for the History of Art and the Humanities. IV. Series.
ND207.A678 1992
759.13–dc20 92-22423
 CIP

CONTENTS

Thomas W. Gaehtgens and Heinz Ickstadt

Introduction

Until recently, American art remained almost exclusively the province of American art historians, and explorations in this realm by European scholars were the exception. This relative isolation has had a significant impact on the history of the subject itself and reflects the fact that many Europeans have remained largely unfamiliar with the American art that was produced from the eighteenth century until World War II. There are, in fact, no collections of pre-Modern American painting in Europe apart from the private collection assembled by Baron Thyssen-Bornemisza in recent years.

Given the pattern of otherwise close academic contacts between the two cultures, such a gap clearly calls for an explanation; and although questions of this sort rarely admit of an easy answer, two interconnected factors do appear to have been at work. On the one hand, the American people have historically seemed to suffer from a lack of confidence in the intrinsic value of their own art and as a consequence have often overlooked the uniqueness of their artistic discoveries. On the other hand, Europeans have tended to equate the history of art with the evolution of their own culture, dismissing American art as a provincial by-product devoid of any sound basis in theory or technique.

Ironically, Americans reinforced the European perception by traditionally opting for allegiance to the established material and cultural values of European art — after all, "anyone who was anyone" collected European, and especially French, masterpieces. Even today Claude Monet and Pierre-Auguste Renoir are more popular with citizens of the United States than George Caleb Bingham, George Inness, or Childe Hassam. Immigrants from the Old World and their descendants put their faith in Western Euro-

1

pean culture and its institutions; few were able to see that the New World
with its different social and historical background was swiftly developing a
cultural consciousness and artistic traditions of its own. It is only in the last
few decades that a surge of national self-confidence, coupled with a critical
interest in the ideological roots of the American self-image, has led Ameri-
cans to discover and to value adequately their own cultural achievement.

In the recent past, a specialization in American art did not hold out much
prospect of academic recognition in the United States, and publications on
the Italian Renaissance or on nineteenth-century French art are still more
prevalent in the art history departments of American universities than are
studies of Bingham or Winslow Homer. The comparatively small number
of scholars active in American art history and the history of the field's iso-
lation in terms of contacts with other disciplines have until recently con-
tributed to a lack of openness of method — a hesitation in confronting the
pressing new art-historical issues that first surfaced in the 1960s.

In other words, American art (unlike American literature, on which the
research efforts of the relatively new discipline of American Studies have
principally been concentrated) has only begun to be adequately investigated
as a part of cultural history or a cultural critique. Those American art his-
torians who have carried their quest for knowledge beyond the aesthetic,
stylistic, and iconographic confines of their specialist field have often met
with cool response from their colleagues or encountered an unprepared
and therefore skeptical or even hostile larger public.

Only recently, the questioning of a traditional interpretation of American
painting led to a political fracas that seems extraordinary from a European
perspective. The exhibition *The West as America*, organized by the National
Museum of American Art in the summer of 1991, set out to analyze the ideo-
logical sources of the historical imagery of America's Manifest Destiny —
the divinely ordained westward expansion. This endeavor aimed to bring
the results of recent scholarship in a variety of fields of American social
and cultural history into art history. It reflects an effort on the part of Ameri-
can art historians to introduce into their discipline the revisionist approach
to traditional historical images that historians and specialists in American
Studies have long employed.

It is hard to believe that the grand, panoramic landscapes of Frederic
Edwin Church and Albert Bierstadt could still be regarded as records of
reality or that the genre paintings of Richard Caton Woodville and George

Caleb Bingham (most of them idyllic renderings of national virtues and characteristics) could still be seen as images of "how it really was." This being the case, however, the American public found itself rather too abruptly confronted with the truth that "landscape" and "genre," which increasingly came to assume the functions of history painting, served to legitimize, and thus conceal, historical processes rather than to depict them "realistically." Many visitors to the exhibition were shocked at the prospect of subjecting the "sacred" images of the pioneer myth to historical critique, regarding such activity as virtually iconoclastic.

This reaction indicates, of course, that American art is still not taken seriously enough *as* art. Too many take the paintings at face value, accepting the artistic image as a "reflection" of reality rather than as an interpretation of it. Clearly, this is a signal that the changes that American art history has recently been undergoing are long overdue. When outraged senators can endanger positions and demand revision of museum budgets, it is obviously high time to question critically the outworn historical images and dogmas.

It is a truism that ideologies call for the closest academic scrutiny; and, in recent American historical writing, the revisionist school of New Western History has set out to cast a critical light on beloved stereotypes. It was inevitable that the impulses generated by this body of work would find their way into art history; and *The West as America* was an unpopular — because unfamiliar — attempt at a new and more informed presentation of the history of American art. However, its massively didactic effort to demythologize the frontier was not well received. Scheduled to tour a number of cities, the exhibition closed early; and in the city of Saint Louis, which owes its existence to the frontier, it was never seen at all.

Given this situation, there is much to be said for a comparative approach, both in cultural history and in the history of art. To examine American art from the outside, undistracted by national ideology, becomes an urgent and vital task. However, some of the preconditions for such an undertaking have yet to be fulfilled.

The low opinion of American art that prevails on both sides of the Atlantic is based on a misunderstanding. This is art that can be properly evaluated only if we avoid looking, exclusively and a priori, for affinities. All com-

parisons between European and American art — especially when governed by doubtful criteria of quality — are doomed if they fail to reflect the differing conditions that have governed artistic evolution on the two continents.

By the time that American painting first came into existence, art in Europe had long since come to be taken for granted as a part of everyday life. Few eighteenth-century Europeans failed to encounter a work of art in some way at some time in their lives. Across wide sections of the population, the interest in art was fast growing. The bourgeoisie of the Age of Enlightenment, vastly more confident than ever before, expected to play an active part in the academy, the museum, and the salon, that is to say, in art as a part of public life.

None of this was even thinkable in America, hence the need to look for the specific, distinctive quality of the American tradition. American art emerged under conditions totally different from those in Europe. Not only did the Puritan prohibition of images preclude the religious function that led to the finest flowering of painting in Europe: from the very first the priorities of settler life were different. Until well into the nineteenth century those who went West to the ever-advancing "Frontier of Civilization" faced a land that was rich in natural beauty and in natural wealth but also posed a constant threat to survival. No wonder the arts bore the stigma of uselessness; no wonder, too, that they developed primarily in those areas where they could show themselves to be useful — in portrait painting or as documentary records of hitherto unseen landscapes and native peoples beyond the frontier.

This confinement of art to its societal and, above all, practical and communicative functions corresponded to the virtual absence of all the institutional mechanisms of artistic production and appreciation that had evolved long before in Europe. At the same time, this pragmatic bent gave rise to a populist, democratic view of art that was to survive all subsequent tendencies toward the establishment of a hierarchy of aesthetic values by an increasing differentiation and specialization of the art public as well as the art market. The thematic and stylistic emphasis on the dignity of the democratic and the common — "the equality of things and the unity of men," as the realist writer William Dean Howells put it[1] — and the idealization of good craftsmanship, as appealing equally to the judgment of gentleman and common man, became recurrent features of an artistic tradition that relied upon "the patronage of the people." It was a tradition that countered

4

the imported European division between high and low art and clashed with the institutionalized definition of art promoted by the academies. In search of appropriate places to show their paintings, the trompe l'oeil painters thus alternated between the museum and the saloon, thereby reflecting a democratic aesthetic that valued popular culture and refused to leave art to the judgment of educated connoisseurs. Not that these artists would have turned down the patronage of the nouveaux riches, if offered — far from it. As it happened, however, the latter preferred to fill their salons with still lifes by Jean-Baptiste-Siméon Chardin.

In this connection, it is significant that the emergence of a national art coincided with the most intensive phase of the quest for an American political and cultural identity in the late eighteenth and early nineteenth centuries. In accepting its public function, art participated in an ongoing process of national self-interpretation by producing concrete images of a new and democratic nation as well as, on occasion, by expressing fears concerning the course of the republic (vide Thomas Cole's exhortatory "The Course of Empire" or Bingham's satirical versions of frontier life). The history painting of the late eighteenth century, faithfully patronized by the founding fathers of the youthful republic, and the subsequent idealization of the American landscape by the Romantic painters created a national iconography as part of a symbolic self-invention in which the whole nation was engaged. If history painters interpreted secular events in terms of sacred history and historical developments as the fulfillment of a quasi-religious promise, landscape painters presented American views, majestically stylized, as a revelation of God and thus, by implication, America as a divinely decreed "Nature's Nation."

It is therefore no great exaggeration to say that American painting satisfied its need for legitimacy and also for financial patronage primarily by playing its part in a public — even, to a degree, official — process of national self-creation in which America's history was transformed into myth. In its depiction of wilderness and of frontier life, in its metaphorical interpretation of the drive westward, in its glorification of the wide open spaces, even in its highly ambivalent ritual of grief for the idealized victims of the white man's "civilizing mission" (wild Nature in the widest sense of the term, as represented by Indians, forests, and buffalo herds), American painting not only identified with the American myth but labored to extend and perpetuate it.

5

Barbara Novak has shown that the rise of American landscape painting exactly coincided with the wholesale destruction of the American landscape in the 1830s and 1840s, just as, one might add, the self-definition of America as Nature's Nation went hand in hand with the beginnings of industrial development. Striving to capture what must soon fall victim to the "ravages of the axe,"[2] the American landscape painters — not unlike the trappers, backwoodsmen, and pioneers of fiction and history — represented the vanguard of a civilization from which they were themselves trying to escape. Landscape painting and landscape clearance might even be seen as metaphorically related actions, as contrasting forms of cultivation, subduing untamed Nature to the formative Will.

This is a plausible interpretation of the ax that makes its appearance in several of Cole's paintings. It is both a sign of impending destruction and a metaphor for the painter's brush, a token of mastery over the thing that has been painted. The social order that is established by the detested "axe of civilization"[3] and the aesthetic order that is imposed by the brush — the one symbolically restoring what the other has literally destroyed — are opposed but complementary systems, related through a shared faith in the historical inevitability of progress.

Such ambivalences left their mark on American landscape painting right down to the threshold of the twentieth century: still dedicated to the American myth, it almost entirely ignored the new world of experience supplied by urban and industrial expansion. And yet that world is present through the very intensity of the effort required to suppress it. In Bierstadt's huge paintings of a Rocky Mountain Arcadia, it is the theatricality of his nostalgia for a primeval world that inadvertently reveals the change that had already overtaken American society.

The American writers of the 1830s and 1840s complained that political independence had not ended the country's cultural dependence on Europe; it is a complaint that applies still more forcibly, perhaps, to painting than to literature. For, even though the American painters of the later eighteenth and nineteenth centuries sought to anchor their art in the uniqueness of the American experience (both that of the country and that of its history), they were also under constant pressure to legitimize themselves by reference to traditional European models. Their painting, therefore, was a complex act of mediation between different cultural worlds. Even where they defined themselves in terms of their mastery of European conventions, their

6

manner of painting remained clearly marked by American themes, motifs, and convictions. Conversely, however keenly aware they were of their American uniqueness, they still needed the techniques that only Europe's artistic conventions could supply.

It would be an oversimplification to see this relationship only as a more or less successful imitation of European models. For American artists, Europe was a storehouse of traditions and styles from which they could choose at will. To innovate, in this context, was not so much to depart from existing conventions as to transpose them into new forms and contexts with specifically American ends in view. And so Cole used and transformed motifs taken from religious iconography to create an American "Natural Sublime," while Bingham reinterpreted the conventions of Dutch genre painting in a democratic myth of commonness.

More or less explicitly, all the essays in this book address the issue of the similarities and differences between American and European art, although they approach it from different directions: thus, Werner Busch, William Hauptman, and Barbara Gaehtgens adopt a comparative perspective; Barbara Groseclose, in her inquiry into the representation of Columbus, links academic and popular art, while Ursula Frohne's essay on the social status of the American artist discusses the possibilities and dangers of a "people's patronage"; Martin Christadler and Françoise Forster-Hahn pursue specifically American developments in the mythopoeic rendering of history; Barbara Novak and Olaf Hansen discuss the specific, quasi-religious status of objects in still life and also in landscape; Nicolai Cikovsky analyzes Winslow Homer's conception of a democratic (national) art; Hubert Beck discusses late nineteenth-century city painting and Kathleen Pyne the specifically American variant of the fin de siècle.

The contributions by Pyne and by Beck mark the chronological limit of the volume. The next topic would be the American path to Modernism, which made use of the European avant-garde in its own search for that "American Newness"[4] that had always resided in the American object as well as in the subject of America.

The present volume sets out to initiate a necessary dialogue. In it American and European scholars comment on themes in American painting from the end of the eighteenth century to the end of the nineteenth. Not all of

the contributions are by art historians; some are by Americanists, and this introduces an interdisciplinary dimension. The essays all revolve around the defining characteristics of American art; however, the hope that the authors would focus on the relationships between European and American art has not in every case been fulfilled. These processes of exchange and appropriation remain largely virgin terrain or, better, terrain that has been cultivated only at the margins. Even so, this book will surely stimulate, through the multiplicity of its methodological approaches and the variety of questions that are raised.

The book itself is the result of an unusual symposium that took place in Berlin in 1989. Unusual because at long last it brought together a number of scholars from areas in which one might have supposed collaboration to be long since established. However, as Wanda Corn ruefully pointed out in her brilliant survey paper on historical scholarship in American art,[5] there is virtually no intellectual contact between those art historians whose concerns extend beyond American art and those who make it their specialty. The Berlin symposium set out to establish that contact. It also brought together two other groups of researchers: European art historians and German Americanists, that is, those cultural historians at German universities whose field of study is American culture and literature. These unprecedented encounters led to some extraordinarily fruitful and stimulating exchanges. The differences in the contributors' backgrounds will be apparent to the attentive reader of this book, which contains not the papers given on that occasion but subsequent essays by the participants on selected themes.

The symposium was held to complement the exhibition *Bilder aus der Neuen Welt*, in which a superb selection of American art was presented to the German-speaking public at Schloß Charlottenburg in Berlin and later at the Kunsthaus Zürich. Controversy was stimulated in particular by the opportunity to compare the evolution of American art with that of German art. In attempting to define the nature of the artistic discoveries made on the two continents, the participants could agree only in recognizing the differences. The task of analyzing those differences and of understanding the context in which they arose remains a largely unexplored avenue of comparative research.

The essays collected here mark a beginning. Even though the comparative approach does not always prevail, all contributors use their familiarity with their "own" art to ask, or to answer, questions about the other. The

question is no longer that of artistic quality, on which American scholars expended so much effort for so many years. That issue has long been settled and to defend American painting on aesthetic grounds now would be like pushing an open door.

It is still worth arguing, however, that a European view of artistic developments in the New World (or an American view of the art of the Old World) has many new revelations to offer. The perspective from outside ingrained national traditions and prejudices is a great promoter of insight. This certainly applies to the essays included here on John Singleton Copley, George Caleb Bingham, Fitz Hugh Lane, and Winslow Homer, whose American authors discuss their respective subjects from an awareness of European developments in the arts as well as in the study of art history. It is equally true of the essays on Benjamin West, Emanuel Leutze, and William Michael Harnett, and on the representation of the city from Impressionism to the Ash Can school, whose German authors have sought new answers by choosing fresh approaches.

For the stimulus to take this first step and to press forward into what was formerly a rather circumscribed area of study, all those involved owe a debt of gratitude to the constant, generous, and erudite support of David Huntington to whom this volume is dedicated.

NOTES

1. William Dean Howells, "Editor's Study," *Harper's New Monthly Magazine* 72 (May 1886).

2. Thomas Cole, "Essay on American Scenery," *American Monthly Magazine* 1 (January 1836): 1–12.

3. Anonymous review of an exhibition held at the National Academy, *The Literary World* (8 May 1847).

4. Irving Howe, *The American Newness* (Cambridge, Mass.: Harvard Univ. Press, 1986).

5. Wanda Corn, "Coming of Age: Historical Scholarship in American Art," *The Art Bulletin* (June 1988): 188–207.

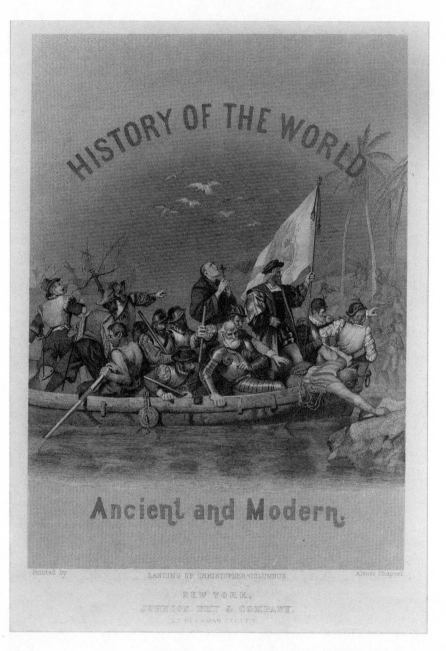

1. Engraving after painting by Alonzo Chappel
 (American),
 Landing of Christopher Columbus.
 From *History of the World, Ancient and Modern*,
 vol. 1 (New York: Johnson Fry, 1858).
 Photo: Courtesy Library of Congress, Wash-
 ington, D.C.

Barbara Groseclose

American Genesis

The Landing of Christopher Columbus

"The myth of the birth of a nation," James Oliver Robertson has written apropos of the significance of 4 July 1776, "provides the structure through which Americans understand their history."[1] Of course — as Robertson acknowledges in passing — myths of beginning prior to that day in the eighteenth century have also shaped us, for they tell of the "discovery" and settlement of a "New World," events that themselves were constructed through a mythopoeic language. Among the overlapping though not exclusionary versions of American genesis, all of which have served as symbolic antecedents for a "national" character and "national" policies, none is so apparently incongruous as that associated with Christopher Columbus.[2] Here was a man who was born in Italy, spent a few years in Portugal, sailed as the admiral of a Spanish fleet, and who never set foot on any land that would later be a part of the continental United States; yet Columbus has been regarded as one of the founders of the American nation and one of the primary models for its people's character.

In this essay I want to consider not so much *how* Columbus became an American forefather (and, by extension, an "American") but some ramifications of the manner in which his story was Americanized. I shall concentrate on the "Landing of Columbus," imagery that portrays the arrival of Europeans and, sometimes, their first meeting with the native inhabitants of the Western hemisphere. Not incidentally, we call these natives "Indians" as did Columbus (who thought he had reached the East), thereby perpetuating European dominance through the controls of language: by permanently misnaming "Indians," we define them as, among other things, irrevocably out of place. Consequently, since Native Americans can never be "right,"

they have all the more easily been perceived as "wrong." Through official United States policy in the Indian Removal Act of 1830, they have had the peculiar experience of finding the dislocation implicit in their name matched post hoc by physical circumstances. While Native Americans were actually transportable, the persona of Columbus has been metaphorically mobile. Columbus started his American life twinned with George Washington; later he was represented as possessing the traits, at once audacious and laudable, of a pioneer; and he ended the nineteenth century with a physical and spiritual demeanor molded by a variety of agendas, from defensive Catholicism to ethnic pride.

Though I shall be concerned primarily with the fine arts, scenes of the Landing of Columbus (fig. 1) appear anywhere an image of American genesis could more or less reasonably be expected — on cigar box labels, in textbooks, on souvenir banners. The scene also occurs in places where even the most dedicated populist might not expect it, for instance, carved on a pipe bowl or printed on a bedspread.[3] Nor have "Landings" been the preoccupation solely of an earlier generation; following the rise of the American Indian Movement, renditions prompted by new perceptions are being created (fig. 2). In fact, the only time the theme did not occur in American art was during the pre-Revolutionary period, probably because the required mise-en-scène (water, land, fauna, foliage, boats, groups of people) was beyond the reach of Colonial artisans and because neither of the settled cultures — Dutch and English — thought of Columbus as having any bearing on their own presence. Indeed, one finds merely isolated references to him or his exploits in Colonial literature.

With the advent of independence and subsequent nationhood, however, Columbus, and especially "Landings," assume more importance. The desire to possess a national beginning point led, ineluctably, to 1492. Joel Barlow, inspired by reading William Robertson's *History of America* of 1777, was apparently the first writer to trace American national origins to Columbus in his lengthy poem *The Columbiad*, first written in 1789. Among other inducements for Barlow's preoccupation with Columbus, we might list the inclination of his era to formulate history around the actions of individuals, as well as Barlow's own desire, born of the Revolution, to posit a non-English patrimony for North America.

An early Landing scene of 1800 by David Edwin and Edward Savage (fig. 3) reflects the adoptive twist, so to speak, given to Columbus's heritage

12

2. Deborah Small (American),
1492, 1986,
two hundred painted panels aligned in
20-meter band. Mixed media installation.
San Diego, Anuska Galerie.
Photo: Deborah Small.

by post-Colonial Americans and likewise springs from the chauvinistic fervor induced by the Revolutionary War. Edwin's figure of Columbus immediately calls to mind a portrait of George Washington, irrefutably a founder of the young nation, by Charles Willson Peale (fig. 4).[4] According to the legend at the bottom of the engraving, Edwin's picture drew on a European prototype, but his pear-shaped Columbus, standing in a self-conscious stance while genially engaging the viewer's eye, looks unnervingly like the cheerful portrait of Washington at Princeton painted by Peale in 1779.

Washington–Columbus ties are even more direct in literature of the Revolutionary era, furthering Columbus's position as a forerunner, thus as an ancestor, of those who birthed the new United States. Barlow's *Columbiad*, for example, expends most of its rhetoric not on Columbus himself but on General Washington, especially on his role in the war. It must have been the meagerness of the new republic's history, or the scarcity of figures in whom historians could discover the shape of the future, or the sheer weight of references to the two together — epitomized by the naming in 1791 of the nation's capital *Washington*, District of *Columbia* — that instilled this popular fixation on Columbus and Washington, re-creating them as the Romulus and Remus of the fledgling nation.[5]

Though Washington and Columbus were briefly reunited in the hyper-American rhetoric of 1893, their imagery went separate ways throughout most of the nineteenth century, and their respective contributions to the establishment of the nation were recognized individually. In place of founding-father motifs in the historical arts came an interest in the heroic character as a behavioral model. In Columbus's case, the traits that presumably made him a great explorer were vaunted at the same time that westward migration was being encouraged through metaphors equating his voyage across the seas "to find a new world" with the spread of settlers across the continent. Columbus's daring, perseverance, intrepidity, and individualism were championed as necessary ingredients to the transcontinental endeavor. In 1849 Senator Thomas Hart Benton named Columbus the spearhead of what Benton envisioned as the completion of the journey of 1492: a westward road to Asia across North America.[6] One needs no further proof of the ease and thoroughness with which Columbus became the very embodiment of an American pathfinder than the familiarity of the Columbian metaphor in the same context today: In celebrating the twentieth anniversary of the lunar landing, President George Bush declared that from "the voyages of

14

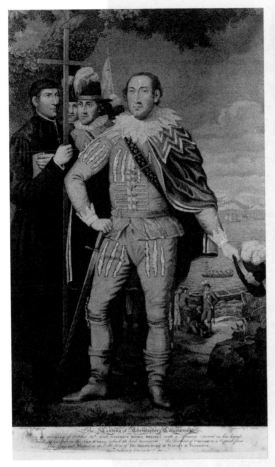

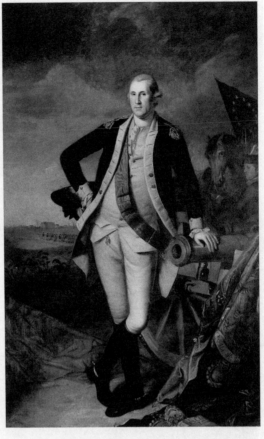

3. David Edwin (American),
The Landing of Christopher Columbus,
ca. 1800,
engraving published by Edward Savage,
61.5 x 46.2 cm.
Worcester, Mass., American Antiquarian
Society.

4. Charles Willson Peale (American),
George Washington at Princeton, 1779,
oil on canvas, 238.5 x 150 cm.
Philadelphia, The Pennsylvania Academy of
the Fine Arts, Gift of Maria McKean Allen
and Phebe Warren Downes through the
bequest of their mother, Elizabeth Wharton
McKean, no. 1943.16.2.

Columbus to the Oregon Trail to the journey to the moon...[Americans] have never lost by pressing the limits of our frontiers."[7] It was, however, not only the historical memory of his four crossings of the Atlantic that matched Columbus to American transcontinental ambitions, for the characteristics ascribed to him had recently been expounded by Washington Irving in *The Life and Voyages of Christopher Columbus* (1828), regarded as the most complete, scholarly, and closely reasoned Columbian biography of its time.[8]

Very little about Columbus the man is known with certainty, though everything from declarations about his abnormally keen sense of smell to hotly disputed claims as to his nationality, religion, stature, and age have been alleged in many and conflicting publications. No verifiable contemporary portrait exists, despite numerous attributions. Hence it is all the more remarkable that Irving's biography of Columbus has been so compelling and persuasive. Irving wrote of a man full of flaws but even more completely possessed of virtues, virtues conspicuously similar to those the New World Adam was finding it highly desirable to develop: resourcefulness, independence, piety, and domesticity accompanied by innate democratic sensibilities and a capacity to lead. These are the qualities to which one might expect pioneers of any sort to aspire, but many of them are, as well, features Europeans thought distinguished them, as "civilized" people, from "savages."

In Irving's treatment of the Landing, Columbus's mettle in these terms is demonstrated by his success at finding land and his actions immediately subsequent to that event. So intensely does Irving narrate the critical incidents that the reader barely notices certain lapses in his descriptions as to where and how the encounter with Indians took place. For example, the terrain onto which Columbus stepped, Irving writes, was "covered with trees like a continual orchard" (p. 93). But this is really all he has to say about an island that must have seemed exotic by both American and European standards. Irving states that Columbus "threw himself on his knees, kissed the earth and returned thanks to God" (p. 93) as soon as he was ashore. However, he says nothing more (at this point) about the missionary zeal that Spaniards (and, intermittently, Columbus himself) claimed motivated their dealings with the native inhabitants, nor does he put a name to the Catholicism that sustained Columbus personally. Finally, Irving simultaneously allowed Columbus to acknowledge his royal patrons yet implied

his complete independence from them. The eventual popular conception of Columbus's Landing — the feat of a crypto-Protestant explorer who, acting alone, first set foot on soil somewhere near Plymouth Rock — clearly was made possible by points of vagueness in this otherwise apparently authoritative biography.

John Vanderlyn's *Landing of Columbus at the Island of Guanahaní, West Indies* (fig. 5), a mural on canvas in the United States Capitol, which both by its location and its significance deserves to be called an "official" portrayal, filled in the lacunae of Irving's story. In so doing, the painting completed the Americanization of the Landing and, perhaps more important, made evident the extent to which Columbus's personal glory could be carried. Although very little can be discerned of the terrain of the island Vanderlyn so carefully gives a proper name, Guanahaní, a lone tree stands on the right. It is not a palm but instead looks very much like a specimen that might grow in a temperate climate such as one finds in the United States. A crucifix pokes above the heads of the crowd, unemphasized in terms of the neighboring verticals of spears, halberds, and standards, but strategically placed behind Columbus's head. That head, bearded, with a fair complexion, and shoulder-length, grayish-brown hair, is tilted slightly upward, following the diagonal of the standard planted on the ground. Thus Columbus looks toward heaven with the crucifix behind him, suggesting the cruciform halo usually associated with portrayals of Christ. In addition to the insertion of these subtle but crucial details, Vanderlyn, like Irving, managed contradictions smoothly. Columbus is isolated from and so appears to be independent of the men who surround him.

The Native Americans are also isolated, but for a different reason. Engravings more nearly contemporaneous with Columbus's own time illustrate Native Americans bringing gifts to the Europeans as they come ashore, a welcoming gesture Columbus himself noted in his diary.[9] Vanderlyn, on the other hand, depicts the natives as near-feral beings identified with the forest, who crouch behind trees or fall forward in genuflection (reinforcing the Christological overtones with which Columbus is endowed). These bare-breasted women and fearful males behave like defenseless animals, a treatment that at once heightens the primordial condition of the "New World" and confirms the subhuman status of its inhabitants.

At this point we might stop to ponder briefly the inferences imperialists draw from their "knowledge" of a people they (intend to) subjugate. For

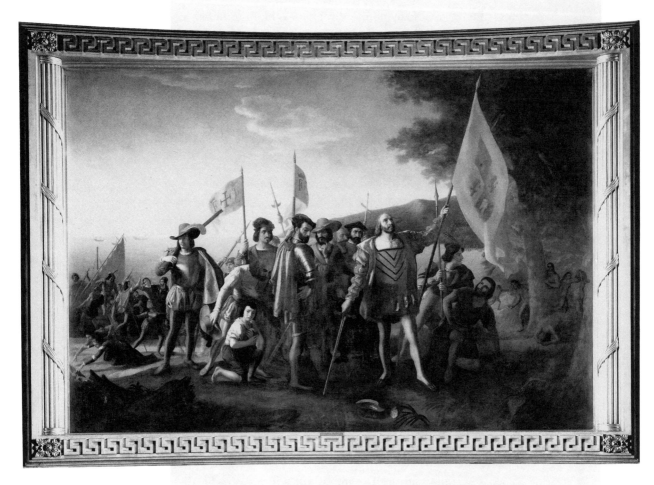

5. John Vanderlyn (American),
*Landing of Columbus at the Island of
Guanahani, West Indies*, 1846,
oil on canvas, 369 x 554 cm.
Washington, D.C., United States Capitol
Art Collection.
Photo: Courtesy Architect of the Capitol.

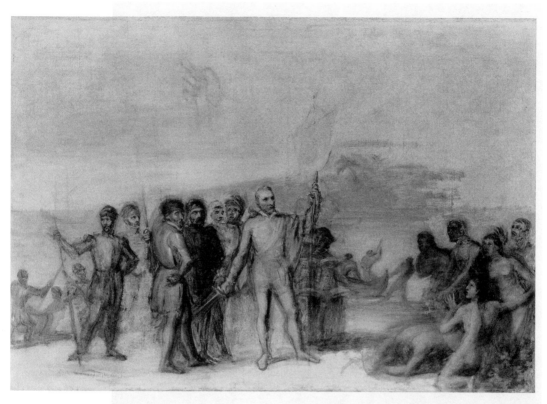

6. John Vanderlyn (American),
 The Landing of Columbus, 1840,
 oil on canvas, 69.5 x 102.3 cm.
 Washington, D.C., National Museum of
 American Art, Smithsonian Institution, Gift
 of I. Austin Kelly, III, no. 1971.5.

example, an argument advanced by Columbus and many of his Western descendents in favor of imperialist deeds, from the taking of slaves to the taking of land, was that most of the native population was too debased to be converted. Conversion of benighted souls usually forms at least part of the rationale for modern Western imperialism, but if it can be determined that the souls are beyond reach — that the invaded culture is permanently stalled, not momentarily halted in the great progressive climb toward "civilization" — then the European imperialist is not constrained to behave in a "Christian" manner toward them. As Columbus pointed out to his sponsors, the slaves he took on the islands he "discovered" were *only* those natives who were cannibals and so beyond redemption. After he had taken nearly five hundred Native Americans as slaves, it began to look as though he meant to designate nearly all the native inhabitants unredeemable.[10]

Oddly, an oil sketch of 1840 (fig. 6) for Vanderlyn's mural differs so pointedly it might stand as a contradiction to the attitude toward Native Americans that one senses in the finished work. In the preliminary work, roughly the same European cast of characters meets a group of Native Americans; among the latter some cower, prostrate or crouched, others huddle together. However, the two groups occupy the same ground, literally and hence figuratively, a feature that allows one to read both within the framework of a shared humanity. Whatever Vanderlyn's reasons for altering this sketch, which among other things left him with a caped Martin Pinzon in the center of the mural disdainfully glaring at nothing, the decision takes on an element of irony when one considers his timing. While Vanderlyn was making the choice to demote Native Americans within the artistic centerpiece of the United States Capitol Rotunda, the Indian Removal Act of 1830 had swung into force, and entire tribes, for instance, the Cherokee nation, were removed from areas of European settlement.

Irving and Vanderlyn together contribute in no small way to the fashioning of a Columbian mystique responsive to growing chauvinistic urges in the nineteenth century. They both blur the location of the landfall. They both acknowledge Columbus's fidelity to his royal patrons at the same time as they suggest his complete independence from them. And they both create a larger-than-life hero (in Vanderlyn's terms, metaphysical), whom they then commemorate in a manner that helped plant the notion that Columbus was a proto-American. Their Landing scenarios also rely in part on establishing a contrast of Europeans and Native Americans, promoting the link-

age then being forged between national character (the traits that prompted Columbus's feat) and national destiny (the possession of a continent already occupied, but "only" by a people "easily" and "deservedly" removed).

Perhaps it was the arresting implications of Vanderlyn's Columbian portrayal and the topical relevance of his diminished Native Americans that helped the painting achieve a *nachleben* of proportions unusual even in a hero-worshiping, image-rich culture like that of the United States at the end of the nineteenth century. More likely, it was the craving for unifying symbols and the painting's presumably official imprimatur that boosted its fame. Circus wagons, stamps, advertisements, and towels circulated the mural's likeness among a public probably already acquainted with reproductions of the scene in school texts. Very often these popular renditions cropped the composition so that the Native Americans and the minimal landscape disappeared altogether, or condensed it so that the figure of Columbus holding his sword and standard stood entirely alone. Far from being trivialized by appearing on commercial products, these depictions of Columbus grew instead to be pannational emblems, and the image of Columbus came to signify the point of origin or consumption of a commercial item as the United States.

The mutually reinforcing perspectives shared by Vanderlyn's painting and two Capitol sculptures must also be considered as furthering the mural's impact. Luigi Persico's *Discovery of America*, 1844 (fig. 7), a colossal free-standing marble commissioned in 1836 and formerly installed on the left side of the main staircase, and Randolph Rogers's bronze relief doors to the main entrance, 1861 (fig. 8), likewise treat the Landing. Rogers's doors, patterned after Lorenzo Ghiberti's fifteenth-century baptistry doors for the Florence cathedral, give the place of honor to the Landing in a lunette. In composition, Rogers's scene varies scarcely at all from the Vanderlyn mural except to arrange the participants on a hill with Columbus at the crest. The readily observable connection between Rogers's door panels depicting the life of Columbus and those of Ghiberti depicting the life of Jesus merely adds lustre to Vanderlyn's Christlike Columbian portrayal. Persico's two-figure group, a composition more essentialized than reduced, extravagantly throws the accepted historical scenario to the winds, representing, said then-Senator James Buchanan, "the great discoverer when he first bounded with ecstasy upon the shore, all his toils past, presenting a hemisphere to the world, with the name America inscribed on it."[11]

21

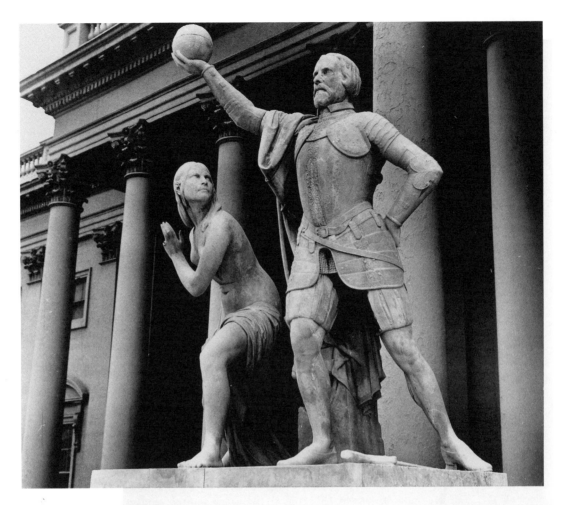

7. Luigi Persico (Italian-American),
 Discovery of America, 1844,
 marble, 492 x 259 cm.
 Originally located near the east front
 entrance to the Capitol, transferred to the
 Smithsonian Institution for storage in 1976.
 Photo: Courtesy Architect of the Capitol.

8. Randolph Rogers (American),
 Rotunda Doors, 1861,
 bronze, 513 x 300 cm.
 Washington, D.C., United States Capitol
 Art Collection.
 Photo: Courtesy Architect of the Capitol.

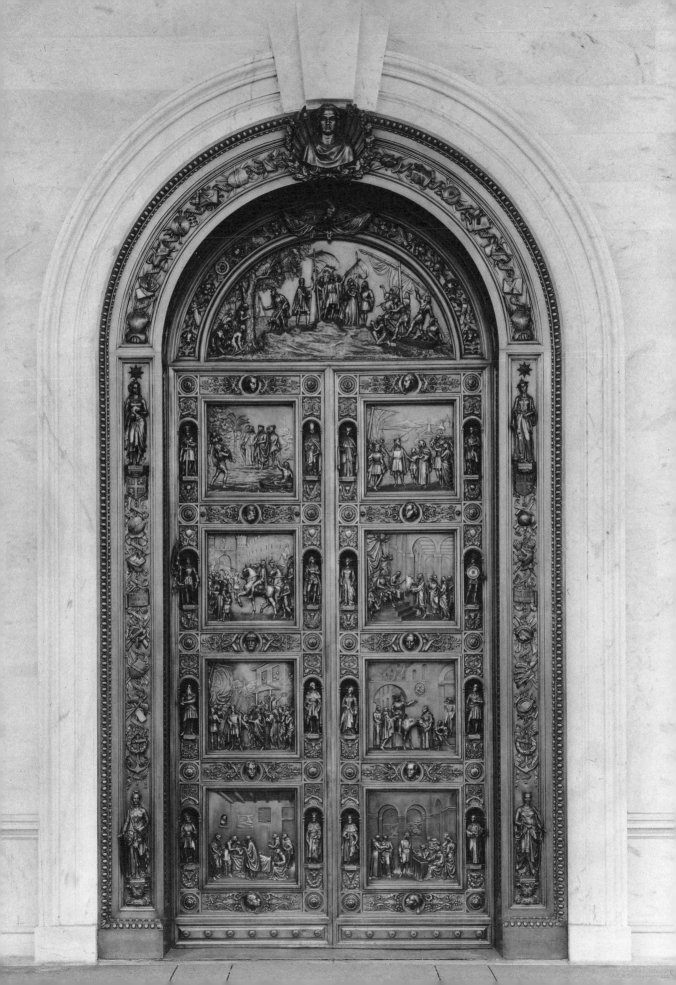

Anachronisms aside, the Persico statue can be regarded today as the bluntest of the three Capitol "Landings." Instead of identifying Native Americans as "savages" and thus at the bottom of the ladder of human development, as Vanderlyn did, Persico portrayed them in more human terms but qualified the ability and power of the personification by making the figure female. Mother of any future generations, she also signals (by her gender) the vulnerability of the race and by her exposed breasts gives proof of its otherness. What is most unavoidable is her ugly fleeing motion. The removal and eventual extermination of the majority of Native Americans, as the logical and, if not desirable, certainly inevitable consequence of the white advance westward, are conveyed by her awkward movement. One United States representative interpreted both the aesthetic and iconographic message unequivocally: "Gentlemen might laugh at the nudity [of the woman]; but the artist, when he made Columbus the superior of the Indian princess in every respect knew what he was doing," he claimed and went on to announce, "We got [Indian] possessions by the strong arm of power. We removed these tribes from their hunting grounds, who did not cultivate the land, in order that we might accomplish the greatest amount of good to the human race."[12]

It may be that the familiarity of the three Capitol "Landings" preempted further artistic examination of the theme or that the ubiquity of the subject in the popular arts exhausted its appeal. Whatever the case, although the print industry continued to turn out the scene, no major new works represented the Landing of Columbus until the turn of the century. Then, prompted no doubt by the Chicago World's Columbian Exposition of 1893, large paintings and public monuments once again took up the topic. Edwin Austin Abbey conceived the event in dramatic terms with the hero identified as a white-haired, armor-encased knight (fig. 9). Beginning in 1882, when the Knights of Columbus formed, Columbus's Catholicism had been vigorously reasserted in the face of nativist groups insisting on a "traditionally" Anglo-Saxon Columbus. Here Abbey's elderly admiral kneels behind a magnificently robed prelate who is conducting a ceremony of thanksgiving flanked by two decoratively clad friars. As a bizarre embellishment, Abbey filled the sky with dozens of flamingos. The "Protestant" versus "Catholic" Columbus comes into play in later years in N. C. Wyeth's *Columbus Discovers America*, 1944 (fig. 10). Wyeth's Nordic-looking, Puritan-plain Columbus staggers gratefully onto shore accompanied by a few crew

24

members and then closes his eyes in private prayer; most of his men are likewise personally offering thanks.

New emphasis on Columbus's Italian heritage also appeared in the last quarter of the nineteenth century. Italian-American communities in Philadelphia, New York, Baltimore, New Haven, Scranton, and Providence, among other places, erected statues of Columbus. Usually carved by Italian sculptors, they were all single figures, sometimes holding a globe, sometimes staring manfully ahead as though simultaneously looking out to sea and into the future. These monument commissions were not the result of increased prosperity nor of patriotism among immigrants but a profound reflection of Columbus's symbolic role in the new kingdom of Italy. Occasionally, bas-reliefs on the pedestals of these monuments — that in New York's Columbus Circle, for example — include a Landing scene, but the overall impact of the solitary figure is that discrete episodes in Columbus's history count little against the overwhelming significance of the man as an individual, an Italian, who was seen by his compatriots during the Risorgimento as a figurehead for a new Italian nation. Native Americans, one could say with justice and appropriateness, were neither here nor there as far as these monuments, their makers, and their patronage were concerned.

We might begin to appreciate the essentially self-reflexive significance of American typologies of the Landing of Columbus and their relation to racial issues throughout the century by comparing them to European treatments of the event. While scenes of Columbus's departure from Palos and of his triumphant return to the court after his first voyage not surprisingly predominate in Italian, French, and Spanish art, "Landings" appear with enough frequency to identify exemplary canvases. Ligurian art provides an intriguing case. In the nineteenth century, nationalists of that region symbolically invested Columbus, by most accounts a native of Genoa, with a patriarchal role as a means of identifying a past separate from that of the Kingdom of Savoy, under whose authority Liguria fell after the Congress of Vienna. With the exception of a few naval heroes, Ligurians, like eighteenth-century Americans, could not summon many figures on whom to pin a new national flag; however, they could refer to a rich tradition of Columbian iconography. The seventeenth-century Landing scenes by G. B. Carlone in the Palazzo Ducale and by Lorenzo Tavorone in the Palazzo Belimbau, both in Genoa, exhibit a pronounced interest in the royal and religious sponsorship of the enterprise as well as in Columbus's personal devoutness and decidedly well-

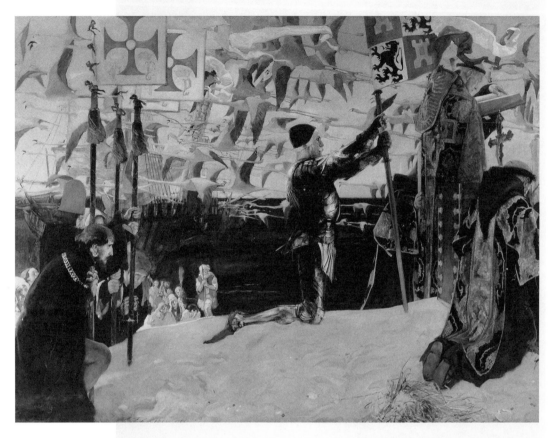

9. Edwin Austin Abbey (American),
 Columbus in the New World, 1906,
 oil on canvas, 221 x 304.8 cm.
 New Haven, Yale University Art Gallery,
 The Edwin Austin Abbey Memorial Collec-
 tion, no. 1937.2317.

10. N. C. Wyeth (American),
 Columbus Discovers America
 (*The Royal Standard of Spain*), 1944,
 oil on wood, 69.2 x 65.4 cm.
 Annapolis, Md., United States Naval
 Academy Museum, no. 44.16.2.

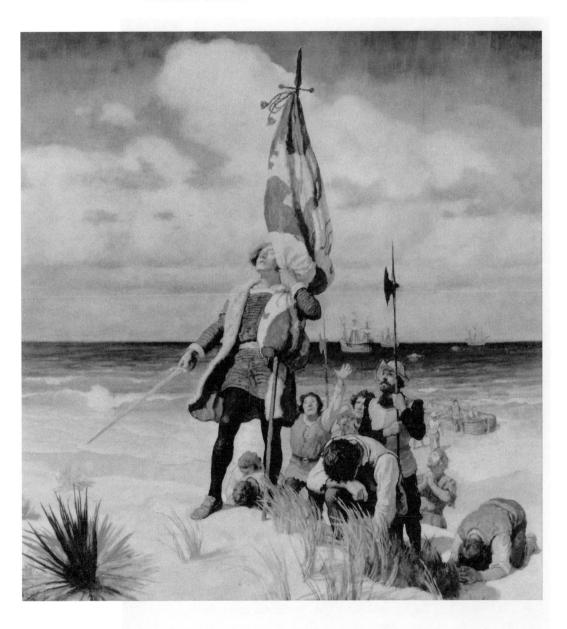

born appearance. A nineteenth-century painting (fig. 11), also in Genoa, by Francesco Gandolfi continues the tradition and adds the hosannas of a myriad of otherworldly beings to the occasion. Two French artists, Pharamond Blanchard in 1850 (fig. 12) and Jean-François de Troy a century earlier, also underline the mission's proselytizing aspect and Columbus's courtliness.

It would be unwise to read the European concentration on conversion of the native inhabitants or the "enlightenment" offered by Christianity to the New World as a sign of sympathy for the Native Americans or of highmindedness in singling out the alleged Christian purpose of imperialism. Instead, it should be remembered that none of the documents available then (or now) describing Columbus's landfall mentions the presence of religious or the erection of a cross. Europeans were not ignorant of the devastation their advent wrought on the native populace through disease as well as through deportation into slavery.[13] Europeans also had the possibility of learning, through biography, that Columbus certainly never conceived his mission as an effort to convert natives, despite what happened subsequently. Image and "knowledge," in other words, did not match. European artists, like their American counterparts, lived within a culture in which heroes embodying pannational concepts or ideals were never born but always made. Thus, even as he became Americanized in the United States, Columbus never lost his European identity in Europe.

What seems important is not that Europeans or Americans each constructed their own Columbus but what that construction was. Using the fine and popular arts of the present as well as the past century as an index, one can conclude that in the United States Columbus has been perceived as Christian but not popish; of European heritage but detachable from any foreign ties, even those of the Spanish monarchy; a heroic individualist, yet one who served others. He eventually became a man so obviously destined to found the American Republic that artistic license nudging the place of his disembarkation to the north and west of the Caribbean has seemed not out of keeping with Columbus's original intentions.

And what were those original intentions? It seems likely many Americans would answer, as artists have done, "to find the New World." Columbus's own words present him as a good sailor obsessed with the strongly mercantile goal of finding a water route to a very old world — Cipangu or Japan, at that time believed to be the farthest point of the East, which was called in general "India." He named the native inhabitants of the islands on which he

28

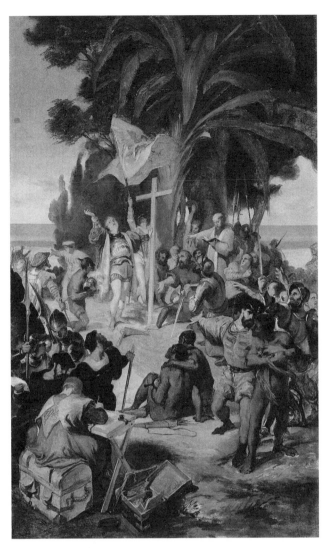

11. Francesco Gandolfi (Italian),
 *Columbus Takes Possession of the Newly
 Discovered Land* (*Cristoforo Colombo prende
 possesso della terra scoperta*), 1861–1862,
 oil on canvas (sketch), 76 x 46 cm.
 Genoa, Museo dell'Accademia Ligustica di
 Belle Arti, no. 674. Photo: Polidori.

12. Pharamond Blanchard (French),
 First Mass in America
 (*La première messe en Amérique*), 1850,
 oil on canvas, 200 x 152 cm.
 Dijon, Musée des Beaux-Arts, Donation
 Granville, no. 5045.

landed "Indians" because, in the ecstasy of the moment, he thought that he had found what he sought. Most Westerners know the word "Indian" reveals that Columbus did not in fact realize where he was. Such is the flexibility of myth, however, that it has been possible to acknowledge his error without relinquishing the belief that his achievement lay in his ability to discover what became the United States of America. And such is the empowerment to be gleaned from myths of beginning that Americans could use as part of their arsenal of symbolic sanctions for the destruction of the native inhabitants the image of Columbus, destroyer of the Native Americans in the first encounter of the races.

Notes

1. James Oliver Robertson, *American Myth, American Reality* (New York: Hill & Wang, 1980), 54.

2. Much of my thinking in the following essay has been prompted by research undertaken with a committee of scholars who formed an advisory group for an exhibition, *The Americanization of Columbus*, which ultimately did not take place. I am particularly indebted to my cocurator, Ann Uhry Abrams, and to Terence Martin and Christian Zacher. See especially Terence Martin, "The Negative Structures of American Literature," *American Literature* 57 (March 1985): 1–22.

3. My approach to the study of American art is based on the premise that it can be conceived as a potential "national expression" having a class-spanning rather than a class-less social distribution, one in which visual imagery from commercial objects, as well as "fine arts," graphs the prevalence, dominance, and tenacity of belief systems.

4. I am grateful to Ann Uhry Abrams for making me aware of this connection.

5. The phrase was used in the manuscript of a public lecture on Columbus by Professor Delno West of Arizona. I am grateful to Professor West for his generosity in sharing his Columbian material with me.

6. See Henry Nash Smith, *Virgin Land: The American West as Symbol and Myth* (Cambridge, Mass.: Harvard Univ. Press, 1950), 27–29.

7. Administration of George Bush, *Papers*, "Remarks on the Twentieth Anniversary of the *Apollo* Moon Landing," 20 July 1989.

8. Washington Irving, *The Life and Voyages of Christopher Columbus*, ed. John Harmon McElroy (Boston: Twayne, 1981). All text references are to this edition.

9. *The "Diario" of Christopher Columbus's First Voyage to America, 1492-1493*, transcribed

and trans. Oliver Dunn and James E. Kelley, Jr. (Norman: Univ. of Oklahoma Press, 1989), 65: "Later they came swimming to the ships' launches where we were and brought us parrots and cotton thread in balls and javelins and many other things.... In sum, they took everything and gave of what they had very willingly."

10. See Tzvetan Todorov, *The Conquest of America: The Question of the Other*, trans. Richard Howard (New York: Harper & Row, 1984), 45:

> Columbus behaves as if a certain equilibrium were established between the two actions: the Spaniards give religion and take gold. But, aside from the fact that the exchange is rather asymmetrical and does not necessarily benefit the other party, the implications of these two actions are contrary to each other. To propagate the faith presupposes that the Indians are considered his equals (before God). But what if they are unwilling to give their wealth? Then they must be subdued, in military and political terms, so that it may be taken from them by force; in other words, they are to be placed, from the human perspective this time, in a position of inequality (inferiority). Now, it is without the slightest hesitation that Columbus speaks of the necessity of subduing the Indians, not perceiving any contradiction between what each of his actions involves, or at least any discontinuity he thereby established between the divine and the human. This is why he remarks that the Indians were timid and did not know how to use weapons. "With fifty men Your Highnesses would hold them all in subjection and do with them all that you could wish" ("Journal," 14/10/1492): is it still the Christian speaking here?

> Compare also the sixteenth-century writer Antonio de Herrera y Tordesillas, who charged that Columbus "would not consent to baptism of the Indians whom the friars wished to baptise because he wanted more slaves than Christians." Quoted in Edward T. Stone, "Columbus and Genocide," *American Heritage* 26, no. 6 (October 1975): 79.

Compounding the issue of religion, one recalls that in Irving's (and others') account Columbus undertook his voyage in order to raise funds for a new crusade to Jerusalem, there to "liberate" the Holy Sepulcher. John Hazlett, "Literary Nationalism and Ambivalence in Washington Irving's *The Life and Voyages of Christopher Columbus*," *American Literature* 55 (December 1983): 567, uses Irving's praise of what Irving called Columbus's "devout and heroic schemes" to illustrate the "nationalist text" as distinguished from the "anti-imperialist sub-text," for Irving elsewhere castigated crusades as "a mask behind which [Christians] exploited foreign peoples."

11. See Vivien Green Fryd, "Two Sculptures for the Capitol: Horatio Greenough's *Rescue* and Luigi Persico's *Discovery of America*," *The American Art Journal* 19, no. 2 (1987): 20.

12. Ibid., 21–22. Although Persico's Italian training would indicate his acquaintance with traditional personifications of America as a Native American princess, nothing in this com-

position suggests the woman is intended to represent a continent, and everything points to her role as an emblem of race. I would like to acknowledge Professor Fryd's generous assistance in matters having to do with the art in the United States Capitol and to thank Barbara Wolanin, curator of the Capitol's fine arts collections, for her help.

13. Using the commentary on Columbus's actions in the *Historia de las Indias* written by Father Bartolomé de las Casas – a participant in Columbus's third voyage who later took vows in the Dominican order – over a period of thirty years, beginning in 1527 (first published, Madrid: M. Ginesta, 1873–1886, 5 vols.), and Columbus's own log or diary, abstracted by Las Casas, Stone (see note 10) documents "the somber chronicle of the events that ended in the genocide of the peaceful Arawaks of the Caribbean islands" (p. 6). Las Casas's writings became part of the public discourse surrounding the European discoveries in the New World.

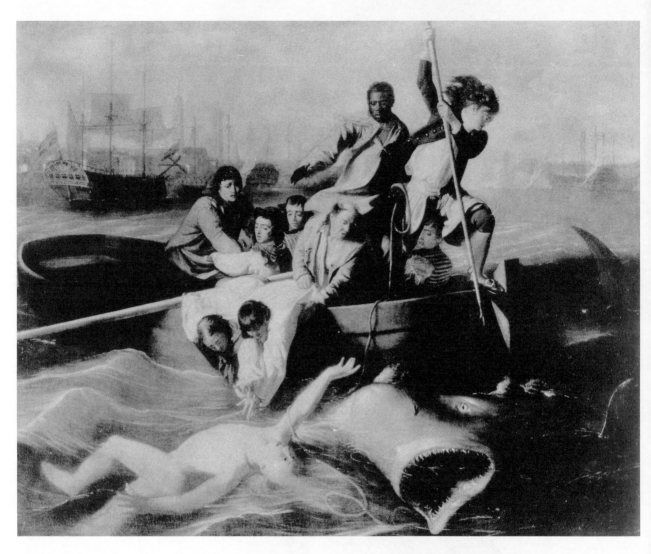

1. John Singleton Copley (American),
 Watson and the Shark, 1778,
 oil on canvas, 182.1 x 229.7 cm.
 Washington, D.C., National Gallery of Art,
 Ferdinand Lammot Belin Fund, no. 1963.6.1.

Werner Busch

Copley, West, and the Tradition of European High Art

We have become used to seeing American painting of the eighteenth and nineteenth centuries from a European perspective, that is, as an art of only relative merit. In the eighteenth century, American art seems totally dependent on English models, while in the nineteenth century it is largely dominated by the influence of the Düsseldorf school. Very often it is precisely the American element in American painting that is considered provincial and naive. Recent exhibitions — such as Thomas Gaehtgens's *Bilder aus der Neuen Welt* — have tried to do justice to the particular contribution of American painting.[1] As a correction of current views, this is useful and necessary. In academic discourse, however, established positions are not that readily discarded. I think it justifiable, therefore, to assume the European role once more — playing a kind of devil's advocate.

In the following discussion of American history painters working in England at the end of the eighteenth century, I shall argue that the novelty of American history painting — so abundantly stressed in recent critical discussion — is not so much a specifically American phenomenon but instead follows an English tradition and is part of a general change of the European conception of painting in the late eighteenth century. It is possible, however, that the American origin of these painters made them react more sensitively and decisively to these new trends, which can be related to a new manner of art reception resulting from the changed character of the public.

England's prominent role in this change derives, roughly speaking, from two English peculiarities: first, from the early existence of a constitutional monarchy, which, at least in large cities, brought about a measure of

35

social transparency, if not social permeability, with a powerful debating press, and, second, from the absence of a specifically English art tradition before the first third of the eighteenth century. Subsequently, this absence led to a need to compensate by inaugurating a national school of history painting, and at the same time it created an awareness of English particularity. The general change in the European conception of painting first became evident as an international Neoclassicism during the second half of the eighteenth century in Rome. The important share English artists had in this development has only now been realized. The separate English way and the change of European art language converge in what we now call the rise of historical thinking.

This meant that English art did not see itself as an integral part of a European tradition of High Art but began to look at this tradition in an art-historical way (which was connected to the rise of a new public and facilitated by the development of a new aesthetics of perception). It also meant that the archaeological dimension of this international Neoclassicism — its attempt to reconstruct the purity of classical antiquity — accounted for its sentimental and reflective tendency. This specifically English consciousness of artistic and historical difference was expressed with great lucidity by Sir Joshua Reynolds in 1790 in the last of his Royal Academy discourses:

> In pursuing this great Art [i.e., the High Art tradition of Michelangelo], it must be acknowledged that we labour under greater difficulties than those who were born in the age of its discovery, and whose minds from their infancy were habituated to this style; who learnt it as language, as their mother tongue. They had no mean taste to unlearn; they needed no persuasive discourse to allure them to a favourable reception of it, no abstruse investigation of its principles to convince them of the great latent truths on which it is founded. We are constrained, in these later days, to have recourse to a sort of Grammar and Dictionary, as the only means of recovering a dead language. It was by them learned by rote, and perhaps better learned that way than by precept.[2]

I shall attempt to show in a detailed analysis of a single painting by John Singleton Copley what consequences such consciousness and the recourse to the dictionary of a lost language of art had for the American-English art of the late eighteenth century. It will be necessary, however, occasionally to

broaden the context to include Benjamin West and, beyond West, William Hogarth, in order to show the relevance, in this context, of a genuinely English tradition.

Copley's *Watson and the Shark* (fig. 1) has certainly received exhaustive critical attention.[3] This appears to be even more true of West's *Death of General Wolfe* (fig. 2).[4] Nevertheless, I shall discuss Copley's painting once more, using West's *Wolfe* as a foil. I cannot come up with new historical evidence, but I hope to give more depth to what we already know by looking at it from a different perspective.

The novelty of West's as well as Copley's historical paintings lies — as established scholarly opinion has it — in its concentration on contemporary history in contemporary guise. This new realism in history painting is the first American contribution to Western art, as one can read in the standard work on Copley.[5] West, the Quaker from Philadelphia, and Copley, the Puritan from Boston, developed a distinctly naturalistic pragmatism, free from the burden of European tradition. West — as the more nuanced opinion of a more recent monograph would have it — on the one hand aimed at authenticity, at the reconstruction "of how it actually was," and on the other strove to achieve the monumental dignity of the classic historical tradition.[6] In the case of *Wolfe* he was able to link both by transcending the merely illustrative elements: Wolfe's death connoted Christian martyrdom by the dying general's assumption of the pose of the dead Christ. Or, as maintained elsewhere, the death for the fatherland is ennobled by the allusion to Christ's death for mankind.[7] In similar fashion one could say of Copley's *Watson* that its youthful hero, in attacking the monstrous shark, assumed the role and figuration of Saint Michael forcing Evil back into hell. Thus the common contemporary event was made part of Christian sacred history.[8] None of these interpretations is wrong: West's *Wolfe* is indeed modeled after the scene of the Lamentation of Christ, and Copley's hero definitely follows the Saint Michael type. And yet both observations are nevertheless insufficient, for the connection to the Christian model is in both cases much more complex. Therefore its meaning has to be modified.

First we shall examine Copley's *Watson*, exhibited in 1778 at the Royal Academy in London. Its quality of reportage has often suggested a comparison with Théodore Géricault's *Raft of the "Medusa"* (*Radeau de la "Méduse"*), 1818–1819 (Paris, Musée du Louvre). In other respects, too, these two paintings would seem to be related: with the unusual novelty of their themes,

37

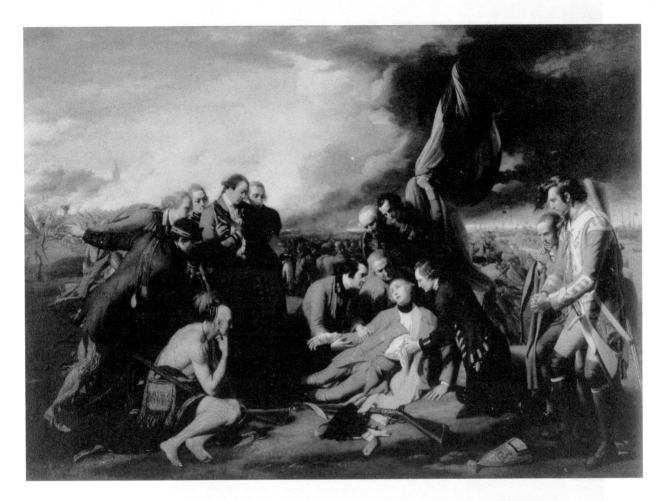

2. Benjamin West (American),
 The Death of General Wolfe, 1770,
 oil on canvas, 153.7 x 213.4 cm.
 Ottawa, National Gallery of Canada, no. 8007.

they both aimed, quite successfully, at the audience's curiosity, its lust for excitement and sensation.[9] Thus, the functional aspect of a new bourgeois art becomes evident: since the reaction of the public — that is, the audience and the press — determined the ranking and success of an artist, the artist had to surpass in novelty his competitors, whose works covered the walls of the Academy exhibition by the hundreds. Ever since the late eighteenth century, the arts, compelled by the market and its peculiar forms of distribution, have thus been under constant pressure to innovate.

Copley's painting — and this is also significant here — is a private commission to record a singular and dramatic event in the life of its patron. Nevertheless, the painting obviously courts the public by its covert allusions to High Art. It therefore comes as no surprise that Copley made two reproductions, and as in the case of West's *Wolfe*, the print after the painting was an enormous success. Later, Copley painted contemporary history directly for the public without an intervening patron, organized his own exhibitions, and became dependent on the income from entrance fees and from the sale of reproductions offered for subscription (since the selling of contemporary history painting was decidedly difficult without the help of a patron). Such painting necessarily implied taking sides in contemporary political debate and thus inevitably became entangled in party politics. But it thrived on the curiosity of the public no matter what position it assumed toward the event it represented.

The particular quality of Copley's *Watson* also relates to the character of the new bourgeois public. In its allusion to established convention and its use of formula, the private subject matter becomes available to collective reception — which is, however, individualized in as much as the private invites individual and subjective interpretation since it cannot claim historical or universal meaning.

The event that occasioned the painting can be told in few words. Brook Watson, a successful London merchant, had been attacked by a shark in 1749 when, at the age of fourteen, he was swimming in the harbor of Havana. He received serious leg injuries and lost his right foot in the shark's second attack. When it attacked for a third time, however, it was driven away by the inmates of the accompanying boat. Copley records this dramatic and decisive moment of the story. The composition is relatively simple: a triangle shifted from the center in accordance with the rules of the golden section. The triangle ascends from the brightest part of Watson's body

(helplessly drifting in the water), to the man on the right bending forward, to the figure holding him, and from there to the black man standing upright behind him; then it leads downward again along the straight line of the harpoon. The basis of this triangle is formed by Watson and the shark. In addition there is a correspondence between the rising line of the oar and the descending line of the monster's back.

For Copley the history painter there is an obvious dilemma. The main protagonist of the painting had to be its patron. But Watson is completely helpless in the water. Because of the passivity of the painting's principal figure, the hero's role is shifted to the young harpooner at the bow of the boat, who, with hair streaming, raises the lancelike boat hook to deal the decisive and saving blow. In contrast to the classical conception of history painting, however, all persons in the boat receive the same attention. Their presence is not dependent on a hero; each one is allowed to react individually. The press praised especially Copley's ability to differentiate physiognomies. The garments of the protagonists appear to be contemporary; it can also be proved that Copley used contemporary views for his silhouette of Havana. Nevertheless, two things seem unusual: first, Watson is almost completely naked, and the extreme paleness of his body had critics remark with some irritation that it made him look as if he were already dead.[10] Second, the white undergarment of the youthful hero falls unusually wide and, in distinctly noncontemporary fashion, well down below the belt; furthermore it is draped above the knee of the left leg, which is raised at a right angle. Here the contemporary is represented in a definitely classical manner.

The motif can be traced to the iconography of Saint Michael, whose iconographical type was firmly established already during the Middle Ages. It found its classical form in the circle of Raphael, and from there it spread over all Europe. Especially famous in England was Guido Reni's version of 1635 (fig. 3), which exists in a great number of copies, one of which was in the possession of Benjamin West. In 1776/1777, just before Copley delineated *Watson*, West had painted, in the manner of Reni, a huge Saint Michael for the chapel of Trinity College in Cambridge. It is very likely that West had familiarized his compatriot and protégé Copley with his copy of Reni, his own painting of Saint Michael, and with the whole Saint Michael iconography. West's painting clearly shows that he had examined this complex iconography in great detail.[11] Here, as in many other examples of the

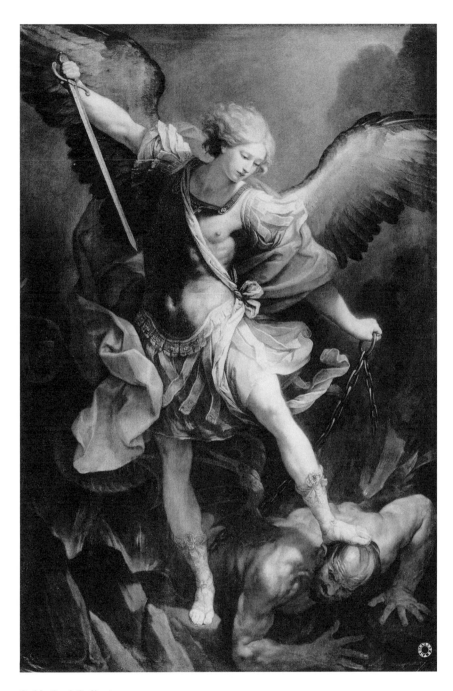

3. Guido Reni (Italian),
 Saint Michael (San Michele), 1635,
 oil on canvas, 293 x 202 cm.
 Rome, Santa Maria della Concezione.

Raphael tradition, Saint Michael is shown in the act of conquering Satan, who is writhing underneath him, often with a huge and gaping mouth and quite frequently, as with Reni, with the long, coiling tail of a serpent. There can be no question that in Copley's painting the incarnation of evil is the shark with its threatening mouth wide open and its tail fin rising out of the water behind the boat. Yet, in his version of the Saint Michael topic Copley goes several steps further.

The group of Saint Michael and Satan is found in Revelation 20:1–3. In Reni's painting, the chain in Saint Michael's hand refers precisely to this passage. But the iconographical type is taken from a larger scenic context: that of the fall of the angels, Revelation 12:7–9. Lucifer had taken possession of God's throne, from which Michael expelled him, pushing him with his lance into hell along with his whole devilish brood. Theologically, this marks the beginning of the history of salvation. Analogous to this topic is another iconographically related theme that also involves Saint Michael and marks the end of the history of salvation: the Last Judgment. Michael, the weigher of souls, separates the saved from the condemned, who writhe at his feet as did the fallen angels. Quite often, Michael uses his lance to rush the damned into hell a little faster. Seen in this iconographic tradition, the motif of *Watson* and the range of its meaning become a little clearer.

The figuration of *Watson* derives from the group of the resurrected souls at the Last Judgment, who, with writhing and distorted bodies, fearfully await God's judgment and its execution by Saint Michael. Just as Satan has to give up the soul saved by the divine judgment, so the satanic shark, at the last moment, has to let go of Watson, whom it was about to tear apart. Thus Watson can be said to experience his resurrection already during his lifetime. In addition, the shark also incorporates the gaping mouth of hell — indeed this may help explain the rather strange appearance of its forehead.

The problem inherent in this conception of history becomes apparent in its secularization of the sacred. As such the transfer of the iconographic type to the actual historical event is not yet blasphemy. The use of an iconographical figuration in thematically related contexts was common classical practice and had also been applied to the topos of Saint Michael. Let me mention just one example, which, by the way, is a good illustration of the motif of the left knee intentionally bare of garment. It derives from the Eastern iconography of the ruler and can be traced uninterrupted to Ingres's official representations of Napoleon as emperor.

42

The print by Egidius Sadeler after Bartholomäus Spranger (fig. 4) shows the victory of science over ignorance and barbarism in the figuration of Saint Michael.[12] Here the transfer of the Michael motif is rather far-reaching. The donkey-eared embodiment of ignorance and barbarism takes Satan's place, and the angel's palm of victory and the flying garment of science optically replace Saint Michael's wings; furthermore, the fetters derive from the chain with which Michael throws Satan into the abyss.

And yet there is a fundamental difference between these two forms of transfer. With Spranger the motif functions exclusively as a formula indicating conquest that was canonically developed in classical picture language in connection with the Saint Michael topos. The meaning of the Christian paradigm from which it originated is by no means called into question. It may be recognized by the connoisseur of art, who will read it as a confirmation of the classic and normative quality of Spranger's work and as a reference to the Christian foundation of all psychomachia. The art public of the eighteenth century, however, for whom the motif had lost its normative meaning, could comprehend its origin only art historically. It could make it an object to prove one's education. But this knowledge had to include not only the meaning of the motif but also the historical and art-historical function of its meaning — and this, indeed, is an important difference. We can see it very clearly in the entire contemporaneity of its new context. For the motif is used, not — as it is by Spranger — as part of an abstract transhistorical allegory but for the real Watson existing beyond the painting and its frame. The timeless motif is radically transplanted into time. Thus it becomes necessary to comprehend the timeless motif from within its new context of contemporary perception and usage. There is a noticeable gap — a discrepancy not solved in or by the painting — between the real private existence of the protagonist and the religious and nonsecular direction of the motif. It seems to transform the Last Judgment into a secular event and its representation, whether intended or not, into blasphemy.

One might ask, of course, whether the allusion to the Last Judgment was not within the range of Puritan religion and mentality. Might not Watson, in retrospect, have considered his accident in the harbor of Havana the central event, the turning point of his life, providing it with new meaning and direction? Despite the physical handicap he had suffered, Watson had again and again been able to start from scratch and to work his way up. Upon returning to Boston after his terrible accident, he learned that his guardian

43

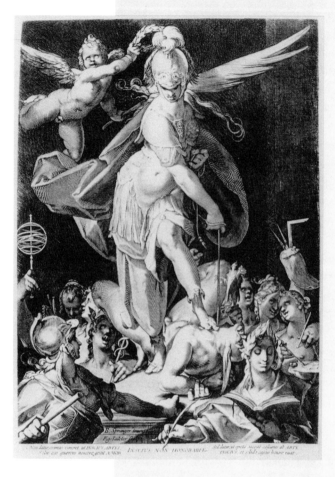

4. Egidius Sadeler (Flemish) after
Bartholomäus Spranger (Flemish),
*Triumph of Science over Ignorance and
Barbarism*, after 1595,
engraving, 49.5 x 35.7 cm.
Braunschweig, Herzog Anton Ulrich-
Museum, no. AB 2.121.
Photo: B. P. Keiser.

had run away. Through courage and self-confidence Watson had nevertheless been able to make something of himself: he became a highly decorated British agent, an independent and wealthy merchant, and later, in 1796, he was made Lord Mayor of London after he had been, for many years, a member of the British Parliament. Thus, what had happened to him in Havana might later have appeared as a sign of his election, of his salvation from Evil, a sign of God's providence and of his own experience of grace. Such an interpretation would be supported by the fact (of which the critics have been aware for some time) that the two figures leaning out of the boat in the effort to rescue Watson seem to be modeled after the fishermen hauling in their nets in Raphael's *Miraculous Catch*, 1514–1515 (London, Victoria and Albert Museum).[13] All this may indeed have been part of Copley's (and Watson's) intention — yet the way that intention was put into practice is nevertheless highly problematic.

Copley evidently tried to reconcile classical form and individual particularity. The highest objectivity and the highest subjectivity were to be brought together in a coherent form of representation. One may doubt, however, whether such reconciliation was indeed possible. The appropriateness of applying the traditional language of iconography to the private event depended on the audience — and the audience decided according to personal taste or political opinion. Seen aesthetically, however, there is a discrepancy between form and content; at least we are aware of their rather tentative connection. The Christian image and motif become mere formula, in Reynolds's sense, a mere word in the vocabulary of High Art, whose main function now consists of ennobling its secular and prosaic subject. Such ennobling seemed indeed necessary since reportage had no artistic value in the eyes of the public. In other words, the public's conception of art remained conventional, that is, the public demanded more from art than what it was consciously willing to allow.

Let me test this assertion by briefly looking at West's *Death of General Wolfe*. West's strategy is the same as Copley's: not only is the main figure modeled after a Christian prototype but in its composition the whole painting is an imitation of a complete iconographical scheme. In a Christian context this method of transference is the method of typology, of prefiguration. In West's case, it has obviously been secularized, to say the least. In ennobling his theme, West actually returns to one of the most elevated formulas of Christian art — the type of the Lamentation of Christ. Just as Saint John

45

or the Marys assemble around Christ, so the soldiers surround Wolfe, who is rendered entirely in the pose of the dying Christ, a pose that was well known in England through the tradition of Anthony van Dyck (fig. 5): the body elegantly swerved, the left arm hanging down in a curve and supported by an angel or by one of the Marys, the eyes raised in transfiguration upward toward the sky, which has opened after the battle, announcing a new day. In the Baroque tradition, this is the locus of divine self-revelation — in West's painting the dissolving smoke of the battle reveals a steeple as the sign and promise of salvation. (This, by the way, is a motif that can be traced to the iconography of the Prodigal Son, who experiences conversion at the sight of a steeple.) Likewise, West does not stop here but demonstrates his downright art-historical awareness and iconographical finesse. The mourning Native American not only supplies an exotic element of local color but evokes a specific type of the traditional scene of lamentation: the isolated figure of the mourning Saint John.[14] The painting's second figure of importance, Brigadier General Robert Monckton — who was Wolfe's deputy and like him was severely wounded in the battle — equally evokes a very specific type, namely, that of the fainting Mary in the scene of Christ's Descent from the Cross. This is apparent in the curious rendering of Monckton's limp left arm, which hangs loosely over the arm of the figure supporting him. In this case we can name the source from which West borrowed the motif: Rembrandt's *Deposition*, 1634 (Saint Petersburg, State Hermitage Museum), of which there existed at least one copy or variant in eighteenth-century England, which is now in the National Gallery of Art in Washington, D.C. Rembrandt's fainting Mary is supported by her companions in precisely the same way that, in West's painting, the wounded Monckton is held upright by his officers. Here, too, the adaptation of a Christian type reaches extremely far, and it is just as complex as in Copley's case. We may even assume that Copley and West discussed this method of image formation. A small detail would seem to confirm this. In West's *Wolfe*, the assisting figure to the right — a grenadier meant to represent the mourning of the common soldier — is modeled, as Charles Mitchell observed some time ago,[15] after the facial expression of Charles Le Brun's *Compassion*, down to the inclination of the head and the cascading hair. No wonder West resorted to a classical type of the passions, especially for the representation of a figure that did not need the particularity of portraiture. This tall figure standing in the foreground strikes the psychic note required here,

46

5. Anthony van Dyck (Dutch),
The Lamentation of Christ (*Pietà*), 1634,
oil on wood, 108.7 x 149.3 cm.
Munich, Alte Pinakothek, no. 606.

6. Detail of figure 1. Photo: Markus Hilbich.

7. Charles Le Brun (French),
 Dread (*La Crainte*), 1698,
 engraving, 9 x 5.5 cm.
 From Charles Le Brun, *Méthode pour
 apprendre a dessiner les passions* (Amsterdam:
 François van der Plaats, 1702), fig. 18.
 Santa Monica, The Getty Center for the
 History of Art and the Humanities.

8. Detail of figure 1. Photo: Markus Hilbich.

9. Charles Le Brun (French),
 Astonishment with Fright
 (*Etonnement avec Frayeur*), 1698,
 engraving, 9.1 x 5.3 cm.
 From Charles Le Brun, *Méthode pour*
 apprendre a dessiner les passions (Amsterdam:
 François van der Plaats, 1702), fig. 35.
 Santa Monica, The Getty Center for the
 History of Art and the Humanities.

true to Leon Battista Alberti's ancient recommendation.[16]

Copley applies this method of guiding the viewer's reaction to the painting by way of the classical typology of the passions to his *Watson*, making use of the same source that West had used: Le Brun's treatise on the passions. This may explain the very positive reaction of the newspapers to Copley's representation of emotion in the different faces of the figures in the boat. Thus the London *Morning Chronicle* wrote that the face of the black man "is a fine index of concern and horror."[17] Hence, Copley would seem to have reached the highest level in the classical representation of the passions, namely, the representation of the so-called mixed passions. If we examine this in more detail, we see that the facial expressions of the boat's crew largely follow Le Brun's prototypes. Thus the figure on the left half-standing in the boat (fig. 6), is modeled on Le Brun's *Dread* (fig. 7); the old man holding by the shirt one of the two figures leaning out of the boat (fig. 8) is clearly an imitation of Le Brun's *Astonishment with Fright* (fig. 9), as evidenced especially in his round, open mouth. This differentiation between *Dread* and *Astonishment with Fright* is quite logical. The man on the left looks only at Watson and fears for him, while the old man stares at the monstrous shark that emerges directly in front of him, his fright mixed with wonder at its huge dimension. Within the frame of contemporary thought this may have suggested to the viewer the experience of the sublime, which, according to Edmund Burke's famous treatise of 1757, *On the Sublime and Beautiful*, is a category of high aesthetic value. In contrast to the beautiful, it results from our reaction to something dangerously powerful that is yet distant enough for us to feel safe from its energy of destruction.

Copley had learned his lesson in the language of European classical art. He seems to have known its complex iconography, its repertoire of formal conventions, and its typology of the passions. He appears to have been so fully aware of contemporary aesthetics that his work may be considered a conscious exercise "in sublimity." That he also quoted well-known formulas and consulted Le Brun like a dictionary, may be shown by two completely literal renditions. In *Watson*, the sad oarsman staring through the legs of the Saint Michael-type is placed so that his right eye remains concealed. The face of Le Brun's *Sadness* (*Tristesse*), in the illustration of his treatise, is in large part completely hidden — just as it is in Copley's oarsman — by the shadow of the nose. Le Brun's illustrations seem to have been sacrosanct to Copley even in their smallest detail. The same holds true for the hero with

the lance (fig. 10): his profile with its wide-open eye — which is not completely logical in the context of the picture — duplicates, in fact, Le Brun's *Contempt* (fig. 11). Contempt vis-à-vis the monster shark may be the suitable response of a hero, yet on the aesthetic level these painfully exact repetitions from Le Brun seem evidence almost of the consciousness of a historicist — as if a book of samples had been opened. Apparently Reynolds was right: European art had become "a dead language," which — as Copley also seems to have believed — had to be revived.[18]

Contemporaries, however, noticed the discrepancy between the traditional types and the new context of their application. West's *Wolfe* — which already had its predecessors — produced a flood of representations of heroic deaths, all of them more or less following the type of the *Pietà*. As a reaction to this specifically English inflation there is a rather malicious caricature of 1792 by Richard Newton entitled *Tasting a Norfolk Dumpling* (fig. 12). In it the duke of Norfolk is shown lying on a table tasting (or rather, testing) the three daughters of the duchess of Gordon in order to find the one who kisses best and is best qualified for marriage. Newton's satire uses the complete scheme of the Byzantine type of the Entombment of Christ (fig. 13), with the dead Christ on the stone of ointment and Mary embracing and kissing him (as one of the duchess's daughters kisses the duke) while the other Marys stand about. The target of Newton's wit is a fashion of historical painting that mechanically cloaked its representation of dying heroes with the Christian prototype. Newton makes fun of its hollow idealism and the presumptuousness of its ennobling formulas. The role of the contemporary hero is exposed to public debate and thus thrown into doubt. In the case of West's *Wolfe*, we can see this in the controversy over Wolfe's monument and in the fact that West's figuration was caricatured repeatedly.

The existence of a caricature paraphrasing the Byzantine type of the Lamentation proves once more to what an extent the late eighteenth century was indeed able to see and reflect in an art-historical way. This reflection on the tradition of art in England began with William Hogarth, and it is possible that Benjamin West knew this. West's recourse to Christian iconography in his representation of the painting's central figure (and of one of its minor ones) has its precedent in Hogarth. The final scene of *The Rake's Progress*, 1735 (fig. 14), enacts to the last detail a Lamentation of Christ (fig. 15); even Christ's pot of ointment reappears in the soup bowl of the rake. The fifth scene of *Marriage à la Mode*, 1745 (fig. 16), uses, to an even greater extent than

51

10. Detail of figure 1.

11. Charles Le Brun (French),
 Contempt (*Le Mépris*), 1698,
 engraving, 8.8 x 5 cm.
 From Charles Le Brun, *Méthode pour
 apprendre a dessiner les passions* (Amsterdam:
 François van der Plaats, 1702), fig. 9.
 Santa Monica, The Getty Center for the
 History of Art and the Humanities.

Tasting a Norfolk Dumpling

12. Richard Newton (English),
 Tasting a Norfolk Dumpling, 1792,
 etching with some burin, 25.5 x 35.2 cm.
 London, Collection of Andrew Edmunds.

13. Ugolino di Neri (Italian),
 Entombment (*Deposizione*), ca. 1325,
 oil on wood, 40.8 x 58.4 cm.
 Berlin, Gemäldegalerie, no. 1635B.

53

14. William Hogarth (English),
 The Rake's Progress, Scene 8,
 Scene in Bedlam, 1735,
 etching and engraving.
 From *The Complete Works of William Hogarth*
 (London: The London Printing and Pub-
 lishing Co., 1861–1862?), vol. 1, pl. 29.
 Santa Monica, The Getty Center for the
 History of Art and the Humanities.

15. Lucas van Leyden (Dutch),
 The Lamentation of Christ (*Pietà*), 1521,
 engraving, 11.5 x 7.4 cm.
 Berlin, Staatliche Museen zu Berlin,
 Kupferstichkabinett.

does West's painting, the type of the Deposition, especially Rembrandt's version, as can be seen in the pose of the dying protagonist.[19]

One further example of Hogarth should be mentioned. His *Cruelty in Perfection* from the third scene of *The Four Stages of Cruelty,* 1751, in which the murderer Tom Nero — who has killed his mistress in a beastly manner — is taken prisoner in the churchyard by a crowd of infuriated citizens, is modeled on the capture of Christ. Even the disciple of Christ, mentioned in the Bible, who loses his garments reappears in a somewhat different form: he has become a citizen approaching in great haste.[20]

What do we have here? The blasphemic transformation of an iconographic tradition or its total loss of meaning? I would maintain that it is neither one nor the other. Since the method of transfer is a rather complex one, I shall have to focus on one aspect. Religious art had no place in eighteenth-century England, even if Hogarth painted an altarpiece once and Reynolds tried to revive it from an academic point of view, with West following in his footsteps. On the other hand religious art poured into the country — collected by aristocratic connoisseurs. The religious became almost exclusively an aesthetic object — cult, as Hogarth remarked, was "out of date." In developing its repertoire of forms, classical art had made ample use of religious art with its canonical themes and figurations. Hogarth had revealed its syntax and applied it to contemporary themes and objects. The connoisseur was able to see the sacred subtext within the contemporary text. This strategy provided aesthetic pleasure and raised the contemporary subject to the level of art in the classical sense. This, however, is only one side of the problem, for it seems hardly possible not to realize that aesthetic pleasure gave way to an awareness of the discrepancy between the traditional meaning of the religious scheme and its contemporary application. Contemporary experience increasingly undermined the value of Christian convictions as example and as norm of action. Thus they became objects of historic or aesthetic contemplation. Let me emphasize again that this had radical consequences for history painting. Form and meaning were drifting farther and farther apart throughout the eighteenth century. Indeed, art was well on its way toward what we now call aesthetic autonomy. After all, this is not only a gain but a loss, too.

16. William Hogarth (English),
Marriage à la Mode, Scene 5,
Death of the Earl, 1745,
etching and engraving.
From *The Complete Works of William Hogarth*
(London: The London Printing and Pub-
lishing Co., 1861–1862?), vol. 1, pl. 8.
Santa Monica, The Getty Center for the
History of Art and the Humanities.

NOTES

1. Thomas W. Gaehtgens, ed., *Bilder aus der Neuen Welt: Amerikanische Malerei des 18. und 19. Jahrhunderts*, exh. cat. (Munich: Prestel, 1988).

2. Sir Joshua Reynolds, *Discourses on Art* (London: Collier-Macmillan, 1966), 244 (Discourse 15, 10 December 1790).

3. Jules D. Prown, *John Singleton Copley* (Cambridge, Mass.: Harvard Univ. Press, 1966), 2:267, no. 371; Alfred Neumeyer, *Geschichte der amerikanischen Malerei* (Munich: Prestel, 1974), 72–73; Roger Stein, "Copley's *Watson and the Shark* and the Aesthetics in the 1770's," in Calvin Israel, ed., *Discoveries and Considerations: Essays on Early American Literature and Aesthetics, Presented to Harold Janta* (Albany: State Univ. of New York Press, 1976), 85–130; Irma B. Jaffe, "John Singleton Copley's *Watson and the Shark*," *The American Art Journal* 9 (May 1977): 15–25; Ann Uhry Abrams, "Politics, Prints, and John Singleton Copley's *Watson and the Shark*," *The Art Bulletin* 61 (1979): 265–76.

4. To mention only the most important: Edgar Wind, "The Revolution in History Painting," *The Journal of the Warburg and Courtauld Institutes* 2 (1938/1939): 116–27; Charles Mitchell, "Benjamin West's *Death of General Wolfe* and the Popular History Piece," *The Journal of the Warburg and Courtauld Institutes* 7 (1944): 20–33; Werner Busch, *Nachahmung als bürgerliches Kunstprinzip: Ikonographische Zitate bei Hogarth und in seiner Nachfolge*, Studien zur Kunstgeschichte, vol. 7 (Hildesheim and New York: Olms, 1977), 68–70; Dennis Montagna, "Benjamin West's *The Death of General Wolfe*: A Nationalist Narrative," *The American Art Journal* 13 (Spring 1981): 72–88; Ann Uhry Abrams, "The Apotheosis of General Wolfe," in idem, *The Valiant Hero: Benjamin West and Grand Style History Painting* (Washington, D.C.: Smithsonian Institution Press, 1985), chap. 8, 161–84; Helmut von Erffa and Allen Staley, *The Paintings of Benjamin West* (New Haven: Yale Univ. Press, 1986), cat. nos. 93–100.

5. Prown (see note 3), 2:267–74.

6. Von Erffa and Staley (see note 4), 57, 62.

7. Werner Busch, "Die englische Kunst des 18. Jahrhunderts," in Werner Busch and Peter Schmoock, eds., *Kunst: Die Geschichte ihrer Funktionen* (Weinheim and Berlin: Quadriga/Beltz, 1987), 651–52.

8. Horst Woldemar Janson, *History of Art* (New York: Abrams, 1963), 465; and Jan Białostocki, *Stil und Ikonographie: Studien zur Kunstwissenschaft* (Dresden: VEB Verlag der Kunst, 1966), 163.

9. On this aspect of Géricault's *Raft of the Medusa*, see Wolfgang Kemp, "Kunst wird gesammelt — Kunst kommt ins Museum," in Busch and Schmoock (see note 7), 167–70.

10. Prown (see note 3), 7, on contemporary press reaction.

11. Von Erffa and Staley (see note 4), cat. nos. 406–408.

12. Gerhard Langemeyer and Reinhart Schleier, *Bilder nach Bildern: Druckgrafik und die*

Vermittlung von Kunst, exh. cat. (Münster: Landschaftsverband Westfalen-Lippe, 1976), cat. no. 77. See also R. J. W. Evans and Joaneath Spicer, *Prag um 1600: Kunst und Kultur am Hofe Rudolfs II*, trans. Petra Kruse, exh. cat. (Frehen: Luca, 1988), cat. no. 159.

13. Neumeyer (see note 3), 72–73. The painting also produced different iconographical associations: J. Richard Judson, "Marine Symbols of Salvation in the Sixteenth Century," in Lucy Freeman Sandler, ed., *Essays in Memory of Karl Lehmann* (New York: Institute of Fine Arts, New York Univ., 1964), 136–52, saw the group in the water as imitating the iconography of Jonas and thus as alluding to the theme of the Resurrection. Even if the reference is not convincing, the fact that it has been produced by Copley's painting is in itself a case in point. In combining classical form, a classical claim for validity, and modern subject matter the painting creates a need for endless iconographical exegesis and a search for profound meaning.

14. This type had already been used by Hogarth, see Busch (note 4), 5.

15. Mitchell (see note 4), 31.

16. Leon Battista Alberti, *On Painting* (1436), trans. with introduction and notes by John R. Spencer (New Haven and London: Yale Univ. Press 1966), 78.

17. See Prown (note 3), 2:267.

18. See Reynolds (note 2).

19. Busch (see note 4), 3–6, 9–10.

20. Ibid., 11–12; also, idem, "Die Akademie zwischen autonomer Zeichnung und Handwerkerdesign – Zur Auffassung der Linie und der Zeichen im 18. Jahrhundert," in Herbert Beck, Peter C. Bol, and Eva Maek-Gérard, eds., *Ideal und Wirklichkeit der bildenden Kunst im späten 18. Jahrhundert*, Frankfurter Forschungen zur Kunst, vol. 11 (Berlin: Mann, 1984), 183–87.

1. Winslow Homer (American),
 Croquet Scene, 1866,
 oil on canvas, 40.7 x 66.8 cm.
 Chicago, The Art Institute of Chicago, Friends
 of American Art Collection, no. 1942.35.
 ©1992 The Art Institute of Chicago,
 All Rights Reserved.

Barbara Novak

Self, Time, and
Object in American Art

Copley, Lane, and Homer

Theories of the self have themselves a history, traditionally preoccupying philosophers and theologians and more recently psychologists and psychoanalysts, from Freud's ego, superego, and id, to Jung's ego, anima/animus, and shadow, to Jacques Lacan's special readings of *je* and *moi*. These are models, just as we have models of the atom, which was once seen as a miniature planetary system and is now succeeded by a far more paradoxical model of electrons and quarks. Each of these opens avenues of insight, and the criterion for their currency is their usefulness. Yet, one cannot look at these models, both of the self and of the atom, without a sense of the extraordinary imaginative coefficients that have been brought to bear on these problems. In a way, Freud, Jung, and Lacan are fulfilling their fantasies of what the self might be — fantasies that many have found extremely convincing.

So the definition of the self is always debatable, and in that debate one may invoke a variety of models. No wonder James Joyce spoke of a man who was Jung and Freudened. After him, Lacan has written, "I shall speak of Joyce...only to say that he is the simplest consequence of a refusal...of a psycho-analysis, which, as a result, his work illustrates. But I have done no more than touch on this, in view of my embarrassment where art — an element in which Freud did not bathe without mishap — is concerned."[1]

As we know, Lacan's "embarrassment" with art did not prevent him from making important contributions to our understanding of the artist's self, and especially, of the gaze.

But in the broadest sense, the most useful psychoanalytic text for our present purposes is offered by Heinz Kohut, the psychologist of self who defines the self as "an independent center of initiative, and independent

recipient of impression."[2] This is very simply and directly applicable to the artist.

But the artist is also a historical consciousness, and one aspect of self as we will consider it here is historical. What *is* the idea of the self held explicitly or implicitly in any period?

In early and mid-nineteenth-century America, the artist was told that "before Nature you are to lose sight of yourself and seek reverently for truth... It is not of the least consequence whether *you* appear in your studies or no"; and, "A painter should lose sight of himself when painting from nature — if he loves her — if a painter loves nature he will not think of himself."[3]

How did mid-nineteenth-century American aesthetics identify the self when it appeared in painting? Obviously, the work of art has issued from a source that, however removed from the final work, submits itself to what we usually call a "reading," to distinguish it from mere "looking." That source could be said to function as Kohut's independent recipient of impression.

The one factor common to all paintings, at least up to certain works in the twentieth century, is that they are painted stroke by stroke with the hand. Just as the fingerprints on the hand vary, so does the hand as it writes or paints. And traditional systems of connoisseurship have been built upon this. Attributions are made according to the scholar/connoisseur's reading of the stroke — an ambiguous sign — that operates as personal signature. How does that stroke, the *hand*ling, as it is called, of the paint, give us access to the self? Freud's famous comment may be useful here: "The ego is first and foremost a bodily ego; it is not merely a surface entity, but is itself the projection of a surface."[4] Can the tissue of paint be seen as an extension of that bodily ego? This is perhaps more viable for our purposes than traditional ideas of expressiveness. The artist's body is displaced into modalities of touch, pressure, and movement on a plane surface.

The medium of paint, which is art's body, can also have a corporeal or biological connotation. It is juicy. It oozes. It accumulates layers and tissues. We can perhaps take stroke then as connoting a bodily ego that is a displacement or residue of self. But what if the stroke is *absent*? Is this a repression or denial of self? And how does this idea relate to what I believe to be specifically American attitudes, from Puritanism through Transcendentalism and up to this moment?

Let us take some paintings as texts, basing our reading on the syntax of

stroke — which includes its absence. We must recognize that the possibility of reciprocal paradox is always with us in these ambiguous matters. Just as a violent and energetic stroke can be read as conveying emotion in certain Expressionist paintings, in Van Gogh for example, the repression of the stroke may in some cases — and this is true in some Surrealism — also be a sign of violence or hysteria.

In earlier periods, in America especially, the erased or masked self also requires a reading. But *how* are we to read it? Is not the repression of stroke itself an assertion of self? Missing or not, the stroke is primed by other factors that operate through the executive mind or hand. Though we might be able to read in stroke the self as bodily ego, we must also remember that stroke can be the carrier of style as well. How much then, we must ask, is self and how much is style, in the sense of a shared period formula or convention?

But the problem is even more complex. We cannot read self only in terms of the presence or absence of stroke. How is the painting approached? It is, after all, the result of the artist's strategies, method, and procedure. In American art, that procedure has to do with certain confrontations with nature, object, or thing, which I feel implicate attitudes in the culture at large.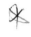

We have then, to summarize, the issue of the self from several points of view: its presence or absence, as signified by stroke and by procedure, by how nature is engaged and represented, how that process is related to broader social and cultural practices, including, but extending beyond, style — all the while aware that the self itself is a highly labile construct, an individual or social fiction for which no single definition has been achieved.

I should say, too, that another set of texts — Walt Whitman and Frederic Edwin Church, for example — would involve a different reading, but I have chosen here to deal with the three New England artists, John Singleton Copley, Fitz Hugh Lane, and Winslow Homer, and through them to track the vanished self.

The first mature American master, John Singleton Copley, offers us a plethora of *p*'s. To philosophical, and perceptual, we might add the words phenomenological, pragmatic, practical, provincial, primitive, precursor, and even to some extent puritanical. Yet on some levels, Copley seems to have been far from a Puritan. He was an Anglican of Anglo-Irish lineage. His sensual handling of stuffs indicates an apuritanical love of luxe. Yet he is practicing his

art in Boston, the cradle of American Puritanism. He is painting portraits, not only of Anglicans but mostly of Congregationalists, and he marries a Congregationalist, Sukey Clarke, whose father had his tea tossed overboard in the Boston Tea Party. Copley is working not long after the Great Awakening, indeed he is a child in the crucial decade after the Awakening of 1740. Thus, he is situated in time quite close to the great theologian Jonathan Edwards, who dies in 1758, five years after Copley made his earliest paintings.

Like Edwards, Copley may be said in some ways to be a child of one of the age's dominant philosophers, John Locke. Edwards had discovered Locke perhaps as early as 1717.[5] We have no direct proof that Copley read Locke (but we know he read art theory in the library of his stepfather, Peter Pelham, including Francesco Algarotti, who *did* read Locke).[6] We could also paraphrase Michael Baxendall on Jean-Baptiste-Siméon Chardin and say that there was no need for Copley to read Locke: The culture was Lockean.[7] Edwards, the revivalist, was also a philosopher of idea and matter, and this philosophical aspect of his thinking is shared by Copley's canvases — which are also very pragmatic.

Copley's pragmatism relates to that of another key figure for the eighteenth century, Benjamin Franklin, who vigorously embodies a pragmatic, how-to strain in American thinking and practice. That strain can be seen as part of the utilitarian tide that, as Thomas Cole was to maintain in 1838, set against the fine arts in America. In America, it generally has.

This was certainly so in Copley's time, when portraiture was the only art making that patrons found acceptable. It had the useful function of providing a likeness. But the *idea* of the practical and the useful also directed the artist's procedure. The work of art was *crafted* with a kind of common sense. This notion of craft situates the artist between High Art and the workingman's craft. Copley was sensitive to this issue. He wrote that it was mortifying to make art in a place where the artist was treated as no better than a shoemaker.[8] But he had no idea, since he had not yet been to Europe, what the art of the great masters looked like. He felt acutely the provincial's distress at the ocean separating him from the artistic mainstream, and he had no access to the studio training that would have taught him artistic formulas and conventions. So with little to go on but the ideational primitivism of the early limners and some eighteenth-century English mezzotints, he *invented* his art according to his idea of what great art would look like. Like R. W. B. Lewis's American Adam, Copley started virtually at the beginning.[9]

In doing so he defined attitudes and properties that can still be found in American art today, for instance, the habit of solving problems freshly as if they had never been solved before and approaching them with the practical query ultimately formalized by William James into a philosophical system: Does it work?

Copley's astonishing achievement raises questions about the making of art that are very difficult to answer. One is moved to look at this, not only as an extraordinary triumph of the will but as a visual product of much contemporary philosophical inquiry.

The figure of Locke enters here in a tantalizing way. Copley's method of procedure, his validation of idea through sensation and experience, is a visual analogue to Lockean theory. Locke stressed Sensation, "this great source of most of the ideas we have, depending wholly upon our senses, and derived by them to the understanding."[10] As one look at his paintings will show, so did Copley. Edwards had noted, "The whole of what we any way observe whereby we get the idea of solidity or solid body are certain parts of space from whence we receive the ideas of light and colors, and certain sensations by the sense of feeling.... These parts of space, from whence we receive these sensations, resist and stop other bodies."[11]

This reveals a man intensely involved in the act of looking at something — of figuring it out. The source of this kind of basic speculation is obvious. The regnant philosophy dealt with how the mind formulates ideas from sensations. As we read Locke and also George Berkeley, the problem of how the external world is perceived is an urgent issue.

The concreteness of Copley's objects, the felt volume and dimension of his sitters, the sheen and gloss of silk and satin surfaces, represent a kind of sensational literalism, or vice versa (fig. 2). Out of his pragmatic responses, Copley literally mimics the process of perception. In so doing, his practice, relying on consciousness, also reminds us that Locke, in a very provocative addendum of 1694 to the second edition of his famous *Essay Concerning Human Understanding* of 1690, had located the self in consciousness, thereby launching fierce literary and philosophical battles about identity in eighteenth-century England.[12]

Copley exhibits a great urge to reexperience his sensations on the canvas, to exercise a kind of power that in some cultures, certainly in this one, is intimately involved in the re-presentation — indeed re-creation — of things. This impulse draws not only on the sensation of sight but on the

66

2. John Singleton Copley (American),
 Mrs. Ezekiel Goldthwait (*Elizabeth Lewis*), 1771,
 oil on canvas, 127 x 101.6 cm.
 Boston, Museum of Fine Arts, Bequest of
 John T. Bowen in memory of Eliza M. Bowen,
 no. 41.84.

3. John Singleton Copley (American),
 Mrs. Richard Skinner (*Dorothy Wendell*), 1772,
 oil on canvas, 100.9 x 78.1 cm.
 Boston, Museum of Fine Arts, Bequest of
 Mrs. Martin Brimmer, no. 06.2428.

sensation of touch, which serves to reinforce and confirm the visual.

Copley investigates the nature of thingness, of — we might say — Locke's *materia prima*. On one level, he is a Colonial phenomenologist, dealing with *things*. In so doing he immediately presents us with another problem: What is the nature of the things he deals with? And what does his dealing with things signify? For this concern with thingness, with what Etienne Gilson has called the "actionless existentiality"[13] of things, seems to nag at the American artist as periods and eras wax and wane. Is this persistent subtext in American perception derived from a durable amalgam of Locke, Edwards, Puritanism, and primitivism? And, we may ask, why does it persist when the force of the original components has been dissipated?

Perry Miller wrote of Jonathan Edwards that he represented "Puritanism recast in the idiom of empirical psychology."[14] Much the same thing could be said of Copley. Though he was an Anglican, it would have been difficult for a painter such as Copley in mid-eighteenth-century Boston to avoid subscribing to *some* Puritan values, if not theological, then simply social and cultural. Can we also read in his images the growing Yankee approval in the 1760s and 1770s of the gathering of property? Do they indicate the values of the New England patrons, many of them merchants, who are having their portraits and those of their families painted — their images preserved — for a portrait is an investment in self, a displacement of one's living image into property and thus value. Do these patrons by now have few metaphysical or Puritanical qualms about their pursuit of wealth — including the representation of themselves as capital? These portraits of Copley's implicitly authenticate the value system that they in turn represent. And what of the maker of these portraits?

Copley was himself a property owner. He owned three houses in Boston. Benjamin Franklin might have called that success. A scholar of the Enlightenment, Henry May, has written of the strong grip of Arminianism and ideas of personal happiness in Boston after the Awakening.[15] Are we dealing here with simulacra that signify material success? With objects that are equated with freedom and happiness? Such interpretations have already been presented by Copley scholarship.

To this we might add additional queries. Is the sensuality of fabrics a sign of Copley's own sensuality, a self-reflexive joy and pleasure in the sumptuousness of the *matière*? Is there here some retention of his Anglican roots, a reverberation of High Church splendor?

68

But we are confronted with the objects, the things themselves. The artist is hard to find because the things have displaced him. This is the enigma of Copley. The self as indicated by the hand, by the handwriting of stroke, has been erased from the smooth surface. The anonymous paint surface of the primitive has been transformed by Copley into the surface skin of the objects he depicts, the satins and laces and brocades that adorn his sitters (fig. 3). Self as procedure, located in consciousness, has been utilized, but all trace of it is gone. What is the meaning of this vanished process? Copley's self was ultimately declared in the ambition that brought him to Europe in 1774, there to indulge in the bodily sumptuousness of paint, not things, an expression of both self and historical style. But in his American work of the 1760s and early 1770s self has been erased, not only through the stylistic retention of anonymity via the limner tradition from which he springs but possibly also through the humility of Puritan habit and environment. Are there in these American Copleys some echoes of the admonitions of the seventeenth-century English Puritan Richard Baxter?: "It is self that Scripture principally speaks against.... The very names of Self and Own, should sound in the watchful Christian's ears as very terrible, wakening words, that are next to the names of sin and satan."[16]

Sacvan Bercovitch reminds us of the ambivalence of the Puritan attitude toward self when he notes that "the force of I-ness is transparent in the violent vocabulary of self-abhorrence" and suggests that "the very process of self-denial is also a provocation of the self."[17] Where then has the self gone? Has it been erased, sequestered, immersed, violently displaced? Can we speak, following Bercovitch, of an antiself that works against the self's assertiveness to take on the mask of things? The object's presence is in inverse relationship to the absence of the self. Are Copley's objects vessels for the transformation, displacement, and annihilation of this hidden self? If this is so, we may ask, to what end?

Do the objects, the things, in Copley's paintings, which anticipate the demands of the nineteenth century for a reconciliation of the real and the ideal, also resolve a conflict between the secular and the metaphysical? If we compare Copley's still life of fruit in the portrait of Mrs. Goldthwait with a still life by the seventeenth-century Spaniard Francisco de Zurbarán, it is evident that Zurbarán's forms have a more clearly articulated and very different spiritual agenda. But does the way in which Copley's objects present themselves also raise questions about their metaphysical status?

69

Perry Miller has said of Edwards, "His technique remained that of the Boston lecture, a rigorously unornamented prose, and a stark, logical dissection of some Calvinist platitude, where the deceptive simplicity concealed the fact that certain immense metaphysical assumptions had been smuggled in through the vocabulary."[18] Miller's point could again apply to Copley's *things*. An *overt* metaphysics could have been suppressed, not only by the growing spread of Enlightenment reason but by certain latent aspects of Puritan dogma itself. Yet it is also true that Copley's *things* are more than things, that there is in them precisely that actionless existentiality cited earlier, in which time, checked by the absence of process, stops, delivering them into that suspenseful precinct where the ideal and the real conjugate an illusion of timelessness. There the fictions of the masked self or antiself regulate their own displacement into the representation of the natural world. It is a situation to which the nineteenth century in America returns again and again in different contexts.

Like Copley's, Fitz Hugh Lane's earliest works are primitive. Copley, we recall, found it mortifying to be considered little better than a shoemaker. Lane's nephew, Edward, informs us that "before he became an artist he worked for a short time making shoes, but after a while, seeing that he could draw pictures better than he could make shoes, he went to Boston and took lessons in drawing and painting and became a marine artist."[19]

Lane went to Boston from his native Gloucester and while there worked as a printmaker. In the late 1840s he returned to Gloucester and with his brother-in-law, Ignatius Winter, he built a stone house inspired by the historic House of Seven Gables, immortalized shortly afterward by Nathaniel Hawthorne. We do not have the shoes but the house and records of some banners Lane designed survive. All these are solid evidence of a grounding in craft. Early craft experience occurs frequently in the personal history of American artists. We could perhaps say that the idea of self-taught craft lies behind the American obsession with the how-to: How to Make Your Own Furniture, or How to Lose Ten Pounds in Seven Days. Lane's house, also proceeding from the primitive and the pragmatic, is as spare as Copley's carefully crafted portraits. On another centennial occasion, the anniversary of Lane's death in 1865, the poet Charles Olson, also of Gloucester, wrote that Lane was "one of the chief definers of the American 'practice' —

the word is Charles Peirce's for pragmatism — which is still the conspicuous difference of American from any other past or any other present, no matter how much we are now almost the true international to which all bow and acknowledge."[20]

As it is in Copley, the reciprocal relation between object and idea in Lane's work is painstakingly negotiated. The making of an object is rehearsed by mimicking its substantive creation, by recreating it from its ideational naming to its tangible presence. The same meticulous observation duplicates experience sensation by sensation. The paint is again smoothed into a virtually anonymous surface (fig. 4). With this erasure of stroke, of handwriting, of the hand, of overt personality, we must again try to follow the voyages of the missing self. But now, eighty years after Copley, in a different time and, though still New England, in a different place, we may well ask, what self? We recall that the mid-century critics had advised the artist, "It is not of the least consequence whether you appear in your studies or no." This was a direct contemporary acknowledgment of the issue of the missing self.

William James reminds us that "the oddly-named thing pragmatism… can remain religious like the rationalisms, but at the same time, like the empiricisms…preserve the richest intimacy with facts."[21] Well, let us look at the facts, the facts in Lane's painting *The Western Shore with Norman's Woe* (fig. 5). Each object, each pebble and rock is perceived, clarified, and represented with a hyperintensity that doubly confirms its presence. (This necessity for doubled sensations in American art possibly connects to a larger distrust of the senses in American culture as a whole. The world would seem to need confirmation over and over again.) The artist has become the transparent medium through which the spectator apprehends the scene. Again we can invoke the inverse rule of the object's powerful presence and the painter's absence. But the terms of that absence have changed.

Does a Puritan suppression of self linger here? Or are we dealing with something else? Can we perhaps say that Lane achieves in these paintings what Wilhelm Worringer would have called "a human self-consciousness" so small and a "metaphysical submissiveness so great?"[22]

To raise the name of the great German theorist Wilhelm Worringer here is not coincidental. We are all well aware that there are powerful parallels between the works of the Luminist Lane (fig. 6) and his German colleague Caspar David Friedrich (fig. 7). The American Transcendentalists, as we know, were deeply steeped in German philosophy. If, with Copley, we could

GERMAN PHILOSOPHY ⟷ AM. TRANSCENDEN

4. Fitz Hugh Lane (American),
 Boston Harbor, Sunset, 1850–1855,
 oil on canvas, 61 x 99.7 cm.
 Los Angeles, collection of Jo Ann and
 Julian Ganz, Jr.

5. Fitz Hugh Lane (American),
 The Western Shore with Norman's Woe, 1862,
 oil on canvas, 56.7 x 92.9 cm.
 Gloucester, Mass., Cape Ann Historical
 Association, no. 1147C.

6. Fitz Hugh Lane (American),
Brace's Rock, 1864,
oil on canvas, 25.6 x 38.5 cm.
Gloucester, Mass., collection of Mr. and Mrs.
Harold Bell.

7. Caspar David Friedrich (German),
 Mist (*Meerestrand im Nebel*), 1807,
 oil on canvas, 33.5 x 51 cm.
 Vienna, Österreichische Galerie, no. 3700.

find an intellectual parallel in the ideas of Locke in England, now we can find powerful intellectual confirmation for American artists and writers in Friedrich Wilhelm Joseph von Schelling's *Naturphilosophie*; in Goethe, who was a hero to nineteenth-century American culture; in ideas that came to the Americans, primarily the literary figures, through their own readings in German ideal philosophy and through the translations by Samuel Taylor Coleridge and Thomas Carlyle. The intellectual and philosophical rapport was strong. Many American landscape paintings of the mid-nineteenth century, especially those we call Luminist, can be seen against such a background.

Elsewhere I have discussed the relations between Lane and Friedrich,[23] so I will just summarize them here. Their mutual sophistications in each instance grew out of the primitive and planar folk/craft traditions, advancing finally into Transcendental invocations of the numinous. Although there are many cases in art history when similar forms embody differing content, here there are distinct philosophical correlations that tally also with the verbal declarations of Goethe and Karl Gustav Carus in Germany and with such figures as Ralph Waldo Emerson in America. As when Goethe states, "The works of nature are ever a freshly uttered word of God."[24] Emerson not only quoted this in his journal but then offered his own, "The noblest ministry of nature is to stand as the apparition of God."[25] And Carus's "You are nothing, God is all"[26] could apply to many works by both Friedrich and Lane.

Nonetheless, there are also crucial differences, especially in the area of the self, for Friedrich, in speaking out for "heart" or "feeling" ("The heart is the only true source of art.... A painter should not merely paint what he sees in front of him, he ought to paint what he sees within himself"),[27] indicates that his smooth anonymous surfaces are not intended fully to mask the self. Despite Friedrich's vanished process, his belief in the subjective differs from the almost Asian impersonality of the Americans.

Worringer has noted that "mysticism: born of individualism...immediately preaches against its own origin."[28] With Friedrich, the overt disappearance of self maintains the idea of an original self. Indeed, the German self often seems to remain present, despite its striving for mystical annihilation. It is perhaps for this reason that the object in Friedrich's art, far from asserting its own presence, remains mainly a painted form. Though not painterly, it nonetheless carries within it the diachronic "bud" of later German Expressionism.

76

So for all the similarities between Friedrich and the Americans, the differences enable us to distinguish between the various artistic traditions. Friedrich's self is distilled abstractly into the overall feeling of his mat painted surfaces. Lane's self is immersed in and masked by the hyperrealism of the objects or "facts" in his painted world. The self or ego is somehow displaced into the object of its attention. It is the *thing*, not the self, that remains obdurately present. In the Transcendental period in America, moreover, the natural fact is more readily equated with Deity without signifying other cultural systems through overt signs.

Perry Miller, to whom this essay might most properly be dedicated, puts it succinctly when he speaks of the Transcendental discard of the husks of Puritan theological dogma separating God, Man, and Nature.[29] Now, in the Transcendental era, they are inseparable, and Lane's halated forms, his harbored boats and luminous expanses of still water, can be seen in Emerson's words, as facts that are "the end or last issue of spirit."[30] To go from Copley to the Luminist Fitz Hugh Lane is to go from the metaphysical assumption of the thing to the thing as the embodiment of a metaphysical, that is, Transcendental, system. The objects in Lane's paintings are presented in terms of Transcendental hermeneutics. They are emblems, to use Emerson's phrase, and as emblems transport a providential worldview, enhanced by correspondences. I have always held that Lane is the painter whose works best parallel many of Emerson's most deeply felt dicta. He is *the* American Transcendental painter.

Is Lane then just illustrating Emerson? And if he is, which Emerson is he illustrating? We do know that Emerson was as contradictory of himself as a weather vane. Literary historians have questioned Emerson's intent in the famous "transparent eyeball passage" that was first connected with Luminism thirty-five years ago by the late John I. H. Baur.[31] We see Emerson as a transparent eyeball in the caricature by the poet and painter Christopher Cranch. In Emerson's words, "All mean egotism vanishes. I become a transparent eyeball, I am nothing, I see all."[32] But though Emerson and Lane probably met at the Gloucester Lyceum when Emerson was lecturing there, no direct influence is necessary to confirm the extraordinary consonance between many aspects of Emerson's thinking and Lane's implicit aesthetic.

"It is not words only that are emblematic," Emerson wrote in *Nature*, "it is things which are emblematic. Every natural fact is a symbol of some spiritual fact."[33] Lane nonetheless grasps the Emersonian fact pragmatically, like

Copley's fact or thing, in a self-reliance that has by now also become part of the Transcendental credo. Emerson, in an interesting comment that deals with the flow of sensory traffic between the interior and exterior worlds, says, "I am always environed by myself. What I am, all things reflect to me. The state of me makes Massachusetts and the United States out there." He also said, "Here's for the plain old Adam, the simple, genuine self against the whole world."[34]

Insofar as Lane partook of this Emersonian self, he too was Adamic. But one of the most jealously guarded canons of art-historical theory is that there are no Adams among artists, that art basically derives from other art. In America, I feel, this is not so much the case. Kohut's definition of self as an independent recipient of impression is useful here. The pragmatic procedure is itself ad hoc and by definition a rejection of the past. R. W. B. Lewis, in his classic study *The American Adam*, has written about the American case against the past.[35] We have seen Copley invent art. Throughout American art we can point to the American habit of starting from the beginning, again and again. And in Lane, we witness the same pragmatic reliance on his own eyes, the clinical tang of the ad hoc encounter with nature. I have long stressed that the American artist's consistent pragmatic relation to nature and the object is one of the things that distinguishes American from European painting. Though my own research has pointed up Dutch prototypes for Luminist structure, I have also argued for the Dutch example of going directly to nature and observing.[36]

What did Lane observe? In discussing his philosophical implications, one must never lose sight of the way in which his observation was firmly grounded in a specific place with a specific economy. Place, topos, and the recording of place, have a crucial role here. Though Lane painted and traveled in other places, especially Maine, Gloucester was his most compelling model. From the outset the town claimed its identity from the sea and ships, as well as from the fish and fisheries that were part of its livelihood and economic and social raison d'être. A plaque set in a huge rock near Stage Fort memorializes the founding of the Massachusetts Bay Colony and the fisheries at Cape Ann in 1623. Ships, fish, and rocks define Gloucester as much as do the houses and streets that Lane from the very beginning of his career had delineated in topographical prints.

Today Gloucester maintains the same essential character. The town documents, the archival records of Lane's friends and patrons, the stones at Oak

Cemetery where he is buried, all bear names that are still a vital part of Gloucester today, so that the slowed rate of contemporary change offers within itself an odd parallel to the suspended time of Lane's paintings. Insofar as Lane's work sustains this illusion of time stilled, it finds access to the Transcendental idea.

It is both difficult and telling to speak of time in relation to a work of art. The work itself is of course subject to time. It ages and crackles. But each work has in it an attitude toward time, particularly landscape painting, which often chooses, especially in America, a specific time of day. How do Lane's works represent time? Not only what time is it but also what kind of time is so represented? For with the displacement of the self through a perfectly graded, smooth surface, something also happens to time.

There are moments before nature — particularly at dusk — when the world seems to hold its breath, as it were, and silence adds its auditory coefficient to the general stillness. There is nothing remarkable here. We've all experienced those moments. But what if they are sought and stilled in a painting from which the author has vanished? And what if they are regularly structured with the kind of discipline that holds the scene doubly still?

James Jackson Jarves, the most sensitive of mid-century American critics, had complained that artists such as Church and Albert Bierstadt left their labor trail on the canvas.[37] With Lane, we see no labor trail. Rather, the self assumes the state described by Henry David Thoreau when he stated, "He will get to the Goal first who stands stillest."[38]

The stilled self in Lane's paintings is aided in its effects by the measure that clarifies the reading of distances inward from the foreground, as plane parallel to plane the scene steps firmly back, however these planes may be disguised by the accidentals or incidentals of the scene. Along with the erased stroke, this measure is how he manufactures the illusion of stopped time, thereby bringing the scene into the realm of one of mid-nineteenth-century America's obsessions — the Eternal, for behind every change was an immutable presence. To make that presence present, by holding everything still, seems a reasonable strategy, here brilliantly carried through. It brings to mind Thoreau, the surveyor, at Walden Pond, measuring its dimensions with obsessive exactitude to confirm his own physical experience of the scene. It would seem, in fact, that to think of the Transcendental mind as simply up in the clouds is to misjudge it severely. It is the strong dose of the concrete in American Transcendentalism that enables it to exist

side by side with the pragmatic, in the art as well as in the philosophy.

To the perennial question of how we experience time, we might add the question of time in Luminist paintings. Maurice Merleau-Ponty has remarked that "time as the immanent object of a consciousness is time brought down to one uniform level, in other words it is no longer time at all." Such time is timeless. It has lost its own process. It is, Merleau-Ponty says, "of the essence of time to be in process of self-production and not to be; never, that is, to be completely constituted."[39] The complete constitution of time in Lane's paintings, as in Copley's, converts the present into timelessness. It is no longer time at all.

There is an interesting literature in this area, and we can perhaps take a clue from Samuel Beckett, who wrote, "time has turned into space and there will be no more time";[40] or from Thomas Mann, who wrote in *The Magic Mountain*, "Time is drowning in the measureless monotony of space, motion from point to point is no motion more, where uniformity rules; and where motion is no more motion, time is no longer time."[41]

Thoreau's journal also conjures up marvelously the lost self that has vanished along with time from Luminist painting and reports on what is left behind, "Drifting in a sultry day on the sluggish waters of the pond I almost cease to live and begin to be...I am never so prone to lose my identity, I am dissolved in the haze."[42]

When the Luminist self is not dissolved in haze, it is dissolved in light. Light, in Emerson's words, is "the first of painters."[43] The universe, for Emerson, becomes transparent, and the light of higher laws than its own shines through it. We usually think of painters of light as Impressionists, plein air artists capturing actual sunlight by that tiny synaptic crackle between strokes on the white surface. The Impressionist self stands assertively behind those strokes, each one signs the artist's presence. And the canvases glow when we retreat from them.

In Luminist art too, with Lane's paintings, the canvas yields up its glow as we retreat, until from the end of the gallery it often seems as if the painting is holding a pocket of air and light. Close up, however, we can see no stroke, only a rather primitive matness and anonymity of surface. Yet that surface is deceptive, because like the structure it, too, is governed by measure. The graduated tonalities of hue are so infinitesimal as to be invisible, mimicking their author's stealthy retreat from view. Precisely because they are so subtly controlled, they emanate that celestial glow. More than the

vanished stroke (of which, however, it is a function), that glow attests to the artist's orderly control of his own transcendent entry into a larger universe, where, as Emerson reminds us, "the laws of moral nature answer to those of matter as face to face in a glass."[44] These surfaces, too, are glasslike. The Luminist painter, like Emerson's poet, turns the world to glass.

And where there is glass, there is reflection. Luminist paintings are filled with reflections, as indeed are Copley's paintings. In Copley's burnished table tops, stuffs and still lifes gleam with a doubled existence. This doubling has, of course, a convenient metaphysical analogue, for this world was commonly spoken of as the reflection of the next. Jonathan Edwards wrote of the images or shadows of divine things, "The whole outward creation, which is but the shadows of His being, is so made as to represent spiritual things."[45] This is brought home sharply in the art of the mid-nineteenth century. God is reflected in nature, there are reflections of nature in nature's mirrors, the painting reflects nature, within the painting represented nature is reflected, and on all this the mind itself reflects. So between natural reflection and painted reflection is a series of translations as the artist reflects on, and in turn reflects, God's original creation. A complex system of reflections lies open for decoding.

The aesthetic, philosophy, and religion of the period abound in reflections, twins and doubles. Representations of nature negotiated their way between the real and the ideal, dialectical twins, and a central theme in American nineteenth-century art and taste. Emerson had referred to the universality of "this old double."

Lane's art, and Luminist art in general, was arguably the most authentic answer to nineteenth-century America's call for a perfect merger of the real and the ideal. Lane's marine paintings are carefully controlled by his knowledge of weather, shipbuilding, rigging, designer's plans, and even an occasional photograph. The painting's facts are instructed by ideas about reality that clarify the mess we might call actuality. But beyond this conceptual expertise, an ideal core inhabits the Luminist object, and ultimately halates it with its Platonic perfection. The ideal it represents presses on the thin membrane of the Emersonian fact as "the end or last issue of spirit."

With Lane's reflections, then, we are dealing with mirrors within mirrors. The painting itself, by aesthetic criteria going back beyond Leonardo and Leon Battista Alberti to Plato, is of course a mirror of reality. But what happens if the painting, like the mind, is given the possibility of reflec-

tion? The conditions for reflection — calm and stillness — are the same for nature and for the mind. These conditions donate their mood to the Luminist painting. Reflections have — as we know — the most fragile of surfaces. The fragility, which a pebble can fracture, makes for suspense. This perfection cannot hold. So time, though suspended, is imminent, and we hold our breath lest we disturb it. This perfect double is fugitive and transient and has an apparitional quality. Reflections are visible but vulnerable to the slightest touch, and to the degree that we can destroy them, they empower us. In the mathematics of desire, they inversely reproduce a reality that is knowable, while they themselves cannot be fully known. In Transcendental terms, a reflection is a glimpse of a perfection that puts us in a state of grace and returns us to Emerson's laws of moral nature answering to those of matter as face to face in a glass. They also recall Emerson's comment that "when the act of reflection takes place in the mind, when we look at ourselves in the light of thought, we discover that our life is embosomed in beauty."[46]

Self-reflection, as thought's light, and actual reflections as otherworldly mirroring are linked through idea and ideal and through the submersion of self in the Emersonian universe. The thinking creature, reflecting, both discovers and loses the self, which is asserted sufficiently for thought, and then willingly surrenders. It was in his own mind, wrote Emerson in *Self-Reliance*, that the artist sought his model, the thing to be done, the conditions to be observed. "Insist on yourself," Emerson wrote, "never imitate."[47]

The Luminist self is at once self-reliant, transcendent, pragmatic, and private, inviting also a private response from the spectator, who often must conceptualize his or her own size, reduce it to thought, before entering the painting. In this instance, the mirroring extends from artist's thought to spectator's thought. Thought must answer thought to draw the spectator into the universal currents. Led by the act of reflection and by reflections into that which is beyond nature, both artist and spectator, reduced to thought, enter a Godly realm.

That realm has all the perfection of the pre-Darwinian era. It mirrors the perfect planning of the providential blueprint, the grand design with its carefully plotted rungs of the *scala naturae*. As with Lane's paintings, with their classic mensuration, we always know where we are within this blueprint. We are fortified by the theory of the immutability of species, which has not yet yielded to Darwinian change and chance.

Darwin killed Transcendentalism — Nature becomes Secular

Darwin, of course, changes all this. Winslow Homer, yet another New England artist, makes his first paintings in the mid-1860s, when Darwinian mutability is beginning to be accepted by American science. Boston and Cambridge have witnessed the fierce Agassiz-Gray debate over Darwin's ideas in 1859. Louis Agassiz, Emerson's darling, to whom Thoreau recounted his experiment with a frozen fish at Emerson's dinner table, has lost the contest. By 1865, Lane is dead. Those landscape painters who survive him — Martin Johnson Heade and Church, John Frederick Kensett, Asher Brown Durand, and Bierstadt — continue to paint landscapes embodying spirit. Church, especially, spends the rest of his life trying to reconcile religion with post-Darwinian ideas. The moment for Transcendental painting has passed.

Homer is heir to the new moment, becoming one of America's first primarily secular artists. In his works the Transcendental glow of Luminism converts into the more natural glow of sunlight on objects (fig. 1). Those objects maintain their solidity with an obdurateness that again recalls Lockean primary matter. The solidity probed by Edwards and Copley is still with us. Elsewhere I have called this an American Look. The Look, sparse and spare, recalls Perry Miller's comments about the rigorously unornamented prose of the Boston lecture. But Miller in that same comment had alluded to metaphysical assumptions. We may question whether these also remain. We are also confronted with an element of time that recalls Luminist time.

Though we are now at a point in advanced thinking that embodies evolutionary flux (in Europe signaled by Impressionism), the time component in Homer remains curiously stilled. This despite the active skin of paint, which Homer often shares with the international tradition. That paint suggests process, but it does not carry its temporal components.

The paradoxes are compounded by Homer's relation to the European developments. He was in France in 1867, the year of the Universal Exposition in Paris, at a time when Impressionism was developing. Did he encounter any of the Impressionists? We do not know. Years ago, one of my graduate students placed him on the same street as Edouard Manet and his friends at the Café Guerbois. Did Homer ever walk through the door? Again, we do not know. He could have seen paintings by Manet and Gustave Courbet at a special exhibition, and he could have seen the works of the Barbizon men. But what else he might have seen eludes us.

Like many Americans before him, Homer paid as much attention to the landscapes and people he saw in Europe as to the art. He was familiar with

the Louvre, so he could have known the splendid gallery of Poussins. Do they partly account for the rigorous, classic mode that defines his works from 1871 to 1874? But that mode also inherits Luminist geometries and Luminist time. And comparisons with early works by Claude Monet indicate that even before his trip in 1866–1867, Homer was developing attitudes to out-of-door painting that could be characterized as an indigenous American Impressionism.

So unsolved mysteries surround Homer's Parisian visit, inflecting virtually all of our knowledge about his relation to European art. Homer the man was just as mysterious. As with Copley, and to some extent Lane, Homer's self remains an enigma. Copley was a family man, well connected with a wide circle of friends on both sides during the Revolution. Yet we have not yet deciphered his mystery. Lane's reclusiveness could be challenged by scholarship that stresses his community activity in the town of Gloucester. Yet his self remains closed to us. The idea of Homer's isolation is mitigated by recent knowledge of his close family ties in Prout's Neck. Copley, we remember, was a property owner. Homer was something of a land developer, helping his family sell lots and houses in Prout's Neck to summer visitors, even doing some of the handiwork himself. But like Lane, he has left us only a few letters and comments about his art. Scholarship seems to resent this anonymity. It has used Freud to elucidate attitudes toward women in Homer's paintings and has translated his last obsession with the sea in sexual terms. Some accounts present a self suffering the ubiquitous Modernist affliction, that angst so familiar to us in Van Gogh or Edvard Munch.

However, with Homer, as with Eakins, who has received similar attention, the pressures of the inner vision, if such they be, do not distort the integument of the external world. Despite the stroke that signals his presence, the terms of that presence are unusually distant. His stroke shows the *force* of the personality but does not *express* it. Homer's self remains impersonal. As with Copley and Lane, the idea of self is deferred or perhaps referred to that equivocal location — *elsewhere*. Homer's forceful style and painterly impastos emphasize the convention of painting, qualifying the thing represented with the process of representation. To the definition of nature is added an implicit definition of the nature of art. Nature now begins to lose some of its preeminence in American art. The object, however, survives this growing tide of process. From Homer's pragmatism, so evident in

84

8. Winslow Homer (American),
 Northeaster, 1895,
 oil on canvas, 88.5 x 128.2 cm.
 New York, The Metropolitan Museum of Art,
 Gift of George A. Hearn, 1910, no. 10.64.5.
 All Rights Reserved, The Metropolitan
 Museum of Art.

his attitude toward the concrete, it is but a short step to William James's comment, "A pragmatist...turns towards concreteness and adequacy, towards action and towards power."[48] This can be applied not only to the concrete thing but to the process by which it is apprehended and recorded. James goes on to say, "At the same time it does not stand for any special results. It is a method only."[49]

As with Copley and Lane, Homer's method starts from the conceptual, then pragmatically builds the picture out of blocks of experience. Again James states it well, "Theories become instruments, not answers to enigmas, in which we can rest. We don't lie back on them, we move forward, and on occasion, make nature over again by their aid."[50]

Homer's paintings are *re*-made, *re*-formulated, *re*-shaped through the instrumentation of his empirical responses. In his late works he paints as though he were using large geometric sections — hunks — of sea, which have what Edward Hopper called "Homer's weight" (fig. 8). They are pieced together almost as a workman might, with some of the practical how-to efficiency of his two artistic predecessors, Copley and Lane. Like them, Homer would seem to be answering a Jamesian query: does it work?

It has always interested and excited me that American artists practiced pragmatism long before James codified it. As Harold Bloom has said of Emerson, "His relation to both Nietzsche and William James suggests that Emersonian Transcendentalism was already much closer to pragmatism than to Kant's metaphysical idealism."[51] This applies to the *artists* of Emerson's era as well. If Homer, following upon them, also fortifies idea through the pragmatic encounter, this encounter seems even more telling now because it corresponds historically to the development of the pragmatic systems in Peirce and James.

For all this, what strikes me most when looking at Homer's art is the continued emphasis on thingness, on the blunt thereness of the object, which now, however, lacks the specific identity of differentiated surface texture found in Copley and Lane. Copley's fabrics are shiny and satiny. His tables are made of wood. Lane's sails are sewn for his ships. His water is crystalline clear and reflective. Homer's objects all have the same texture. In the works of America's greatest sea painter, water is not wet (fig. 9). It solidifies, returning us to a kind of Lockean primary matter.

Why this extended concern with solidity, this need to transform the transient state of water into the minerallike density of rock? In Freudian terms,

86

9. Winslow Homer (American),
West Point, Prout's Neck, 1900,
oil on canvas, 76.4 x 122.2 cm.
Williamstown, Mass., Sterling and Francine
Clark Art Institute, no. 7.

there might seem to be a cathexis here, a holding or *Besetzung*, in which the psychic energy of the artist is invested in the solid state of thingness. When we identified this property in Copley, it was easy to attach it, through convenient historical congruity, to John Locke. Now we find it in a post-Darwinian moment, a moment brimming with prerelativistic flux, a flux also signaled by some aspects of Jamesian philosophy, as well as by the stylistic maquillage of strokes in the painting itself.

If we wish, we might query whether the object here functions to some extent, in Kohut's terms, as a self-object, mirroring the self in a partial narcissistic fusion. But if we put psychoanalysis aside, we can perhaps ask it still more simply: is the necessity for this object, with its solid connection to a primary tactile function, as something that can be touched and grasped, a basic and fundamental statement about existence within this culture? Homer's self is reified here into a sea that is presented to us as a calcified tundra. In presenting the sea in this way, Homer also succeeds in halting time, freezing it into those solid sections mentioned earlier, removing it to that place so eloquently described by Thomas Mann when he wrote, "Where motion is no more motion, time is no longer time."

I began this discussion of Homer with the comment that he was a secular artist. Certainly, he is no longer imbued with Transcendental faith. But perhaps it could be argued that his concern with the concreteness of things, with the solidity of the fact beyond time, borders on areas of the timeless and eternal. In this, he also brings us to William Butler Yeats quoting Villiers de L'Isle-Adam quoting Saint Augustine, "Eternity is the possession of one's self as in a single moment."[52]

Over one hundred years, despite profound changes in the intellectual climate from Locke, Edwards, and Franklin, through Emerson to Darwin and William James, the works of these three major American artists share distinct attitudes toward the object, toward the self that perceives it, and toward the temporal context of that perception. These attitudes reify self and time into the irreducible density of the object, and we may well continue to ask, what does this persistence of the object through various cultural contexts imply? A material passion, a pragmatic mind-set, a primitive terror, a Transcendental urge, a reductive modesty, the morality of craft, a cyclical desire to begin culture anew, a repetition that implies forgetting, a memory that seeks confirmation, a tactile urgency signaling an existential dilemma, a desperate yearning for an absolute — or any and all of these

Now: self as flimsy ephemera

often held in contradiction. These contradictions are inseparable from any definition of a culture. They are contradictions that reveal our own assumptions as much as they reveal the object of our inquiry. ©Barbara Novak

NOTES

1. Jacques Lacan, *The Four Fundamental Concepts of Psycho-Analysis*, ed. Jacques Alain Miller (New York and London: Norton, 1981), ix.

2. Heinz Kohut, quoted in Lynne Layton and Barbara Ann Schapiro, eds., *Narcissism and the Text: Studies in the Literature and the Psychology of Self* (New York: New York Univ. Press, 1986), 3.

3. See *The Crayon* 1 (6 June 1855): 354; and William Sidney Mount, undated journal entry following 9 November 1846. Ms. Suffolk Museum and Carriage House, Stonybrook, Long Island.

4. Quoted in Didier Anzieu, *The Skin Ego: A Psychoanalytic Approach to the Self* (New Haven and London: Yale Univ. Press, 1989), 85.

5. See Perry Miller, *Jonathan Edwards* (New York: Sloan Associates, 1949), 52. This early date is questioned by Wallace E. Anderson, ed., *Jonathan Edwards: Scientific and Philosophical Writings* (New Haven and London: Yale Univ. Press, 1980), 15–18, 24–26.

6. See Jules D. Prown, *John Singleton Copley*, 2 vols. (Cambridge, Mass.: Harvard Univ. Press, 1966), 1: 16, and Michael Baxendall, *Patterns of Intention* (New Haven and London: Yale Univ. Press, 1985), 79–80.

7. Baxendall (see note 6), 103.

8. See *Letters and Papers of John Singleton Copley and Henry Pelham, 1739-1776* (Boston: Massachusetts Historical Society, 1914), 65–66. Letter from Copley to Benjamin West or Captain Bruce, circa 1767.

9. See R. W. B. Lewis, *The American Adam: Innocence, Tragedy, and Tradition in the Nineteenth Century* (Chicago: Univ. of Chicago Press, 1955; reprint, Chicago: Univ. of Chicago Press, 1965).

10. John Locke, *An Essay Concerning Human Understanding*, abr. and ed. Andrew Seth Pringle-Pattison (Oxford: Clarendon, 1956), 43.

11. Anderson (see note 5), 379.

12. See Christopher Fox, *Locke and the Scriblerians: Identity and Consciousness in Early Eighteenth-Century Britain* (Berkeley, Los Angeles, and London: Univ. of California Press, 1988).

13. Etienne Gilson, *Painting and Reality* (New York: Pantheon, 1957), 27–28.

14. Miller (see note 5), 62.

15. Henry F. May, *The Enlightenment in America* (New York: Oxford Univ. Press, 1976), 57.

16. Sacvan Bercovitch, *The Puritan Origins of the American Self* (New Haven: Yale Univ. Press, 1975), 17.

17. Ibid., 23, 26.

18. Miller (see note 5), 48.

19. John Wilmerding, *Fitz Hugh Lane* (New York: Praeger, 1971), 18.

20. Ibid., 95.

21. William James, *Pragmatism and Four Essays from "The Meaning of Truth"* (New York: New American Library, 1974), 33.

22. Wilhelm Worringer, *Form in Gothic*, ed. Herbert Read (New York: Schocken, 1964), 35.

23. See Barbara Novak, *Nature and Culture: American Landscape and Painting, 1825-1875* (New York: Oxford Univ. Press, 1980), 255–72.

24. Quoted in Stanley Vogel, *German Literary Influences on the American Transcendentalists* (New Haven: Yale Univ. Press, 1955), 103.

25. Ibid.

26. Quoted in Elizabeth Gilmore Holt, ed., *From the Classicists to the Impressionists: A Documentary History of Art* (Garden City, N.Y.: Anchor, 1966), 90.

27. Quoted in Lorenz Eitner, *Neoclassicism and Romanticism, 1750-1859*, Sources and Documents in the History of Art Series, vol. 2 (Englewood Cliffs, N.J.: Prentice-Hall, 1970), 54–55.

28. Worringer (see note 22), 179.

29. See Perry Miller, *Errand into the Wilderness* (New York: Harper & Row, 1964), 202.

30. *The Selected Writings of Ralph Waldo Emerson*, ed. Brooks Atkinson (New York: Modern Library, 1950), 19.

31. See John I. H. Baur, "American Luminism," *Perspectives USA* 9 (Autumn 1954): 90–98.

32. *Selected Writings* (see note 30), 6.

33. Ibid., 15.

34. *The Journals of Ralph Waldo Emerson*, abr. and ed. Robert N. Linscott (New York: Modern Library, 1960), 273, 29.

35. Lewis (see note 9), 13–27.

36. See Barbara Novak, *American Painting of the Nineteenth Century* (New York: Praeger, 1969), 113–15; and idem (see note 23), 232–36.

37. James Jackson Jarves, *The Art Idea*, ed. Benjamin Rowland, Jr. (Cambridge, Mass.: Harvard Univ. Press, Belknap Press, 1960), 205.

38. *The Selected Journals of Henry David Thoreau*, ed. Carl Bode (New York: New American Library, 1967), 50.

39. Maurice Merleau-Ponty, *Phenomenology of Perception* (London: Routledge & Kegan Paul, 1976), 415.

40. Samuel Beckett, *Stories and Texts for Nothing* (New York: Grove, 1967), 112.

41. Thomas Mann, *The Magic Mountain* (New York: Vintage, 1969), 547.

42. *Selected Journals* (see note 38), 38, 4 April 1839.

43. *Selected Writings* (see note 30), 9.

44. Ibid., 18.

45. Jonathan Edwards, *Images or Shadows of Divine Things*, ed. Perry Miller (New Haven: Yale Univ. Press, 1948), 63.

46. *Selected Writings* (see note 30), 190.

47. Ibid., 166.

48. James (see note 21), 45.

49. Ibid., 45–46.

50. Ibid., 46.

51. Harold Bloom, *Agon: Towards a Theory of Revisionism* (New York: Oxford Univ. Press, 1983), 20.

52. Quoted in James Olney, *Metaphors of Self: The Meaning of Autobiography* (Princeton: Princeton Univ. Press, 1972), 281.

1. Edward Hicks (American),
 The Residence of David Twining in 1785,
 ca. 1845–1848,
 oil on canvas, 66 x 75 cm.
 Pittsburgh, The Carnegie Museum of Art,
 Howard N. Eavenson Memorial Fund for the
 Howard N. Eavenson Americana Collection,
 no. 62.39.

Martin Christadler

Romantic Landscape Painting
in America

History as Nature, Nature as History

America as "Nature's Nation" — Perry Miller used the concept as key to the self-interpretation of American culture in the pre–Civil War period, and Barbara Novak has demonstrated its relevance to the representation of American landscape from Thomas Cole to Frederic Edwin Church and the Luminists.[1] The concepts of the nation, of nature and space, dominated the cultural discourse of the first sixty years of the new republic, serving as tools for the ideological construction of the meaning of national history. As experience of the wilderness, of apparently limitless space and continental expanse, as a useful rhetorical and legitimizing concept in political discourse, and as a base for economic exploitation and scientific knowledge, nature was a category deeply interwoven with the intellectual, cultural, and social development and self-constitution of the United States. But while granting a privileged role to the concepts of nature, of landscape, and of open space in the historical-cultural discourse of the new republic — at least up to Frederick Jackson Turner's frontier thesis — in what way can it be said that these concepts generated a form of landscape painting different from the established European traditions, genres, and types? Given the widely shared conventions of the sublime, the beautiful, and the picturesque and given also the type of mythological and historical landscape so widespread and pervasive in Europe and England since the Venetians, since Claude, Poussin, and the Dutch, it is difficult to make a case for the exceptionalism and specificity of the American variations on these generic and iconographic traditions.

This essay will nevertheless make an attempt to describe some of the emphases in American landscape painting before the Civil War that we have

93

come to consider distinctive: the georgic rural pastoral and the heroic wilderness sublime, the special tension between these two modes and their characteristic thematic repertoires (as country and city, wilderness and culture, work and ease). Such an analysis will require more than the identification and description of motifs, topoi, and tropes; it will have to consider the rhetorical and symbolizing strategies through which the basically meaningless materiality of the earth's topography achieves meaning in painting. Meaning derives from history and social construction, from cultural process and discourse; and it is the embodiment, the enactment of problems of history and culture, of conceptions of history in these paintings, that primarily interests me. The meaning-generating strategies in question have variously been described as those of Emersonian Transcendentalism and Humboldtian scientific idealism, by Barbara Novak; as those of prophetic nationalism, Manifest Destiny ideology, and natural theology, by David Huntington; and as those of self-reflective Romanticism questioning assumptions about the mind and the nature of reality, the validity of authority and tradition, by Bryan Wolf.[2]

Ronald Paulson has observed that "the major shift in 18th century art was from history painting to landscape"; in the nineteenth century landscape painting became the norm of artistic expression.[3] This did not mean that all historical content was eliminated or that landscape paintings became simply exercises in escapist exoticisms and fantasy. M. H. Abrams, Karl Kroeber, and James Heffernan,[4] in their studies of the English Romantic poets and of J. M. W. Turner and John Constable, have made it clear that after the breakdown of the utopian politics and millennial hopes awakened by the American and French revolutions and with the rise of the natural sciences, history became displaced and translated into the private and psychological and into new perceptions of the natural — especially of natural, that is, geological time. Displacement of history, according to Heffernan, refers to "the process by which natural phenomena, personal history, or rural episodes are made to assume the value and the importance traditionally associated with scriptural episodes or sociopolitical history."[5]

After its flowering in the post-Revolutionary and Federal periods, history painting in the United States indeed became displaced by landscape and genre — the two major forms through which the culture of the new republic explored and articulated the meanings of America. Thomas Sully's *Washington Crossing the Delaware*, 1819 (Boston, Museum of Fine Arts), and

94

the installation of John Trumbull's Revolutionary paintings in the Capitol Rotunda in Washington, D.C. (1817–1824) marked the termination of what one might call "heroic republicanism," which would not surface again until the 1850s with Emanuel Leutze's monumental and successful *Washington Crossing the Delaware*, 1851 (see p. 176), Daniel Huntington's *Republican Court*, 1851 (Brooklyn, The Brooklyn Museum), and Winslow Homer's Civil War paintings, especially the great *Prisoners from the Front*, 1866 (see p. 246). The dominant form of artistic expression that emerged from the 1830s on was a culture of images that projected historic-national concerns through the use of landscape — concerns connected with Jacksonian republicanism, westward expansion and colonization, sectional conflict over "free soil," industrialization and urbanization, the spread of technology, and the tensions between science and religion. In this ongoing transformation, the ideological, philosophical, religious, and political certainties and beliefs of the post-Revolutionary, Federal, and Constitutional periods were shaken and partly dissolved, partly — in nostalgic retrospect — apotheosized in etiological myths of origins and "the Fathers," partly adapted to, and fused with, the new mind-sets and worldviews.[6]

Landscape painting responded and related to these social and ideological processes not by "mirroring" them but by reflecting them in and through its distinctive grammar and syntax, which it obviously owed to conventions of the sublime, the beautiful, and the picturesque, to the heroic and the pastoral landscape, but which were increasingly modified by the two competing mindsets of the nineteenth century: instrumental rationalism and empirical science on the one hand, religious idealism in the form of evangelicalism and natural theology on the other.

The modes or types of landscape painting that emerged from this matrix of discourses, traditions, iconographic conventions, and social processes can be classified, with some conceptual boldness and simplification, as the georgic pastoral, agrarian and republican in its ideological implications; the heroic wilderness sublime, religious and scientific; and the topographical prospect, essentially factual and documentary. The latter is largely outside the scope of this essay, but its factual bias has fed and enriched the iconography of the other two more traditional forms of representation. It is linked to the surveying expeditions and to the technological opening up of the new territories, to the documentation of the land used or destined for use by American railroads, pioneers, military, farmers, and founders of

towns and parks. Appropriately, it quickly merged with the new visual tech-nology, photography.[7] The ideological forces and the "mythical" compo-nents it reveals are those of instrumental empiricism, expansive capitalism, and nationalism.

Nationalism encouraged the production of images of supposedly "char-acteristic" American landscapes, scenery, and wonders that would hold their own against the great European travel and tourist landscapes and would affirm national identity and self-contemplation. The pastoral — ubiq-uitous as it had become since the Venetians and Claude, and the Dutch and English country-house painters in the nineteenth century — took a distinct turn toward the georgic or "hard pastoral."[8] Between Thomas Jefferson's vision of an agrarian America, a yeoman farmer republic,[9] and the widely disseminated lithographs of Currier & Ives,[10] the georgic version of the pas-toral came to dominate the economy of images of Jacksonian and antebel-lum America, both as "high" art and as "primitive" or "folk" art. As early as 1782, in his *Notes on the State of Virginia*, Thomas Jefferson had defined the materials and the rhetoric of the sublime and of the pastoral landscape in his descriptions of the passage of the Potomac and Shenandoah rivers through the Blue Ridge Mountains and of the Natural Bridge over Cedar Creek in Virginia. In both instances, he opens his description with the vision of a convulsive moment of origin and creation, a catastrophic collision of natural forces. He then proceeds to delineate and envisage a prospect in the far distance, "the fine country around Fredericksburg" or the mills or farms along the banks of the river: culture, the prospect of civilization, a utilitarian palimpsest, is directly inscribed at the heart of the elemental and the wild. The telos of Jefferson's prospect, which emerges so apocalyp-tically from the sublime landscape of original creation, is neither Eden nor the divinely inhabited wilderness: it is the agrarian pastoral showing up at the end of the visual axis, suggesting that American space embodied the temporal movement away from origins toward the man-made future of his-tory and civilization.[11]

It was with the emergence of the Hudson River school, with Thomas Cole, William Sidney Mount, and Asher Brown Durand, that the pastoral image of America in painting came to the fore. "High" and "low" repre-sentations of American landscape in this period used the same vocabulary and repertory but differed in complexity of register and grammar, in their semantic emphases, and in their structure of appeal. Vernacular pastoral

96

paintings — Edward Hicks's *Residence of David Twining in 1785* (fig. 1), the innumerable views of portraits of individual farms, the images of idyllic farming by G. H. Durrie and Currier & Ives (fig. 2) — presented the pastoral landscape in terms of ownership and possession. This mode produced icons of social status, proprietorial pride, and social progress, emphasizing the achievements of culture and the transformation of nature into socially controlled and useful space. At the same time, these artists showed little concern for the problems of process, for the collision between the competing ideologies of nature and culture. By contrast, the high-cultural idiom of the Hudson River school painters betrayed a consciousness of cultural conflict and the cost of change, that is, of history (fig. 3). These paintings did not simply depict rural life in the East; they nostalgically celebrated a moral idea and a way of life that were passing, one that the social theory of the Jacksonians had elevated to a normative position: the freehold, the yeoman, the agrarian republic. The georgic pastoral is part of a larger discourse on the values of republicanism — the morality of the simple life, the virtue of "true," that is, productive work, the pernicious and corruptive influences of commerce, luxury, the city — and their diminishing reality in an America of growing sectional dissension, mass politics, and capitalist land speculation.

Mount's and Henry Herrick's evocations of rural work and leisure uneasily refer to evidence of social change and political strife while simultaneously trying to suppress such evidence and to make it invisible (fig. 4).[12] The great pastoral images of Durand, Jasper Francis Cropsey (fig. 5), and George Inness are a sharp contrast to the Civil War photographs of Mathew B. Brady, Alexander Gardner, and George N. Barnard (fig. 6), which displayed an American countryside violated and victimized by fortifications, trenches, siege artillery, mine explosions, and corpses.[13] The paintings offered for contemplation landscapes of calm opulence and plenitude, villages and farms integrated with the rhythms of the seasons, immune to time, purged of history: an America restored to the pristine shape of the ideal original agrarian republic. In articulating the myth of America as garden, the very brutality and force involved in the process of transforming natural space into culture was rendered invisible.

That other mythical vision of the American landscape, the high Romantic landscape of the wilderness sublime as we encounter it in the works of Thomas Cole and Frederic Edwin Church, even more rigorously excluded

97

2. Currier & Ives (American),
 American Farm Yard – Morning, 1857,
 lithograph, 43.2 x 61.4 cm.
 From *Currier and Ives' America*, ed. Colin
 Simkin (New York: Crown, 1952), fig. 13.
 Santa Monica, The Getty Center for the
 History of Art and the Humanities.

3. Sanford Robinson Gifford (American),
 Hunter Mountain, Twilight, 1866,
 oil on canvas, 77.8 x 137.5 cm.
 Chicago, Terra Museum of American Art,
 Daniel J. Terra Collection, no. 5.1983.
 Photo: Courtesy Terra Museum of American
 Art, Chicago.

overt social thematics from its system of representation. Rooted in the Protestant religious traditions and modes of thinking from the seventeenth century and now under pressure from the secularizing forces of scientific naturalism and expansive nationalism, the sublime became the preferred mode and vehicle for – in Thomas Weiskel's phrase – "the massive transposition of transcendence into a naturalistic key," for the attempt on the part of the religious culture to preserve and salvage the concept of the divine from the impact of secularization by "naturalizing" it.[14] Biblical creationism and prophecy, the natural theology of "design" based on Newton's cosmos governed by law, providential history of America as "the New Heaven and the New Earth" promised to the elect by the Revelation of Saint John the Divine – these traditional elements of Protestant theism had to be adjusted to the conditions of modernity and the major discourses that articulated it. These discourses included Manifest Destiny nationalism, which instrumentalized the American land for power politics, and the new science of landscape – geology – which since the end of the eighteenth century, and with Alexander von Humboldt and Sir Charles Lyell, proposed a non-Biblical, anticreationist genesis of the history of the earth. The high Romantic landscapes of Cole and Church were one of the cultural arenas in which the clash of ideologies and discourses was enacted. The attrition of the traditional religious semantics of the sublime, the drama of a consciousness threatened by the waning authority of religious and metaphysical beliefs can be observed nowhere better than in these paintings and in the writings of Poe, Emerson, Hawthorne, and Melville.

Even if one accepts the contention that Cole, Durand, and especially Church construed the meaning of America in terms of apocalypse and epiphany, as original creation and continuous regeneration (a preoccupation also shared by Henry David Thoreau in *Walden*, 1854), as prelapsarian and prehistoric "Nature's Nation" not yet contaminated by Old World guilt, corruption, and decay, and by the fatality of unregenerate man's history – even if this interpretation, most eloquently formulated by David Huntington and Barbara Novak, is accepted – it is imperative to recognize, as Bryan Wolf has done for Cole, the strain and tension, the ruptures and discords in the semantic strategy, the rhetoric of appeal, and the structuring of the spectator relation in the works of these painters. For these paintings reflect their painters' and their culture's growing uncertainty about the moral meaning of landscape and of the natural world generally. Contrary to Emerson's opti-

99

4. Henry Herrick (American),
 Life on the Farm, 1867,
 wood engraving, 39 x 27.5 cm.
 From *Harper's Weekly Magazine* 11
 (10 August 1867), 504–505.
 Photo: Courtesy University of California,
 Santa Barbara, University Library, Special
 Collections.

5. Jasper Francis Cropsey (American),
 The Valley of Wyoming, 1865,
 oil on canvas, 124.4 x 215.4 cm.
 New York, The Metropolitan Museum of Art,
 Gift of Mrs. John Newington, 1966, no. 66.113.
 All Rights Reserved, The Metropolitan
 Museum of Art.

6. George N. Barnard (American),
 Rebel Works in Front of Atlanta, 1864,
 albumen print, 25.5 x 35.6 cm.
 Malibu, The J. Paul Getty Museum,
 no. 84.XM.468.39.

mistic and wishful statement in *Nature*, 1836, natural facts did not easily, if at all, flower into symbol and sign, into spiritual truth. For the American Romantic painter, from Washington Allston to the Luminists, the attribution of significance, of meaningfulness to the topographical phenomena of the American landscapes, the work of semantic determination, became increasingly difficult, indeed, became the enactment of a crisis of consciousness that, often enough, was suppressed or only hesitantly acknowledged by the artists themselves.

The strategies of semantic negotiation adopted by the "consciousness in crisis" sensitive to the changes in social and ideological formation may be conceptualized in three ways: psychoanalytically, as projections of the fantasmatic operations in the ego and the unconscious; syntagmatically, as reorganization of conventional or traditional semantic elements of the sublime and the pastoral to form a new "narrative"; and semiotically, as the increasingly willful allegorization of the process of signification, the imposition of secondary systems of meaning in landscape representation.

In his psychoanalytically informed study of Allston, Cole, and the tradition of the sublime, Bryan Wolf has connected the morphology and iconography of paintings such as *Landscape, Composition, Saint John in the Wilderness*, 1827 (fig. 7), *Expulsion from the Garden of Eden*, circa 1827–1828 (Boston, Museum of Fine Arts), and *Sunny Morning on the Hudson*, 1827 (Boston, Museum of Fine Arts), with the working out of ego processes: the private self struggling with fantasmatic figurations of authority and power, enacting in the arena of the painting the oedipal situation and the anxiety of influence, in ambivalent movements of rebellion against and submission to "the Father," to power and domination.[15]

Syntagmatic analysis, as it partly informs the approaches of Wolf, John Barrell, and Ronald Paulson, describes nineteenth-century landscape painting as a profound, if not revolutionary, revision and transformation of the heroic-idealistic model for the representation of landscape, namely, Claude Lorrain (fig. 8). His landscapes had been constructed around a central axis of vision leading from an object-filled foreground and middle ground to a zone of visual rest and calm on the horizon — a Platonic-Christian "narrative" of pilgrimage that took the eye of the viewer through, past, and along a set of objectified referential signifiers: embankments and rocks; woody dells; shrubs and trees; brooks, rivers, and lakes; human activities and habitations; monuments and ruins; places of worship; and the passage of time.

7. Thomas Cole (American),
 Landscape, Composition, Saint John in the
 Wilderness, 1827,
 oil on canvas, 91.4 x 73.5 cm.
 Hartford, Wadsworth Atheneum, Bequest of
 Daniel Wadsworth, no. 1848.16.

8. Claude Lorrain (French),
 Hagar and Ishmael Exiled (*Paysage avec*
 Abraham chassant Agar et Ismaël), 1668,
 oil on canvas, 106 x 140 cm.
 Munich, Alte Pinakothek, no. 604.

9. Frederic Edwin Church (American),
 Niagara, 1857,
 oil on canvas, 229.9 x 108 cm.
 Washington, D.C., The Corcoran Gallery of
 Art, Museum Purchase, no. 76.15.

At the end of this axis was a distant light-suffused sky, irradiated by the rising or setting sun, that is, a dematerialized sphere of spiritual promise and suggestion. Barrell and, after him, Wolf have shown how in the works of John Constable, Allston, and Cole this visual axis has become obstructed, the progress of the eye through space complicated, and the zone of rest and redemptive refuge inaccessible.[16] If this can be argued for paintings such as *Expulsion*; *Landscape, Composition, Saint John in the Wilderness*; *The Voyage of Life*, 1842 (Washington, D.C., National Gallery of Art); or even for Asher Brown Durand's *Kindred Spirits*, 1849 (New York, New York Public Library), where the eye has to travel an ascending path lined with signs of mortality, toward a distant epiphany behind the hills, it seems perhaps somewhat surprising to read Church's thunderous *Niagara*, 1857 (fig. 9), also as a variation on the Claudian landscape of pilgrimage, which, however, it both implies and negates. Its furiously dynamic and accelerated world of process deprives the beholder of any imaginary foothold or sheltering place, of any sense of control in one's progression, forcing one along a "path" leading straight into the abyss rather than toward a Platonizing, spiritually significant, morally charged rising or setting sun. Of course, the very brightness emanating from the white wall of water, which one can read as a substitution for the Claudian horizon, seems to reaffirm the link with the epiphanic, apocalyptic landscape of Romanticism: Shelley's "white radiance of eternity" and his "light whose smile kindles the universe," or Emerson's "religion of Abyss-radiance."[17] However, if we place Church in the context of the works of Edgar Allan Poe and Herman Melville, after all contemporaries of his, we discern in the engulfing whiteness of the wall of foaming water also "the heartless voids," the "thought of annihilation and nothingness" of *Eureka* and *Moby-Dick*. And observe that the rainbow in *Niagara* (also used by Melville as an alternative emblem to oppose the abyss) is thin, feeble, broken.[18]

As Church produced his series of major paintings in the crisis decade between 1855 and 1866 — *Heart of the Andes*, 1859 (see p. 225), *Cotopaxi*, 1862 (fig. 10), *Icebergs and Wreck*, circa 1860 (see p. 197), *Twilight in the Wilderness*, 1860 (Cleveland, The Cleveland Museum of Art, no. 65.233), *Aurora Borealis*, 1865 (Washington, D.C., National Museum of American Art, Smithsonian Institution), and *Rainy Season in the Tropics*, 1866 (San Francisco, The Fine Arts Museums of San Francisco) — he seems to have searched out and composed landscapes that confronted him and the viewer with the pos-

sibility of a universe of sheer matter, governed by flux, catastrophe, and energy, challenging the customary modes of meaning attribution and spiritualization. The perception of pure force, destructive and indifferent to human purpose, in Niagara Falls, in the volcanic geology of the Andes, or in the frozen world of eternal ice of the Arctic, together with the political earthquake of the Civil War, which was shaking the political foundations of the American Republic, put pressure on Church's beliefs and convictions, as well as on those of the entire culture, causing strain and crisis in the signifying systems and codes of Christian-idealist middle-class culture. The immediate result was a heavy emphasis on allegorization.

In his study of John Constable and J. M. W. Turner, Ronald Paulson has pointed out how much the development of nineteenth-century landscape painting toward "pure" landscape — that is, into a nonnarrative genre — involved an emancipation from traditional systems of signification. He suggests that the loss of meaning was compensated for, on the one hand, by the projection of private, autobiographical, often sexual contents and, on the other, by the introduction of quasi-linguistic signs referring to concepts and doctrines.[19] In American Romantic painting it was Thomas Cole who relied most directly both on the expression of the private dynamics of the unconscious and on conceptual signifiers in his representations of landscape — most clearly so, as Bryan Wolf has demonstrated, in *Landscape, Composition, Saint John in the Wilderness*, in which the overt reference to the Word and to Biblical history, to the cultural activity of naming, brings a potentially threatening abysmal landscape into the safe orbit of Christian meaning. Cole's later cycles are based on the same strategies of narrative and allegorization, in order to rearrange a world slipping from the established structures of meaning.

This particular kind of semantic structuring was continued by Church but was made more difficult and complicated by his deeper involvement in the naturalistic perception of nature and in the discoveries of modern science. In *Heart of the Andes* he succeeded in constructing a virtually symmetrical world, perfectly balanced between signifiers of flux and stability, of energy and repose, of vast spaces and intimate shelters, of concrete specificity and transformative dissolution. The painting offers a totalizing mythical image of nature as a harmony of opposed forces, as regenerative cycle and process, as organic unity, indebted and comparable to Humboldt's idealistic science and to Walt Whitman's poetic myth. In *Cotopaxi*, however,

Losing Religion?
Compensating
with Self-concern
& sex & theory

106

10. Frederic Edwin Church (American),
Cotopaxi, 1862,
oil on canvas, 121.9 x 215.9 cm.
Detroit, The Detroit Institute of Arts,
Founders Society Purchase with funds from
Mr. and Mrs. Richard A. Manoogian, Robert
H. Tannahill Foundation Fund, Gibbs-
Williams Fund, Dexter M. Ferry, Jr., Fund,
Merrill Fund, and Beatrice W. Rogers
Fund, no. 76.89.

Cotopaxi

Church — now under the double impact of volcanic geology and of the bloody battles of the war — finds it more difficult to contain his anxieties concerning the possible predominance of a destructive rather than a redemptive-regenerative principle at work in the creation. Characteristically, however, he counters such doubts and possible misreading of his landscapes as mere matter by imposing on the moral indeterminacy and neutrality of his naturalistic, scientifically informed vocabulary the christological-redemptive symbol of the cross. In *Heart of the Andes* the very title signals the key role of the devotional scene (*Andachtsszene*) in that painting; in *Cotopaxi* the sun's reflection in a lake in the shape of the cross is seemingly inscribed by a divine agent into the very body of the natural creation; in *Twilight in the Wilderness* a shrub in the foreground is twisted into the shape of the cross, and on the right a cluster of three trees alludes vaguely to the crosses of Golgatha; similarly, the rainbow in *Rainy Season in the Tropics* contains a reference to the Biblical emblem of grace and reconciliation of the deity with his world. In all these cases, such "imports" from another symbolic order, from theological-religious discourse, serve to clarify the notion of the presence of a transcendent order and purpose in pictures of wilderness and chaotic energy, inserting conceptions of sacred history and providential design into the history of the earth. These paralinguistic signs function, then, to clarify doubts and confusion in the discourses on nature and the truths of religion.

To the extent that Church's "cosmoramas" aim at a symmetrical representation of destructive and regenerative forces and of eternal cyclical transformation, implying the presence of structure and design in the order of matter, Church subjects his naturalistic vision to the idealistic-religious argument from design of the ministers' natural theology and of anti-Darwinian scientists such as Louis Agassiz. And yet the specter of a nonhuman and indifferent universe is raised, as in Melville's *Moby-Dick*, and the resulting anxiety assuaged only by a reaffirmation of the symbolism of the redemption of man from a fallen world. Contrary to Gerald Carr's claim, in Church's works "nature and spiritual symbolism" are not, or are only very uneasily, united. As a matter of fact, in the superimposition of elements from two different symbolic orders there is a semantic violence at work that suggests the clash of two opposing, finally incompatible codes.

Icebergs and Wreck[20] seems to represent a different case, as it (in its original form, without the shipwreck in the foreground) apparently dispenses

The Anxiety of the self in a nonhuman and indifferent universe; a nonmoral nihilistic universe.

108

with the strategy of symbolic superimposition and unfolds a world purely of the elements. At least one contemporary critic commented perceptively on the absence of any "trace whatever of human association" in this painting (see the *Albion*, New York, 4 May 1861). Contemporary critical opinion, however, reacted primarily in two other ways. One was to stress the *féerie magique* of Church's striking color and lighting effects and the bizarreness of the shapes of the icebergs, that is, the surrealism of the painted landscape. These comments, interestingly, imply a primarily aesthetic point of view, making the painting conceptually available in terms of Poe's proto-Modernist aesthetics of negativity. We can see in Church's painting the beginning of the freeing of the signifiers from their function of reference to "reality," the characteristically Modernist construction of an "autonomous" object, separated from the world, liberated from the burden of representation. Again I would argue that in the case of Church this "aestheticization" of a world of ice and empty space served the painter to distance and to control the anxieties arising from the recognition of a possibly nonmoral, nihilistic universe.

The other approach prominent in the critical reception of Church's paintings worked precisely to override and to suppress the implications of meaninglessness. This was the approach of allegorization in terms of the dominant "systems" of knowledge and ideology of the time: natural science, Christian belief, and the doctrine of nationalism. *Cotopaxi* was read as an illustration of the theories of volcanism and neptunism, as an allegory of the War between the States, as a symbol of divine power and wrath, a reflection on a Calvinist, Old Testament conception of the deity.[21] *Icebergs and Wreck*, in the light of scientific and exploratory investigations of the Polar Sea and the Arctic, was explained and interpreted as a commentary on the "Law of Circulation" in the terrestrial economy, on the slow, eternal rhythms of natural time. It was variously seen as an image of "the white throne of Apocalypse," "the celestial city," the cathedral of Milan, and the creation of light — in short, as an allegorization of Genesis and the Revelation of Saint John the Divine. Church was surrounded by writer friends and minister critics and by books in his library that drew on the language and doctrines of the books of Revelation, Genesis, and Ecclesiastes and, equally, on the discoveries in Arctic exploration and volcanic geology. They were engaged in the effort of nineteenth-century liberal, enlightened Christianity and idealistic philosophy to reconcile and integrate the emerging worldview

of modern science, its new conceptions of time and of the history of nature, with Biblical creationism and idealistic metaphysics. In their attempt at synthesizing the paradigms of science and religion, Church's contemporaries relied on the "argument from design," with its twin principles of divine origin and rational law, on the notion, in Agassiz's phrase, "of a general plan fully matured in the beginning,...the work of a God infinitely wise, regulating Nature according to immutable laws which He has Himself imposed on her" (*Comparative Physiology*, 1861).[22] This pre-Darwinian, essentially Newtonian view was, several years after the publication of *The Origin of Species* and in light of Romantic process philosophy (as in Emerson's essay of 1842 "The Method of Nature"), a definitely exhausted paradigm.

Church's major paintings of the years between 1857 and 1866 have been read as a resolute and informed contribution to the effort to construe and maintain such a geognostic synthesis, to hold together "geography and Christianography."[23] David Huntington has documented carefully all the likely sources for such an intention on the part of Church. It is nevertheless interesting to note that Church himself, in his own descriptions and self-commentaries seems carefully to have refrained from providing explicit attributions of meaning, leaving an indeterminacy that certainly allowed for, maybe even counted on, the semantic slippage of the signifiers in his naturalistic vocabulary. It is this slippage that is "stabilized" by the introduction of Christological emblems and by the allegorizations in the critical discourse. In the late work of Church, from the 1870s, I find that the synthesis of the naturalistic code and the religious code has finally fallen apart. On the one hand, we have the purely "naturalistic" views from Olana, meteorological studies à la Constable that do not seem to have any idealistic-religious connotations; on the other hand, there is the series of images of the great ancient cities around the Mediterranean, views of the cradles of civilization and religion and of the ruins of history and empire. With this separation of the historical and the natural, the project of American Romantic painting — to see the two spheres as fused, compatible, and reconciled, to discover the meaning of America through and in nature and landscape — has come to an end.

The works of the Luminists Fitz Hugh Lane, Martin Johnson Heade, and John Frederick Kensett, though at first glance so different in rhetoric and expression, nevertheless reveal tensions similar to those in Church. Barbara Novak[24] has made an eloquent and strong case that their light-

drenched, quietistic, and self-renunciatory canvasses represent the last flowering of Emersonian Transcendental idealism, an affirmation of faith in a pre-Darwinian, Newtonian, divinely inhabited universe. To claim, however, as she does, that Luminist paintings depict a mystic state in which "oneness with Godhead is complete," or that they represent "the transformation of the formal appearance of nature into a new vocabulary of religious symbols," or that their light is a "spiritual metaphor for divinity in nature" is to read these works too much in terms of a spiritualized, optimistic Transcendentalism. Many Transcendentalists, including Emerson and Thoreau, showed an interest in "desert places" and reveal, beneath their apparent calm confidence and quietude, disturbed accents of concern and unease, distinct semantic tensions and ambivalences.[25]

The foreground in paintings by Heade (figs. 11, 12) and Lane is often a desert of rocks and shale, delineated with a hallucinatory precision and hard-edged sharpness, a stretch of barrenness only timidly balanced by traces of sparse vegetation.[26] Quietude and silence suggest muteness and stasis; symmetry can be read as stagnation and inertness; and translucent light-filled spaces signify emptiness and absence.[27] Massive rocks, glassy surfaces, and pure skies bespeak the impenetrability and barrenness of nature as much as epiphany; and narrative details — boats dilapidated and beached on the shore or pushing out into the vastness of sea or lake, tiny human figures gazing out into space — suggest shipwreck and alienation as well as quest, mystic immersion, and union. Lane and Heade are still linked to the paradigm of the Christian pilgrimage landscape à la Claude Lorrain, but like Church in *Niagara* they revise and subvert it. Narrow openings between rocks and islands in Lane's shore pictures (see pp. 73 and 74) and the curving river in Heade's paintings of the Newport Marshes form central visual axes taking the viewer's eye toward a distant low horizon, which still alludes to the model. But the towering clouds and soft mists, or the bloody red of sunset in Heade's paintings, and the glassy surfaces and smooth transparent skies in Lane's create a sense of threat, of bleakness and emptiness. The austerity of Lane's compositional geometry, the abstract sparseness or minimalism of his shore views, imply a denial of the myth of plenitude, of growth and the very life of things. They are evidence of a need for control, a will to rule over nature. In Heade one can observe a development away from the bleakness of landscapes such as his *Lake George* or the glaring light contrasts of *The Coming Storm* to the fantasies of humming-

111

11. Martin Johnson Heade (American),
 The Coming Storm, 1859,
 oil on canvas, 71.1 x 111.8 cm.
 New York, The Metropolitan Museum of Art,
 Gift of the Erving Wolf Foundation and Mr.
 and Mrs. Erving Wolf, 1975, no. 1975.160.
 All Rights Reserved, The Metropolitan
 Museum of Art.

12. Martin Johnson Heade (American),
 Lake George, 1862,
 oil on canvas, 66 x 126.3 cm.
 Boston, Museum of Fine Arts, Bequest of
 Maxim Karolik, no. 64.430.

birds and orchids. Kensett's marine and shore pictures project a view of landscapes in which massive rocks and hills are juxtaposed with immobile waters, in which the precise curve of beaches, like a knife, divides sea, land, and the vast reaches of the sky — images perhaps more of the alien and nonhuman in matter and space, of solitude and indifference rather than of the presence of spirit.

Such a vision differs considerably, not only from the Christianizing views of a Cole and Church but also from that of the Transcendentalists. For Emerson, Thoreau, and Whitman, redemption, transcendence over death and annihilation, were the result of the regenerative power of the natural universe, of change, growth, and process, of metamorphosis. But it is precisely the dimension of change and movement that is lacking in — seems even negated by — the paintings of the Luminists with their geometrically ordered composition, their crystalline hardness, their frozen stasis and classicist balance. Theirs is an almost ideologically willed and conscious effort to counter and neutralize the extraordinary pressures of time and history impinging on American culture during the decades before and after the Civil War — pressures that had to do with the acceleration of conflict, with the prospect of the failure of the redemptive idea of America, the dawning awareness that what America would inherit from the apocalypse of the war would be its terrors without the redemption and the renewal. The silence in the Luminists' representations of American landscape connotes the absence as much as the presence of metaphysical sense, muteness as much as promise. Even if these artists did study Emerson's essays and listen to his lectures, they were just as likely to have come across his less optimistic, darker utterances in "Experience" or in "Fate." Like other readers of Emerson of the 1850s — Herman Melville, Emily Dickinson, Frederick Goddard Tuckerman, even Walt Whitman in his darker moods — they were participants in a discourse that had increasingly become suspicious and critical of the premises and certainties of idealism. Poe's theory of the autonomy of the aesthetic object, the freeing of the sign from referentiality, and the unspeaking signs of Melville's universe — the hieroglyphic wrinkles and the blank, or polyvalent, whiteness of the whale — are such debunkings of the myth of oneness and harmony between self and nature. The space and light of the Luminists may hark back to Claude and Platonic myth, but in the context of their time they also point to an epistemology of the void, a crisis of the sensibility, of the intellect, and of faith.

114

NOTES

1. Perry Miller, *Nature's Nation* (Cambridge, Mass.: Harvard Univ. Press, Belknap Press, 1967); idem, "Nature and the Nation's Ego," in idem, *Errand into the Wilderness* (Cambridge, Mass.: Harvard Univ. Press, Belknap Press, 1956); Barbara Novak, *Nature and Culture: American Landscape and Painting, 1825–1875* (New York: Oxford Univ. Press, 1980).

2. Novak (see note 1); David Carew Huntington, *The Landscapes of Frederic Edwin Church: Vision of an American Era* (New York: Braziller, 1966); idem, "Church and Luminism: Light for America's Elect," in John Wilmerding, ed., *American Light: The Luminist Movement, 1850–1875*, exh. cat. (Washington, D.C.: National Gallery of Art, 1980); idem, "Frederic Church's *Niagara*: Nature and the Nation's Type," *Texas Studies in Language and Literature* 25 (Spring 1983): 100–138; Bryan Jay Wolf, *Romantic Re-vision: Culture and Consciousness in Nineteenth-Century American Painting and Literature* (Chicago: Univ. of Chicago Press, 1982), chap. 5.

3. Ronald Paulson, *Literary Landscape: Turner and Constable* (New Haven: Yale Univ. Press, 1982), 16.

4. Meyer Howard Abrams, *Natural Supernaturalism: Tradition and Revolution in Romantic Literature* (New York: Norton, 1971); Karl Kroeber and William Walling, eds., *Images of Romanticism* (New Haven: Yale Univ. Press, 1978); James A. W. Heffernan, *The Re-creation of Landscape* (Hanover, N.H.: Univ. Press of New England, 1985); Karl Kroeber, *Romantic Landscape Vision* (Madison: Univ. of Wisconsin Press, 1975).

5. Heffernan (see note 4), 56 n. 1.

6. For the interpretation of the "historical mind" in the culture of the United States between 1820 and 1870, see Perry Miller, *Life of the Mind in America: From the Revolution to the Civil War* (New York: Harcourt, Brace & World, 1965); Marvin Meyers, *The Jacksonian Persuasion: Politics and Belief* (Stanford: Stanford Univ. Press, 1957); Rush Welter, *The Mind of America, 1820–1860* (New York: Columbia Univ. Press, 1975); Michael G. Kammen, *A Season of Youth: The American Revolution and the Historical Imagination* (New York: Knopf, 1978); Alan Trachtenberg, *The Incorporation of America: Culture and Society in the Gilded Age* (New York: Hill & Wang, 1982).

7. Novak (see note 1), chap. 8, "Man's Traces: Axe, Train, Figure," esp. 166–84, with photographs by William Henry Jackson, Andrew J. Russell, and Carleton E. Watkins of technical operations from a nonpictorial point of view. See also Peter B. Hales, *William Henry Jackson and the Transformation of American Landscape* (Philadelphia: Temple Univ. Press, 1988).

8. On the history of pastoral painting, see Robert C. Cafritz, Lawrence Gowing, and David Rosand, *Places of Delight: The Pastoral Landscape*, exh. cat. (Washington, D.C.: Phillips Collection; New York: Clarkson N. Potter, 1988).

9. On the concept of the agrarian, yeoman-farmer republic and its importance for antebellum culture, see Meyers (note 6), and the work of Chester E. Eisinger, "The Freehold Concept

in Eighteenth-Century American Letters," *William and Mary Quarterly*, 3rd ser., 4 (1947): 42–59; also Henry Nash Smith, *Virgin Land: The American West as Symbol and Myth* (1950; Cambridge, Mass.: Harvard Univ. Press, 1970). A comprehensive study of rural, georgic imagery is found in Sarah Burns, *Pastoral Inventions: Rural Life in Nineteenth-Century American Art and Culture* (Philadelphia: Temple Univ. Press, 1989).

10. Cf. Morton Cronin, "Currier and Ives: A Content Analysis," *American Quarterly* 4 (Winter 1952): 317–30.

11. Thomas Jefferson, *Notes on the State of Virginia* (1782), ed. William Peden (1954; New York: Norton, 1972), Queries IV and V; see also Martin Christadler, "American Romanticism and the Meanings of Landscape," in Dieter Meindl and Friedrich W. Horlacher, eds., *Mythos und Aufklärung in der amerikanischen Literatur.* Hans-Joachim Lang festschrift. Erlanger Forschungen, vol. 38 (Erlangen: Universitätsbund Erlangen-Nürnberg, 1985).

12. J. B. Hudson, "Banks, Politics, Hard Cider, and Paint: The Political Origins of William S. Mount's Cider Making," *The Metropolitan Museum of Art Journal* 10 (1976): 107–18; Elizabeth Johns, "The Farmer in the Works of William S. Mount," *Journal of Interdisciplinary History* 17, no. 1 (1986): 257–81.

13. For Civil War photography and its links with pastoral discourse, see Alan Trachtenberg, "Albums of War," *Representations* 9 (Winter 1985); idem, *Reading American Photographs: Images as History, Mathew Brady to Walker Evans* (New York: Hill & Wang, 1989), chap. 2.

14. Thomas Weiskel, *The Romantic Sublime: Studies in the Structure and Psychology of Transcendence* (Baltimore: Johns Hopkins Univ. Press, 1976), 18.

15. Wolf (see note 2). On the sexual coding of landscape and the conception of landscape painting as a psychological text, see also Jack Lindsay, *J. M. W. Turner* (London: Cory, Adams & Mackay, 1966), and Paulson (note 3), esp. 3–18. On the ideology of the subjective "naturalistic" landscape, see Ann Bermingham, "Reading Constable," *Art History* 10 (March 1987).

16. Paulson (see note 3), chap. 5; John Barrell, *The Idea of Landscape and the Sense of Place, 1730-1840* (Cambridge: Cambridge Univ. Press, 1972), 6–12; Wolf (see note 2), 28–40; idem, "All the World's a Code," *Art Journal* (Winter 1984): 328–37; Marcel Roethlisberger, *Im Licht von Claude Lorrain*, exh. cat. (Munich: Haus der Kunst, 1983).

17. Harold Bloom, *Agon: Towards a Theory of Revisionism* (New York: Oxford Univ. Press, 1982), chap. 6.

18. The literary parallels or analogies of Church's *Niagara* are developed more fully in Christadler (see note 11). For documentation, see Edgar Allan Poe, *Complete Works*, Virginia edition, ed. James Albert Harrison (New York: John D. Morris, 1902–), 16: 185, 302, 311; Herman Melville, *Moby-Dick*, ed. Harrison Hayford and Hershel Parker (New York: Norton, 1967), 164–69; Percy Bysshe Shelley, "Adonais," stanzas LII and LIV; Bloom (see note 17), 150, 158, 175. Obviously, my interpretation differs significantly from that of David Huntington (see note

2), who sees in Church's image "a perfect conception of the young American nation" and reads it essentially as a historical-nationalist allegory. The difference results from the fact that he approaches the painting through the discourse on Manifest Destiny and Transcendent Nationalism, while I try to place it in the context of Romantic literary and philosophical discourse on Nature and Transcendence.

19. Paulson (see note 3) discusses the problems arising from the potential vacuum of meaning in "pure" landscapes, esp. in chaps. 6 and 13; see also pp. 5–11, 16–18.

20. Gerald L. Carr, *Frederic Edwin Church* – The Icebergs (Dallas: Dallas Museum of Fine Arts, 1980), with an introduction by David Carew Huntington. Carr and Huntington document the contemporary critical reception of the painting by extensive quotation from the reviews. Huntington establishes its links with a number of possible sources: Louis Legrand Noble, *After Icebergs with a Painter: A Summer Voyage to Labrador and around Newfoundland* (1861; New York: Appleton, 1979); Matthew Maury, *The Physical Geography of the Sea*, 6th ed. (New York: Harper & Brothers, 1860); Isaac Israel Hayes, *The Open Polar Sea: A Narrative of a Voyage of Discovery Towards the North Pole, in the Schooner "United States"* (New York: Hurt & Houghton, 1867); Louis Agassiz, *Comparative Physiology* (1861, see Carr, this note, p. 12).

21. For contemporary comments on *Cotopaxi*, see Huntington, 1980 (see note 2), 179–80. For the context on volcanic geology, cf. Katherine Manthorne, *Creation and Renewal: Views of Cotopaxi* (Washington, D.C.: National Museum of American Art, Smithsonian Institution, 1985).

22. Agassiz, quoted by Huntington in Carr (see note 20), 11–12.

23. Viola Sachs, "The Gnosis of Hawthorne and Melville," *American Quarterly* 32 (Summer 1980): 143.

24. Novak (see note 1), 28–32, 42–45; idem, "On Defining Luminism," in Wilmerding (see note 2), 23–30.

25. Cf. David Cameron Miller, "Kindred Spirits: Martin Johnson Heade, Painter; F. G. Tuckerman, Poet; and the Identification with 'Desert' Places," *American Quarterly* 32 (Summer 1980): 167–85.

26. Cf. for example Heade's *Lake George* (fig. 12 here), with Fitz Hugh Lane, *Norman's Woe*, 1862 (see p. 73), *Brace's Rock*, 1864 (see p. 74), and *Stage Fort across Gloucester Harbor*, 1862 (New York, The Metropolitan Museum of Art).

27. On the problems of Luminist light, see also Christadler (note 11).

1. George Caleb Bingham (American),
 The Trappers' Return, 1851,
 oil on canvas, 66.7 x 92.1 cm.
 Detroit, The Detroit Institute of Arts, Gift of
 Dexter M. Ferry, Jr., no. 50.138.

Françoise Forster-Hahn

Inventing the Myth of the American Frontier

Bingham's Images of Fur Traders and Flatboatmen as Symbols of the Expanding Nation

On 13 December 1988 the *New York Times* published a lead article under the headline "Old West's Centennial Effort: Hail Indians (and Custer, Too)." The article addressed the deep conflicts between Native American peoples and United States government officials as six Western states prepared to celebrate their centennials in 1989 and 1990.[1] While Native American peoples strongly oppose both official and popular versions of "how the West was won," historians struggle to effect a radical reassessment of the country's history and to deconstruct the most persistent mythologies of the "frontier": those of the cowboy, the trapper, and the "wild" Indian. As one historian explained, "the hardest concept to change may be the Western image of the lone cowboy or settler who fights Indians and the elements to clear the wilderness for civilization.... There may be no hope for ever seeing the cowboy in his true form.... We're just now finishing up with a President who is the embodiment of that myth."[2]

The rewriting of the history of the American frontier must necessarily include its visual culture and particularly those images that invent the histories of the West. The recent exhibition *The West as America: Reinterpreting Images of the Frontier, 1820–1920* and the vehement political debates it raised among the international community of Americanists reveal the explosive character of the current historical discourse that categorically rejects Frederick Jackson Turner's frontier thesis and its interpretation of westward expansion as a "mystical nation-building process." If the revisions of the New Western History are brought to bear upon interpretations of the rich and varied visual culture that accompanied America's westward expansion, then we must read George Caleb Bingham's images *beyond* their func-

tion as symbols of heroic progress in order to investigate their position in a particularly conflicted historical moment, the violence, displacements, and contradictions of which not only shaped Bingham's personal life and artistic temperament but also determined the very choice of his subject matter and its mode of representation.[3]

While American historians, perhaps beginning with Frederick Jackson Turner, have tried to explain how certain national images began to function as symbols and how the "mythology of the American frontier" cuts across American history as well as its art,[4] historians of art have been slow to recognize the powerful role myth making has played in the production of images.

Already in the 1840s, however, the American Art-Union advocated the persuasive power of pictorial representation: "It is the object of art not to reproduce itself, but to look to Nature for its models, and these exist within the limits of our own territory, in as grand and imposing forms as in France or Italy."[5] Two years later, in 1845, the same committee was even more emphatic in its advocacy: "Every great national painting of a battle-field, or great composition illustrating some event in our history — every engraving, lithograph and wood-cut appealing to national feeling and rousing national sentiment — is the work of art; and who can calculate the effect of all these on the minds of our youth? *Pictures* are more powerful than *speeches*."[6] Here, the organization directly links the making of images with the invention of an American identity.

The ambivalence of many Americans toward their own history is evident in the centennial commissions referred to above, but it has also shaped several generations of art-historical scholarship. The diverse readings of George Caleb Bingham's images of life on the Missouri and the Mississippi rivers provide a good case in point. E. Maurice Bloch, whose work on Bingham laid the foundation for future scholarship, sees in Bingham the "realist" artist of innovative Western genre scenes: "Bingham's individuality and strength lay in the virile realism he was able to bring to his portrayals of the local scene."[7] Jules Prown followed this interpretation in a paper on the *Fur Traders Descending the Missouri*, 1845 (New York, The Metropolitan Museum of Art).[8] In his analysis, Prown discussed "the conjunction of civilization and wilderness" in the context of the frontier. He rejected the methods of social history in favor of a reading based primarily on "internal evidence." By contrast, Henry Adams has stressed the "spirit of western

expansion" in the *Fur Traders*.[9] Dawn Glanz concentrated on the theme of racial intermarriage, reading the image as a symbol of harmony between civilization and wilderness: "Bingham's French trader and his son can thus be seen as symbols of the white man's integration with the Indian and, by implication, with the wilderness."[10] In 1986, in the revised edition of his earlier catalogue raisonné, Bloch modified his reading of Bingham's *Fur Traders* slightly, but he insisted that the image was intended to convey "factual statements" about the scene portrayed and that it should be read "primarily as a commentary on the family unit and on a social structure already firmly established on the Missouri frontier through racial intermarriage."[11]

Most recently, it is Bingham's river paintings that have been the objects of scholarly attention. Following Bloch, Ron Tyler interprets these images as representations of "authentic frontier types" and "an accurate document of certain elements of frontier society."[12] Nancy Rash connects the river scenes more specifically to Bingham's political activities and to Whig politics, reading the *Fur Traders* as "the 'forerunners' of commerce and, by extension, of civilization."[13] According to her, the three early riverboat paintings are "as optimistic as the images on Bingham's political banners." Chronicling river trade and celebrating the life of hunters and boatmen, these pictures reflect "Whig sentiments about economic progress and the morality of labor."[14] The most recent scholarly assessment of Bingham's work and of his role as an artist comes in a book of essays published in conjunction with a comprehensive exhibition.[15] Here, Barbara Groseclose reads the *Fur Traders* as an image that "calls attention to assimilation."[16] Elizabeth Johns sees *The Jolly Flatboatmen* as "enjoying a natural Eden" and Bingham's genre and landscape world as "receptive and peaceful."[17] Michael E. Shapiro relates the *Fur Traders* "to the popular and sentimental use in the nineteenth century of the image of water as a metaphor for life."[18] Likening *The Jolly Flatboatmen* to "the poetry of Walt Whitman," he reads the picture as "a song of the open road"[19] and "an ode to the positivist spirit."[20] It is certainly true that the river scenes represent "a series of utopian views" and articulate "the complex dialogue of meditation on labor, on nature, on progress, and commerce."[21] However, I would seriously question Shapiro's conclusion that Bingham's images "bear within themselves the most exemplary values of American experience,"[22] as their very utopian agenda precludes representation of the American experience. Only through the sublation of the disjuncture between life and art, between historical document and fic-

121

tional transcendence, did Bingham produce images that so effectively contributed to the creation of an American myth.

Despite efforts to contextualize Bingham's work, there remains the task of revealing those disjunctures and contradictions between the so-called realism — or reportage — of Bingham's river paintings and their highly fictional and artificial nature; between the popular demand for contemporary authenticity and the painter's evocations of the past; and, perhaps most unsettling, between the paintings' reception as authentic "American" art and Bingham's pictorial mode based almost entirely upon European models in the academic tradition. Rather than seeing in Bingham's scenes of the Missouri and the Mississippi rivers pictorial documents or "reportage" of an authentic nature, or even symbols of a "new harmony" between man and nature, civilization and wilderness, I propose to show how they functioned to generate myths. Consciously conceived as characteristically "American" scenes, these paintings had a strong patriotic appeal from the time of their first public exhibition. An analysis of historical and biographical circumstances, of patronage, critical reception, and manipulative pictorial strategies uncovers ruptures — rather than coherence — between historical experience and artistic invention.

Let me first turn to some of the biographical circumstances that left their mark upon Bingham as an artist. George Caleb Bingham was born in 1811 on a plantation in Augusta County, Virginia. When he was eight years old, his family moved westward to Franklin in Howard County, Missouri Territory, then a typical small town on the Western frontier, where his father operated a tavern. When the Binghams settled in Franklin in 1819, it was a booming town with a population of about one thousand and new settlers arriving daily. As the local newspaper, the *Missouri Intelligencer*, stated on 19 November of that year, "Emigration to this Territory, and particularly to this County during the present season almost exceeds belief.... Immense numbers of waggons, carriages, carts...[and] families have for some time past been daily arriving." The lore of the "West," which at that time meant the Missouri Territory with its river, had already found vivid expression in popular songs:

> To the West, to the West, to the land of the free,
> Where the Mighty Missouri rolls down to the sea.
> Where a man is a man, so long as he'd toil,
> Where the humblest may gather the fruits of the soil.[23]

When Bingham's father died in 1823, the family was left destitute. The following year, Bingham's mother opened a school for girls in Franklin to support her children. In 1827, when Bingham was sixteen years old, the family moved to a farm near Arrow Rock, where the boy reportedly was tutored by a cabinetmaker and Methodist minister, the Reverend Jesse Green. From about 1828 to 1832, Bingham was apprenticed to the Reverend Justinian Williams, also a cabinetmaker and Methodist minister. It was during these years that, inspired by the works of itinerant portrait painters who traveled throughout the country in search of commissions, Bingham decided to become an artist. Largely self-taught and inspired by the model of these itinerant artists, Bingham began his own career as a portrait painter, first in Arrow Rock and later in Columbia and Saint Louis. It was a miserable, strenuous, and insecure existence, one from which the artist only slowly emerged as the celebrated painter of Western genre scenes. At the age of twenty-seven Bingham visited the cities on the East Coast for the first time: in 1838 he spent three or four months studying in Philadelphia, then the cultural capital of the country, and also visited New York City. In the autumn of that year, he exhibited his first scene from life on the "middle border," entitled *Western Boatmen Ashore* (present location unknown), at the Apollo Gallery in New York. From this time onward, Bingham traveled continuously, studying intermittently during his visits to the East Coast. Though he still worked as a portraitist, by 1845 his focus had shifted to the painting of genre scenes from life in Missouri. In that year, he submitted four paintings to the American Art-Union in New York: among them were two landscapes entitled *Fur Traders Descending the Missouri* (*French Trader and Half-Breed Son*), 1845 (New York, The Metropolitan Museum of Art, no. 33.61) and *The Concealed Enemy*, 1845 (Orange, Tex., Stark Museum of Art).[24]

The actual circumstances of Bingham's early years clearly account for this new direction in his painting, but in a rare conjunction, the artist's own childhood recollections of life on the Missouri River frontier would be sanctioned as a typically "American" experience by the Art-Union, whose philosophy and mission converged in support of nationalistic patriotism. The Art-Union promoted paintings of a "national character" in a dual effort to encourage young American artists and to "cultivate the general taste," thus revealing its intentions to educate simultaneously both the makers and the consumers of art. A "Notice" in the Art-Union's *Transactions* for 1844 stressed: "No American can fail to be proud of the fact, that American art-

ists in every walk of Fine Art, have already won distinction, even in the most cultivated circles of the Old World, and that amongst us, artistical talent is showing itself in every quarter."[25] The organization, originally an outgrowth of the same Apollo Gallery that in 1838 had exhibited Bingham's first Missouri genre scene, *Western Boatmen Ashore*, clearly articulated its "philanthropic and patriotic desire to foster American Art through (1) the financial and moral encouragement of producing artists and (2) the aesthetic education of the public."[26] In addition to organizing exhibitions, the Art-Union instituted a system of membership subscription through which works of art were distributed to its members by lot at annual meetings. The Art-Union's *Bulletin* promoted Bingham's reputation as "The Missouri Artist," and in 1849 — four years after agreeing to buy his best and most original paintings — issued the first biographical account of his life. In view of the confluence between Bingham's river scenes and the Art-Union's espoused nationalistic and democratic ideology, it is no surprise to read in the *Bulletin* the patriotic interpretation of *The Jolly Flatboatmen, Raftmen Playing Cards*, 1847 (Saint Louis, Mo., The Saint Louis Art Museum), and *The Stump Orator*, 1847 (present location unknown), as "works [that] are thoroughly American in their subjects, and could never have been painted by one who was not perfectly familiar with the scenes they represent. It was this striking nationality of character, combined with considerable power in form and expression, that first interested the Art-Union in these productions."[27]

When Bingham sent the *Fur Traders* to the Art-Union in 1845, it was purchased for distribution at the annual meeting in December of the same year.[28] The painting immediately elicited such a response that in 1851 the artist produced a variant entitled *The Trappers' Return* (fig. 1),[29] which, along with *The Jolly Flatboatmen* of 1846 (fig. 2),[30] will be the subject of the following discussion.[31]

The two subjects Bingham chose for his debut at the Art-Union were scenes depicting life on the frontier, scenes of hunting, trading, and the transportation of goods on the Missouri and the Mississippi, potentially dangerous and violent pursuits on the untamed rivers. Yet both images, one peaceful and serene, the other optimistic and exuberant, deny the very existence of danger and violence, as if the artist had produced them in direct response to the Art-Union's preference for paintings "taken from the every day scenes of life, those that are not suggestive of…[nor] create painful emotions" and its advocacy of "anything, however, that illustrates

2. George Caleb Bingham (American),
The Jolly Flatboatmen, 1846,
oil on canvas, 97.4 x 124.4 cm.
Taylor, Mich., Manoogian Collection.
Photo: Dirk Bakker.

3. George Caleb Bingham (American),
 Trapper's Son, 1851,
 black India ink, wash, and pencil on rag
 paper, study for *The Trappers' Return*,
 17.6 x 25.3 cm.
 Kansas City, The Nelson-Atkins Museum of
 Art, Acquired through the generosity of
 Interco Incorporated Charitable Trust.
 Photo: Courtesy the People of Missouri.

our country, [its] history or its poetry."[32]

Beyond simply describing its subject, the original title of the first version of *Fur Traders*, that is, *French Trader and Half-Breed Son*, specifically refers to the phenomenon of interracial marriage in a region where white, primarily French, traders often married Native American women. These hunters and traders lived and worked in rough, unstable, generally "unsettled" situations, moving between the wild interior of the country and the rapidly developing centers of commerce along the rivers and taking advantage of an open geographical and social space as yet not firmly defined by borders. Sharing wilderness and civilization, Native American and Western culture, and communicating in a language of their own, these men came to represent the very idea of freedom.[33] Their existence inspired American folklore and was soon forged into a persuasive symbol of the free and unfettered life in the vast expanse of the West.

In 1836 Washington Irving published his account of the hunters and traders, describing their situation in poetic terms that at once elevated and popularized it.[34] In the mid-1840s, when Bingham painted the *Fur Traders*, he must have been aware of the literary and folkloristic traditions that had firmly established images of the trapper and fur trader in the American imagination and that held great appeal for his audience on the East Coast. Bloch noticed that the painting indeed reads like an illustration of certain passages in Irving's book. Bingham's pictorial representation, however, contains a "subtext" that betrays something other than the harmony the viewer so easily reads at first glance. The long, narrow boat moving gently downstream, a simple dugout, lies parallel to the picture plane with space enough in the foreground for its own mirror image. The two figures — the old French trader in the stern and his half-breed son, in pensive pose, leaning over the cargo amidships — dominate the composition. On the left side, at the bow of the dugout, a small black bear cub is chained to the boat.[35] It hardly counterbalances the monumental figures of father and son, thus subtly introducing imbalance into an otherwise stable composition. All three figures, the two humans and the animal, look directly out of the picture to engage the spectator's attention. The stillness of the water reflects the boat, its passengers, and the cargo. But the frame of the picture sharply cuts into this reflected image, severing the heads of the two human figures but leaving ample space for the small animal's reflection. Only the animal, part of untamed nature, is shown in complete mirror image in the shiny surface of

127

the water. A golden haze — in the manner of Claude Lorrain — envelops the scene, whose serenity is undisturbed by the movement of wind over the water or by any other sign of traffic on the river. As Irving had written, "Sometimes the boat would seem to be retained motionless, as if spell bound, opposite some point round which the current set with violence, and where the utmost labor scarce effected any visible progress."[36] By excluding any hint of looming danger or abrupt change of scenery, Bingham created a sense of timelessness that effectively communicated the illusion of harmony rather than the prospect of collision. Yet the sign of destruction is visible at the center of the picture: the gun, over which the young son leans as if to protect his booty, is aimed toward the land along the shore. While the bushes and rocks on the shoreline protectively frame the two human figures, the small dark animal is sharply silhouetted against the golden surface of the water. Standing forlorn, set apart, the bear cub signals displacement from, rather than harmony with, nature. Both the gun and the animal function as signs of rupture. Moreover, the firmly contoured boat and its figures — carefully prepared in preliminary drawings (fig. 3) —introduce a sense of discrepancy, for it appears like a "cutout" placed in front of, not integrated into, the composition. Thus, the apparent harmony between nature and civilization, native and Western culture, is subtly jarred by alarming signals of confrontation and conflict. But the golden haze and dreamlike stillness of the scene — "as if spell bound" — conveniently veiled for Bingham's audience the destruction of nature, its fauna and flora, and foremost, of its native population.[37] It was by no means the painting's "authenticity" or factual properties that elevated it to the status of an icon of the American West, but rather its very denial of reality.

One year after the success of the first version of the *Fur Traders*, Bingham painted *The Jolly Flatboatmen*, first entitled *Dance on the Flat Boat*. He submitted that to the Art-Union as well, which published it as a print in the *Transactions* of 1846 (fig. 4). The Art-Union had instituted a plan whereby "every subscriber of five dollars is a member of the Art-Union for the year, and is entitled...First...to the production of *a large and costly Original Engraving* from an American painting,"[38] thus guaranteeing the widest possible dissemination of Bingham's image. A year later, in September 1847, an anonymous wood engraving after *The Jolly Flatboatmen* appeared in *Howitt's Journal of Literature and Popular Progress* as an illustration to a story about life on and along the Mississippi and the Missouri rivers (fig. 5).[39] Describ-

128

4. After George Caleb Bingham (American),
 The Jolly Flat-boat Men, 1846,
 etching, 48.7 x 61.5 cm.
 From *Transactions of the American Art-
 Union for 1846* (New York, 1847). Ithaca, N.Y.,
 Cornell University Library.

5. After George Caleb Bingham (American),
 Life on the Mississippi, 1847,
 wood engraving by H. Linton. From *Howitt's
 Journal of Literature and Popular Progress*
 2, no. 3 (4 September 1847): 145.
 Berkeley, University of California at
 Berkeley, The Library.

JOHN BANVARD'S GREAT PICTURE.

LIFE ON THE MISSISSIPPI.

In the year 1840, a young man, hardly of age, took a small boat, and, furnished with drawing materials, descended the river Mississippi, resolved to gain for his country a great name in the kingdom of art. It had been said that America had no artists commensurate with the grandeur and extent of her scenery, and John Banvard, now in his little boat, sets sail down the Mississippi, to prove how unfounded was this assertion.

We will now say something of his former life, which, with its hardships, disappointments, and privations, had fitted him for the accomplishment of his great undertaking. He was born in New York, and well-educated by his father, who was the pastor of Harvard Church, Boston. Being of delicate health in childhood, he was unable to enjoy the active out-of-doors sports of other boys, and accordingly amused himself by drawing, for which he very early showed a decided talent. Besides drawing, he devoted himself also to natural philosophy, and made some clever instruments for his own use, one of which was a camera obscura. His room was a perfect laboratory, or museum. He constructed a little diorama of the sea, on which he exhibited moving ships, and even a naval engagement. The money which was given him, he spent, not in toys and sweetmeats, but in the purchase of types for a little printing-press of his own construction, at which he printed hand-bills for his juvenile exhibitions.

The child was truly father of the man, in this, as in so many other cases. But he had much to pass through yet, before the promise of the boy could be developed in the accomplishments of the man. Banvard's father, like many another honest and unworldly man, entered into a partnership in trade, and soon after found himself pennyless; this unfortunate connexion swept away all the frugal earnings of his life; his family were turned adrift upon the world, and with this heart-breaking knowledge he died. John was then fifteen, and, taking leave of his family, he set off into Kentucky, to seek his fortune; he tried first of all with an apothecary, but being detected drawing portraits on the wall with chalk instead of making up prescriptions, the apothecary dismissed him.

He then took to painting in earnest, but unluckily, there was not sufficient taste for the fine arts in the West to maintain him; so meeting with some young men of his acquaintance, they took a boat, and set off down the river in search of adventures, and of these they had no lack—among others, narrowly escaping wreck during a storm. We next find him at the village of New Harmony, on the Wabash river, where, in company with three or four other youths, he built and fitted-up a flat-boat, with some dioramic paintings of his own preparation, and then started down the Wabash, with the intention of coasting that river into the Ohio, and so down the Mississippi to New Orleans, exhibiting by the way their works of art to the scanty population of the wilderness. Although their boat was of their own manufacture, they were too poor to complete it entirely before they set out on their extraordinary expedition, but hoped to finish it out of their proceeds as they went along. They took with them such a supply of provisions as their means would afford, and this of course was small enough. The river was low, and none of them having descended the Wabash before, they were consequently ignorant of its navigation; they, therefore, were

ing "all the toil, and danger, and exposure, and moving accidents," the author also refers to the rich folklore that the print of the "jolly flat-boat men" evokes: "In speaking of these boats, who does not immediately call to mind the well-known songs of the boatmen on these American rivers, with their merry and yet half-melancholy airs, and which, like all music which is truly national, have grown out of the life of the people."[40] He goes on to praise the steamboats that navigate the Mississippi for "their immense size, as if built to correspond with the magnitude of the river."[41] Thus Bingham, eager to carve out a reputation as the Missouri artist, consciously chose another subject that was as rich in folkloristic connotations as it was typical of "national" character: the image of the flatboatmen conjured up a powerful vision of youthful vigor and unfettered life at the borders of civilization.

The work of the boatmen was rough, hazardous, and not at all well paid. Yet Bingham's image does not depict work, danger, or violence: just as the *Fur Traders* does not represent the action of hunting or trading but rather a moment of tranquillity, so *The Jolly Flatboatmen* does not depict the boatmen laboring but instead their carefree recreation after work. If the *Fur Traders* reads in part like an illustration to Washington Irving's text, *The Jolly Flatboatmen* seems to represent a scene from Timothy Flint's account of *The History and Geography of the Mississippi Valley*, published in 1832.[42] In fact, long passages from Flint's text were reprinted in *Howitt's Journal* with Bingham's print serving as an illustration:

> All the toil, and danger, and exposure, and moving accidents of this long and perilous voyage, are hidden, however, from the inhabitants, who contemplate the boats floating by their dwellings on beautiful spring mornings, when the verdant forest, the mild and delicious temperature of the air, the delightful azure of the sky of this country...the broad and smooth stream rolling calmly down the forest, and floating the boat gently forward, present the delightful images and associations to the beholders. At this time there is no visible danger, or call for labour. The boat takes care of itself; and little do the beholders imagine how different a scene may be presented in half an hour. Meantime, one of the hands scrapes a violin, and the others dance. Greetings, or rude defiances, or trials of wit, or proffers of love to the girls on shore, or saucy messages, are scattered between them and the spectators along the banks.[43]

The artist transforms the activities of the boatmen into a spectacle for the beholder on shore. Like Flint, who assumed the observer's point of view,

6. George Caleb Bingham (American),
 Flatboatman, 1846,
 graphite on paper, 23.7 x 18.6 cm.
 Kansas City, The Nelson-Atkins Museum of
 Art, Acquired through the generosity of
 Governor and Mrs. Christopher S. Bond.
 Photo: Courtesy the People of Missouri.

Circular Composition.

Plate 6.

Fig 1.

Reubens.

Fig 2.

B. West.

Fig 3.

Rembrandt.

Fig 4.

Domenichino.

Fig 5.

Raffaelle.

John Burnet Sc.

London, Published by W.H. Carpenter, Lower Brook Street, June 1st 1822.

Bingham effectively distances his subject from reality. He "orders" the eight figures that make up *The Jolly Flatboatmen* within a pyramidal frame as if to contain their often "riotous behavior"[44] within a static and closed pictorial construction. Like the dugout in the *Fur Traders*, the boat has been placed parallel to the picture plane, and only the narrow strip of water in the painting's foreground separates the viewer from the painted scene. Traces of work are relegated to the lower deck of the boat, while several of the colorful boatmen set against the calm surface of water and sky and framed by the forests on shore look out from the painted scene to engage the viewer's attention. Each of the highly individualized figures, again the result of careful preparatory studies (fig. 6), comes into sharp focus in contrast to a landscape that recedes into indistinct haziness. Among the eight flatboatmen, it is clearly the central figure of the "dancer" at the top of the pyramid who dominates the scene and commands the spectator's attention, though his self-absorbed look does not acknowledge the viewer. The pictorial construction virtually hinges on his pose, which at once epitomizes Bingham's compositional strategies and locates the artist's specific historical situation: the dancer is obviously modeled upon the figure of Christ in Raphael's *Transfiguration* (*La Trasfigurazione*), 1517–1520 (Vatican, Pinacoteca, no. 333).[45]

Bingham's symmetrical and stable compositions derive from a careful study of Renaissance and Baroque compositions, and his frequent quotations of specific motifs point to a unique juncture between European and American culture. Though primarily self-taught, the young artist must have studied popular treatises on painting. These typically offered rather crude graphic reproductions of masterworks of the European tradition to accompany practical advice. John Burnet's *Practical Treatise on Painting in Three Parts* of 1828, in which a reproduction of Raphael's *Transfiguration* (fig. 7) appears, is only one of the examples Bingham might have seen. In the "Practical Hints on Composition in Painting" Burnet singles out the image of Raphael's *Transfiguration* as particularly "well suited for a display of the powers of eloquence."[46] At a moment when the flatboatmen were about to be lost in the margins of American history, Bingham was able to picture them with such compelling immediacy because he underpinned his image with a powerful Renaissance model of "eloquence." With this ingenious pictorial strategy, the artist elevated a subject of reportage through rhetorical abstraction to an icon of native virtues whose "eloquence" suggests conviction because of — rather than despite — its distance from reality. By com-

7. John Burnet (English),
Raphael's "Transfiguration," 1822,
uncolored line etching.
From John Burnet, "Practical Hints on
Composition in Painting," pl. 6, fig. 5, in his
*A Practical Treatise on Painting in Three
Parts* (London: Author, 1828). Santa Monica,
The Getty Center for the History of the Arts
and the Humanities.

pressing his image of youthful exuberance and unrestrained life on the frontier into a composition based on a classical formulation, he fashioned a scene with "a charm for the imagination" that reproduces "a tempting and charming youthful existence, that naturally inspires the wish to be a boatman."[47] Indeed, Bingham's regional theme transcended a specific historical moment — which had already been fictionalized in contemporary lore — and in the process he forged the persuasive symbol of a youthful and free nation engaged in Western expansion.

The mutually beneficial arrangement between patron and artist, as well as the Art-Union's insistence on "national" themes, must have influenced the production of this genre of painting, for which the public displayed an avid taste. But just as we have come to question literary "idealization" of the West — in the works of Washington Irving and James Fenimore Cooper and in the journalistic and scientific reportage of figures such as John James Audubon, Edmund Flagg, Timothy Flint, and Basil Hall — so we must now attempt to deconstruct the often-praised "authenticity" of Bingham's images. By the time the Art-Union's *Bulletin* began to promote Bingham's paintings as "thoroughly American,"[48] the actual frontier had already shifted westward to California, where the gold rush lured miners, explorers, adventurers, and settlers by the thousands. Missouri became the "middle-border," the gateway to the Far West. Bingham's idyllic scenes are thus not observations of contemporary reality but rather memories from his childhood. His paintings evoke images of a past that had vanished as quickly as white settlers and their technology began to advance across the West, but they also idealize a past that had in fact never existed in the terms he depicted.

If the artist Bingham ordered the rough and unsettled populace into pictorial formulations of seemingly classical balance, scientists sought to organize and classify systematically an abundance of hitherto unknown material. One of them, the German ethnographer and naturalist Maximilian, Prince of Wied, traveled with the Swiss artist Karl Bodmer on an expedition into the interior of North America between 1832 and 1834. Acclaimed for his published explorations of Brazil, Maximilian was well prepared for his ventures into the Missouri and the Mississippi territories, where he undertook extensive studies of flora, fauna, and geological and meteorological conditions and, most important, of the native population he encountered. Upon returning to Europe, he published his observations in a German edition entitled *Reise in das innere Nord-America in den Jahren 1832 bis 1834* (*Travels*

8. Karl Bodmer (Swiss),
Tower-Rock, View on the Missisippi [*sic*],
aquatint, 46.2 x 62.8 cm.
From Maximilian, Prince of Wied, *Travels in the Interior of North America* (London: Ackermann, 1843), accompanying *Atlas* by Karl Bodmer, vignette IX. Los Angeles, William Andrews Clark Memorial Library, University of California, Los Angeles.

135

9. Karl Bodmer (Swiss),
 Franklin and Arrow Rock on the Missouri, 1833,
 pencil on paper, 16.3 x 22.1 cm.
 Omaha, Joslyn Art Museum.

in the Interior of North America, 1832–1834) — two volumes accompanied by an atlas descriptively illustrated by Bodmer — which was soon followed by French and English editions.[49]

Maximilian, of course, came as a foreigner. Unhampered by the American desire for a national ideology, the German scientist was free to apply a lens that focused, not only on new discoveries and the innovative but also on the very conditions that fostered them. While he often refers to the American literature on the subject, Maximilian consciously positions himself as an outsider whose interest is inspired by the "rude, primitive character of the natural face of North America, and its aboriginal population, the traces of which are now scarcely discernible in most parts of the United States" rather than "the immigrant population, and the gigantic strides of civilization introduced by it."[50] In his preface the prince candidly writes that "the observation of the manners of the aborigines is undoubtedly that which must chiefly interest the foreign traveller in those countries, especially as the Anglo-Americans look down on them with a certain feeling of hatred."[51] His view, however, is not restricted to the Native Americans: criticizing "the very favourable colours" of picturing the "oppressed race" of the "negro slaves" in Saint Louis, the author observes that "the manner in which they are treated is generally not so good as has been represented."[52] He reports at length about the activities of the fur-trading companies that were already using steamboats to conduct their extensive business dealings.[53] There are long passages describing the commercial traffic on the rivers, the particulars of life in the new settlements, the situation of the "half-breeds," but also the destruction of nature and native populations, who, he observes, "in the eastern part of the continent are supplanted, extirpated, degenerated, in the face of the constantly increasing immigration, or have been forced across the Mississippi, where they have for the most part perished."[54] With the penetrating eye of the naturalist, he recognizes in the ravages of hunting a haunting metaphor for the devastation of the wilderness: "The scene of destruction…the whitening bones of buffaloes and stags, recurs everywhere in the prairie."[55] As an acute observer from Europe, Maximilian had no interest in concealing the circumstances of "the gigantic strides of civilization" he witnessed.

When Bingham started out as a young artist in 1832, Maximilian and Bodmer were ascending the Missouri in primitive paddle-wheel steamers and keelboats (fig. 8). Their paths may actually have converged when, in

April 1833, Maximilian and Bodmer visited New Franklin and Arrow Rock (fig. 9), where Bingham was just beginning his career as a local portrait painter.[56] When John Jacob Astor's giant fur-trading company was pushing up the Missouri River into Indian country, Maximilian and Bodmer set out – just in time – to record life along the rivers. Their documentation of the American frontier and beyond and, even more important, of the Native American tribes they met in the course of their travels (fig. 10), constitutes one of the most comprehensive and scientific visual records of the American West before photography. Bodmer's studies of the Native American peoples – perhaps more than Charles Bird King's and George Catlin's, both of whom traveled up the Missouri River in 1832, shortly before Bodmer arrived —are recognized as an accurate record worthy of the greatest scholarly attention; but his highly descriptive drawings and watercolors of life along the river, including detailed visual accounts of new settlements and bustling commercial activities, constitute equally important documents. For example, the first steamboat had sailed up the Missouri in 1832, just before Maximilian and Bodmer took passage on the steamer *Yellow Stone*. Bodmer sketched examples of the various other types of boats used to transport cargo and passengers along the riverways: keelboats, flatboats, sailboats, and canoes – some of which would soon be replaced by the steamers.[57] Even as Bingham painted his first version of the *Fur Traders*, in 1845, the introduction of steamboats on the rivers and the rapid decline of the fur trade due to extinction of the animals had already drastically altered the demographic and socioeconomic structures of the Missouri Territory.

Life on the frontier was rude, violent, and dangerous. Certainly Maximilian and Bodmer suffered due to crude conditions of travel through the wilderness and the uncouth habits of traders. But one cannot overlook the stark disparity between Maximilian's letters and Bodmer's luminous images, most of which convey a majestic peacefulness but reveal little about the real-life conditions that Maximilian recorded, for example, at Fort Clark: "We are tired of life in this dirty fort to the highest degree. Our daily routine is conducted in such a filthy manner that it nauseates one."[58] Whereas Maximilian's private letters express the two travelers' frustrations, Bodmer's colorful images, intended for public consumption, seem to observe the canons of exotic travel-book illustration. Similarly, Bingham's *Fur Traders* – intended for an American audience – at once evokes nostalgia for a bygone era and conceals the confrontation between civilization and nature that both

ZUSAMMENKUNFT DER REISENDEN MIT MONNITARRI INDIANERN
bei Fort Clark.

RENCONTRE DES VOYAGEURS AVEC DES INDIENS MEUNITARRI
près de Fort Clark.

THE TRAVELLERS MEETING WITH MINATARRE INDIANS.
near Fort Clark.

10. Karl Bodmer (Swiss),
*The Travellers Meeting with Minatarre
Indians near Fort Clark*,
aquatint, 46.2 x 62.8 cm.
[The artist is shown at the extreme right
with Maximilian by his side.]
From Maximilian, Prince of Wied, *Travels in
the Interior of North America* (London:
Ackermann, 1843), accompanying *Atlas* by
Karl Bodmer, vignette XXVI. Los Angeles,
William Andrews Clark Memorial Library,
University of California, Los Angeles.

139

Bingham and Bodmer witnessed. Bingham's pictorial strategies — pyramidal structure and symmetrical composition — reinforce the sense of harmony and timelessness that dominates his paintings. Though most of them are about the bustling commercial activity on the rivers — for instance, *Watching the Cargo*, 1849 (Columbia, Mo., State Historical Society of Missouri), or *Boatmen on the Missouri*, 1846 (San Francisco, The Fine Arts Museum of San Francisco) — they transcend reality and evoke a realm of the imagination. Bingham shared the American public's vision of "the land of the free — where a man is a man," which he monumentalized in images based on the pictorial formulae of the classical tradition. For *The Jolly Flatboatmen*, the painter devised a compositional scheme that ingeniously merges the pyramidal structure of Raphael's *Transfiguration* with a symmetrical configuration ultimately patterned on such models as his *School of Athens* (*La Scuola d'Atene*), 1510–1511 (Vatican, Stanza della Segnatura). Thus, by applying the pictorial principles of the grand tradition to an idealized depiction of life on the frontier, Bingham achieved both monumentality and transcendence of reality.

As fur traders crossed the borders between indigenous and Western cultures, and as flatboatmen traversed the boundaries between wilderness and civilization, Bingham mediated a new American subject matter and the established artistic traditions of the old continent. Perhaps he succeeded in manipulating Renaissance and Baroque formulas to articulate an American discourse on man's harmony with nature and the utopian concept of freedom because his own activities in the political arena and his allegiance to the Whig belief in free enterprise and progress propelled the painter's agenda beyond the aesthetic sphere. Thus, the artist framed themes of an unfettered — but often chaotic — existence on the frontier in conventional pictorial schemes that effectively undercut the construction of authenticity. The optimistic vision conveyed in *Trappers' Return* and *The Jolly Flatboatmen* is rooted in Bingham's artistic choices. Rather than picturing what Maximilian described as "the rude, primitive character of the natural face of North America," Bingham responded to an articulated need for images that projected harmony. Committed as he was to shaping both an American ideology and an American image-making tradition, he edited the historical facts of the concrete situation, in the process coining symbols that would fuel the nation's westward expansion.

NOTES

I gratefully acknowledge the research and editorial assistance of Stacy Miyagawa and Denise Bratton.

1. Timothy Egan, "Old West's Centennial Effort: Hail Indians (and Custer, Too)," *New York Times*, 13 December 1988, A1, A10, where the centennials of Washington, Idaho, Montana, Wyoming, North Dakota, and South Dakota are discussed.

2. Ibid., A10.

3. The manuscript for this essay was completed before the exhibition opened at the Smithsonian Institution's National Museum of American Art in Washington, D.C., in the spring of 1991. For an excellent discussion of the political implications of the exhibition and its relationship to the new Western history, see Eric Foner and Jon Wiener, "Fighting for the West," in *The Nation* 255, no. 4 (29 July–5 August 1991): 163–66.

4. I refer here to the subtitle of Richard Slotkin's *Regeneration through Violence: The Mythology of the American Frontier, 1600–1860* (Middletown, Conn.: Wesleyan Univ. Press, 1973). For a discussion of the historiography, see Henry Nash Smith, "The Myth of the Garden and Turner's Frontier Hypothesis," in idem, *Virgin Land: The American West as Symbol and Myth* (1950; Cambridge, Mass.: Harvard Univ. Press, 1978), 250–60. The standard literature on the American West includes the following titles: Ray Allen Billington, *Westward Expansion: A History of the American Frontier* (1949; New York: Macmillan, 1967); idem, *Land of Savagery, Land of Promise: The European Image of the American Frontier in the Nineteenth Century* (New York: Norton, 1981); Dawn Glanz, *How the West Was Drawn: American Art and the Settling of the Frontier*, Studies in the Fine Arts: Iconography, no. 6 (Ann Arbor, Mich.: UMI Research Press, 1982); William H. Goetzmann, *Exploration and Empire: The Explorer and the Scientist in the Winning of the American West* (1966; New York: Norton, 1978); idem, *New Lands, New Men: America and the Second Great Age of Discovery* (New York: Viking Penguin, 1986); William H. Goetzmann and William N. Goetzmann, *The West of the Imagination* (New York: Norton, 1986); Peter Hassrick, *The Way West: Art of Frontier America* (New York: Abrams, 1977); Robert V. Hine, *The American West: An Interpretive History*, 2nd ed. (Boston: Little, Brown, 1984); Richard Slotkin, *The Fatal Environment: The Myth of the Frontier in the Age of Industrialization, 1800–1890* (New York: Atheneum, 1985). The "new" historians who contest the very notion of the "frontier" investigate the history of the American West, taking into account issues of gender, class, and race; foremost among them are Patricia Nelson Limerick, *The Legacy of Conquest: The Unbroken Past of the American West* (New York: Norton, 1987) and idem, *Troubled Land: Failure and Defeat in Western Expansion* (forthcoming); Richard White, *"It's Your Misfortune and None of My Own": A History of the American West* (Norman: Univ. of Oklahoma Press, 1991); Donald Worster, *Rivers of Empire* (New York: Pantheon, 1985). For a new cultural

history approach, see David S. Reynolds, *Beneath the American Renaissance: The Subversive Imagination in the Age of Emerson and Melville* (New York: Knopf, 1988), and Bryan Jay Wolf, *Romantic Re-Vision: Culture and Consciousness in Nineteenth-Century American Painting and Literature* (Chicago: Univ. of Chicago Press, 1982).

5. Mary Bartlett Cowdrey, *American Academy of Fine Arts and American Art-Union: Introduction, 1816–1852*, with a history of the American Academy by Theodore Sizer and a foreword by James Thomas Flexner (New York: The New York Historical Society, 1953), 1:152.

6. Ibid., 153, emphasis in the original text.

7. E. Maurice Bloch, *George Caleb Bingham: The Evolution of an Artist* (Berkeley: Univ. of California Press, 1967), 70; the same author published *George Caleb Bingham: A Catalogue Raisonné* (Berkeley: Univ. of California Press, 1967) as volume 2; for a revised edition with comprehensive bibliography, see idem, *The Paintings of George Caleb Bingham: A Catalogue Raisonné* (Columbia: Univ. of Missouri Press, 1986); for the drawings, see idem, *The Drawings of George Caleb Bingham with a Catalogue Raisonné* (Columbia: Univ. of Missouri Press, 1975).

8. Jules D. Prown, "Bingham's *Fur Traders Descending the Missouri* (*French Trader and Half-Breed Son*)," in *Abstracts of the Sixty-Ninth Annual Meeting of the College Art Association* (1981), 106.

9. According to Henry Adams, *Fur Traders* and *The Concealed Enemy* were viewed by William Sidney Mount as companion pieces intended to convey "the spirit of western expansion" and a symbolic comparison between Indian "savagery" and "emerging American civilization"; see Henry Adams, "A New Interpretation of Bingham's *Fur Traders Descending the Missouri*," *The Art Bulletin* 65 (December 1983): 675–80; this reading is refuted by Bloch, 1986 (see note 7), 29.

10. Glanz (see note 4), 43.

11. Bloch, 1986 (see note 7), 29.

12. Ron Tyler, "George Caleb Bingham: The Native Talent," in Ron Tyler et al., *American Frontier Life: Early Western Painting and Prints*, exh. cat. (Fort Worth, Tex.: Amon Carter Museum, 1987), 45. Tyler gives a detailed account of the early literary sources and the critical reception of the paintings.

13. Nancy Rash, "George Caleb Bingham's *Lighter Relieving a Steamboat Aground*," *Smithsonian Studies in American Art* 2 (Spring 1988): 27. The author provides a detailed discussion of political issues, including regulation of the waterways and traffic on the rivers. She also emphasizes that the coonskin in *Jolly Flatboatmen* has "long" been "a symbol of the Whig party." The manuscript for this essay was completed before the publication of Nancy Rash's book *The Painting and Politics of George Caleb Bingham* (New Haven and London: Yale Univ. Press, 1991).

14. Ibid.

15. Michael Edward Shapiro, Barbara Groseclose, Elizabeth Johns, Paul C. Nagel, and

John Wilmerding, *George Caleb Bingham*, exh. cat. (Saint Louis, Mo.: The Saint Louis Art Museum, 1990).

16. Ibid., 59, in "The 'Missouri Artist' as Historian."

17. Ibid., 101, in "The 'Missouri Artist' as Artist."

18. Ibid., 147, in "The River Paintings."

19. Ibid., 153.

20. Ibid., 154.

21. Ibid., 173.

22. Ibid.

23. Quoted from Alberta Wilson Constant, *Paintbox on the Frontier: The Life and Times of George Caleb Bingham* (New York: Crowell, 1974), 25.

24. Regarding Henry Adams's interpretation of *The Concealed Enemy* as a pendant to *Fur Traders Descending the Missouri* (see note 9), and regarding these two images as a juxtaposition of Indian "savagery" and a visualization of "emerging American civilization," see Barbara Groseclose's essay "The 'Missouri Artist' as Historian" (note 15), 58–59, where she discusses the implications of connecting Bingham's scenes as a pair.

25. Quoted after Bloch, 1986 (see note 7), 12.

26. Cowdrey (see note 5), 1:98, quoted after Bloch, *The Evolution*, 1967 (see note 7), 73.

27. Cowdrey (see note 5), 1:159.

28. For a discussion of all pertinent information and bibliography with reference to the preparatory drawings, see Bloch, 1986 (note 7), 172, no. 158.

29. Idem, 196–97, no. 253, with all the documentation and reference drawings.

30. *The Jolly Flatboatmen* (1) of 1846 (here fig. 2), Bloch, 1986 (see note 7), 176, no. 175. *The Jolly Flatboatmen* (2), 1877–1878, idem, 240–41, no. 413. *The Jolly Flatboatmen in Port*, 1857, painted while Bingham resided in Düsseldorf (Saint Louis, Mo., The Saint Louis Art Museum), idem, 211–12, no. 301.

31. The following description is based on the version of 1851. Both *Trappers' Return* and *The Jolly Flatboatmen* were exhibited in Berlin in 1988: Thomas W. Gaehtgens, ed., *Bilder aus der Neuen Welt: Amerikanische Malerei des 18. und 19. Jahrhunderts*, exh. cat. (Munich: Prestel, 1988), nos. 36 and 37; for a discussion of the paintings, see my essay in that catalog, "Bingham's Trapper und Bootsleute: Bilder vom Mythos der amerikanischen 'Frontier,' " 87–92.

32. Quoted from a letter by Corresponding Secretary A. Warner addressed to Frederick E. Cohen, dated 12 August 1848, taken from Bloch, *The Evolution*, 1967 (see note 7), 81.

33. For a contemporary account of the activities of the fur companies, see Washington Irving, *Astoria, or Anecdotes of an Enterprise beyond the Rocky Mountains*, 2 vols. (Philadelphia: Carey, Lea, & Blanchard, 1836), esp. 1: chaps. 14 and 15, 141–62. In *The Evolution*, Bloch (see note 7), 80, points to the parallels between Irving's text and Bingham's paintings. For a

discussion of how the roles of trapper and fur trader were transformed into symbols of freedom in the American imagination, see esp. Hine (note 4) in his chapter "The Fur Trade and Freedom," 67–81, and Glanz (see note 4), in the chapter "Civilization's Advance Men: Images of Fur Trappers and Traders," 27–54.

34. Irving's account is based on the papers of the American Fur Company, which John Jacob Astor — himself born in Germany — had made available to the author.

35. There is wide disagreement in the literature about the identification of the animal, which has been classified variously as a fox, a cat, or a bear cub. However, most recently, scholars seem to agree that it is a bear cub.

36. Irving (see note 33), 1: 145.

37. For a discussion of the devastating consequences of extensive hunting and of the fur-trade business, see Calvin Martin, *Keepers of the Game: Indian-Animal Relationships and the Fur Trade* (1978; Berkeley: Univ. of California Press, 1982).

38. *Transactions for the Year 1846* (New York: American Art-Union, 1847), no pagination.

39. *Howitt's Journal of Literature and Popular Progress* 2, no. 36 (4 September 1847): 145.

40. Ibid., 148.

41. Ibid.

42. See Bloch, *The Evolution*, 1967 (note 7), 86.

43. *Howitt's Journal* (see note 39), 148.

44. Ibid.

45. In his detailed discussion of the three versions and the compositions of *The Jolly Flatboatmen* in *The Evolution*, 1967 (see note 7), 85–97, Bloch refers to the importance of Raphael. In his analysis of *The Jolly Flatboatmen* (2), which he dates to 1877–1878 in the 1986 edition of his catalogue (see note 7), he points to the model of the hellenistic *Dancing Faun* from the Museo Nazionale, Naples; see *The Evolution*, 89–90 and ill. no. 57. The dancer in the first version, however, is clearly based on the figure of Christ in Raphael's *Transfiguration*. See Rash, 1991 (note 13), 84–85 and n. 56, where similar conclusions are drawn.

46. John Burnet, *A Practical Treatise on Painting in Three Parts, Consisting of Hints on Composition, Chiaroscuro, and Colouring* (London: Author, 1828). A print of Raphael's *Transfiguration* is reproduced in plate 6, and the "Practical Hints" on pages 26–27 give further explanations. Bloch, in *The Evolution* (see note 7), 35–48, discusses how Bingham, as a young artist, taught himself by studying illustrated gift books, by copying engravings and later plaster casts, and, primarily, by following instruction books such as Burnet's.

47. *Howitt's Journal* (see note 39), 148.

48. Cowdrey (see note 5), 159.

49. The two-volume German edition was published in Koblenz in 1839–1841; a French edition, three volumes with an atlas, was published in Paris in 1840–1843; the English version

appeared in a single volume in London in 1843. In the following, I quote from a reprint of the text in *Early Western Travels, 1748-1846: A Series of Annotated Reprints of Some of the Best and Rarest Contemporary Volumes of Travel, Descriptive of the Aborigines and Social and Economic Conditions in the Middle and Far West, During the Period of Early American Settlement*, vol. 22, ed. and intro. Reuben Gold Thwaites (1904–1907; New York: AMS Press, 1966). Maximilian's papers, travel diaries, journals, books, and drawings, and Bodmer's nearly four hundred original studies are in the collection of the Joslyn Art Museum, Omaha. For a discussion of Bodmer and Maximilian's expedition, see John C. Ewers, *Early White Influence upon Plains Indian Painting: George Catlin and Carl Bodmer Among the Mandan, 1832–34*, Publication 4292, Extract from Smithsonian Report (1957), in facsimile reproduction (Washington, D.C.: Shorey Book Store, 1971); John C. Ewers, et al., *Views of a Vanishing Frontier* (Omaha: Center for Western Studies, Joslyn Art Museum, 1984); William H. Goetzmann et al., *Karl Bodmer's America*, exh. cat. (Omaha: Univ. of Nebraska Press, 1984); David Thomas and Karin Ronnefeldt, eds., *People of the First Man: Life Among the Plains Indians in Their Final Days of Glory. The Firsthand Account of Prince Maximilian's Expedition up the Missouri River, 1833–34*, with watercolors by Karl Bodmer (New York: Dutton, 1976). For a brief discussion of Bodmer's work, especially the difference between the more dramatic and often violent scenes of the lithographs and the tranquillity of the watercolors, see Hugh Honour, *The New Golden Land: European Images of America* (New York: Pantheon, 1975), 232–34.

50. Maximilian, Prince of Wied, *Travels in the Interior of North America, 1832-1834* (London: Ackerman, 1966), 26.

51. Ibid., 29.

52. Ibid., 216.

53. Ibid., 240. Maximilian gives detailed accounts of the activities of the fur-trading companies, whose networks helped to facilitate his travels; he also describes Astor's business and the fur trade on the upper Missouri River, pages 232 and 377–84, respectively.

54. Ibid., 26–27.

55. Ibid., 384.

56. Ibid., 244.

57. See Goetzmann et al. (note 49).

58. See Goetzmann and Goetzmann (note 4), 57, and Thomas and Ronnefeldt (note 49), 200–201.

1. Carl Friedrich Lessing (German),
 *The Inquisition of Hus at the Council of
 Constance* (*Johannes Hus vor dem Konzil zu
 Konstanz*), 1842,
 oil on canvas, 308 x 455 cm.
 Frankfurt am Main, Städelsches Kunstinstitut
 und Städtische Galerie, no. 901.

Barbara Gaehtgens

FICTIONS OF NATIONHOOD

Leutze's Pursuit of an American History Painting in Düsseldorf

The history of German-American artistic relations has been rich in fruitful exchanges but also in prejudices. Among the most persistent misconceptions has been the image of the American artist as a mere derivative echo of his European mentors. As late as 1920, the German art historian Richard Muther wrote:

> American painting...is distinct from European painting only in a spatial sense. Walk the streets of New York, and you will see nothing but old acquaintances. A bank building looks like the Loggia dei Lanzi, a post office like Saint Peter's, a department store like the Palazzo Barberini. And the painting is no more American than the architecture. Fertilized by its European counterpart, it has contented itself with the prompt and skillful execution of maneuvers dictated to it from Europe.
>
> First there were portrait painters, such as Gilbert Stuart, who went to England for their technical equipment. Then there were history painters, like Emanuel Leutze, who used the tricks they had learned at the Düsseldorf Academy to present the incidents of American history in a decidedly dry style of reportage. From 1859 on, young Americans mostly sought enlightenment in Paris. Some were at pains to repeat the message of the academicians Cabanel and Bouguereau. Others roamed the park of Fontainebleau, or the woods of L'Isle-Adam, in the company of Rousseau and Corot.[1]

All the prejudices that set their mark on art-historical scholarship for decades, not only in Germany but also in America, are here fully represented. Muther was denying the existence of a national American school of

147

art: an art with a tradition and a stylistic identity of its own. The image of the American imitator, who pursues his European mentor like a shadow and remains dependent on his every move, has remained remarkably persistent. It seems, indeed, to retain some of its potency even now, to judge by those articles on early nineteenth-century American art in which — over and over again, and mostly apropos of those painters who studied in Europe — a European work is set up as the "original" alongside an American "imitation."[2] The intention in such cases is less to analyze the individual achievement of the recipient artist than to find circumstantial evidence to support the old legend of the original and the copy.

This is not, and manifestly cannot be, a productive approach. Recently, therefore, attempts have been made — and made from a European viewpoint — to emphasize the distinctive nature of American art and to use comparisons with Old World painting to define the achievement and the individuality of American artists.[3] It has thus been proved that when American artists visited the academies and studios of certain European artistic centers, they did so not only to gain technical proficiency but — just as on the grand tour — to clarify their own ideas. By observing and studying other national schools, they hoped to bring their own identity into sharper focus. All were well aware that their new nation lacked both an artistic tradition of its own and an academy where they could obtain a solid technical grounding.

It therefore seems worthwhile to trace the course of such a quest for artistic identity, and for that the case of the history painter Emanuel Leutze (1816–1868) offers a useful example. Leutze was born in Germany, in Schwäbisch-Gmünd, and emigrated to Philadelphia with his parents at the age of nine. In 1841, now an American, he returned to Germany to enter the Düsseldorf Academy.

How did an American painter explain the unfamiliar artistic context of his chosen place of study? What kind of teacher, and what kind of stylistic model, was this particular student looking for? Does the choice of a teacher in itself denote an artistic goal? And, perhaps most important of all: how, in contact with the regional and local traditions of the host country, did the artist succeed in putting into practice his own ideas of an American national form of history painting?

At the outset we need to ask whether the specific artistic context in which Leutze found himself in Düsseldorf — and in Germany generally — was a

148

defining influence on his painting of American history. Was he affected by the debate on history painting within the Düsseldorf school, which pitted the idealistic concepts of Peter Cornelius and Wilhelm Schadow against an art of more immediate, concrete, topical relevance?

Large areas of Leutze's extremely varied output must be left out of consideration here. The main focus is on those historical works in which, in pursuit of his own idea of American history painting, he was imitating or radically adapting sources primarily derived from Düsseldorf. At the same time, it will become evident that his new historical approach also reflects influences from beyond Düsseldorf: namely, those of Belgian history painting.

The presence of American painters as students in Düsseldorf is a brief but crucial chapter in the history of German-American artistic relations. The attractiveness of the Düsseldorf Academy to American artists first became evident in the early 1840s; it culminated in 1848 with the "Düsseldorf Gallery" exhibition in New York, which coincided with successes for Leutze in Germany and America; and it ended around 1860, when Düsseldorf lost to Munich its reputation as the best academic training ground.

The intervening years provide rich material on the relations between American painting and the Düsseldorf school.[4] However, there have as yet been no studies of detail;[5] and most accounts have restricted themselves to the accumulation of materials, the bald recital of historical facts, and the classification of styles, with no attempt at a closer scrutiny of these extremely important artistic encounters. A lack of interest in the interpretation of the social and artistic context of the available German exemplars has tended to block access to the question whether such artistic relationships were fruitful or whether the Americans deliberately chose to depart from their German contemporaries' ideas. An artist such as Leutze seems either to be lumped in wholesale with the Düsseldorf school or — as has most recently been the case — placed in an exclusively American context.[6] There is still room for a closer examination of the encounters, appropriations, and new impulses that were involved.

The present study is an attempt to set in motion this second stage in the investigation of the material. It therefore centers on an analysis of the status of "original" and "imitation" and of the divergent aims of German and American history painting in the mid-nineteenth century, by reference to the examples of Carl Friedrich Lessing and Emanuel Leutze: fictions of nationhood.

149

When Leutze arrived in Düsseldorf from Philadelphia in 1841, he had already served an apprenticeship in the studio of the painter John Rubens Smith and had launched his artistic career with a number of portraits and paintings on historical subjects.[7] At the same time, his resolve to become a history painter seems to have been confirmed by the decisions on two occasions (in 1830 and 1836) of the United States Congress to commission Washington Allston to paint two historical scenes in the Capitol Rotunda in Washington, D.C.[8] These commissions caused a great public stir and must have made a particular impression on an aspiring artist such as Leutze. In the period between 1817 and 1824, John Trumbull had painted four scenes for the Rotunda, one of which in particular, *The Declaration of Independence, July 4, 1776*, was regarded as the first manifestation of an American continental school of history painting. However, the debate that followed the offers of the commissions to Allston revealed history painting in America as a highly problematic business.

Allston declined the commissions on the grounds that the events of the War of Independence were not suitable subjects for history painting. Plainly, America lacked an official art through which to celebrate its own importance and its democratic ideals. Unlike the French state and the monarchies of Europe, which could look back on a long tradition of painting on historical, allegorical, and mythological subjects, a democracy such as the United States had great difficulty, in the capacity of patron of the arts, in finding an appropriate iconography. Virtually no themes or precedents existed for the official art of a liberal, bourgeois society. There was a keen awareness of the dearth of those great themes that might prompt citizens from a variety of cultures to identify themselves with the body politic to which they all owed allegiance.

After Allston's withdrawal, the congressional committee charged with commissioning the paintings set itself the goal of formulating a program that would remedy this deficiency. The instructions were how to depict an event, "civil or military, of sufficient importance to be the subject of a national picture, in the history of the discovery or settlement of the colonies."[9] Discovery, settlement, a shared British past, and a common religion furnished a pictorial program well calculated to persuade all Americans of the sound historical foundation of the aims pursued by the present government.

One figure whose importance was not merely national but global was, of course, Christopher Columbus — as both a discoverer of America and a repre-

sentative of a new world order founded on science. Around 1836, as William H. Truettner has convincingly shown, there emerged an iconographic program – rooted in, and promoted by, patriotic conviction – through which the American nation established the framework of a historical tradition of its own.[10] This program was to remain valid throughout the two decades that followed.

The four scenes in the Rotunda were painted, respectively, by John Vanderlyn (see p. 18),[11] John Gadsby Chapman,[12] Henry Inman and William Powell,[13] and Robert Weir.[14] The public response was cool. Whether the cause lay in the shortcomings of the individual works or in the failure of the themes to add up to a convincing national iconography, the history of this ambitious project – that of creating a showpiece of American narrative art in the very seat of government – made all the more apparent the lack of a national school of history painting that could carry conviction either in technique or in content.

All this must have made Leutze, along with many other young painters of his time, acutely aware that his own training had left him unqualified to undertake a major commission of this kind. And, although clients for historical painters were few, history painting – in accordance with a French academic tradition that dated back to the seventeenth century – was regarded as the noblest form of art in the new United States. Whether or not prompted solely by the topical debate in America, Leutze resolved to leave the country for a while to pursue his education as a history painter at the Düsseldorf Academy.

There are several possible reasons for Leutze's decision to go to Düsseldorf. For one thing, a period of residence in Europe was bound to enhance the prestige of any American artist who wanted to paint historical subjects. For another, the Düsseldorf Academy had a rich tradition and an up-to-date, respected curriculum devised by its former and current directors, Peter Cornelius and Wilhelm Schadow. In addition, its prestige had recently been enhanced – and Leutze's choice may well have been influenced – by Count Atanazy Raczyński's three-volume history of modern German painting, published in French and in German from 1836 onward. In his first volume, devoted to the Düsseldorf school,[15] Raczyński gave great prominence to the history paintings of Schadow and to those of his most distinguished student, Carl Friedrich Lessing (1808–1880). In a brilliant stroke of cultural diplomacy, this German-Polish collector and diplomat had endowed the

Düsseldorf Academy, and the Düsseldorf school of painting, with an international reputation.

Leutze arrived in Düsseldorf in 1841 and some time later entered the academy.[16] Nothing is known of the nature or duration of his studies there, except that he soon left and moved into a studio of his own in Düsseldorf. This decisive step is mentioned only in passing in the literature, but it is clearly of extraordinary importance. Leutze had already trained as an artist in America before he reached Düsseldorf. At the academy, he was compelled to submit to the same rigorous and protracted course of instruction as everyone else. This could hardly satisfy him for long. One thing is certain, however: even a brief stay at the academy, say eighteen months or two years, would have been quite enough to familiarize him with the practical application of Schadow's ideas. And so, in addition to the technical instruction he received, he was initiated into the current controversy in Düsseldorf over the nature of a German school of history painting.

Since succeeding Cornelius as director in 1826, Schadow had devised a curriculum based on thorough instruction in drawing, painting, and composition.[17] The course generally lasted several years; the student advanced, step-by-step, from the elementary class to the so-called master class, in which, with a studio of his own, he was entrusted to the individual tutelage of a distinguished teacher. Schadow regarded history painting as the supreme objective toward which the whole program was directed.[18]

When Leutze went to Düsseldorf, the reputation of the academy was still intact. But there were already groups of artists in the city who distanced themselves from Schadow's leadership, which was increasingly felt to be too conservative, too Catholic, and too Prussian. Among those individuals was Lessing, who had lost Schadow's favor and broken his ties with the academy as a result of the public scandal caused by his painting *A Hussite Preaching* (see fig. 2).

Other members of Lessing's independent faction were the landscape painter Andreas Achenbach and the genre painter Johann Peter Hasenclever. They were joined by a large number of other unattached young painters who had made their way to Düsseldorf but had failed to gain admission to the academy. This nonacademic group of rejects, independents, and amateurs formed a pool of uncommitted artists from whom new and invigorating ideas could emerge. They shared an independent attitude, but they lacked the cohesive force that would have made the group a "Secession,"

for, as Karl Immermann pointed out, the link with the Düsseldorf school was fundamentally useful to all of them.[19]

The existence of two warring artistic camps in Düsseldorf is basic to an understanding of Leutze's artistic orientation. Contemporary critics, over-simplifying somewhat, reduced this to a split between "idealists" and "real-ists" and defined the contestants respectively as a reactionary grouping attached to the academy, on one side, and a free brotherhood of artists distinguished by talent and progressiveness, on the other.[20] But the latter was definitely not an avant-garde in the modern sense, since most of the independents themselves were academically trained. The points at issue were these: the nature of the effect and the relationship to reality to be pursued in history paintings; a higher status for genre and landscape painting; and, increasingly, the religious and ideological confrontation between Schadow's strongly Catholic, Nazarene tradition and the Protestant and politically liberal tendencies associated with Lessing and other leading independents.

A contemporary observer, Wolfgang Müller von Königswinter, was to define the new tendency as follows:

> Times were changing, and a fresh breeze was blowing away the sweet dreams
> of Romanticism. Hollow abstractions were no longer in demand; what was
> wanted was solid depictions of flesh and bone.... Without realizing it,
> Düsseldorf painters began to fight the same battles that were raging in the
> contemporary world at large.[21]

In other words, Düsseldorf painters, and the independents in particular, were beginning to sense — and to work into their art — the political conflict and turmoil of their age and society.

Müller von Königswinter also recorded that Leutze embarked on an ambitious project immediately after arriving in Düsseldorf. This was a history painting, *Columbus before the High Council of Salamanca*, 1842 (present location unknown),[22] which was based — significantly enough — on Washington Irving's book *The Life and Voyages of Christopher Columbus*, published in 1826, an apotheosis of the navigator and discoverer of America. Here Leutze adopted a subject that was by now common artistic property in Europe but that was also — as the paintings in the Capitol in Washington had shown — regarded by Americans as part of their own early history. The young Leutze thus promptly and deliberately adopted a theme that

satisfied the historical criteria laid down by Congress in 1836. From the very first, he apparently painted with an American market in mind. In Germany, too, as he knew, he could expect to arouse interest by showing a confrontation between a scientifically minded pioneer and a conservative and theocratic ideology.

Leutze's subject was the occasion in 1486 when Columbus was granted a hearing before a tribunal of professors and ecclesiastics. In this confrontation between the representative of the new, scientific mentality and the dignitaries of the Church, "the noble, simple figure of Columbus, with his poetic expression of honest conviction," marks, says Müller von Königswinter, "a wonderful contrast. The artist leaves us in no doubt as to who is in the right."[23] At the same time, as Müller von Königswinter went on to point out, with the onlookers Leutze portrayed a multitude of individuals in whose features the viewer could read every nuance of sympathy and hostility.

This painting made Leutze's reputation in Düsseldorf. Schadow himself recommended that the Kunstverein Rheinland Westfalen purchase it. The painting has since disappeared, but its theme, and the contemporary testimony of Müller von Königswinter, a Düsseldorf man, suffice to show that here — in spite of his "American" choice of subject — Leutze was intentionally competing with a specific German history painting, namely Lessing's *Inquisition of Hus at the Council of Constance* (fig. 1), completed in the same year. In Lessing's painting Jan Hus, religious rebel and forerunner of the Reformation, appears in a medieval ecclesiastical setting, confronting an array of representatives of the Church, who listen to his words with mixed reactions. The two works seem to have shared the theme of confrontation between individual truth-seeker and Church establishment, as well as an individualized treatment of the audience.

Düsseldorf gave a unanimously favorable reception to Leutze's small-scale painting of an event interpreted by him as an American theme. For "conservatives" and "independents" alike, it seems to have fitted uncontroversially into the academic tradition of Leutze's chosen place of study. Lessing's large-scale work, on the other hand, dealt with a German theme, and in spite of the lofty serenity of its pictorial effect, it unleashed a storm that revealed, not for the first time, the entrenched positions that divided the world of German historical painting.[24] Behind the historical subject, the painting's explosive topical relevance was obvious to a contemporary eye. Lessing himself never admitted this, but his painting was open to inter-

pretation as a comment on the conflict that was raging in the Rhineland
between the Catholic Church and the Prussian state.

In this work, Lessing was reverting to a theme that he had used a few
years before. In 1836 he had painted a large-scale work, *A Hussite Preaching*
(fig. 2), in which, in a rural setting, he showed an anonymous follower of
Hus raising to the peasants the chalice of the Eucharist, which was forbid-
den to the laity, thus inciting them to rebel against the Church. This aroused
lively controversy, and contemporary critics saw the work as a turning point
in the evolution of German history painting.[25] In their analysis they made
the following points:

1. Lessing was showing an individual in passionate resistance to authority. In so
 doing, he was overtly taking sides in the contemporary conflict between
 Catholics and Protestants, especially in the Prussian-ruled, Catholic Rhine-
 land; and in depicting a layman offering the chalice to the people, he was
 presenting what was for Catholics an act of sacrilege.
2. The painting broke with all the principles of elevated history painting, as
 practiced in Germany to date, which maintained the convention of an enclosed,
 stagelike pictorial space. Instead, the theme was so realistically presented
 that the Hussite preacher's appeal seemed to be directed not so much to his
 listeners inside the picture as to the viewers outside it. This, again, must
 have looked like sacrilege to Schadow and his school.
3. As the painting seemed to take sides politically and to treat the common
 people as a historical subject, it looked like a *Tendenzbild*, or thesis picture, a
 work with a theme outside of art, and thus an intervention in public affairs.
 At the same time, there was some sympathy for Lessing's desire to free his-
 tory from the idealizing light in which it had been shown by the school of
 Cornelius and Schadow and to transform it into a living statement with
 contemporary relevance.[26]

Students of the period have generally recognized that Lessing was the
one painter in Düsseldorf who was in a position to teach Leutze the most
modern form of history painting. However, Leutze's response to his men-
tor's work still calls for study.

Lessing's most recent paintings had features that must have appealed at
once to Leutze in his pursuit of an American history painting. One aspect
that invited close study was the immediacy with which historical events

2. Carl Friedrich Lessing (German),
 A Hussite Preaching (*Hussitenpredigt*), 1836,
 oil on canvas, 223 x 293 cm.
 Düsseldorf, Kunstmuseum, on permanent
 loan from Berlin, Staatliche Museen zu
 Berlin, Preußischer Kulturbesitz,
 Nationalgalerie, no. A II 829.
 Photo: Jörg P. Anders, Berlin.

were evoked. At the same time, however, Leutze must have been aware that Lessing's history paintings embodied a profoundly critical attitude toward their subject matter. The Hus paintings conveyed no assent to the scenes represented: they were an invitation to pass critical judgment. They addressed themselves to a viewer politically conscious enough to draw his own conclusions as to the historical significance of what was shown.

This was a new posture for an artist to adopt, especially with a contemporary reference thrown in; and for Leutze, in quest of an American history painting, it raised problems. He evidently knew this from the start; what he was looking for, no doubt partly under the influence of the iconographic program laid down for the Capitol, was an attitude that viewed the nation and its achievements not critically but affirmatively.

The selective nature of Leutze's response to Lessing is evident in the second of his Düsseldorf paintings, *The Return of Columbus in Chains to Cadiz* (fig. 3). This shows the episode when after a spell of self-aggrandizing rule in defiance of the Spanish Crown as governor of Santo Domingo, Columbus was returned to Spain in irons, together with his two brothers. Columbus is clearly depicted as a martyr. Eyes turned heavenward, bathed in light, and stretching out his clasped and fettered hands, he offers the image of a great man who is suffering an injustice. One of his brothers is characterized as a proud, unbending grandee, the other as a penitent sinner. At their feet, a crowd gives Columbus a mixed reception: some passionate, some accusing, some pensive, some hostile. A Native American kneeling and seen from behind, raises his manacled hands toward the discoverer of America. The composition clearly alludes to an *Ecce homo* scene.

With its dominant diagonals and the foreground figures who lead the eye into the central action, the layout of the painting is entirely in keeping with the academic practice taught in Düsseldorf. The carefully executed details, the clear identification of individuals through the use of contemporary costume, and the figures of Columbus and his brothers reveal close and detailed historical research. The varied and incisive drawing of the individual figures endows the action with a monumental immediacy and a sense of historical presence.

In formal terms, it is apparent that the painting has been staged as a *tableau vivant*, but in its content there is something novel. The artist has established a wide range of characterization not only in the central group but also in the crowd of onlookers, entirely through different individual reac-

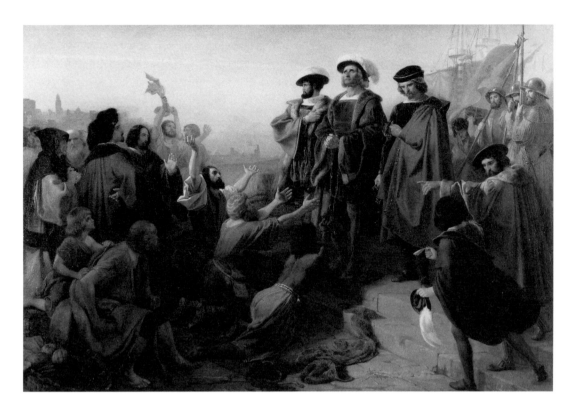

3. Gottfried Emanuel Leutze
 (German-American),
 *The Return of Columbus in Chains to
 Cadiz*, 1842,
 oil on canvas, 94.2 x 134.6 cm.
 Taylor, Mich., Private collection.

tions to the person of Columbus himself. This was something that Lessing had taught Leutze in *A Hussite Preaching*, which was the first history painting at that time to allow individual members of the common people to show emotional reactions of their own.

Leutze's work, painted at the Düsseldorf Academy, made two things clear. In style, it marked the first appearance in his work of the full academic technique of history painting, as learned in Düsseldorf. In substance, it showed Leutze's close dependence on works by Lessing, who had decisively influenced his handling of figures. The foreground crowd incorporates a number of direct quotations from Lessing's *Hussite Preaching*. It is worth observing, even so, how Leutze has converted Lessing's frontal staging, with its histrionic preacher, into a calmer and more self-contained scene.

Leutze thus seems to have kept in mind all along that Lessing conceived and painted his works for a German public in a specific political context. To contemporary Germans, the resistance of the fifteenth-century Hussites to the dogmatism and secular ambitions of the Church presented a many-layered analogy to the ecclesiastical and political situation of their own time. Between the revolutionary upheavals of 1830 and 1848, a politically minded German public found Lessing's paintings highly topical.[27] But how was Leutze to adapt Lessing's specifically German style of history painting for an American public? All along, he unquestionably set his sights on an American public; and, with that market in view, he maintained close contacts with American patrons and collectors.[28]

Certainly, Leutze was neither able nor willing to tackle as wide a political spectrum as Lessing. But the liberal temper of Lessing's work must have touched a chord in him. Lessing's Hus paintings were primarily about individual autonomy and freedom and the aspiration to change the world. They were not meant in any spirit of hostility to state power as such, let alone anarchistic in intention; their basic message was optimistic and forward-looking, based on the expectation that everyone would one day be able to assert his own freedom and make rational use of it.[29] Lessing's Hus paintings were an appeal for the maintenance of individual freedom against Church or state tyranny.[30] In this liberal aspect of their message, Lessing's themes were decidedly relevant to American history painting.

In his early Düsseldorf works, Leutze systematically "Americanized" Lessing's concepts for his own ends, that is to say, he absorbed Lessing's imagery only to the extent that it could be adapted to suit the needs of an

American public. In his Columbus paintings, he followed Lessing in plac-
ing his protagonist centrally. He used the reactions of the subsidiary fig-
ures to convey the fateful and dramatic nature of the action and thus to
manipulate the viewer's involvement. But what he sought to convey was
not the impassioned appeal of a preacher — which would most likely have
been lost on his American public — but above all a sense of the protago-
nist's aspirations or sufferings, with which the viewer could empathize and
identify. He reinterpreted Lessing's histrionic preacher as a more sober and
emotionally more approachable figure. He thus created a national role
model better suited to the American historical awareness: not a personifi-
cation of history so much as an individual who could elicit an emotional
response to a historic event of major national importance. Lessing and the
Düsseldorf Academy had furnished him with the resources, both of style
and content, that he was now able to use for purposes of his own.

Müller von Königswinter, who recorded the genesis of this second
Columbus painting, commented that the painter had no great success with
it in Düsseldorf and that the constraints of his academic schooling had led
him, in the end, to ruin the work. Plainly, Müller regretted the absence of
anything "American" in the painting. It seemed to him to be far too close to
the Düsseldorf formula. The great advantage enjoyed by the American art-
ist over his European counterpart was that "his past was almost his pres-
ent"; his history painting ought therefore to be marked by "a fresh, lively
approach." In an American painter, Müller plainly expected more sponta-
neity and something much more like an eyewitness version of history.[31]
What he failed to appreciate was that this was precisely what Leutze was
trying to get away from; he had come to Düsseldorf to learn to treat histori-
cal subjects in an academically sanctioned way.

In 1843 Leutze left Düsseldorf. In so doing, he gave up on precisely the
systematic academic training that he had set out to acquire. It is possible
that the success of his first painting and the failure of his second had made
him doubt the usefulness of the rigorous course of instruction in which he
was engaged. That same year he moved to Munich, which he now regarded,
in his own words, as "the best school of painting in the world."[32] There,
evidently in close contact with another of Cornelius's former students,
Wilhelm von Kaulbach, he painted his next ambitious history painting,
Columbus before the Queen (fig. 4),[33] in which he nevertheless continued to
work through the lessons of Düsseldorf.

160

4. Gottfried Emanuel Leutze
(German-American),
Columbus before the Queen, 1843,
oil on canvas, 98.4 x 130 cm.
Brooklyn, The Brooklyn Museum, Dick S.
Ramsay Fund and A. Augustus Healy Fund
B, no. 77.220.

This, the third painting in his Columbus series (which is not a true cycle, as the paintings vary in size), shows the latest, chronologically speaking, of the scenes that Leutze selected from the life of the great explorer. Having returned to Spain, Columbus appears in chains before the Spanish king and queen and puts his patrons to shame. We can see that the king has just loosened his chains. Columbus stands in the center of a Moorish hall. Deep in thought, the discomfited king and queen sit beneath a canopy on the left listening to the words of the accused, who, hand on heart, is evidently making a proud speech in his own defense. He is flanked to the left and right by a throng of courtiers: dignitaries, both lay and clerical, men, women, and a page in rich costumes, all listening to his words. Some are enraptured, some skeptical; most are thoughtful. A few occupy themselves with tracing his voyages on a map.

Commentators mostly compare Leutze's painting with Lessing's *Inquisition of Hus at the Council of Constance* (painted one year previously, in 1842, see fig. 1),[34] on the assumption that Leutze modeled his work on Lessing's. At first sight, this idea seems plausible. There are clear analogies between the two, not only in the arrangement of the figures in two groups but also in the placement and attitude of the accused, surrounded by the representatives of ecclesiastical and secular power. The lessons that Leutze had learned from Lessing are apparent in the way both artists capture the listeners' animated reactions to the words of the centrally placed protagonist. But this is not the whole story. It has hitherto been overlooked that Leutze was responding to other stimuli that were affecting artists, critics, and the German public at the time.

In the wake of the public controversy aroused by Lessing's historical subjects, the whole issue of national history painting gained new attention in Germany through a triumphantly successful touring exhibition of two paintings by Belgian artists. This was a show whose progress Leutze, more than anyone, must have followed with the greatest interest. From Cologne, the Belgian works traveled to a number of cities, including Düsseldorf, Berlin – where they were shown together with Lessing's *Inquisition of Hus at the Council of Constance* – and, in 1843, Munich. Leutze thus had more than one opportunity to see them. One painting, *The Abdication of Charles V* (fig. 5), was by Louis Gallait; the other, *The Compromise of Breda* (fig. 6), by Edouard de Biefve.

These two paintings attracted great attention wherever they were shown

and provoked a debate in the artistic press on the question of topical relevance in history painting. This led Leutze to look beyond Lessing's example and toward new categories of national imagery.[35]

The Kingdom of Belgium, founded in 1830, was still a young state when it commissioned these two large-scale paintings in 1837. They represent two important events in the sixteenth-century wars of liberation fought by the Netherlands against Spanish Habsburg rule. Contemporary commentators on the paintings dwelt on two issues in particular. One was the choice of the decisive moment in a process of historical change, a moment that encapsulated the whole future course of a nation's struggle for liberation and national unity. These paintings, it was also said, not only depicted the historic event as a specific, historically authenticated act: by evoking a concentrated moment of human decision and emotion, they also brought the past to life. The event was, as it were, shared among a number of characters, whose reactions afforded the viewers an emotional access to the work and made them eyewitnesses to the making of history.

There were, it is true, some dissentient voices.[36] However, the message received in Germany, generally speaking, was this: that Belgium, having just achieved national unity, was able to draw on native traditions to present itself in its history paintings with a greater sense of patriotic identity than the fragmentary German states could muster.

For Leutze, this notable artistic event must have had a distinct personal relevance, one that students of the period have hitherto overlooked. He, too, was preoccupied with a quest for national themes that would convincingly express the identity of his own country. In this, he was not so much interested in topical politics as in subjects that would evoke a national consensus. As he saw it, American history painting needed to find and depict the precise moment in history that would succeed in concentrating the emotions of Americans on their shared past.

One glance at Gallait's *Abdication of Charles V* is enough to reveal that this was an artistic source far more important to Leutze than anything in Lessing's work. True, he took from Lessing's major painting the central, erect figure of Hus, together with his gesture, which is that of a man who expounds and justifies a sincerely held position. Leutze also repeated the effect of a cardinal's red mantle on the far left from Lessing's work, and he converted the passageway that opens behind Lessing's Hus figure into a perspectival tour de force of Moorish architecture. But when it came to

5. Louis Gallait (Belgian),
 The Abdication of Charles V
 (*L'abdication de Charles-Quint*), 1841,
 oil on canvas, 485 x 683 cm.
 Brussels, Musées Royaux des Beaux-Arts de
 Belgique, no. 2695. ©A.C.L.-Brussels.

6. Edouard de Biefve (Belgian),
 The Compromise of Breda (*Le Compromis
 des Nobles*), 1841,
 oil on canvas, 482 x 680 cm.
 Brussels, Musées Royaux des Beaux-Arts de
 Belgique, no. 2696. ©A.C.L.-Brussels.

matters of substance, Lessing's unequivocally Protestant, anti-Catholic, and thus critical posture had nothing to offer Leutze.

Unlike Lessing, Leutze made it his first priority to capture the historic occasion in a scene that was dramatic right down to the incidental details of the staffage. He therefore took from Gallait's work rather more than the lavish presentation of historic royal pageantry. The steps that rise to the enthroned couple under the canopy, with an empty space in front of the principal figures, reflect a pictorial strategy derived from the works of both the Belgian artists. These steps, intersected in the foreground by the edge of the painting, are Leutze's variation on the theme of inviting the viewer to "enter" the picture and thus be integrated into the scene as an eyewitness.

Leutze also adopted Gallait's diagonal composition, though not the lighting scheme that divides and articulates his animated masses. In Leutze's painting the scene is bathed in brilliant light. Every figure and every object is clearly distinguishable. The magnificently ornate room and all the individuals in it, from the knight in his plumed helmet (a typical touch of Düsseldorf-style medieval romance) through the varied representatives of the Church, to the sorrowful queen and the apparently crestfallen king, all these, in their precision of drawing and their realistic rendering, convey an impression of immediacy and historic authenticity. To an unprejudiced contemporary observer, Leutze's painting suggested that what he saw before his eyes, being so clearly visible and based on such evident historical learning, must be the truth.

Leutze also owed much to Gallait in terms of content. *The Abdication of Charles V* depicted a decisive turning point in history. It captured the moment at which the Habsburg Empire was divided and its decline began. The dark figure of Philip II and the brighter one of William of Orange were the opposite poles of a long historical process that would one day lead to the foundation of the Belgian nation-state.

Here, for Leutze, was the central idea of a type of historical painting that he could also apply to American history. *Columbus before the Queen* is not, of course, set in America, but it contains the germ of American independence and democracy. Columbus, the founding father of America, holds the stage. He stands there as a prisoner and a man accused; and yet, despite his chains, his noble composure and air of calm and collected argumentation clearly mark him out as a free man. In his confrontation with the mor-

166

tified and irresolute king and queen, Columbus appears more confident, more kingly, than any of the courtiers who sit in judgment of him.

Leutze thus depicts the discoverer of America, even in his dependence on the Spanish monarchy, as the first of those confident democrats who were to mold the future of the American nation. Taking his cue from his Belgian predecessors, he focuses on the historic occasion that encapsulates America's democratic, bourgeois destiny.

Leutze, like John Singleton Copley and Benjamin West in the eighteenth century, was using his knowledge of current European history painting to create a form of historical image that would shape his own nation's self-perception. Not as a mere echo of Lessing, but by consciously taking stock of the various schools of patriotic history painting that existed in Europe, Leutze had created a form of imagery that was specific to the American viewer. In later years, the formal affinities between his art and the Düsseldorf school would be adduced to discredit it as "un-American." To contemporary eyes, however, its careful, academic drawing, its rich coloring, and its use of historic source material dating back to the sixteenth century were just what was required to satisfy the positivist craving for authentic and verifiable facts and thus to manifest the renewal of American history painting.

Clearly, there was no ready market in America for ambitious historical subjects on a large scale. Leutze therefore painted a series of small, genrelike histories drawn from the lives of the kings of England and of the Puritan divines in which the emphasis was on the private aspect of great historical events and personalities. Scholars have hitherto dismissed these scenes as "purely anecdotical,"[37] relegating them to a subordinate role in evaluations of Leutze's work. It is high time to consider them in the context of an evolving tradition of history painting. For what all these scenes had in common was the depiction of English history as an anticipation of the American present. There was also, no doubt, an implicit message that the United States had outgrown the intrigues of royal courts and the religious strife of the Puritan age. The depiction of the English past could serve the certainty of American progress.

Leutze's next ambitious project, with its continuing emphasis on the English connection, invites a similar interpretation. His search across Europe for a specifically American form of history painting now led him in a new direction. In 1844 his friend and patron, Edward Carey of Philadelphia, evidently gave him a commission for a large-scale painting of the

mythical landing in America – long before Columbus – of two Anglo-Saxon chieftains, Hengist and Horsa. This painting is now little known and its importance has usually been overlooked.

Leutze, who had now moved on from Munich to Italy, completed the commission in Rome and sent his painting from there to America (fig. 7).[38] Müller von Königswinter had seen the cartoon for the painting in Düsseldorf[39] and regarded it as one of the artist's finest achievements. In his account of the cartoon, he wrote:

> A comparatively small vessel has carried the brave heroes of that mighty nation far across the ocean and has made landfall on a lovely, verdant coast. Proud, blooming, blond men in lofty eagle helmets stride ashore, bearing a girlish figure on their shoulders; they raise a cheer in face of the unknown land whose trees offer them shade and whose vines give them a smiling welcome. A strangely poetic charm hangs over this scene, in which a mighty breed of men and a mighty land greet one another for the first time.[40]

Müller von Königswinter had unequivocally caught the national and indeed nationalistic message of the painting; and, from a German point of view, he had clearly approved of it. It invoked a legendary band of Anglo-Saxons, from whose two chieftains the kings of Kent traced their ancestry, as the true founding fathers of America. To present these European warrior chiefs in the guise of idealized American settlers was to legitimize America's national pedigree as a polity founded by English immigrants. This brought the painting manifestly within the thematic ambit of "Discovery and Settlement" that had been proclaimed as a national theme for the paintings in the Capitol.

Gone unnoticed so far, Leutze's theme was in itself an allusion to the official iconography of the young republic. In 1775 Thomas Jefferson designed an official seal for the United States. One face showed the Israelites in the wilderness, led by a cloud by day and a pillar of fire by night. On the other face were Hengist and Horsa, the Saxon chiefs.[41] Leutze had thus taken his cue from his American patron to illustrate a patriotic interpretation of history, whereby historical figures from the remote past could be invoked as symbols of American political identity.

Another fact that has yet to be remarked upon is that, at the time when Leutze painted this picture, the German public was concerned about very

similar issues. Just as Leutze's American patron looked to the heroes of the Dark Ages for symbols of national origins and national liberties, so the bourgeois democratic movements in Germany were seeking a symbol of national liberty that would antedate Germany's territorial dynasties. When Leutze painted his two armor-clad Anglo-Saxon chiefs, he may well have been thinking of a project that had unleashed great patriotic enthusiasm in Germany shortly after his own arrival in Düsseldorf in 1841. This was Ernst von Bandel's colossal monument to Arminius the Teuton, the *Hermannsdenkmal*, in the Teutoburg Forest (fig. 8).[42]

The inaugural ceremony of the plinth structure had caused a great sensation and attracted thousands of visitors. Illustrations of the projected monument were everywhere. Not only the figure of an ancient champion of liberty, with upturned gaze, but also the raised arm (which in the German case carried a sword), the shield, and the winged helmet, were part of the heroic typology that Leutze transposed into American historical painting from the European national monumental art of prehistory.

Artistically, he failed to bring the scene fully to life; even so, the variety of characterization, the powerful joint resolve expressed by the Anglo-Saxons in the boat, and the auspicious flood of light from on high are effective means of transforming this legendary ancestral landfall into an appointment with destiny.

It is hard to say whether Leutze had any success in conveying Jefferson's political allegory to an American public. Any American history painting that had been done outside America — and based, furthermore, on "foreign" sources — faced self-evident problems. This seems, however, to have been Leutze's first attempt to deal with a theme that was later to find its definitive form.

It was not until he painted his celebrated *Washington Crossing the Delaware* (fig. 9)[43] that Leutze once more touched on a theme related to the Columbus series. In George Washington, Leutze had chosen the one American hero who could unite all of his country's patriotic concerns. At the same time, this was a figure who — as Müller von Königswinter had said — could virtually serve as a link between the history of the young country and the present day.[44]

Unlike Leutze's earlier history paintings, this work is still central among the incunabula of American art. It has been the object of a number of detailed analyses,[45] mostly concerned with its genesis and with the power

169

(next page)
7. Gottfried Emanuel Leutze
 (German-American),
 The Landing of the Norsemen in America,
 1844,
 oil on canvas, 153 x 204 cm.
 Düsseldorf, Kunstmuseum Düsseldorf im Ehrenhof, on loan from the Volmer collection, Wuppertal, 1985.

of its subject matter for American history. It is accepted, too, that Leutze owed its theme to his own zealous support of the German democratic movement that led to the revolution of 1848.

The aim of that failed revolution was the creation of a German nation-state. The figure of Washington played an important role for the German democratic movement, and already in 1846, Ferdinand Freiligrath had hailed him in a poem as the helmsman of the good ship *Revolution*.[46] This is not the place to discuss this at length. But the painting's dual nationality — with its thematic source in contemporary political movements in Germany and its form and content aimed at an American public — does merit a few additional remarks. On one hand, *Washington Crossing the Delaware* is a masterpiece of the Düsseldorf school, manifesting an exemplary fusion of Schadow's academic conception and Lessing's new, realistic approach to history. On the other, Leutze has succeeded in emancipating himself from his artistic sources and creating out of them, for all to see, a new, a convincing, and — at last — an American version of history painting.[47]

It is noticeable that the German popular paintings and prints of the year 1848 consistently use the raising of the flag of a unified nation as a topos of freedom (fig. 10). This was a motif with a long artistic tradition behind it, but in 1848 it took on an urgent topical relevance. It is quite possible that this motif — which his German contemporaries regarded as a political one — supplied Leutze with his central inspiration. Transforming the historical context, he elected the corresponding moment in American history: the moment immediately before the unfurling of the flag of liberty.

Here Leutze was making two crucial statements. First, at a time when German unity had become a forlorn hope, he was holding up the history of the American nation as an example. Second, he was looking beyond contemporary events to give his fellow Americans a national, indeed nationalistic, apotheosis of the ultimate American hero. This perfectly answered the demand from American art critics for a national school of history painting that must be both "heroic" and "calculated by its commemoration to elevate the character of its hero in the minds of his countrymen."[48]

In terms of Schadow's principles, the germ and stimulus of Leutze's painting were thus embodied in the motif of the national flag, raised and about to unfurl. This he combined with the pictorial tradition of fateful water crossings, as seen in Théodore Géricault's *Raft of the "Medusa"* (*Radeau de la "Méduse"*), 1818–1819 (Paris, Musée du Louvre), and Eugène Delacroix's

8. Ernst von Bandel (German),
 Monument to the Germanic Chief Arminius
 the Teuton (*Hermannsdenkmal*), 1830–1846,
 bronze.
 Teutoburg Forest, Germany.

Dante and Virgil (*La Barque de Dante*), 1822 (Paris, Musée du Louvre); in Ludwig Richter's *Crossing of the Elbe at Schreckenstein* (*Überfahrt über die Elbe am Schreckenstein bei Aussig*), 1837 (Dresden, Gemäldegalerie Neue Meister); and above all in Copley's popular *Watson and the Shark*, 1778 (see p. 34).

According to Schadow's outline of the genesis of a painting, this initial idea must be followed by a subject sketch, which is then worked out in detail with the aid of suitable models. As Schadow himself pointed out, it was no easy matter to find models who could achieve an emotional identification with the poses that the painter required them to assume. In his quest for total authenticity of pictorial content and form, it seems that Leutze went in search of American models sufficiently tall and stalwart to be inserted into the picture as heroes of liberty. As his contemporary Müller von Königswinter remarked, "Even the boatmen are no ordinary working men; they are patriots."[49] The American painter Worthington Whittredge tells in his autobiography how, immediately after his arrival in Leutze's Düsseldorf studio, he was obliged to pose as Washington.[50] He also tells us that Washington's uniform had already arrived from America, as historical reference material, and that the portrait itself derived from the celebrated bust by Jean-Antoine Houdon. The realism of detail for which the Düsseldorf school was celebrated reveals itself in Leutze's study of historical material, which was intended to endow the painting with documentary value in its own right.

After the studies of detail, the next stage in the process, according to Schadow, was the cartoon, followed by sketches to establish the color and lighting. In an American private collection there is an oil sketch, which Barbara Groseclose regards as a replica of the first version of the painting with corrections made in preparation for the second.[51] It is quite possible, however, that it actually represents one of those intermediate stages that were inserted, in academic practice, between the initial cartoon and the finished work, in order to make sure of the overall effect. The pencil underdrawing on which this oil sketch is based has a precision of line that recalls the cartoons of the Nazarenes; its technique could have come from nowhere but Düsseldorf.

Leutze had thus achieved his original purpose in coming to Germany to study: At the Düsseldorf Academy and in the studios of his Düsseldorf mentors and friends, he had so thoroughly absorbed the academic routine of pro-

ducing a history painting that he was ready, as a technician and as a painter, to create one that was "in accordance with all the rules of art." The precision he had learned in Düsseldorf lent an illusive reality to his paintings.

In the process, he reintroduced to American painting a technical proficiency that had long been sorely missed; and, at the same time, he won recognition in Europe. The perfection of his technique drew singular attention in the citation for the gold medal that he won at the Berlin Salon of 1852 for the first version of *Washington Crossing the Delaware*. Topical though the theme also was in Germany, it was explicitly categorized as belonging to American history.[52] Leutze's success induced young painters to flock to Düsseldorf in order to pursue, in the painter's own studio, the link between Düsseldorf technique and American themes that had won him such fame on both sides of the Atlantic.

When it came to content, however, Leutze had not at all followed the pattern taught at the academy and practiced by his Düsseldorf friends. His engagement with the work of Lessing and with such other contemporary European painting as he then knew had led him to adopt a highly personal approach to the pictorial rendering of history.

In 1850 Lessing was working on his large painting *Hus at the Stake*, later shown in the Düsseldorf Gallery in New York (fig. 11). Its theme was the failure of the Hussites' hopes of freedom of worship, and in it Lessing showed the aspirations of the 1848 revolution going up in flames. Leutze's contemporaneous view of the idea of national liberty was a far more positive one, not — as with Lessing — a retrospective look at medieval Germany and a yearning for unity but a prophetic look forward, as defined by the decisive moment before Washington's victory over the British.

Leutze's painting was a vision of future national greatness. Its theme was the "principle of liberty," as exemplified in the person of a victorious hero who united many diverse interests and also in the motif of the star-spangled banner that was raised behind him. Where Lessing reconstructed a historical event as a lesson to the present, Leutze projected an idea of nationhood into the future. The painting sprang from an engagement with national history that was not critical — as Lessing's was — but entirely affirmative.

Leutze must have been keenly aware, at that moment, of the gulf that separated his painting, so perfect in its conformity with the prevailing political ethos of his own country, from the backward-looking posture of Lessing in Düsseldorf. In 1854 when Leutze was awarded the commission for the

175

9. Gottfried Emanuel Leutze
 (German-American),
 Washington Crossing the Delaware, 1851,
 oil on canvas, 382 x 656.4 cm.
 New York, The Metropolitan Museum of Art,
 Gift of John S. Kennedy, 1897, no. 97.34.

10. Bernhard Stange (German),
 Commemorative Broadside for the Year 1848
 (*Gedenkblatt auf das Jahr 1848*), 1848,
 lithograph.
 Munich, Münchner Stadtmuseum, no. z 1860.

11. Carl Friedrich Lessing (German),
 Hus at the Stake (*Hus vor dem
 Scheiterhaufen*), 1844–1850,
 oil on canvas, 360 x 533 cm.
 Berlin, Staatliche Museen zu Berlin,
 Preußischer Kulturbesitz, Nationalgalerie,
 no. 558.

major mural painting in the Capitol, he wrote in triumph: "Give us a chance, and my word on it we'll do what Europe cannot do even with her best artists (and I can say so because I know them all...personally) we will paint 'American pictures.' "[53]

NOTES

I wish to express my gratitude to John Wilmerding and Heinz Ickstadt for their careful readings of this essay and many constructive suggestions.

1. Richard Muther, *Geschichte der Malerei* (Berlin: Carl P. Chryselius, 1920), 3: 382.

2. Most recently in William H. Gerdts, "The Düsseldorf Connection," in William H. Gerdts and Mark Thistlethwaite, eds., *Grand Illusions: History Painting in America*, exh. cat. (Fort Worth, Tex.: Amon Carter Museum, 1988), 125ff.

3. See Thomas W. Gaehtgens, ed., *Bilder aus der Neuen Welt: Amerikanische Malerei des 18. und 19. Jahrhunderts*, exh. cat. (Munich: Prestel, 1988).

4. I mention here only Barbara S. Groseclose, *Emanuel Leutze 1816–1868: Freedom Is the Only King*, exh. cat. (Washington, D.C.: Published for the National Collection of Fine Arts by the Smithsonian Institution Press, 1975); Rolf Andree and Ute Rickel-Immel, *The Hudson and the Rhine: Die amerikanische Malerkolonie in Düsseldorf im 19. Jahrhundert*, exh. cat. (Düsseldorf: Kunstmuseum Düsseldorf, 1976); Gerdts and Thistlethwaite (see note 2).

5. A study of the Düsseldorf Gallery with all that is still traceable of the work shown there (now widely dispersed) would be highly desirable, as would a collection of the American art critics' comments on Düsseldorf painting. Equally revealing would be a study of the German and European response to the American painting that was to be seen at the great international exhibitions.

6. See William H. Truettner, ed., *The West as America: Reinterpreting Images of the Frontier, 1820–1920*, exh. cat. (Washington, D.C.: Published for the National Museum of American Art by the Smithsonian Institution Press, 1991), 59ff., 84ff., 117f.

7. Groseclose (see note 4), 16.

8. Mark Thistlethwaite, "The Most Important Themes: History Painting and Its Place in American Art," in Gerdts and Thistlethwaite (see note 2), 21.

9. Quoted from Lillian B. Miller, *Patrons and Patriotism: The Encouragement of the Fine Arts in the United States, 1790–1860* (Chicago: Univ. of Chicago Press, 1966), 51.

10. William H. Truettner, "Prelude to Expansion: Repainting the Past," in Truettner (see note 6), 73.

11. *Landing of Columbus at the Island of Guanahani, West Indies.*

179

12. *The Baptism of Pocahontas at Jamestown, Virginia, 1613.*

13. *The Discovery of the Mississippi by De Soto, A.D. 1541.*

14. *The Embarkation of the Pilgrims at Delft Haven, Holland, July 22nd, 1620.*

15. Count Atanazy Raczyński, *Geschichte der neueren deutschen Kunst*, trans. from the French by F. H. von der Hagen (Berlin, 1836), vol. 1, *Düsseldorf und das Rheinland.*

16. Wolfgang Müller von Königswinter, "Düsseldorfer Künstler aus den letzten fünfundzwanzig Jahren," in idem, *Kunstgeschichtliche Briefe* (Leipzig: Weigel, 1854), 138–39, tells us that Leutze painted his *Columbus before the High Council of Salamanca* before he was given leave to work in the academy studios in the Altes Schloß in Düsseldorf. It can thus have been only after the completion of this painting that he was invited to become a student at the academy: "With so magnificent a talent, it was desired to have him among the students of the academy." This would explain why Leutze did not begin his studies at the academy until nine months or so after he arrived in Düsseldorf.

17. Wilhelm Schadow, "Gedanken über eine folgerichtige Ausbildung des Malers," in Raczyński (see note 15), 1: 318ff.

18. On this topic in general, see Cornelius Gurlitt, *Die deutsche Kunst des 19. Jahrhunderts: Ihre Ziele und Thaten* (Berlin: G. Bondi, 1899), 2: 242ff., and Julius Hübner, *Schadow und seine Schule: Festrede bei Enthüllung des Schadowdenkmals zu Düsseldorf, 1869* (Bonn, 1869).

19. Karl Immermann, "Düsseldorfer Anfänge: Maskengespräche (1841)," in idem, *Schriften* (Hamburg: Hoffmann & Campe, 1840–1843), 14: 385. See also Irene Markowitz, *Der frühe Realismus in Deutschland, 1800–1850: Gemälde und Zeichnungen aus der Sammlung Georg Schäfer, Schweinfurt*, exh. cat. (Nuremberg: Germanisches Nationalmuseum, 1967), 91.

20. Elke von Radziewsky, *Kunstkritik im Vormärz, dargestellt am Beispiel der Düsseldorfer Schule*, Bochumer Studien zur Publizistik und Kommunikationswissenschaft, no. 36 (Bochum: Brockmeyer, 1983).

21. Müller von Königswinter (see note 16), 140.

22. Groseclose (see note 4), cat. no. 26.

23. Müller von Königswinter (see note 16), 138.

24. The painting was purchased for the Städelsches Kunstinstitut in Frankfurt, leading to the resignation in protest of Philip Veit, the Städel's director and himself an exponent of Nazarene painting who had only recently completed a large and overtly propagandist Catholic painting entitled *The Triumph of the Church.*

25. See, most recently, Radziewsky (note 20), 118ff.

26. Reactions are summarized by Vera Leuschner, "Der Landschafts- und Historienmaler Carl Friedrich Lessing, 1808–1880," in Kunstmuseum Düsseldorf, *Die Düsseldorfer Malerschule*, exh. cat. (Düsseldorf: Kunstmuseum, 1979), 86ff.

27. Adolf Rosenberg, *Geschichte der modernen Kunst* (Leipzig: Friedrich Wilhelm Grune,

1894), 2: 377, correctly observed that Lessing was the first to introduce the Third Estate into the aristocratic world of history painting and that there was modern life in his pictures.

28. Groseclose (see note 4), 48.

29. In this context Rosenberg (see note 27), 377, referred to Lessing's ancestor the poet Gotthold Ephraim Lessing (1729–1781) and the appeal he made, in the spirit of the Enlightenment, for "freedom of conscience" — an ideal to which, according to Rosenberg, the painter also subscribed. See also Donat de Chapeaurouge, "Die deutsche Geschichtsmalerei von 1800–1850 und ihre politische Signifikanz," *Zeitschrift des deutschen Vereins für Kunstwissenschaft* 31 (1977): 115ff., esp. 125ff.

30. See Thomas Nipperday's chapter on "Liberalismus," in idem, *Deutsche Geschichte, 1800–1866: Bürgerwelt und starker Staat* (Munich: C. H. Beck, 1983), 2: 287.

31. Müller von Königswinter (see note 16), 139.

32. Henry Theodore Tuckerman, *Artist-Life: or, Sketches of American Painters* (New York: Appleton, 1847), 177.

33. Also known as *King Ferdinand Removing the Chains from Columbus*.

34. Gerdts (see note 2), 147–49.

35. See Christian Frommert, "Typologie der Gefühle — Bemerkungen zu zwei Bildern der Ausstellung von 1842," in Peter Gerlach, Wilfried Dörstel, and Wulf Herzogenrath, eds., *Kölnischer Kunstverein: Einhundertfünfzig Jahre Kunstvermittlung: Texte zu Bürgern, Bürgerverein und Kunstvermittlung* (Cologne: Kunstverein, 1989), 74ff.

36. See Wolfgang Beyrodt and Werner Busch, eds., *Kunsttheorie und Kunstgeschichte des 19. Jahrhunderts in Deutschland: Texte und Dokumente* (Stuttgart: Reclam, 1982–), 1: 184–206.

37. Groseclose (see note 4), 33ff.

38. Ibid., cat. no. 31.

39. Müller von Königswinter (see note 16), 139ff.

40. Ibid., 140.

41. Kenneth Silverman, *A Cultural History of the American Revolution* (New York: T. Y. Crowell, 1976), 321f.

42. Thomas Nipperday, "Regt sich der alte Hermann noch? Festvortrag zum hundertjährigen Bestehen des Hermannsdenkmals," *Frankfurter Allgemeine Zeitung* (23 August 1975), and Gerd Unverfehrt, "Ernst von Bandels Hermannsdenkmal: Ein ikonographischer Versuch," in Günther Engelbert, ed., *Ein Jahrhundert Hermannsdenkmal, 1875–1975* (Detmold: Naturwissenschaftlicher und Historischer Verein für das Land Lippe, 1975), 129–49.

43. In November 1850, when the first version was almost finished, it was damaged in a studio fire. However, it was repaired and exhibited in Cologne later that same year. After 1863 it entered the Kunsthalle in Bremen. It was destroyed during World War II. The second version, now in the Metropolitan Museum of Art in New York, was painted in 1851.

44. Müller von Königswinter (see note 16), 136f.: "But the American is the most fortunate of all. His history is brief and brilliant. He is acquainted with all of his country's most important personages, so to speak, face to face; or, where this is not the case, he knows of them from his parents and grandparents. His past is almost his present. The obvious consequence must be a fresh and lively approach, whose effect is manifest even in connection with periods for which recent knowledge is lacking. The truth of this principle is confirmed in literature by such phenomena as Washington Irving and Charles Sealsfield; with them, all is freshness and immediacy. Our artist has the same qualities."

45. Most recently Groseclose (see note 4), 34ff. and cat. nos. 55–59; Mark Thistlethwaite, "The Most Important Themes: History Painting and Its Place in American Art," in Gerdts and Thistlethwaite (see note 2), 7ff.

46. Groseclose (see note 4), 36ff., 65.

47. Müller von Königswinter (see note 16), 146ff.

48. Groseclose (see note 4), 46.

49. Müller von Königswinter (see note 16), 147.

50. Worthington Whittredge, "The Autobiography of Worthington Whittredge," ed. John I. H. Baur, *Brooklyn Museum Journal* 2 (1942).

51. See note 43. Groseclose (see note 4), cat. no. 58: *Incomplete Study for Washington Crossing the Delaware*, 1850? (USA, private collection).

52. See note 35.

53. Emanuel Leutze to Montgomery C. Meigs, 14 February 1854, Records of the Architect of the Capitol, Washington, D.C. Quoted from Patricia Hills, "Picturing Progress in the Era of Westward Expansion," in Truettner (see note 6), 117.

William Hauptman

KINDRED SPIRITS

Notes on Swiss and American Painting of the Nineteenth Century

When in 1984 the French public saw a large retrospective of nineteenth-century American painting organized a year earlier in Boston, the event prompted some revealing remarks by Pierre Rosenberg on how little known this aspect of New World art had been in the Old World.[1] He noted in particular that in Europe distinctly American painting was generally associated, in an almost mythic fashion, with the ground-breaking paths of the Abstract Expressionists, to the point that there existed a collective ignorance of earlier American artistic movements. One of the reasons why American painting had been relegated in the past to a minor or even marginal framework in the context of the nineteenth century — falling far behind, it was thought, the achievements of France, England, or Germany — lies in the previously accepted notion of quality as a synonymous component of the avant-garde. In this archaic system, European scholars have had difficulty discerning the American equivalents of Paul Cézanne, or J. M. W. Turner, or Caspar David Friedrich. Only recently has this equation of value and merit changed so that now artistic interest and excellence can be more fully comprehended within an ongoing tradition in which the mainstream and the avant-garde cohabit, if at times uncomfortably. The resulting artistic judgments offer a wider historical scope of the totality of artistic accomplishment and provide a more fulfilling picture of artistic development and production outside the once tightly knit but restrictive Paris/London/Berlin axis.

Rosenberg's astute remarks on the European view of American art may equally be applied, although in a different context and perspective, to the traditional European and American view of Swiss art. Like American paint-

1. Karl Bodmer (Swiss),
 Pehriska-Ruhpa, 1832–1834,
 aquatint and etching, printed by Bougeard,
 64.5 x 44.7 cm.
 Lugano, Thyssen-Bornemisza Foundation.

ing before its rediscovery, Swiss art has escaped vigorous art-historical inves-
tigation and indeed has generally been relegated to footnote status in most
surveys of nineteenth-century art. Leading Swiss artists were often falsely
associated with artistic schools according to the generic origins of their
names. Thus, Arnold Böcklin was sometimes thought of as a German,
Giovanni Segantini as Italian, Charles Gleyre as French, and so forth, with
the inevitable result that it was difficult to imagine the very existence of a
flourishing native school. To be sure, the international art-historical com-
munity has always acknowledged the importance of such titular figures as
Johann Heinrich Füßli (although at times he still is listed as belonging to
the English school), or Léopold Robert, or Ferdinand Hodler, and in our
own century, Paul Klee or Alberto Giacometti. But the point to be raised
here is, what about the other artists who formed a continuous line from Jean-
Etienne Liotard, the contemporary of Jean-Jacques Rousseau, to Hodler,
the contemporary of Albert Einstein? Why has it been so difficult to trace
that line or even to place it firmly within the framework of artistic develop-
ment from Jacques-Louis David to Cézanne?

These questions are difficult to answer — they are linked to political and
economic reasons as well as artistic ones — and should be addressed in
greater depth in a different forum altogether. Nevertheless, one answer that
must be underscored here is the fact that Swiss art has remained almost
exclusively localized in the domain of Swiss art historians,[2] who like their
American counterparts suffered from a national inferiority complex regard-
ing their own respective cultural traditions. It was as though the Swiss
thought there were no local equivalents of Cézanne, Turner, or Friedrich
and therefore no need to explore further for fear of being mired in study
of second-rate figures. As late as 1948, one of the prominent Swiss art his-
torians, Adrien Bovy, asked why the Swiss Romantic Movement never pro-
duced a local analogue of Eugène Delacroix or Paul Delaroche.[3] Even today,
detailed scientific investigation of Swiss art of the nineteenth century, car-
ried out with the same standards that Americans have practiced in their
art, is still rare and often consigned to journals of history or archaeology;
there is at present no art-historical journal or review in Switzerland devoted
exclusively to the study of Swiss art. But it must be said that the makeup of
the country itself helps to impede that kind of rigorous and impartial inves-
tigation: with a total population smaller than that of New York City dis-
persed into four distinct regions, each with its own cultural, economic, and

linguistic roots and with greater differences than similarities, unity of pur-
pose and interest cannot always find a common voice.

However, when we look at the nature of Swiss painting from the end of the
eighteenth century, when the Old Confederation was coming to an end and
the new Swiss state was emerging, we notice remarkable parallels between
Swiss and American art. This fact is so striking and indeed so prominent in
character that I know of no other similar resemblances in artistic production
in any other two countries so geographically separated from one another.
When I began to examine the nature of these relationships, I returned to
Barbara Novak's important study *Nature and Culture*, in which the author
examined the notion of landscape *and* painting during the crucial years
between 1825 and 1875. The last chapter concerns the conjunctions between
America and Europe and contains a brilliant discussion of American artis-
tic associations with France, England, Germany, and the Scandinavian coun-
tries, but no mention is made of the parallels with Swiss art.[4] The only Swiss
painter cited in the text is Karl Bodmer, who is mentioned in a section
devoted to European travelers in the New World frontier. The fault of omis-
sion is not the author's; the past insular approach of Swiss art historians,
fostered in part by this sense of national artistic insecurity, has severely
limited the knowledge of Swiss art beyond its borders, a situation in fact
not unlike that in America regarding its own art some fifty years ago.

It may be surprising to learn that the issue of national artistic inade-
quacy did not escape the attention of the Swiss authorities. On 11 January
1799 the newly installed minister of art and science, Philipp August Stapfer,
published an inquiry asking a wide range of artists why native Swiss paint-
ers in particular were known and celebrated elsewhere but remained unrec-
ognized and unencouraged in the motherland.[5] He documented his claim
by citing Swiss painters well established in London, Paris, and Rome who
were virtually unknown — or at least unappreciated — in Geneva, Zurich,
or Basel; Stapfer noted almost ironically that a part of their very celebrity
was due to the fact that their art production was on foreign soil and thus
removed from their inherently Swiss identity. Stapfer wanted to know why
the Swiss painter had to emigrate in order to educate himself and practice
his art, why the republic itself could not accommodate the artist economi-
cally or socially within its borders, and what could be done by the state to
alter this appalling situation so that the artist could train, produce, exhibit,
and thrive within the country and thus contribute to the emergence of a

truly national republican culture. Stapfer's inquiry, as high-minded and worthy as it was, met with little response, and the unstable political and economic situation before the creation of the modern Swiss state with the Federal Constitution of 1848 — in which, incidentally, there was no clause on cultural policies — prevented any significant changes.[6]

This, too, was noted indirectly again in 1867, on the occasion of the Universal Exposition in Paris. The Swiss pavilion was organized, not without some difficulty, by the celebrated Swiss painter Charles Gleyre, who wrote a summary report on his activities along with a critical evaluation of the artistic results.[7] While Gleyre could rightfully acknowledge the strength of the Swiss landscape contribution, he also stated that Swiss painting hardly compared in quality or inventiveness with other European schools in the more exacting and ennobling areas of history painting and other artistic genres. Without mentioning Stapfer's appeal, which he probably did not know, Gleyre noted the fact that little had changed in the political or economic structure of his own country that might have permitted excellence or a more vibrant national expression. Gleyre made no comparisons to the American pavilion that year nor to how the Swiss might be regarded in light of the American painting seen nearby. But it is interesting to note that the Swiss representation was about double that of the American, a revealing statistic considering the relative views we have today of the merits of Swiss and American painting of the nineteenth century.[8]

Stapfer's pioneering interests in 1799 coincided almost exactly with the ideals expressed by the early American presidents, who likewise sought a way to encourage native American expression in New York and Philadelphia rather than London, Rome, or elsewhere. The intention was very similar — that is, to envision a meaningful place for art on native soil within the fabric of a nascent mercantile society ready for and in need of an inherent cultural tradition. Both governments felt that the rulers had a moral obligation to provide the people with accessible intellectual enlightenment along with stable political order. In each case, they could not resort to a lasting aristocratic patronage, nor to the support of the Church, nor to an already existing academic structure that could accommodate the artistic need. Both countries tried to implant the conditions that would permit a new national artistic expression and, at the same time, tried to educate audiences to appreciate the fruits of that expression. It is no accident that in America and in Switzerland the first national societies of art were founded

within four years of each other.

It is perhaps commonplace to say that parallels in social and political systems in two different countries would necessarily influence the production of artistic affinities, yet these structures are very much in evidence in America and Switzerland and should be discussed, if only briefly. First, the notion of geographic isolation as a determinant factor: just as in America the Atlantic on one side and the frontier on the other provided a formidable physical and psychological distance from Europe, so in Switzerland the Alpine ranges acted as perpetual insulators and isolators from neighboring countries. In each case, these daunting barriers at once protected and alienated artists, creating an intrinsic provincialism.[9] Switzerland had indeed maintained ties with her adjacent countries at all cardinal points, but these ties, as in America, were more commercial and ancestral than physical or aesthetic. In this sense, Geneva was as far away from Paris as was New York.

An equally important factor, although an obvious one, was the shared republican form of government, which likewise served to differentiate, if not exclude altogether, each country from its European roots. While both democracies were widely respected — and even served as models for each other[10] — it was also recognized that as enviable as that form of government was, it did not always stimulate artistic expression in a beneficial manner. This can best be illustrated in Swiss history when in 1865 a liberal faction of the government of the oldest democracy sought to pay homage to the newest in the form of a commission for the Bundeshaus in Bern.[11] Frank Buchser, a Swiss painter of uncommon energy and invention, even undertook a voyage to America to prepare studies for the commission; he was able to paint portraits of Andrew Johnson, Robert E. Lee, and William Seward, as well as gather valuable iconographic documentation on the American scene after its wrenching Civil War.[12] However, the painted homage he had in mind never came to fruition, partly because of the gnawing question of what type of painting would best serve to exemplify the democratic ideals. During a debate on the subject, it was decided that the true symbols of democracy that should ornament the Swiss capitol — thus, the worthiest veritable homage to the American ideal — should be wise laws and nothing else, an all too practical application of conservative Swiss Calvinism, which incidentally underscores an aspect of the basic situation to which Stapfer earlier addressed himself. In certain ways, this polemic recalls the heated debates in the 1820s surrounding John Trumbull's decoration

scheme for the Capitol Rotunda in Washington.[13] The diverse nature of the population of each country during the nineteenth century — both at once assimilated but not wholly, both based in agriculture and trade and therefore removed from the time-honored domain of High Art, and both heavily oriented toward the Protestant ethic — should also be considered as important elements in explaining these artistic correspondences.

It is not surprising, then, that each country had an active interest in folk art at a time when it was hardly esteemed elsewhere.[14] From this common point it can readily be seen that one of the affinities most in evidence throughout the century was a widespread lifting of the stature of genre and anecdotal painting. In Switzerland this form of painting, with its subjects drawn from peasants and community life, was generally associated in the early nineteenth century with the Geneva school.[15] A typical example is Wolfgang Adam Töpffer's *Village Wedding* (fig. 2).[16] The simple scene, appropriately rustic and vividly quaint, has no pretensions other than recording a joyous event, not unlike William Sidney Mount's numerous dancing and reposing figures, who take a moment from their toil for amusement. It is correct to see a common denominator between the two in the influence of Dutch art of the seventeenth century, an influence that is particularly apt in Swiss painting since Dutch painting was avidly collected in Geneva and elsewhere, often with the same zeal with which Americans would purchase Italian art later in the century.[17] We even see Dutch art as a proud symbol of local taste in Jean-Etienne Liotard's portrait of 1757 of the collector François Tronchin (Geneva, collection of L. Givaudan), in which a Rembrandt canvas is eminently displayed on an easel at the right side of the composition, a painting within a painting that seems like a curiously disoriented icon in a portrait of a distinguished contemporary of Voltaire.[18]

Töpffer's associates in Geneva — especially Pierre-Louis de La Rive, Firmin Massot, Jean Huber, and Jacques-Laurent Agasse[19] — continued this tradition in the early half of the century, as did Albert Anker in the second half of the century in the German part of Switzerland.[20] Anker spent many of his holidays in his native village of Ins, where he came into direct contact with local peasants. Anker's images of Swiss farmers, like Eastman Johnson's or James Clonney's analogous paintings, incorporate the Romantic image of the happy worker engaged in mundane but fulfilling daily tasks — harkening back to the images of Adriaen van Ostade and Adriaen Brouwer — but without trespassing into the harshness of Gustave Courbet's Realist

2. Wolfgang Adam Töpffer (Swiss),
 The Village Wedding (*La Noce*), 1816,
 oil on canvas, 67 x 90.5 cm.
 Geneva, private collection.
 Photo: Courtesy Schweizerisches Institut für
 Kunstwissenschaft, Zurich.

191

iconography. In both the American and Swiss schools, the picturesque and
the accessible remained a major element, even with regard to subjects of
back-breaking labor, though clearly the basis was present from which to
embark upon social commentary, an aspect that neither school fully ex-
ploited. This is well illustrated in Frank Buchser's masterpiece of 1870, *The
Song of Mary Blane* (fig. 3).[21] The painting is a compassionate portrait of
African Americans after Emancipation but with hints of their earlier plight.
The singer recounts the story of Mary Blane, a slave violated by a white
man and then put on the market, where she is discovered in her humiliated
state by her lover. Although the scene is pregnant with drama and ripe for
social critique, Buchser's treatment, like that of Eastman Johnson in his *Old
Kentucky Home* of 1859 (New York, New York Historical Society),[22] has the
charm of Victorian anecdotal painting without forcefully promoting the
political allusions that its subject might imply or warrant.

One aspect of genre painting, however, that was not shared by both coun-
tries was still life. Even though Swiss artists were strongly drawn to Dutch
art of the seventeenth century, where ornamental still life played a major
role, this form never found a viable and lasting audience in Switzerland
after the late eighteenth century. Liotard, Anker, and Félix Vallotton, to
name but three examples, represented various forms of still life in their
respective later years, but their efforts are considered to be minor excur-
sions into the theme. In America, little still-life painting appeared after
the works of Raphaelle Peale, but the genre flourished in the last quarter
of the nineteenth century in that imaginative trompe l'oeil fusion of art,
artifice, and symbol, as exemplified by Charles Meurer's dazzling *Royal
Flush* (fig. 4).[23] The Swiss have no contemporary equivalent to this kind of
object worship, as indeed neither does any other European school. But the
ultrarealism and playfulness displayed in American trompe l'oeil painting
is not wholly alien to Swiss art either; we must go back a century and a half
to see examples produced by Johann Caspar Füßli, the more famous Füßli's
father, whose *Composition* of about 1740 (fig. 5) is an eerie and unfamiliar
forerunner of William Michael Harnett, John Frederick Peto, and John
Haberle.[24] But Füßli's work in this domain is almost unique and hardly
representative of a trend in Swiss art; it seems to be more a current of eccen-
tricity that appears from time to time in Switzerland, which might be said
to culminate to a large extent in the work of Füßli *fils*.

Perhaps the most obvious form of artistic congruity between American

3. Frank Buchser (Swiss),
The Song of Mary Blane, 1870,
oil on canvas, 103.5 x 154 cm.
Solothurn, Kunstmuseum, Deposit Gottfried
Keller-Stiftung, 1900, no. C 13.
Photo: Courtesy Schweizerisches Institut für
Kunstwissenschaft, Zurich.

4. Charles Meurer (American),
 Royal Flush, ca. 1899,
 oil on panel, 35.6 x 55.9 cm.
 Lugano, Thyssen-Bornemisza Foundation.

5. Johann Caspar Füßli (Swiss),
 *Composition (Stilleben, Kalender
 an der Wand)*, ca. 1740,
 oil on canvas, 83 x 58 cm.
 Solothurn, Kunstmuseum, no. A 57.
 Photo: Courtesy Schweizerisches Institut für
 Kunstwissenschaft, Zurich.

and Swiss painting may be seen in the area of landscape painting. Both countries could boast of almost inexhaustible natural resources and a reverence for nature that formed a part of their respective national identities. It is true that for the American and European alike, America's unspoiled nature represented a mythical, exotic Eden redux, but the monumentality of the Alps and the utopic vision of unimpaired Swiss valleys created a similar impression on generations of travelers.[25] In both countries, the quasi-religious implications of the awesome landscape, at once redoubtable and mesmerizing, could not but serve as an alluring artistic incentive, reflective not only of current trends but particularly of a living expression of the attitudes enumerated by that archetypical Swiss, Jean-Jacques Rousseau.[26] Switzerland's discovery of its own landscape as a viable source for its artists dates to the end of the eighteenth century, chiefly through the works of Caspar Wolf, who produced a new form of nature painting rooted in the national pride in this unique geography, in which faithful representation of topography superseded the purely picturesque.[27]

In the early nineteenth century a wide variety of Swiss painters began assiduously to study the formation of these resources, in much the same manner as painters of the Hudson River school began to explore the pictorial language of the Catskills and areas beyond. In Switzerland artists almost literally adhered to the advice of the painter Pierre-Louis Bouvier, who in 1827 published a widely circulated manual of painting in which he counseled artists to represent what he called the true portrait of the country — that is, the appropriate image that defined the Swiss character of painting.[28] For the Swiss artist that "portrait" was best understood in the common denominator of Alpine geography, one of the few pictorial subjects that linked the disparate cultural divisions of the country. The most important early masters of the genre — Maximilien de Meuron, François Diday, and Alexandre Calame[29] — traveled regularly in the 1820s to still-remote Alpine sites in search of subject matter, this at a time when such travel was still hazardous. In contrast, American painters generally associated with mountain painting — key figures such as Albert Bierstadt — would not explore the Rockies until later and, it is important to note, then generally after having first painted in the Swiss Alps, as was the case not only for Bierstadt but also for John W. Casilear, Worthington Whittredge, William Trost Richards, and others.[30]

As we know, American landscape painting of the nineteenth century has

several facets, and the same appears to be true for the Swiss. Diday was capable of producing the grandiose or the majestic operatic form of composition in the same manner as Thomas Moran, but his colleagues were also adept at depicting the quiet, intimate scene, more pastoral than awesome. However, it is not easy to find in Swiss painting that spectacular sublimity that forms the essence of Frederic Edwin Church's art; there are few equivalents to a composition such as his *Icebergs and Wreck* (fig. 6), here seen in one of his *esquisses*,[31] with its Friedrichlike *paysage moralisé* evoking a fearsome sense of danger. Yet, this form of painting, in which the choice of a specific landscape is metaphoric in principle, finds echoes in some of Calame's compositions, as in the case of his *Landscape with Precipice* (fig. 7), which is contemporary with Church's canvas.[32] The point of view in Calame's work, as in Church's, is crucial, for the viewer is forced in the former picture toward the edge of a void, creating that disquieting feeling of vertigo and menace, cardinal points of the sublime ethic. If Admiral Perry could feel at home in Church's disturbing image, so could Manfred in Calame's.

This sense of landscape as metaphor, generic for the German and American schools, is less pronounced in Swiss art, but it is nevertheless present in veiled form at the end of the century. A work such as Félix Vallotton's *Sunset* (fig. 8)[33] is illustrative of this trend and naturally owes its heritage to Friedrich, in much the same way as does Thomas Cole's blatantly symbolic *The Cross and the World* (fig. 9), painted a half century earlier. But even more than Vallotton, or any other Swiss painter for that matter, it will be Ferdinand Hodler who will best imbue his paintings with an unhesitatingly philosophic and religious content within the scope of his landscape depictions, as is well exemplified by his *Eiger, Mönch, and Jungfrau in Moonlight* (fig. 10). Here, with Hodler's succinct, economic view of Switzerland's most celebrated Alpine troika, strict topography, although clearly discernible, plays a secondary role; context, scale, and traditional perspective are all but eliminated in favor of abstraction. What remains is the pure and now purified metaphor of the mountain as an unreachable infinity, the very notion of the Magic Mountain where faith and communion unite, as in Hodler's image, without a physical, terrestrial base.[34]

In Swiss landscape painting humanity and the stable attributes of civilization do not always appear as dominant characteristics within the iconographic intention. As in Hodler's sparse image noted above, the unpopulated landscape better serves the notion of representing unblemished nature or

6. Frederic Edwin Church (American),
 Icebergs and Wreck, ca. 1860,
 oil on paperboard mounted on canvas,
 20.6 x 33.1 cm.
 Lugano, Thyssen-Bornemisza Foundation.

7. Alexandre Calame (Swiss),
 Landscape with Precipice (*Vallée de haute
 montagne et précipice*), 1857–1863,
 oil on canvas, 33.5 x 52 cm.
 Lausanne, Musée Cantonal des Beaux-Arts,
 no. 586.
 Photo: Courtesy Schweizerisches Institut für
 Kunstwissenschaft, Zurich.

8. Félix Vallotton (Swiss),
Sunset (*Le coucher du soleil*), 1910,
oil on canvas, 54 x 73 cm.
Winterthur, Kunstmuseum, no. 1258.
Photo: Courtesy Schweizerisches Institut für
Kunstwissenschaft, Zurich.

9. Thomas Cole (American),
 The Cross and the World, ca. 1848,
 oil on canvas, 81.3 x 123.2 cm.
 Lugano, Thyssen-Bornemisza Foundation.

10. Ferdinand Hodler (Swiss),
 Eiger, Mönch, and Jungfrau in Moonlight
 (*Eiger, Mönch und Jungfrau im Mondschein*),
 1908,
 oil on canvas, 72 x 67.5 cm.
 Solothurn, Kunstmuseum.
 Photo: Courtesy Schweizerisches Institut für
 Kunstwissenschaft, Zurich.

ideology. Yet, the inhabited landscape in Swiss art may be said to distinguish two purposes. The first is to indicate that the Edenlike setting was not just a propaganda myth created out of Romantic needs. Töpffer represented that concept well in various works in which the idyllic setting is also useful and not just poetic, where local inhabitants can participate, as they do, in picnics and games, just as in some of Winslow Homer's paintings later. The second purpose is to note that even unbridled nature can be colonized and therefore mastered to produce a natural harmony between man and nature, in effect the local manifestation expressed in that American icon, Asher Brown Durand's *Kindred Spirits*, 1849 (New York, New York Public Library), but understood with a slightly different twist; whereas Durand's painting implies a natural order of harmony, in Swiss painting the harmony, particularly in an Alpine setting, is imposed and forged. The concord between man and wilderness in American art is also understood in the domestic image of the log cabin, the American symbol par excellence of taming conquest; the Swiss equivalent of the rustic chalet evokes a similar idea and toward the middle of the nineteenth century appears more frequently as a fixed staple of mountain scenes.

If mountain iconography eclipsed other forms of landscape painting in Swiss art of the period, there were still other possibilities available to portray the less dramatic vision of the bucolic that coincided with the American Luminist Movement.[35] The concerns with light, atmosphere, and pictorial geometry were also primary interests of one of the greatest and most underrated Swiss practitioners, François Bocion.[36] His painting *Tugboat on Lake Geneva* (fig. 11) unifies those graphic elements commonly associated with such Americans as Martin Johnson Heade, Fitz Hugh Lane, John Frederick Kensett, or Francis A. Silva, whose *Kingston Point, Hudson River* (fig. 12), painted only a few years later, could serve as a distant pendant to Bocion's painting. The play of the horizontal and vertical forms, the use of dense colors, and the brilliant splashes in Bocion's canvas bring to mind dozens of American counterparts but only a few contemporary European equivalents. One cannot, however, speak of a true Swiss Luminist Movement, but the movement's general attributes and concerns are present in Bocion's numerous studies of the Lake Geneva area. Unfortunately Bocion left no notable students to continue the tradition, and the Luminist path was an unfrequented one in later Swiss art. Vestiges of this form of *paysage intime* are nonetheless present in the works of the so-called second Geneva school,

201

11. François Bocion (Swiss),
Tugboat on Lake Geneva
(*Le Remorqueur*), 1867,
oil on canvas, 67 x 155 cm.
Lausanne, Musée Cantonal des Beaux-Arts,
no. 280. Photo: Jean-Claude Ducret.

12. Francis A. Silva (American),
Kingston Point, Hudson River, 1873,
oil on canvas, 50.8 x 91.4 cm.
Lugano, Thyssen-Bornemisza Foundation.

especially around such figures as Barthélemy Menn, Gustave Castan, Pierre Pignolat, and Daniel Ihly.[37]

I should like to return briefly to a painting by Albert Anker, his *Peasant Reading a Newspaper* (fig. 13), painted the same year as Bocion's canvas, which wholly typifies Anker's style and choice of subject matter. Once again we are struck by a controlled classicism applied to scenes of everyday life, evocative of the works of George Caleb Bingham or perhaps Richard Caton Woodville.[38] At the far left of Anker's composition, we can discern a crude map of the United States, a surprising element in a Swiss peasant house that curiously shares the background space with the more common folk image of the Crucifixion. This detail in such an unassuming context is a timely reminder of the fascination that America held for the Swiss in the nineteenth century. Anker himself never made the journey to the New World, but his compatriots, including the peasants he portrayed, went in large numbers during periods of political or agricultural insecurity: such American cities as Canton, New Glarus, Geneva, or New Helvetia (later known as Sacramento) attest to the Swiss presence in the New World. This allure for another frontier inevitably attracted dozens of Swiss painters, for example, Frank Buchser, whose voyage to the West produced some remarkable studies still little known in either country.[39] But Buchser's voyage to America was at the virtual end of a cycle that had begun almost a century earlier when, as Stapfer had noted, Swiss painters left the motherland in significant numbers. Johann Wäber, later known as John Webber, accompanied Captain Cook on his third voyage to the South Seas in 1776 and remained in Canada and the American north where he produced a plethora of American images.[40] Peter Rindisbacher, born near Bern, settled in America in 1821 and became one of the first painters actually to live among Native American tribes, painting unusually vivid images of their life and rivaling artists of the caliber of George Catlin and Charles Bird King.[41]

The most gifted Swiss artist to have recorded the American scene without necessarily having been influenced by New World art was certainly Karl Bodmer.[42] He was hired to accompany Maximilian, Prince of Wied, on a trip into the interior of North America, with the intention of documenting the latter's well-known interests in natural history. They docked in Boston harbor on the propitious date of 4 July 1832 and proceeded in the next three years to traverse the continent under conditions that were sometimes excruciating. Like most European voyagers in America, Bodmer was enthralled

202

13. Albert Anker (Swiss),
Peasant Reading a Newspaper
(*Die Bauern und die Zeitung*), 1867,
oil on canvas, 64 x 80.5 cm.
Zurich, private collection.
Photo: Courtesy Schweizerisches Institut für
Kunstwissenschaft, Zurich.

203

by the diversity of the landscape and the still-unfamiliar forms of flora and fauna. In delineating the latter, Bodmer practiced and developed an art form that was generally alien to the Swiss painter for obvious reasons but was bred into the American artistic experience, as is best mirrored in John James Audubon's lavish enterprise *Birds of America*, published in part during Bodmer's travels. Bodmer's most distinguished series of works in the United States is composed of the portraits he so assiduously painted of the Indians. While the Native American was hardly unknown in Europe,[43] few Europeans had recorded the minutiae of their daily lives and rituals as did Bodmer. His unflinching scientific portrayals, generally free of the romantic trappings common in his contemporaries, set new standards of ethnographic accuracy, including, as his paintings did, meticulous observation of varied physiognomies, details of dress, body decorations, and tribal ceremonial fineries (fig. 1).

It is true that Bodmer's exotic images, like the works of Füßli or Bocion, remain exceptional examples of Swiss painting and are not always indicative of regional or national trends. Yet, when the more characteristic elements of Swiss painting in the period under consideration are examined in an international context, it can be seen that in most cases similarities of style and purpose between Switzerland and America are very much visible, perhaps more so than between Switzerland and her immediate European neighbors. As was seen at the beginning of this paper, both countries were subject to provincial isolation and to the need, therefore, for artistic self-assertion, dominant factors that helped assure parallel artistic paths. The republican nature of their respective political structures inevitably led to a formation of painterly goals that separated them from older European traditions, thus providing a practical, if simplistic, response to the question why these affinities are at times so striking and indeed expected. These aspects were recently underscored in a major exhibition in Bern, which treated the theme of democratic art as a broad concept and in which both Swiss and American paintings were prominent.[44] One of the results of perusing the examples selected is a surer picture of why Swiss-American artistic correspondences should be considered with still greater depth and scientific attention.

NOTES

The present version of this paper has inevitably been shortened and in some cases wholly abbreviated to meet the needs of publication. Some additional material has been added through conversations with colleagues in Berlin, including Hans A. Lüthy, John McCourbey, David Huntington, Barbara Novak, Françoise Forster-Hahn, Nicolai Cikovsky, Jr., Theodore Stebbins, and Otto von Simson. The research itself grew out of my examination of Swiss painting in my essay, "The Swiss Artist and the European Context: Some Notes on Cross-Cultural Politics," *From Liotard to Le Corbusier: Two Hundred Years of Swiss Painting, 1730-1930*, exh. cat. (Atlanta: High Museum of Art, 1988), 35–46.

1. Pierre Rosenberg, "A French Point of View," in Theodore E. Stebbins, Jr., Carol Troyen, and Trevor J. Fairbrother, *A New World: Masterpieces of American Painting, 1760-1910*, exh. cat. (Boston: Museum of Fine Arts, 1983), 13–15.

2. See in particular Joseph Gantner and Adolf Reinle, *Kunstgeschichte der Schweiz* (Frauenfeld and Leipzig: Huber, 1936–1962), with the appropriate bibliographies cited there. A new history of Swiss art is being published at present in the series Ars Helvetica, of which eight volumes have appeared to date, all by Swiss authors.

3. Adrien Bovy, *La peinture suisse de 1600 à 1900* (Basel: Birkhäuser, 1948), 97.

4. Barbara Novak, *Nature and Culture: American Landscape and Painting, 1825-1875* (New York: Oxford Univ. Press, 1980), 226ff.

5. Stapfer published his inquiry in *Schweizer Republikaner* 2 (11 January 1799): 569, with a French translation in the *Bulletin officiel du Directoire helvétique* (20 January 1799). For a more detailed discussion of Stapfer's appeal, see Pierre Chessex, "Documents pour servir à l'histoire des arts sous la République Helvétique," *Etudes de Lettres*, ser. 3/4, no. 2 (April/June 1980): 93–121. The best study of Stapfer's artistic policy is in Hans Gustav Keller, *Minister Stapfer und die Künstlergesellschaft in Bern* (Thun, 1945).

6. It seems that only fifty-two questionnaires were returned regarding the inquiry, and of these only twenty-two were by artists who listed their true profession as "*artistes-peintres*"; the rest were craftsmen and even musicians.

7. Gleyre's report was published in full in *Feuille fédérale suisse* 20, no. 10 (7 March 1868): 295–99; see, too, the discussion of the document in William Hauptman, "Charles Gleyre and the Swiss Fine Arts Section of the Exposition Universelle of 1867," *Zeitschrift für Schweizerische Archäologie und Kunstgeschichte* 43, no. 4 (1986): 368–70.

8. The *livret* of the painting sections of the exhibition notes the American representation as totaling 82 works by 41 artists, while the Swiss representation amounted to 167 works by 87 artists.

9. The nature of this provincialism, as seen throughout Swiss art in all regions of the country, is treated in Dario Gamboni, *La géographie artistique*, Ars Helvetica, vol. 1 (Disentis:

Desertina, 1987).

10. On the interchanges between Swiss and American ideals of government, see Heinz K. Meier, *The United States and Switzerland in the Nineteenth Century* (The Hague: Mouton, 1963).

11. Johannes Stückelberger, "Die künstlerische Ausstellung des Bundeshauses in Bern," *Zeitschrift für Schweizerische Archäologie und Kunstgeschichte* 42 (1985): 188–89.

12. The major monograph on Buchser remains Gottfried Wälchli, *Frank Buchser, 1828-1890: Leben und Werk* (Zurich: Orell Füßli, 1941). Buchser's own account of his trip to America is edited by idem, *Mein Leben und Streben in Amerika: Begegnungen und Bekenntnisse eines Schweizer Malers, 1866-1871* (Zurich: Orell Füßli, 1942). See, too, Roman Hollenstein, ed., *Frank Buchser, 1828-1890* (Einsiedeln: Eidolon, 1990), which contains an essay by Johannes Stückelberger, pages 139–48, on Buchser's American portraits but with several errors.

13. Trumbull's decorations are discussed in Irma B. Jaffe, *John Trumbull: Patriot-Artist of the American Revolution* (Boston: New York Graphic Society, 1975), and Helen A. Cooper, *John Trumbull: The Hand and Spirit of a Painter*, exh. cat. (New Haven: Yale University Art Gallery, 1982).

14. A classic study of Swiss folk art is Daniel Baud-Bovy, *Peasant Art in Switzerland* (London: "The Studio," 1924), but see, too, Nicolas Bouvier, *L'art populaire*, Ars Helvetica, vol. 9 (Disentis: Desertina, 1991).

15. On the Geneva school, see in particular Daniel Baud-Bovy, *Peintres genevois, 1702-1849* (Geneva: Le journal de Genève, 1903–1904), and Louis Jules Gielly, *L'école genevoise de peinture* (Geneva: Editions Sonor, 1935).

16. On Töpffer, see Walter Hugelshofer, *Wolfgang Adam Töpffer* (Zurich: M. Niehans, 1941). Töpffer painted two versions of the canvas: The first was executed in Paris in 1812 and exhibited in the Salon of that year – *livret* no. 898. This version was bought by Empress Josephine and eventually donated to the Musée d'Art et d'Histoire in Geneva. The second version, illustrated here, was painted in Geneva before Töpffer left for England; see his letter to his wife, dated 21 June 1816, now in Geneva, Bibliothèque publique et universitaire, ms. supp. 1638, fol. 107.

17. The Swiss penchant for collecting Dutch painting is well documented in Marcel Roethlisberger, "Holländische Malerei in der Westschweiz: Sammlungs- und Wirkungsgeschichte," in Petra ten-Dösschate Chu, *Im Lichte Hollands: Holländische Malerei des 17. Jahrhunderts aus den Sammlungen des Fürsten von Liechtenstein und aus Schweizer Besitz*, exh. cat. (Basel: Öffentliche Kunstsammlung Basel, 1987), 41–48. Essential as well for comprehending Swiss collecting habits is Mauro Natale, *Le goût et les collections d'art italien à Genève* (Geneva: Musée d'Art et d'Histoire, 1980), who notes as well the importance of Dutch art in Genevois collections.

18. Renée Loche and Marcel Roethlisberger, *L'opera completa di Liotard* (Milan: Rizzoli, 1978), 109, no. 220.

19. In addition to Baud-Bovy and Gielly (see note 15), see W. Deonna, "Le genevois et son

art," *Genava* 23 (1945): 87–339. Of Töpffer's associates noted in the text, no modern monographs on their respective lives and works exist, except in the case of Agasse; see Renée Loche et al., *Jacques-Laurent Agasse, 1767-1849*, exh. cat. (Geneva: Musée d'Art et d'Histoire; London: Tate Gallery, 1988).

20. The fullest study of Anker's works is Max Huggler, *Albert Anker: Katalog der Gemälde und Ölstudien* (Bern, 1962), but see also Sandor Kuthy and Hans A. Lüthy, *Albert Anker* (Zurich: Orell Füßli, 1980).

21. The literature on the painting is vast, but see Elisabeth Oltramare-Schreiber, "Farmleben in Virginia und 'The Song of Mary Blane' (1867–1870)," in Hollenstein, ed. (see note 12), 170–71, which notes the essential bibliography and recounts the history of the work.

22. On Johnson, see the discussion in Patricia Hills, *The Genre Painting of Eastman Johnson* (New York: Garland, 1977). On the context of the image of African Americans during this period, see Albert Boime, *The Art of Exclusion: Representing Blacks in Nineteenth-Century Art* (Washington, D.C.: Smithsonian Institution Press, 1990).

23. Barbara Novak, *The Thyssen-Bornemisza Collection: Nineteenth-Century American Painting* (London: Sotheby's Publications, 1986), 244.

24. Little information is available on Füßli's work, but see Peter Vignau-Wilberg, ed., *Schweizer Stilleben im Barock* (Zurich: Haus zum Rechberg, 1973), 66–67.

25. The subject is treated in William Hauptman, *Svizzera meravigliosa: Vedute di artisti stranieri, 1770-1914*, exh. cat. (Lugano: Thyssen-Bornemisza Foundation; Geneva: Musée d'Art et d'Histoire, 1991).

26. Hans Christoph von Tavel et al., *Schweiz im Bild – Bild der Schweiz: Landschaften von 1800 bis heute* (Zurich, 1974), and Marcel Roethlisberger and Hans Hartmann, eds., *Die Alpen in der Schweizer Malerei*, exh. cat. (Tokyo: Odakyu Grand Gallery; Chur: Bündner Kunstmuseum, 1977).

27. Willi Raeber, *Caspar Wolf, 1735-1783: Sein Leben und sein Werk* (Aarau: Sauerländer, 1979).

28. Pierre-Louis Bouvier, *Manuel des jeunes artistes et amateurs en peinture* (Paris: F. G. Levrault, 1827).

29. On de Meuron, see Pierre von Allmen, ed., *Maximilien de Meuron et les peintres de la Suisse romantique* (Neuchâtel: Musée des Beaux-Arts, 1984); the best study of Diday remains Alfred Schreiber-Favre, *François Diday* (Geneva: A. Jullien, 1942); on Calame, see Valentina Anker, *Alexandre Calame: Vie et oeuvre* (Fribourg: Office du livre, 1987).

30. On each of these painters' respective trips to Switzerland and the impact of the Alps on their works, see Hauptman (note 25), 182f.

31. Church's painting is discussed in Gerald L. Carr, *Frederic Edwin Church – The Icebergs* (Dallas: Dallas Museum of Fine Arts, 1980); see also Franklin Kelly, *Frederic Edwin Church*,

exh. cat. (Washington, D.C.: National Gallery of Art, 1989), 58–59. The *esquisse* illustrated here is discussed in Novak (see note 23), 96–98.

32. Anker (see note 29), 441, no. 695, there dated 1857–1863.

33. *From Liotard to Le Corbusier: Two Hundred Years of Swiss Painting, 1730–1930*, exh. cat. (Atlanta: High Museum of Art, 1988), 144.

34. On Hodler's mystic attachment to the mountain landscape, see in particular, Oskar Bätschmann, "Das Landschaftswerk von Ferdinand Hodler," in *Ferdinand Hodler Landschaften*, exh. cat. (Zurich: Schweizerisches Institut für Kunstwissenschaft, 1987), 37–41.

35. Barbara Novak, "On Defining Luminism," in John Wilmerding, ed., *American Light: The Luminist Movement, 1850–1875*, exh. cat. (Washington, D.C.: National Gallery of Art, 1980), 23–29. See also Theodore E. Stebbins's essay "Luminism in Context: A New View," 211–34, in which the European schools are also considered but with no mention of the Swiss.

36. Béatrice Aubert-Lecoultre, *François Bocion* (Lutry: Marendaz, n. d. [1977]), is still the best monograph on the painter; see also Patrick Schaefer, *François Bocion* (Lausanne, 1990).

37. See Vera Meyer-Huber, *Die Entwicklung des Paysage Intime in der schweizerischen Landschaftsmalerei des 19. Jahrhunderts* (Zurich: Conzett & Huber, 1946). On Menn's contribution more specifically, see Jura Brüschweiler, *Barthélemy Menn, 1815–1893: Etude critique et biographique* (Zurich: Fretz & Wasmuth, 1960); on Castan, see Albert Schreiber-Favre, *Gustave Castan: Peintre paysagiste, 1823–1893* (Lausanne: Librairie Marguerat, 1955); no monographs exist on Pignolat or Ihly, but see Arnold Neuweiler, *La peinture à Genève de 1700 à 1900* (Geneva: A. Jullien, 1945).

38. The classic study of Bingham is E. Maurice Bloch, *George Caleb Bingham: The Evolution of an Artist* (Berkeley: Univ. of California Press, 1967); on Woodville, see Francis Grubar, *Richard Caton Woodville: An American Artist, 1825–1855* (Ph.D. diss., Johns Hopkins University, 1966).

39. Paul H. Boerlin, *Frank Buchser, 1828–1890* (Basel: Öffentliche Kunstsammlung, Basel, 1990), reproduces various small *esquisses* from the Basel collection.

40. On Webber's work for Cook, see Ruediger Joppien and Bernard Smith, *The Art of Captain Cook's Voyages* (New Haven: Yale Univ. Press, 1988), 3: 171–203; on his American works, see Hugh Honour, *The European Vision of America*, exh. cat. (Cleveland: Cleveland Museum of Art, 1975), nos. 178–80.

41. John Francis McDermott, "Peter Rindisbacher, Frontier Reporter," *The Art Quarterly* 12 (1949): 134–37. On other Swiss images of Native Americans, see Ernst J. Kläy and Hans Läng, *Das romantische Leben der Indianer malerisch darzustellen...Leben und Werk von Rudolf Friedrich Kurz (1818–1871)* (Solothurn: Aare, 1984).

42. *Karl Bodmer's America*, exh. cat., introduction by William H. Goetzmann, annotations by David C. Hunt and Marsha V. Gallagher, and artist's biography by William J. Orr (Omaha:

Univ. of Nebraska Press, 1984).

43. See the discussion in Honour (note 40), 286ff.

44. Georg Germann, Dario Gamboni, and François de Capitani, *Emblèmes de la liberté: L'image de la république dans l'art du XVIe au XXe siècle*, exh. cat. (Bern: Musée des Beaux-Arts and Musée d'Histoire, 1991).

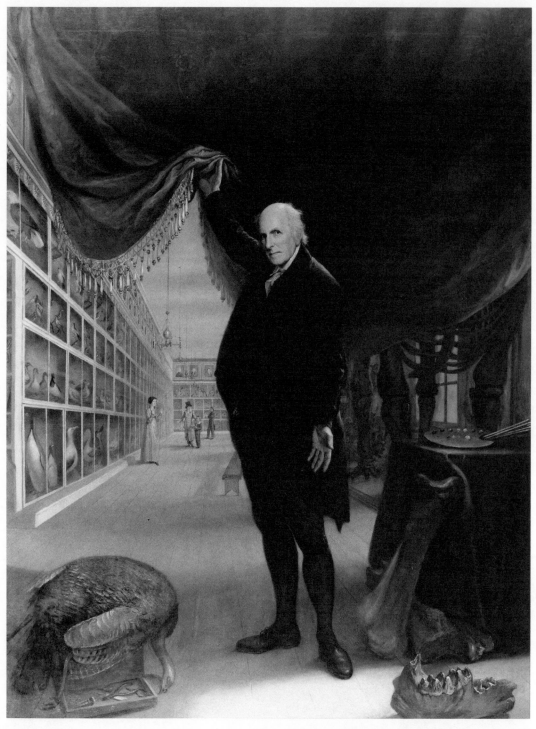

1. Charles Willson Peale (American),
 The Artist in His Museum, 1822,
 oil on canvas, 265.4 x 205.1 cm.
 Philadelphia, The Pennsylvania Academy of
 the Fine Arts, Gift of Mrs. Sarah Harrison
 (The Joseph Harrison, Jr., Collection),
 no. 1878.1.2.

Ursula Frohne

Strategies of Recognition

The Conditioning of the
American Artist between Marginality and Fame

You had better learn to make shoes or dig potatoes than become
a painter in this country.
　　　　　— John Trumbull

Conditions

Over the past twenty years, within the wider context of the American quest
for intellectual and historical identity, art historians have increasingly
joined in arguing the continuity of native traditions. This growing sense of
national self-regard has been affirmed by a stream of exhibitions, accom-
panied by catalogs, monographs, and works of synthesis, many of them with
upbeat, patriotic titles proclaiming the urgent need for cultural autonomy:
*The American Muse, American Light, An American Perspective, American
Paradise, A Proud Heritage*, and *American Art, American Vision* are just a
few examples of this trend.[1] In place of the traditional pattern of exploring
local developments for evidence of European influence, the search is on for
the inherent singularity and originality of American modes of expression.[2]

　This attempt to reinterpret pre-1945 American art, so long dismissed as
provincial and stylistically derivative, as a form of "positively applied eclec-
ticism" can be traced through a wide variety of initiatives. Many of these
attempts to draw closer to the nation's cultural roots are marked by a new
breadth of vision that draws the applied arts and folk art into the discus-
sion of "High Art" and regards them — in defiance of conventional and
hierarchic susceptibilities — as the original motive forces of creativity on
the American continent.[3]

211

With remarkable consistency, a string of recent exhibitions has explored the mutual dependencies and influences that link "High and Low Culture."[4] All these projects have carried the message that traditional views notwithstanding, American art is not a mere by-product of European civilization but possesses a character that has been decisively shaped by the visual setting of Colonial life, by the wilderness as well as by urban folklore, by the multicultural milieu, by mass production, and by the entertainment industry that already flourished in the nineteenth century.[5] With this shift of historical emphasis, the work of American artists, and particularly that of the amateurs among them, has moved into the center of interest. The stigma of stylistic inadequacy has given way to new criteria of judgment intended to validate the unspent freshness of the American artist's visual repertoire in all its innovative power and to celebrate it as an authentic cultural statement. Homebred spontaneity triumphs over imported convention; and the naive, intuitive artist outshines the academician and all his effete stylistic maneuvers. Unmistakably, this new trend in the conception of art exhibitions articulates the view that the history of American art and with it the acquisition and education policies of public museums stand in need of a fundamental change of approach.

Interestingly enough, an appreciation of the vitality of American "natural talent" is by no means a novelty. As far back as 1827, the journalist John Neal waxed enthusiastic over the "wild" brushstroke and inventive ornamental forms of Charles Codman, who worked as a decorative painter, on the fringes of fine art. In his own day, the freshness of Codman's naive and luxuriously ornamented landscapes (fig. 2) was hailed as confirmation of the Romantic idea of the amateur as genius. Significantly, this same notion has been rehabilitated and elevated to the status of a national virtue, in the course of the current debate on "High and Low Culture" in America.[6]

There can be no doubt that the alliance between the aspiring amateur and the professional painter has been a central fact of artistic life on the American continent. The close association between painting and handicraft, which persisted until the mid-nineteenth century, left a decisive mark on artists' lives, both in the institutional and social status of their occupation and in their use of imagery that sprang from the conditions under which they worked.[7] This, in the American context, is where the question of the aesthetic validity of traditional expressive patterns and representational modes arises. How far did the influence of European models really extend,

2. Charles Codman (American),
 East Cove, ca. 1830,
 oil on panel (fireboard), 88.5 x 112 cm.
 Harvard, Mass., Fruitlands Museums,
 Museum Purchase, no. 290.1946.

and at what point did they run out of expressive potential for New World society? At what point did democratic consciousness collide with artistic convention? What freedoms and what possible advantages did the artist derive from his sheer distance from Europe and from European value systems? What, on the other hand, were the obstacles to artistic aspiration in a democratic social order that had been shaped by Puritanism? And at what point along the way to artistic professionalism and to social recognition did the "capitalization" of art take place: the transformation of pictures into marketable commodities through the gradual adjustment of their themes to match the expectations of the public?

"In Colonial America, art's existence seemed to depend entirely on personal decisions."[8] In saying this, Neil Harris is referring to the historical commonplace that it was primarily the Puritan lack of interest in art that depressed the social status of the American artist until the mid-nineteenth century. On closer inspection, however, this alleged disinterest turns out to have been a profound and officially sanctioned hostility. The Colonial Americans of the eighteenth century entrenched themselves behind the facile assertion that their aesthetic indifference could be explained by inexperience and cultural naïveté. They invariably justified their hostility (disguised as apathy) to art by citing their achievements in the more vital realms of science, economic activity, technology, and politics. Ultimately, however, all this ostentatious pragmatism, promoted to the status of a national self-image, was no more than a tactical camouflage for their own moral distrust of aesthetic values.

What place was there for the artist in a society that regarded itself as "Paradise regained"?[9] What ethical significance or moral usefulness could art possess when in the context of democracy all ideological and moral values seemed to be attainable? Did not the utopian dimension of art represent a challenge to the prevailing values of "common sense" and "order without miracle or extravagance"?[10] Did not artistic fiction amount to an attack on reality? And would not art therefore stimulate cravings that were socially harmful and disruptive, either by fostering discrimination on grounds of taste or social privilege or by leading to untrammeled consumerism and, ultimately, to senseless extravagance? Might not art, with its prestige and its emotive power, militate against the equality of social and political opportunity that Americans were so proud of? Would not artistic activity tend to undermine the democratic idea of progress and bring about an inevitable

relapse into the hierarchic structures and social anachronisms of the Old World? Burdened with such misgivings, the fine arts were tainted by the moral stigma of the feudal life-style.

In answer to all this stereotypical prejudice, an anonymous leading article of 1855 in the literary and artistic magazine *The Crayon* sought to vindicate the honor of the artist in America: "We know there are many who are willing to be the *appenda* to wealth and social rank, to keep a foothold in life by fostering pride and flattering vanity; but the true Artist has that desire for reverence and regard, not for himself, but for the truth given him to tell."[11]

In spite of this and similar efforts to rectify the image of the artistic profession, the public in general persisted in identifying the painter with the social caste of his feudal patrons so that any encouragement of fine art was regarded as pernicious propaganda for class distinction. Art was regarded as a social force whose effects were incalculable but avoidable; as a result there was a running debate in Colonial society as to the conditions that might make the artist's work a legitimate activity.

"Has the Artist a right to exist?"[12] In such a context, this question, as formulated in *The Crayon* by the writer quoted above, was by no means merely rhetorical. President John Adams was not alone in distrusting art because of its ability to adapt to any political system. As he saw it, this traditional readiness to serve any master and any policy was proof of a total lack of moral integrity in art, in artists, and in their patrons. He firmly admonished Thomas Jefferson that the fine arts, "which you love so well and taste so exquisitely, have been subservient to Priests and Kings, Nobles and Commons, Monarchies and Republicks."[13]

In these circumstances it is no wonder that the word *artist* long retained the pejorative associations, suggesting an "emotional conspirator,"[14] that placed it, by definition, in opposition to the rationalistic self-image of the Revolutionary period. The image of the artist in America was projected onto a suspect milieu of aristocratic idlers and dominated by the cliché of the artist's servile dependence on patronage, and so he was despised. Nor was he credited with a sense of social responsibility; he stood, in fact, for a corrupt attitude of collaboration with feudal structures of dominance. This was what the writer in *The Crayon* meant when he tackled the question of artists' traditional dependence on their clients: "They rewarded the fool and the artist as they fostered their foibles or flattered their vanity. They

215

3. Thomas Jefferson (American),
Carriage Drawing, ca. 1790?,
ink on paper, 34.6 x 53.7 cm.
Charlottesville, University of Virginia,
Thomas Jefferson Papers (N-532), Tracy W.
McGregor Library, Special Collections
Department, University of Virginia Library.

gave them gifts, but never paid them anything, since the idea of service rendered was one not to be entertained."[15]

The dignity of the artist and the prestige of his work did not, therefore, stand particularly high. There was little admiration for expressive power and ingenuity. Expressions of respect for creative talent were mostly somewhat muted; and the type of the revered genius, the great master, as celebrated by Vasari in his *Lives*, was utterly foreign to the Colonial mind.[16] "Painting as the confession of a 'self,' painting as the expression of a spiritual and intellectual ideology, did not exist."[17]

The American public was impressed only if the aesthetic achievement was one that a lay person could easily follow or that served to improve the quality of useful objects and thus to clothe the daily necessities of life in more pleasing, more profitable, and therefore more progressive forms. For the moment, artistic aspirations were confined to the pursuit of refinement and improvement, in a strictly practical sense.

"To appear unsophisticated was to become an ultimate mark of sophistication."[18] This logic, so neatly formulated by Joshua A. C. Taylor, imposed itself on any artist who sought to escape the effects of the public's resentment of anything that smacked of elitism. Craft skills were welcome; "Art," by contrast, was a luxury that — as John Adams saw it — neither Colonial America nor the young republic could afford. In itself, the semantic indecision between the terms *artist* and *artisan*, which until the early nineteenth century repeatedly occur as synonyms in texts and documents, reflects this popular attitude, which automatically associated the idea of an "artist" with the qualities of a craft.[19]

Portraits — known as "likenesses" — represented only one of the many functions that an unsophisticated public expected the artist to perform.[20] His clients were as likely to ask him to gild frames as to paint business signs or to design interiors. Jefferson's undated, annotated sketch for a carriage (fig. 3) reflects the automatic expectation that the artist would do decorative work. Jefferson's primary demand for plain, simple, and functional forms is entirely in keeping with the political program of rationalism.[21] In his notes on the sketch, he left it to the professional artist to put the final, aesthetic polish on his functional, practical object ("An ingenious artist will readily imagine all the details not particularized here"); and in doing so he subordinated the artist to the utilitarian ethos of the period, in which science and politics, technical progress and artistic work, went hand in hand with

217

the maxims of "common sense" and the all-pervading doctrine of democracy.

However casual Jefferson's sketch may seem, it reveals something of the official relationship between the artist and the American public. In several respects, it exemplifies the aesthetic influence of American utilitarianism. Artistic freedom was subject to the same rules as production in general; and these practical constraints were reflected in the dissipation of talent that any early nineteenth-century painter was forced to accept if he wanted to survive. Alongside portrait commissions, he was expected to turn his hand to technical draftsmanship, ornamental design, and the skilled use of a wide variety of materials. The prima facie criterion of quality was that the result should be easy for the viewer to follow. This official line, with its unmistakable echoes of the writings of John Ruskin, was followed by the contemporary art critics, as can be seen from another leading article from *The Crayon*, this time in 1855: "If the Artist has first based himself on that science which we, equally with himself, can comprehend and judge...if he has been earnest, conscientious, and clear-sighted where we could follow him, we may fearlessly follow him, also, where he can see and we cannot."[22]

To the American democrat, the artist's integrity and the honesty of his work could manifest themselves only in the fulfillment of his function as a trustworthy communicator. The direct enlistment of the artist's work in the service of a social mission — such as constantly motivated the inventive ambition of Jefferson — typifies the image that was not only projected onto the artist by outsiders but willingly adopted by the leaders of the profession. It was part and parcel of their democratic ethos to rescue art from the palaces of feudalism and the temples of elitist connoisseurship and at the same time to define the status of the artist in terms markedly different from the self-stylizing strategies of their European colleagues — both by coming closer to their public and by frequently departing from the beaten track of artistic convention. The Enlightenment aspirations and inventive enthusiasms of such figures as Charles Willson Peale or Samuel F. B. Morse are entirely representative of several generations of American artists who not only acted as their own teachers and their own patrons but above all consented to subordinate their individual inclinations to the moral and educative usefulness of their work.[23]

Ambitions

*Most of our artists paint to live, hoping, perhaps, the time
may come when they may live to paint.*
— Henry Theodore Tuckerman

Peale is undoubtedly the most brilliant representative of this type of universal, pioneering talent. Alongside his work as a painter, he earned particular distinction in science and technology. His practical gifts, which he cultivated as assiduously as he did his artistic interests, led him to bring out a succession of inventions, which he patented, albeit with a limited return.

In accordance with society's expectations, Peale regarded himself as fundamentally an educator. He represented the American ideal of the self-made man, and, as such, his organizational capacity and innovative drive were regarded as exemplary and edifying. Like many self-taught contemporaries, Peale had no clearly defined theory; his energy was fueled by a boundless enthusiasm for progress. Toward the end of his life he painted a series of self-portraits that form a retrospective survey of his many-sided career, and in almost all of them this self-image is reflected in the pose of a scientist lecturing on his work. They reveal him as an artist who was proud to play his part in educating his public.

The first of these works, *The Exhumation of the Mastodon*, 1806–1808 (fig. 4), is an extraordinary combination of group portrait, genre picture, and history painting. It records one of the great moments in Peale's "scientific" career, the dramatic discovery of two nearly complete mastodon skeletons in an Ice Age swamp near Newburgh, New York, in 1801.[24] The artist may be identified by the explicatory gesture of his right hand as he indicates the trench where, to universal astonishment and admiration, the excavation is taking place. In his left hand he holds a life-size reconstruction drawing of mastodon bones, thus making the connection between his activity as a collector and his scientific interest in these specimens of natural history. The viewer stands witness to the first archaeological excavations on the American continent and, at the same time, to an act of self-presentation in which the artist shows himself, in his family circle and flanked by an array of scientists, as the archaeologist and preserver of American natural history.[25]

This unusual form of representation, overleaping all established picto-

rial genres, leads us back to one of the questions posed at the outset. Peale's disregard for academic rules typifies the self-taught American artist's ability to make a virtue out of necessity, converting his own lack of classical training into the freedom to use his artistic resources in new and more original ways. The "absence of routine," which Henry Theodore Tuckerman extolled a few decades later as an inestimable advantage over the "academic trammels, prescriptive patronage, the deference excited by great exemplars" that prevailed in Europe, was the New World painter's sole working capital.[26] Because his democratic relationship with society demanded modes of expression outside the traditional iconographic repertoire, he was forced to adopt methods relevant to his own situation. By sacrificing compositional scruples to the message of his work, Peale elevated a genre subject out of its contemporary context onto the plane of history painting, in a work that can perhaps best be classified, with the benefit of modern experience and visual habits, as "idealized pictorial reportage."

A similar density of statement marks a painting completed more than a decade later, *The Artist in His Museum*, 1822 (fig. 1).[27] The trustees of Peale's museum had asked him for a life-size self-portrait. He wrote to his son Rembrandt on 23 July 1822, "I think it important that I should not only make it a lasting ornament to my art as a painter, but also that the design should be expressive that I bring into public view the beauties of nature and art, the rise and progress of the Museum."[28]

In pursuit of this universalist aspiration, Peale has depicted himself as if standing on a stage, in his dual role of painter and naturalist. As in the work just described, Peale unhesitatingly accepts public curiosity as a challenge to his art. Once more, he has opted for a composition that suggests a sensation. Theatrical lighting effects dramatize the grand gesture of the artist, surrounded by his life's work, as he takes the limelight in the plain but impressive attire of an enlightened democrat, the impresario of American artistic and natural history.

The curtain motif, the professional attributes, and the monumental effect of the artist's figure, leave us in no doubt that Peale has projected this history painting, which is a celebration of the American democratic ideal, directly onto the traditional iconography of the monarchical portrait. Like many of his contemporaries, he has used a well-tried compositional scheme and filled it with a new ideological content.

Countless formal precedents suggest themselves, in works that Peale

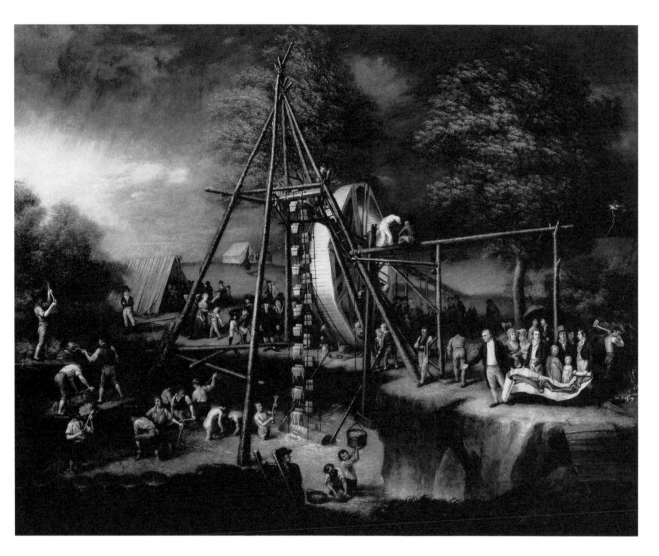

4. Charles Willson Peale (American),
 The Exhumation of the Mastodon, 1806–1808,
 oil on canvas, 128.2 x 160.3 cm.
 Baltimore, The Peale Museum, Baltimore
 City Life Museums, no. MA 5911.

5. Franz Messmer (Austrian) and
 Ludwig Kohl (Czech),
 Emperor Francis I Surrounded by the Direc-
 tors of His Collection (Kaiser Franz I im Kreise
 der Direktoren seiner Sammlungen), 1773,
 oil on canvas, 283 x 302 cm.
 Vienna, Naturhistorisches Museum.

might have known either from European engravings or from his own visits to England. The portrait by Franz Messmer and Ludwig Kohl of *Emperor Francis I Surrounded by the Directors of His Collection*, 1773 (fig. 5), was probably not directly known to Peale,[29] but it is of interest because it illustrates the contrast between, on the one hand, the American view of the character and use of a natural history collection and, on the other, the European aristocratic tradition of cabinets of artistic and natural curiosities.[30] In the painting by Messmer and Kohl the monarch is seen in the exclusive setting of his own cabinet of curiosities, conferring with a select group of experts on the precious items in his prestigious collection. The American democrat, by contrast, gives the signal to admit all and sundry without restriction. In total contrast to the dynastic ruler, who assumes the curatorship of the past behind a screen of hereditary privilege, the American artist steps confidently into the limelight and integrates his contemporaries, both as protagonists and as spectators, into the scenario of American history.

The figures in the background of Peale's *Artist in His Museum* serve as living proof of the egalitarian principle and didactic function of the collection, which Peale expressly threw open to children and to "the fair sex."[31] A man expatiates to his son on the wonders of the objects on display, while a woman in Quaker dress throws up her hands in astonishment at the huge skeleton of the mastodon. They all illustrate the mission that Peale undertook to fulfill, both in his work as an artist and in the conception of his museum. Influenced by the ideas of Jean-Jacques Rousseau, Peale pursued an ideal of culture in which there could be no higher satisfaction than that of giving instruction to one's contemporaries. His noblest task as an artist, as he saw it, was to leave a lasting impression on the visitor to his museum. He had no objection to whimsical diversions in outlandish directions, far from it. It was part of Peale's philosophy of education to use entertainment value as a stimulus to the visitor's interest.[32] It was for the public to derive "rational amusement" from the interplay of fascination and reflection.

This fusion of the rationalism of science, the freedom of artistic expression, and the commercial interest in popularization created the social space in which the first museum in the New World could operate. More than that, it enabled its creator to see himself as the promoter of the emergent social potential of instruction through art; and it was in this in-between region of "rational amusement," artistic education, and resourceful entrepreneurship that the artist at last found his niche in American society.

Commissions

Paint pictures that will take with the public – never paint for
the few, but the many.
– William Sidney Mount

During the Jackson presidency (1829–1837), known as the Age of the Rise of the Common Man, the American painter continued to depend for material success on a strong personal commitment and the ability to adapt to the needs of a wide public. An artist was someone with the courage to be his own patron. In contrast to the support and patronage European painters received from the nobility and the Church, the American artist needed all the ingenuity, shrewdness, and resourcefulness of a born businessman. The idea of transferring the role of patronage to the state was abhorrent to every democratic, individualistic, and anticentralist principle of the American mind. To this day, the same attitude is reflected in the largely private pattern of patronage of cultural institutions in the United States.

Until the early nineteenth century, very few painters could make a settled living in one place. Most were compelled to travel far and wide, not only in the search for clients and patrons but also on adventurous expeditions designed to enrich their own thematic repertoire. A visually unsophisticated public was more readily impressed by spectacular pictorial ideas than by subtle stylistic exercises, and thus impressive renderings of the wonders of nature, drawn from the remotest regions of the Americas, were a sure boost to the artist's finances. In 1859 when Frederic Edwin Church exhibited his vast, panoramic landscape *Heart of the Andes*, 1859 (New York, The Metropolitan Museum of Art, no. 09.95), the public flocked to the Studio Building at 15 Tenth Street, New York, to gaze at the exotic marvel. An enticing arrangement, with swaths of black crepe around the frame and a profusion of palm fronds, turned the painting into a thrilling visual experience.[33] A photograph of the Metropolitan Fair in New York, where the same painting was shown again in 1864 (fig. 6), is a pale reflection of the lavish setting that the astute Church devised for the premiere of the work. On that occasion, the papers reported such a crowd of visitors that the police had to clear the street in front of the Studio Building. And so, at twenty-five cents a head entrance money, Church made around three thousand dollars in one month.[34]

224

6. The New York Metropolitan Fair Art
 Gallery photographed by J. Gurney & Son,
 707 Broadway, N.Y., 1864, showing the exhi-
 bition of Frederic Edwin Church (American),
 Heart of the Andes, 1859.
 Printed from one half of a stereopticon view.
 Novato, Calif., collection of Leonard A. Walle.
 Photo: Courtesy The Brooklyn Museum.

7. John Vanderlyn (American),
 *Description of the City, Palace, and
 Gardens of Versailles*, 1819,
 engraving, 32.1 x 40 cm,
 printed 1833 by E. Conrad.
 Kingston, New York State Office of Parks,
 Recreation and Historic Preservation, Senate
 House State Historic Site, no. SH.1975.612.3.

8. Charles Willson Peale (American),
 The Staircase Group, 1795,
 oil on canvas, 228.2 x 101.2 cm.
 Philadelphia, Philadelphia Museum of Art,
 The George W. Elkins Collection, no. E'45-1-1.

Many followed Church's profitable example. Artists whose ambitions were no longer satisfied by portrait commissions needed to send their paintings on a tour of the big East Coast cities or else risk financial ruin every time they painted a big history or landscape painting. Most of them took to heart William Sidney Mount's advice, cited above: "Paint pictures that will take with the public." With the same lack of inhibition that had once moved Peale to bolster his budget by sending one of his mastodon skeletons on a tour of the European capitals, such celebrated figures as William Dunlap, Rembrandt Peale, George Catlin, Albert Bierstadt, and Frederic Edwin Church showed off their pictures like fairground attractions to a paying public and applied strategies, on occasion, remarkably like those of traveling salesmen.[35] Few of them shrank from spectacular effects, just so long as they would draw in the crowds.

In formal as well as commercial terms, American artists tended to absorb the methods of the new visual media of their day into their own repertoire, drawing on the profane world of the entertainment industry as readily as they did on the realm of High Art.[36] The medium became the message, in a move toward popularization that was a response to the challenge of American public expectations.[37] Thus, when painters displayed their landscapes in three-dimensional settings, they were borrowing the successful techniques of the panoramas and dioramas that diverted and fascinated their contemporaries to the point of becoming a mass medium.[38] In 1819, for instance, the painter John Vanderlyn presented his own panorama of the palace and gardens of Versailles (fig. 7) in a specially constructed rotunda, before taking it on tour to Philadelphia and into Canada.[39] As far back as 1795 Peale had experimented in his own way with the illusionistic possibilities of painting. He placed his portrait of his sons, known as *The Staircase Group* (fig. 8), in a real door frame and continued it out into real space by attaching a wooden step to it, thus combining image and object in a near-perfect illusion of reality comparable to the illusionary effects that were employed by American trompe l'oeil painters at the end of the nineteenth century.[40]

The capacity of "life effects" to enhance the allure of a work inspired George Catlin to add yet another dimension to his strategies of enhancement. For an exhibition of his large collection of Indian portraits, he engaged a troop of members of the Iowa tribe, who roused Paris and London audiences to paroxysms of delight with the splendor of their costumes and the exotic charm of their dances (figs. 9, 10).[41] Sometimes, too, he worked hand

228

in hand with the legendary giants of showmanship. Although these business connections with Phineas T. Barnum and Buffalo Bill Cody stemmed from economic necessity rather than from inclination, they do serve to underscore his general readiness to overstep the boundaries between the artist and the showman.[42]

With these borrowings from the methods of the popular entertainment industry, Catlin and his fellow painters espoused a principle that would eventually, in the twentieth century, lead to the unexampled alliance between art and the New York underground scene, between sensational visual creations and the glamour of Hollywood that marked the heyday of Pop Art. The supreme self-promotional talent of an Andy Warhol, his catalytic function as artist, entertainer, pop star, art industrialist, and boss of the legendary Factory, undoubtedly stands in direct line of succession to the unconventional commercial pragmatists of the early generation of American painters.[43]

To satisfy public demand was a priority and not only for economic reasons. As confirmed democrats, the painters of the day regarded their contemporaries' reactions as an expression of social cohesion. Anyone who shrank from confronting the public at large and its expectations was likely to be dismissed as an elitist with a message confined to a few initiates and thus as an offender against democratic principles. The artist's compact with his public became the criterion of quality. In Europe, when early Romantic artists sought to drop out of society and live as outsiders, this was regarded as a symptom of alienation within society; in contemporary America, such a move was a stain on the individual's reputation.

Ideologically, American artists were far less conscious of being in conflict with the conventions of bourgeois society and with the demands of the market. Instead of relying on a cultivated elite to pay its homage to genius, they concentrated on gaining the tangible recognition and support of a broad and not particularly distinguished public.

A comparison between Charles Bird King's *Itinerant Artist*, circa 1850 (fig. 11), and Georg Friedrich Kersting's portrait of his teacher, *Caspar David Friedrich*, circa 1812 (fig. 12), reveals the deep-seated contrast between these two artistic postures. Where the American artist identifies with simple, unpretentious, ordinary people, Kersting pays homage to the genius of the creative individual who finds his freedom in contemplative seclusion, far from society and all its pressures.[44] King, by contrast, has not even used

229

9. Karl Girardet (French),
 Louis-Philippe Watching the Dance of the
 Indians in the Tuileries (*Le roi Louis-*
 Philippe, la reine Marie-Amélie et la duchesse
 d'Orléans assistent dans le Salon de la Paix
 aux Tuileries à une danse d'indiens Iowa que
 leur présente le peintre George Catlin,
 21 avril 1845), 1845.
 Paris, Musée National du Château de
 Versailles et de Trianon, no. MV 6138.
 Photo: R. M. N.

10. George Catlin's collection in the Salle de
 Séance. From *Catlin's Notes of Eight Years'*
 Travels and Residence in Europe, with His
 North American Indian Collection, 4th ed.,
 vol. 2 (London: Author, 1848), pl. 22.
 Los Angeles, Department of Special Col-
 lections, University Research Library,
 University of California, Los Angeles.

11. Charles Bird King (American),
 The Itinerant Artist, ca. 1850,
 oil on canvas, 114.7 x 146.2 cm.
 Cooperstown, New York State Historical
 Association, no. N-537.67.

12. Georg Friedrich Kersting (German),
Caspar David Friedrich in His Studio
(*Der Maler Caspar David Friedrich in seinem
Atelier*), ca. 1812,
oil on canvas, 51 x 40 cm.
Berlin, Staatliche Museen zu Berlin,
Preußischer Kulturbesitz, Nationalgalerie,
no. A I 931. ©1992 BPK, Berlin.
Photo: Jörg P. Anders, Berlin.

any additional emphasis to set the itinerant artist apart from his rustic clientele. We see the painter in dialogue with his untutored, provincial public, whose judgment of his work he clearly respects. The work exemplifies the view that artistic abilities are inherently learnable and consequently accessible to a wide mass of people. The boy imitating the professional artist's technique behind his back embodies the egalitarian principle that creative talent is no longer the domain of a privileged few or a sign of social distinction but — ideally — accessible to all.[45]

King's iconography is entirely typical of studio scenes from this phase of American painting.[46] The artist had voluntarily surrendered his traditional special status and joined the ranks of his contemporaries. Formerly terra incognita, a place of mystery, a shrine of creative inspiration, the artist's studio in America became a plain "painting room"; but it was also a forum to which the public was admitted to cast a critical eye on the artist at work. The unassailable myth of the artist was passé, and instead the New World masters sought to convince through the rhetorical power of empirical fact alone.

This idealism, with its pursuit of democratization in art, criticism, and taste, has its ambivalent side, particularly in view of today's debate on the banning of pictures from exhibitions. Even then, painters were aware of the problems raised by the categorical nineteenth-century demand for "common sense in art."[47] It was a demand that was voiced with particular vigor and insistence in the leading articles of *The Crayon*.

One artist who was critical of this dictate was a German-American, Johannes Adam Simon Oertel. Although he captures the naive officiousness of the *Country Connoisseurs*, 1855 (fig. 13), with an amusing and liberating touch of comedy, there is no mistaking the seriousness of his fear of egalitarian absolutism. Oertel's genre scene shows the destructive consequences of the invasion of the painter's creative sanctuary by an ill-informed and captious public and the logical conclusion to which the democratic veto leads: the artist almost vanishes from sight behind his phalanx of lay critics and is forced into the background, there to watch helplessly while his work is reduced to the plaything of a grinning mob.

In the context of the recent scandal over an exhibition of photographs by Robert Mapplethorpe and of the legal tussle over the financing of controversial projects by the National Endowment for the Arts, Oertel's satire is as topical as it ever was. Any interpretation of democracy that authorizes

13. Johannes Adam Simon Oertel
(German-American),
Country Connoisseurs, 1855,
oil on canvas, 92.3 x 107.7 cm.
Shelburne, Vt., Shelburne Museum, cat. no.
27.1.1-148. Photo: Ken Burris.

14. Demonstration against censorship of the
photographs of Robert Mapplethorpe in
Cincinnati. From the *International Herald
Tribune*, 9 April 1990.
Photo: Courtesy AP/Wide World Photos.

236

a self-appointed "moral majority," whether in Washington, D.C., or in Cincinnati, to rule through the courts on the presentation and quality of works of art contains the seed of perversion. The public places the artist (or the presenter of art) in the dock, instead of seeing the artistic provocation as a reaction to the same catastrophic decline in the quality of life that is the unacknowledged source of the public's own disquiet. The inquisitorial zeal with which the public is currently assailing the artist's work is only a logical continuation of a profound mistrust, a time-honored American ambivalence toward the unpredictable forces of artistic freedom (fig. 14). Just as the fictional element in art was mistrusted by Colonial Americans as an implicit attack on their idealized present reality, a ferocious assault is today being mounted against images whose alleged obscenity and crudeness pale into insignificance by comparison with the brutal reality of contemporary life. The underlying attitude has not changed much, as can be seen from a retrospective survey of this all-American version of the iconoclastic controversy. The question raised by nineteenth-century artists and their public — "Has the Artist a right to exist?" — has now reduced itself to its ideological nucleus. Today's iconoclasts essentially duplicate the question already raised by their nineteenth-century predecessors. Although they may no longer doubt the artist's right to exist, they certainly question his right to say what he thinks.

Notes

1. See Henri Dorra, *The American Muse*, exh. cat. (Washington, D.C.: Corcoran Gallery, 1959; New York: Viking, 1981); John Wilmerding, ed., *American Light: The Luminist Movement 1850-1875, Paintings – Drawings – Photographs*, with contributions by Lisa Fellows Andrus et al., exh. cat. (Washington, D.C.: National Gallery of Art, 1980); John Wilmerding, Linda Ayres, and Earl A. Powell, *An American Perspective: Nineteenth-Century Art from the Collection of Jo Ann and Julian Ganz, Jr.*, exh. cat. (Washington, D.C.: National Gallery of Art, 1981); John K. Howat et al., *American Paradise: The World of the Hudson River School*, exh. cat. (New York: The Metropolitan Museum of Art, 1987); Ellen M. Schall, John Wilmerding, and David M. Sokol, eds., *American Art, American Vision: Paintings from a Century of Collecting*, exh. cat. (Lynchburg, Va.: Maier Museum of Art, Randolph-Macon Woman's College, 1990).

2. Among the pioneers of this research was James Thomas Flexner. "Disdain for the American tradition in art was the correct sophisticated attitude," is his summary of the institutionalized inferiority complex that he sought to counter in his writings from the 1930s onward (see

his *America's Old Masters* [1939; Garden City, N.Y.: Doubleday, 1980], unpaginated preface). However, his approach shows a strong tendency to hero-worship the uncontaminated natural talents of the Hudson River generation of painters, and some critical revision is called for today.

3. To clarify the term "folk art," see Ian M. G. Quimby and Scott T. Swank, eds., *Perspectives on American Folk Art* (New York: Norton, 1980). See also Lawrence W. Levine, *Highbrow/ Lowbrow: The Emergence of Cultural Hierarchy in America* (Cambridge, Mass., and London: Harvard Univ. Press, 1988).

4. The controversial typology of popular culture and modern art, which Kirk Varnedoe and Adam Gopnik expounded in their exhibition *High and Low: Modern Art, Popular Culture*, exh. cat. (New York: The Museum of Modern Art, 1990), makes no specific reference to American art as such. Even so, their survey belongs in the context of a succession of projects that have juxtaposed so-called elitist and popular culture in order to open up for debate the aesthetic hierarchies involved. Operating on a related wavelength, Elizabeth Broun traces historical connections in pursuit of the identity of American art. She writes of her exhibition *Made with Passion: The Hemphill Collection in the National Museum of American Art*, exh. cat. (Washington, D.C.: National Museum of American Art, 1990–1991), that its primary idea was to "take into account the huge number of people who have had an urge toward visual expression and more or less made up the way they did it"; see Roberta Smith, "Operating on the Gap between Art and Not Art," *New York Times* (23 December 1990), H41. Broun regards the Hemphill Collection as the basis for a concerted program of study that will give the history of American art a new and more vital face by turning serious attention to the work of neglected American artists. An earlier exhibition initiated by Broun and devoted to the life and work of Albert Pinkham Ryder dealt with the myth of an unorthodox artist whose uncorrupted inventive gift made him a role model for the American artistic community.

5. On the history of entertainment and cultural institutions in America, see two books by Neil Harris, *Humbug: The Art of P. T. Barnum* (Boston: Little, Brown, 1973), and *Cultural Excursions: Marketing Appetites and Cultural Tastes in Modern America* (Chicago: Univ. of Chicago Press, 1990). On American popular culture, see also John Atlee Kouwenhoven, *The Arts in Modern American Civilization* (Garden City, N.Y.: Doubleday, 1948; reprint, New York and London: Norton, 1967); and Carl Bode, *The Anatomy of American Popular Culture, 1840–1861* (Berkeley: Univ. of California Press, 1959).

6. On this, see Gracie Felker, "Charles Codman: Early Nineteenth-Century Artisan and Artist," *The American Art Journal* 2, no. 2 (1990): 61–86.

7. A superb survey of the evolution of the profession of the painter in Europe is supplied by Rudolf and Margot Wittkower, who show, for instance, that in the English-speaking countries, until well into the seventeenth century, painters were regarded as "low-class tradesmen." See Rudolf and Margot Wittkower, *Born under Saturn* (New York and London: Norton, 1969).

8. Neil Harris, *The Artist in American Society: The Formative Years 1790–1860* (Chicago and London: Univ. of Chicago Press, 1982), x.

9. Sacvan Bercovitch discusses the use of this term in the chapter "Puritanism and Self" in his book *The Puritan Origin of the American Self* (New Haven and London: Yale Univ. Press, 1975), 15.

10. Ibid., 12.

11. "The Position of the Artist," *The Crayon* 1 (28 March 1855): 193.

12. Ibid.

13. John Adams to Thomas Jefferson, Quincy, 28 February 1816, in *Adams-Jefferson Letters* 2:502–503, cited by Harris (see note 8), 36.

14. This term was coined by Neil Harris (see note 8), xi.

15. *The Crayon* 1 (28 March 1855): 193.

16. America's answer to Vasari was the chronicler Henry Theodore Tuckerman. In his *Book of the Artists* (New York: Putnam, 1867), Tuckerman followed Vasari in discussing the outstanding artists of his own time, but his biographical descriptions concern themselves less with the prestige of the individual and of his work than with the educative value and democratic spirit manifested in that work. In direct contrast to Vasari's literary portraits, Tuckerman's descriptions played down the elitist aura in favor of qualities that his readers could be expected to understand and identify with, qualities that enabled Americans to respect their artists as integrated and valuable members of society.

17. Alfred Neumeyer, *Geschichte der amerikanischen Malerei: Von der kolonialen Frühzeit bis zur naiven Malerei im 18. und 19. Jahrhundert* (Munich: Prestel, 1974), 13: "Malerei als Konfession eines 'Ich', Malerei als Ausdruck geistlicher und geistiger Konventionen existierte nicht."

18. Joshua A. C. Taylor, *America as Art* (Washington, D.C.: Smithsonian Institution Press, 1976), 51.

19. See Harris (note 8), xiff. American society, with its utilitarian bent, initially had no place for the artist at all. Unlike merchants, lawyers, physicians, and craftsmen, who followed traditional patterns that afforded them social status and recognition, visual artists were obliged to create a demand for art among their contemporaries before they could market their own skills. Rightly, Neumeyer (see note 17), 17, too, concludes that any distinction between "art" and "craft" in the assessment of the arts in America constitutes an imposition of the European viewpoint. Consequently, for an understanding of the cultural situation in the late eighteenth century, the phrase "vernacular thinking" is of great importance. For the influence of the "vernacular arts" on American culture, see also Kouwenhoven (note 5), chap. 2, "What is Vernacular," 13–42. The term "vernacular arts" was formerly used to cover all those modes of creative expression that sprang directly from the everyday life of the country. In the current discus-

sion, regrettably, this neutral concept has been displaced by a pair of discriminatory terms, "High and Low Art." Paradoxically, this usage reflects precisely the hierarchic thinking that comes in for criticism in the course of this debate.

20. There were no schools where the artist might learn his trade. The technique of painting "likenesses" was handed down from master to pupil on the "learning by doing" principle. On this see Joshua A. C. Taylor, *The Fine Arts in America* (Chicago and London: Univ. of Chicago Press, 1979), and in particular the chapter "1670–1776: Beginnings," 2–26. Similarly, when it came to commissioning portraits, not much account was taken of the value of creative individuality. The ultimate criterion of quality was the degree of solid craftsmanship. Technical precision was more valued than the personal touch of the painter; and yet, as a result of faulty training methods, technical abilities were often markedly defective by European standards. In her controversial travel notes, written in 1832, Mrs. Trollope gave her view of the dilemma of the self-taught American painters: "In fact, I think that there is a very considerable degree of natural talent for painting in America, but it has to make its way through darkness and thick night.... Boys who know no more of human form, than they do of the eyes, nose, and mouth in the moon, begin painting portraits." Fanny Trollope, *Domestic Manners of the Americans* (Oxford and New York: Oxford Univ. Press, 1984), 306.

21. By contemporary standards, Jefferson had a progressive and liberal attitude toward art; but he was almost exclusively preoccupied with architecture. In his views on the other arts, he too oscillated between indifference and mistrust, on the grounds that their champions stood accused of inclining toward hedonism, luxury, and extravagance. See Harris (note 8), 42ff.

22. "The Artist as Teacher," *The Crayon* 1 (4 April 1855): 209.

23. On Peale's life and work, see Charles Coleman Sellers, *The Artist of the Revolution: The Early Life of Charles Willson Peale* (Hebron, Conn.: Feather & Good, 1939); Berta N. Briggs, *Charles Willson Peale, Artist and Patriot* (New York: McGraw-Hill, 1952); Charles Coleman Sellers, *Charles Willson Peale* (New York: Scribner's, 1969); Lillian B. Miller, ed., *Charles Willson Peale: Artist in Revolutionary America, 1735–1791*, The Selected Papers of Charles Willson Peale and his Family, vol. 1 (New Haven and London: Yale Univ. Press, 1983); Edgar P. Richardson, Brooke Hindle, and Lillian B. Miller, *Charles Willson Peale and His World* (New York: Abrams, 1983); Gillian B. Miller and David C. Ward, eds., *New Perspectives on Charles Willson Peale: A 250th Anniversary Celebration* (Pittsburgh: Univ. of Pittsburgh Press, 1991).

24. One of the two skeletons was installed in the Peale Museum with the aid of the anatomist Dr. Caspar Wistar. The missing parts were replaced with papier-mâché substitutes or with bones carved out of wood by the sculptor William Rush. The other skeleton went on tour to England with Peale's sons Rembrandt and Rubens (Richardson, Hindle, and Miller [see note 23], 85).

25. Some twenty portraits, out of the seventy-five individuals shown, can be identified from the painting (ibid.).

26. Tuckerman (see note 16) invoked the progressive mentality of the American artist, whose work, he thought, could only benefit from the democratic society in which he lived. He went on: "Our atmosphere of freedom, of material activity, of freshness and prosperity, should animate the manly artist. He has vantage-ground here unknown in the Old World, and should work confidently therein" (p. 28).

27. On this see Charles Coleman Sellers, *Portraits and Miniatures by Charles Willson Peale* (Philadelphia: American Philosophical Society, 1952), no. 636; Roger B. Stein, "Charles Willson Peale's Expressive Design: The Artist in His Museum," *Prospects: The Annual of American Cultural Studies* 6 (1981): 139–85.

28. Richardson, Hindle, and Miller (see note 23), 104.

29. Empress Maria Theresa commissioned Franz Messmer and Ludwig Kohl to paint this group portrait in 1773, after the emperor's death. He is shown seated at a *pietra dura* table in one of the rooms of his cabinet of curiosities. Around him stand the directors of the various imperial court collections. Highly prized for its iconographic content, the painting was copied for the Kaisersaal in Frankfurt. See Alfons Lhotsky, "Die Geschichte der Sammlungen: Von Maria Theresia bis zum Ende der Monarchie," in *Festschrift des Kunsthistorischen Museums zur Feier des fünfzigjährigen Bestandes* (Vienna: Ferdinand Berger, Horn, 1941–1945), 433–34, xliv; Walter Koschatzky, ed., *Maria Theresia und ihre Zeit*, exh. cat. (Vienna: Schloß Schönbrunn, 1980), 477.

30. On the history of cabinets of artistic and natural curiosities in Europe, see Barbara Jeanne Balsiger, "The Kunst- und Wunderkammern: A Catalogue Raisonné of Collecting in Germany, France, and England, 1565–1750" (Ph.D. diss., University of Pittsburgh, 1970); Julius Schlosser, *Die Kunst- und Wunderkammern der Spätrenaissance: Ein Beitrag zur Geschichte des Sammelwesens*, rev. ed. (Braunschweig: Klinkhardt & Biermann, 1978); Oliver Impey and Arthur McGregor, eds., *The Origins of Museums: The Cabinet of Curiosities in Sixteenth- and Seventeenth-Century Europe* (Oxford: Clarendon, 1985).

31. On the history of museums in America, see Germain Bazin, "The New World," in idem, *The Museum Age* (New York: Universe, 1967), 241–61; the comprehensive bibliography in Barbara Y. Newsom and Adele Z. Silver, eds., *The Art Museum as Educator: A Collection of Studies as Guides to Practice and Policy* (Berkeley, Los Angeles, and London: Univ. of California Press, 1978); Karin Elizabeth Rawllins, "The Educational Metamorphosis of the American Art Museum" (Ph.D. diss., Stanford University, 1981); Harris, 1990 (see note 5), including esp. the chaps. "A Historical Perspective on Museum Advocacy," 82–95, "Cultural Institutions and American Modernization," 96–110, and "Museums: The Hidden Agenda," 132–47.

32. Experiments on living subjects were among the great sensations of the Peale Museum. Thus, Apollo, a performing dog, showed off his tricks as examples of "animal intelligence"; in 1828 a Miss Honeywell, who had no arms, was engaged by the Museum to demonstrate her

mouth paintings; and in 1829 tribal dances and "maneuvers of scalping" were executed by a group of Sandusky Indians. See Amy Gamerman, "Tom Thumb's Suit and Other Wonders," *Wall Street Journal* (12 February 1991), A12.

33. See David Carew Huntington, *The Landscapes of Frederic Edwin Church: Vision of an American Era* (New York: Braziller, 1966), 5; John L. Baur, *The Autobiography of Worthington Whittredge* (New York: Arno, 1969), 28.

34. See Annette Blaugrund, "The Tenth Street Studio Building" (Ph.D. diss., Columbia University, 1978), 105.

35. There were some critics who objected strongly to this form of presentation. Clarence Cook attacked Bierstadt's exhibition style with particular vehemence: the "vast machinery of advertisement and puffery," the "devices to rouse and stimulate public curiosity," and the "artist's connivance in this system" seemed to him to be unworthy of the painter's noble calling. He accordingly appealed to those artists "who wish to elevate their profession above that of the showman, to help us abate it." See Clarence Cook, "Bierstadt's Rocky Mountains," in Nancy K. Anderson and Linda S. Ferber, eds., *Albert Bierstadt: Art and Enterprise*, exh. cat. (Brooklyn: The Brooklyn Museum, 1990), 31.

36. I am grateful to Thomas W. Gaehtgens for pointing out to me that the business acumen of the nineteenth-century American painters and especially their talent for self-promotion had individual precedents in late eighteenth-century France. For instance, Jacques-Louis David mounted a massive public relations campaign in Paris for *The Oath of the Horatii* (*Le Serment des Horaces*), 1785 (Paris, Musée du Louvre, no. 3692), and told his German colleague Friedrich Tischbein that he intended to keep the painting on show to the public for at least one year before handing it over to the government. It was not until 1799 that David successfully and lucratively carried out a similar plan by exhibiting his painting *The Rape of the Sabine Women* (*Les Sabines*), 1799 (Paris, Musée du Louvre, no. 3691), for five years with an admission fee of 1.80 francs. Thomas E. Crow is right to conclude that this marks the transition from artist to entrepreneur. See Thomas E. Crow, *Painters and Public Life in Eighteenth-Century Paris* (New Haven and London: Yale Univ. Press, 1985), 232. With the enthusiasm of a self-declared "nomadic and independent bohemian," Gustave Courbet took the initiative in bringing his paintings to the people. In 1850 he toured an exhibition to Ornans, Besançon, Dijon, and smaller towns and villages, where with the permission of the local mayors he posted huge bills advertising himself as a master of painting; at the time, such a one-man show was an extremely unusual event. See Werner Hofmann, ed., *Courbet und Deutschland*, exh. cat. (Hamburg: Hamburger Kunsthalle; Frankfurt am Main: Städtische Galerie im Städelschen Kunstinstitut, 1978–1979), 11; Jack Lindsay, *Gustave Courbet: His Life and Art* (New York: Harper & Row, 1973), 70ff.

37. This motto, in its original form, was coined by Marshall McLuhan in the context of the advertising and mass-media strategies of the later 1960s. See Marshall McLuhan and Quentin

Fiore, *The Medium Is the Message* (New York: Bantam, 1967).

38. On the history of panoramas, see Heinz Buddemeier, *Panorama, Diorama, Photographie: Entstehung und Wirkung neuer Medien im 19. Jahrhundert* (Munich: Fink, 1970); Stephan Oettermann, *Das Panorama: Die Geschichte eines Massenmediums* (Frankfurt am Main: Syndikat, 1980); Ralph Hyde, *Panoramania! The Art and Entertainment of the "All-Embracing" View*, with an introduction by Scott B. Wilcox, exh. cat. (London: Barbican Art Gallery, 1988).

39. Since 1988 Vanderlyn's fascinating panorama has been open to the public in the American Wing of the Metropolitan Museum of Art. In the Museum's catalog for this monumental work, the authors refer to Vanderlyn's marketing strategies: "In an effort to attract favorable notice for his exhibitions, the artist often used them in support of one charity or another, donating a percentage of his take for a specified period of time. He did so at the Rotunda in New York in 1819, in aid of the victims of a disastrous fire; in Philadelphia in 1820, in support of the Institute of the Deaf and Dumb; and in Charleston in 1823, for the New York Apprentices Library." This was not as successful as he had anticipated: "His attempts to appeal to the social conscience did not substantially increase his audience." See Kevin J. Avery and Peter L. Fedora, *John Vanderlyn's Panoramic View of the Palace and Gardens of Versailles*, exh. cat. (New York: The Metropolitan Museum of Art, 1988), 26.

40. Anne Hollander's original book *Moving Pictures* is of interest in this connection. She sets out to show how the realistic, panoramalike idiom of American painting anticipated the visual practices of the motion picture industry. See, in particular, chap. 13, "America," in Anne Hollander, *Moving Pictures* (New York: Knopf, 1989), 349–92.

41. On this see also Yvon Bizardel, *American Painters in Paris*, trans. Richard Howard (New York: Macmillan, 1960), esp. on George Catlin's *Louis-Philippe Watching the Dance of the Indians in the Tuilleries*, 118ff. Among the admiring spectators were Charles Baudelaire, George Sand, and Eugène Delacroix; see William H. Truettner, *The Natural Man Observed: A Study of Catlin's Indian Gallery* (Washington, D.C.: Smithsonian Institution Press, 1979), 14–15.

42. See Brian W. Dippie, *Catlin and His Contemporaries: The Politics of Patronage* (Lincoln: Univ. of Nebraska Press, 1990), 101–105.

43. On Warhol's marketing strategies, see Andy Warhol, *"Success Is a Job in New York...": The Early Art and Business of Andy Warhol*, exh. cat. (New York: Gray Art Gallery and Study Center, New York Univ.; Pittsburgh: The Carnegie Museum of Art, 1989).

44. See Hannelore Gaertner, *Georg Friedrich Kersting* (Leipzig: Seemann, 1988), and in particular "Die Atelierbilder," 38–65.

45. See Lucille Wrubel Grindhammer, *Art and Public: The Democratization of the Fine Arts in the United States, 1830–1860* (Stuttgart: Metzler, 1975), 1.

46. The literature on studio motifs in American painting is regrettably inadequate. Most articles on this subject exhaust themselves in purely illustrative coverage of the extant paint-

ings in this category. A concise survey of the iconography of the theme is provided by Nicolai Cikovsky, Jr., in his preface to the catalog *The Artist's Studio in American Painting, 1840-1983*, exh. cat. (Allentown, Pa.: Allentown Art Museum, 1983–1984). Also see Mary Vance, *Artist Studios: A Bibliography* (Monticello, Ill.: Vance Bibliographies, 1988).

47. A leading article under this title proclaims: "The sum of *Common Sense in Art* is, that men are fitted to criticize pictures — not by the time they spend in galleries and studios, but by the extent of their knowledge of Nature, and the comprehension of her mysteries." "Common Sense in Art," *The Crayon* 1 (7 February 1855), 81.

1. Winslow Homer (American),
Prisoners from the Front, 1866,
oil on canvas, 61.5 x 97.4 cm.
New York, The Metropolitan Museum of Art,
Gift of Mrs. Frank B. Porter, 1922, no. 22.207.

Nicolai Cikovsky, Jr.

Winslow Homer's National Style

When we think of America, many of us (not only Americans) think of it in Winslow Homer's terms. Some of the most memorable images of American life are found in his art. At the end of his life, many of his contemporaries thought of him as the greatest and the most important but also — in the apparent imperviousness of his style to foreign influence — the most American of artists.[1] That has been taken largely for granted, without very much thought given to *why* his art is so American. Did its Americanness somehow stem from private intuition or sensibility? Or was it deliberately achieved and consciously part of Homer's artistic purpose? Did he, in other words, create an American art by intention rather than by instinct?

If Homer knowingly and purposely tried to fashion an American art, he was not, of course, the first American artist to do so. Nationality had been a central artistic issue for several generations of American artists. But it was an issue of particular clarity in the decade of the 1850s, when Homer began his artistic life. That decade produced some of the greatest and most legible icons of nationality, such as Frederic Edwin Church's *Niagara* (see p. 104). It was in the 1850s, too, that the influential landscape painter Asher Brown Durand, in his series of "Letters on Landscape Painting" published in *The Crayon* in 1855, wrote what was, in effect, the first treatise on an American national art. Durand's central argument was that to make a national art, an American artist must look first at nature and not at pictures (particularly not at foreign pictures).

One of Homer's first and very few remarks on art was made in the 1850s: "If a man wants to be an artist," he said, "he should never look at pictures."[2] The young Homer was echoing the ruling belief of his time in a national

247

art, as well as a prescription, very similar to Durand's, for how it should be made: by looking at nature, not at pictures. Later, when Homer was learning to paint, we are told that "he bought a tin box containing brushes, colors, oils, and various equipments and started out into the country to paint from Nature,"[3] thus following exactly Durand's recommendation that an American artist should "go first to Nature."[4] Here, at the outset of his artistic life, by words and deeds, Homer affiliated himself with a theoretical principle.

The question of theory and of artistic beliefs has not figured significantly in the discussion of Homer's artistic enterprise, for good reasons. Unlike many other artists, Homer said virtually nothing about his art. He never explained it in private letters or journals, he never had pupils to whom he talked of his aims, and he never made a sustained public declaration of theory. But, as we have just seen, Homer was not uninterested in theory and, it seems, he accepted its guidance. I wonder, therefore, whether theory cannot account for more than has usually been supposed of the character of his art — its subject matter, its style, and its development, all things that have never been adequately explained.

One reason to think that ideas and theories played a role in Homer's artistic formation is that the decade of the 1860s, when his art was first formed, teemed with theories and was charged by belief. The artistic climate in America had never been as electric, as intellectually alert, as it was during the 1860s; ideas had never been as abundant or as freely expressed; theories never as hotly debated; discussion never as animated or as sharp. Words such as "strife" and "stress" and "struggle" were used during the decade itself to describe its ideological climate. That Homer was touched by that climate, its excited temper, and its sense of novelty and change is suggested by the observation of one of his most perceptive critics at the end of Homer's early development: "Impatience, irritability, [and] striving after the unknown [were] written upon all his works."[5]

We usually think of Homer as a solitary, almost reclusive figure, but during his early years in New York, in the 1860s and early 1870s, he was sufficiently closely associated with a number of other artists almost to constitute a circle.[6] One of the more interesting of his friends was the slightly younger Eugene Benson (1839–1908), a negligible painter but important critic and man of letters. The exact extent or effect of their relationship is not adequately known. We do know, however, that Homer and Benson had studios in the same building in New York, that they studied together, and

248

that in 1866 they held a joint exhibition of their work (which Homer never did with anyone else). A review of that exhibition said, "Each has learned through years of friendly intercourse something from the other.... Something, you scarce know what, in their pictures shows that they have painted side by side, and reveals to you the fact that they are friends."[7] We know of Benson mostly through his critical writing, from which he emerges as someone with an unusually sensitive, wide-ranging engagement with the social, artistic, and literary issues of his time. Benson was in no sense a theorist or a disciplined thinker. He was a journalist who expressed his ideas indirectly and as occasion allowed. But it is nevertheless possible to distill a coherent belief and theoretical position from his various writings.

Benson's chief standard of artistic value was modernity, by which he meant the responsibility of art to embody in its subject matter and reflect in its form the characteristic conditions of its age and place. Modern art, for Benson, was democratic art: he spoke of "the modern or democratic form of art [that depicts] the...actual life of men and women in the nineteenth century."[8] Modern art was essentially, and inevitably, national.

Benson's idea of modernity was the major element in his program for an American art. "The gospel of modern art as it must be developed in America," he said, must be "free from tradition, [and] based wholly on the common life of the democratic man, who develops his own being on a free soil, and in the midst of a vast country."[9] He touched on that program in his art criticism. He wrote approvingly (with Homer as one of his chief examples) of "the idea of producing purely American pictures from home subjects alone"[10] and (again with Homer as an example) of "painters who would rather stutter in a language of their own that admits of great development than impose upon themselves the fetters of what is acquired and foreign."[11] Benson developed his ideas so fully in his *literary* criticism that in the late 1860s, when the possibility of an American national literature was seriously being discussed, he was linked with the poet Walt Whitman — the most prominent example at the time of that possibility — as one of the "persons who declare that they crave a literature that shall be truly American."[12]

Benson is an interesting figure in his own right but even more so because of his association with Homer and, more importantly still, because of the ideas that he brought within Homer's range. But is there, apart from that association, any reason to think that Homer had an artistic program or project that corresponded in any way to Benson's — is there any reason to think

249

that the making of a modern and democratic art, derived from native materials and formed in a native artistic language, described Homer's ambition and explained the character of his art?

One reason to think so is the nature of Homer's subject matter. It consisted entirely of what Benson called "home subjects." Of course, by depicting ordinary people in commonplace acts and settings, all of Homer's subjects are, in a real sense, democratic. But that is particularly clear of certain subjects, to the degree that they have an almost ideological edge, almost the quality of a demonstration.

For example, the principal figure in *Prisoners from the Front* of 1866 is Union General Francis Channing Barlow at the right (fig. 1). Barlow was not a professional soldier (he was a lawyer by training), but he enlisted as a private and rapidly rose to the rank of general. For this reason, as well as for his exemplary uprightness and exceptional heroism, he was the representative type of an officer in the army of a democratic republic. Homer understood that, of course, and that is the role in which he cast Barlow, explicitly by contrasting him with the aristocratic Confederate officer.[13]

Homer's postwar subjects were equally democratic. His croquet players, for example (see p. 60), reflected the popularity of a sport newly introduced to America.[14] The game was popular because it was healthful and gave opportunities for romantic encounters. It was characterized by equality of the sexes: in competition with men, women could win. In Homer's paintings, perhaps as the sign of that, women are always the dominant figures.

Whitman spoke of women in democracy as the "robust equals" of men[15] and described the traits of their equality almost as they appear in Homer's art. Whitman wrote, "They are tanned in the face by shining suns and blowing winds. They know how to swim [fig. 2], row, ride [fig. 3], wrestle, shoot, run. They are ultimate in their own right — they are calm, clear, well possessed of themselves."[16] In no other American artist's depiction of women, is there the same lack of sentimentality and condescension as there is in Homer's. He shows women to have an independence, determination, and character that is astonishingly unlike their stereotypical Victorian depiction.

Homer depicted Long Branch, New Jersey, several times, beginning in 1869 (fig. 4). Like croquet, it was a current subject — a newly popular summer resort. He depicted it not only because it was current but because it was, in a way that many found offensively vulgar, America's most democratic resort. "Within its bounds," it was said, "the extremes of our life meet

2. Winslow Homer (American),
 Eaglehead, Manchester, Mass., 1870,
 oil on canvas, 66.7 x 97.4 cm.
 New York, The Metropolitan Museum of Art,
 Gift of Mrs. William F. Milton, 1923,
 no. 23.77.2.

3. Winslow Homer (American),
 The Bridle Path, White Mountains, 1868,
 oil on canvas, 61.9 x 97.4 cm.
 Williamstown, Mass., Sterling and Francine
 Clark Art Institute, no. 2.

251

4. Winslow Homer (American),
 Long Branch, New Jersey, 1869,
 oil on canvas, 40.6 x 55.2 cm.
 Boston, Museum of Fine Arts, The Hayden
 Collection, no. 41.631.

freely."[17] (The depiction of women here, by the way, so different from Homer's usually more robust women, is both satirical and sociological. It ridicules the inappropriateness of their frailty and overdressed finery in the outdoors; and it suggests that one part of the social mixture at Long Branch, as people often noted, was made up of women of the demimonde such as these.)

Through railroads, steamships, and other improved means of transportation, postwar Americans had access to the nature that was often Homer's subject, an open, democratic access very different from the more private and privileged communion with nature that prewar America enjoyed.[18]

Public schools, which Homer began depicting in the early 1870s, were the cornerstones of American democratic civilization, "as vital to our political system," a writer said in 1870, "as air to the human frame."[19]

Homer's paintings of the Reconstruction of the South after the Civil War are more sympathetic and intelligent about the profound social and cultural change that the end of slavery caused than any others made at the time. The dignity of bearing and individuality of appearance in *The Cotton Pickers* (fig. 5) is so very different from the usual caricatured depictions of African Americans (of the kind that Homer himself had made not many years earlier); the tensely strained confrontation of old habits with new social and political realities is made vivid in *A Visit from the Old Mistress* (fig. 6); and the intense craving for the literacy that slavery systematically denied its victims is expressed compactly and compassionately in *Sunday Morning in Virginia* (fig. 7). That such paintings were painted at the time that Reconstruction was being assailed and dismantled gives a special affirmation of the principles they uphold.

If Homer's artistic purpose in paintings such as these resembled Eugene Benson's program for a modern, democratic American art, then it had two parts. First, that program called for "home subjects," depictions of the "actual life of men and women in the 19th century." These Homer produced in an amount that I have only hinted at. Second, Benson's program also addressed the question of style. He preferred that American artists "stutter in their own language that admits of great development" in a style free of the "fetters of what is acquired and foreign" — in other words, a style that though rough and imperfect, broad and imprecise, was capable of national development and that had a national flavor or complexion, free from confining precedent.

What most perplexed (their word) Homer's critics was the incomplete-

5. Winslow Homer (American),
 The Cotton Pickers, 1876,
 oil on canvas, 61.7 x 97.8 cm.
 Los Angeles, Los Angeles County Museum
 of Art, Acquisition made possible through
 museum trustees: Robert O. Anderson, R.
 Stanton Avery, B. Gerald Cantor, Edward W.
 Carter, Justin Dart, Charles E. Ducommun,
 Mrs. F. Daniel Frost, Julian Ganz, Jr., Dr.
 Armand Hammer, Harry Lenart, Dr. Frank-
 lin D. Murphy, Mrs. Joan Palevsky, Richard
 E. Sherwood, Maynard J. Toll, and Hall B.
 Wallis, no. M.77.68.

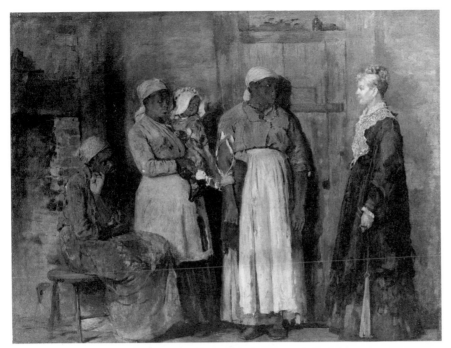

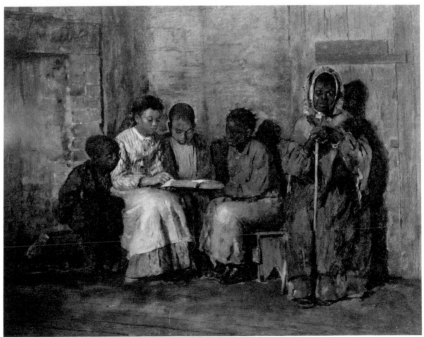

6. Winslow Homer (American),
 A Visit from the Old Mistress, 1876,
 oil on canvas, 45.7 x 61.3 cm.
 Washington, D.C., National Museum of
 American Art, Smithsonian Institution, Gift
 of William T. Evans, no. 1909.7.28.

7. Winslow Homer (American),
 Sunday Morning in Virginia, 1877,
 oil on canvas, 45.8 x 61 cm.
 Cincinnati, Cincinnati Art Museum, John J.
 Emery Endowment, no. 1924.247.

ness of his style. They called it "coarse" and "careless," and they criticized
it repeatedly for lack of refinement and of the resolution of conventional
finish.[20] Homer read his critics, of course, and was aware of what they said
(even in old age he was hypersensitive to criticism). But it did not make
him change. He clearly regarded with favor what his critics regarded as a
fault. What they found objectionable corresponds so closely to qualities of
style that Benson described, qualities he thought of as particularly Ameri-
can, that it is distinctly possible that Homer's style may have been deter-
mined not by his own taste or temperament but by ideas organized into
what we may loosely describe as a theoretical program. The "rude" and
"coarse" suggestiveness of Homer's style that nearly all his critics spoke of
(even when they spoke admiringly) was, I think, Homer's purposeful for-
mulation of an American style, a style, as one critic said, "wholly in sympa-
thy with the rude and uncouth conditions of American life,"[21] one in which,
as another wrote, "The freshness, the crudity...of American civilization
are well typified."[22] This was a style that sought deliberately to achieve a
national character and a discernibly national flavor; a nationally indepen-
dent style unfettered, as Benson said an American art should be, by what is
acquired and foreign.

Lack of finish and a kind of deliberate incompleteness, then, were attri-
butes of a national style, an American style. But for Benson, we remember,
nationality and modernity were inseparable conditions, and they may be
similarly joined together in the function and appearance of Homer's style —
just as many of his national/democratic subjects were at the same time
emphatically modern ones, such as croquet, or Long Branch, or the newly
independent woman.

In his famous essay "The Painter of Modern Life," written about 1860,
Charles Baudelaire defined modernity as "the ephemeral, the fugitive, the
contingent,...[the] transitory."[23] It was exactly those qualities that the most
resolutely advanced modern art in the 1860s — the art of Homer's close con-
temporaries Edgar Degas, Edouard Manet, and the Impressionists — strove
to capture and convey. And it was the concern of Homer's style, too, I think,
to carry in its appearance an expression of modern contingency and tran-
sitoriness — to give in its very incompleteness visible form to those quali-
ties of modern existence and experience.

Homer's style assumed the form it did to express or accommodate Ameri-
canness and modernity but also to capture the brilliance and movement —

256

the fugitive and transitory effects — of natural light. Painting outdoors was a well-known part of his artistic method. As early as 1864, at the beginning of Homer's career as a painter, a critic who obviously had access to him and had watched him paint reported that "if you wish to see him work you must go out upon the roof [of his studio] and find him painting what he sees."[24] When Homer began painting outdoors in the early 1860s, there was no established precedent for doing so. It has been said that he acted under the influence of French Impressionism, but we know that he painted outdoors before he could have seen Impressionist paintings (if he ever saw them at all).[25] I think Homer painted outdoors for another reason — because it *meant* something. That is why he wanted painting outdoors known as his method (when, as a matter of fact, it was not a method he followed consistently throughout his career, or even consistently in the execution of particular paintings, in which some parts were painted outdoors and others were not). He understood it to be less a private practice than a public issue — understood, in a word, that painting outdoors was a *modern* method. Also, and perhaps more importantly, making art from direct visual experience was, by evading the traditions of the past *and* the influences of the present, a way of making art new — a way of escaping custom and tradition by returning to essential, firsthand experience.

The artistic beliefs that shaped Homer's own beliefs may also explain why his art changed so dramatically and profoundly in the early 1880s. The change had several causes, of course, one of which may have been a profound crisis of faith. By the middle of the 1870s, the program and principles that, as I have suggested, influenced Homer's art in its first maturity became manifestly irreconcilable with the actualities of American life. Everything that that program and those principles had been based upon in the 1860s — the ideals of American democracy and the possibility of an American democratic art — had by the 1870s become so deformed and degraded as no longer to be meaningful. Those ideals could find no place amid the blatant venality and rampant corruption of Gilded Age America.

Homer thus disengaged himself from ideas and ideals that had been directly and deliberately tied to specifics of time and place. He disengaged himself physically, first, by going to England in 1881, where he witnessed the honest truths of lives lived in intimate and perilous contact with nature, and later, when he returned to America, by living at Prout's Neck, Maine, where, by choice rather than necessity, he himself enacted a similar life.

257

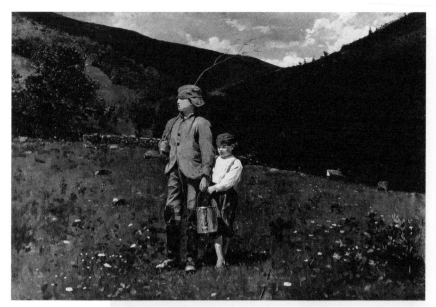

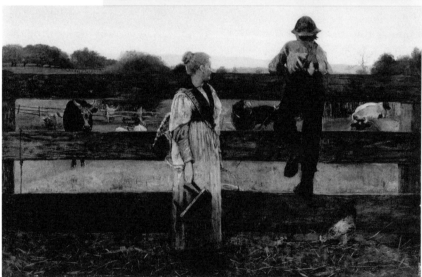

8. Winslow Homer (American),
 Crossing the Pasture, ca. 1872,
 oil on canvas, 67.3 x 97.8 cm.
 Fort Worth, Amon Carter Museum,
 no. 1976.37.

9. Winslow Homer (American),
 Milking Time, 1875,
 oil on canvas, 61.5 x 98.1 cm.
 Wilmington, Delaware Art Museum, Gift of
 the Friends of Art and Interested Members,
 no. 67-2.

10. Winslow Homer (American),
Breezing Up (*A Fair Wind*), 1876,
oil on canvas, 61.5 x 97 cm.
Washington, D.C., National Gallery of Art,
Gift of the W. L. and May T. Mellon Founda-
tion, no. 1943.13.1. ©1992 National Gallery
of Art, Washington, D.C.

His disengagement also involved a deeper concern with the mechanics and formal properties of art itself than he had ever had before. He expressed himself by a new kind and on a new plane of content and by a revised language of style.

In the mid-1870s, subtleties of design and discriminations of formal organization assumed a new, unprecedented role in Homer's style. Earlier, his paintings were constructed in the simplest possible way. In *Crossing the Pasture* of about 1872 (fig. 8), for example, the main figure groups are placed simply and straightforwardly in the center of the painting. But in *Milking Time* of 1875 (fig. 9) pictorial construction has become not only more complex but more self-conscious and self-assertive. Many of the changes Homer made in *Breezing Up (A Fair Wind)* of 1876 (fig. 10), some of which are now visible to the naked eye, were adjustments in design.

At this time Homer also began to look more favorably at new sources of influence; in fact, he began to embrace stylistic, as opposed to ideological, influences more fully and more openly than he had ever done before. The influence of Japanese art, for instance, is clearly at work in the compositional arrangement of *Breezing Up*, with its main form placed far to the left and close to the picture surface, balanced by the empty space and distant form at the right, in a way found repeatedly in Japanese prints. Japanese influence is even clearer in *Backgammon* of 1877 (fig. 11) in the floating of the figure group as a shape against a flat background, in the fan, and even in the form and placement of Homer's signature.

At this time Homer also executed two ambitious, frankly decorative projects for tiled fireplaces (fig. 12).

In their imagery, what is more, the tile decorations clearly draw upon artistic precedent — more clearly than Homer had ever done before. By the 1880s an interest in tradition replaced the assertive modernity of his earlier art — as in the obvious classicism of *Mending the Nets*, 1882 (Washington D.C., National Gallery of Art) or *Undertow* (fig. 13).

Homer never forsook his beliefs, but following what was, as I have suggested, a crisis of disillusionment in the late 1870s, they were no longer bound up with time and place — with issues of modernity or nationality. Instead, they were removed to other levels. They were transposed to higher planes of universal meaning, expressed by themes of human strength and frailty and nature's power, as in *Undertow* or *The Herring Net* (fig. 14), or as deeply private and personal meaning, such as his reflection on death

260

11. Winslow Homer (American),
 Backgammon, 1877,
 watercolor and black chalk on off-white wove
 paper, 45.5 x 57.4 cm.
 Private collection.

12. Winslow Homer (American),
 Shepherd and Shepherdess, 1878,
 painted tiles around fireplace, each tile:
 20.5 x 20.5 cm.
 New York, collection of Mr. and Mrs. Arthur
 G. Altschul, no. 213.

13. Winslow Homer (American),
Undertow, 1886,
oil on canvas, 75.8 x 121.7 cm.
Williamstown, Mass., Sterling and Francine
Clark Art Institute, no. 4.

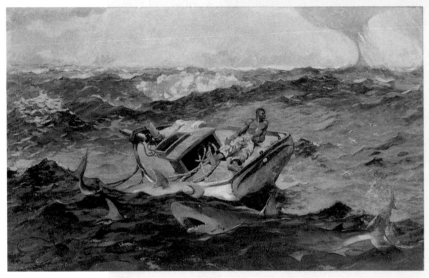

14. Winslow Homer (American),
 The Herring Net, 1885,
 oil on canvas, 77.3 x 124 cm.
 Chicago, The Art Institute of Chicago,
 Mr. and Mrs. Martin A. Ryerson Collection,
 no. 1937.1039. ©1992 The Art Institute of
 Chicago, All Rights Reserved.

15. Winslow Homer (American),
 The Gulf Stream, 1899,
 oil on canvas, 71.4 x 124.8 cm.
 New York, The Metropolitan Museum of Art,
 Wolfe Fund, 1906, Catharine Lorillard Wolfe
 Collection, no. 06.1234. All Rights Reserved,
 The Metropolitan Museum of Art.

and destiny in *The Gulf Stream* of 1899 (fig. 15).

Homer also expressed himself by different terms of style, ones of conception rather than perception, substance rather than surface; ones that no longer told of specificity, transience, and contingency but rather of permanence and universality. There is a passage in Henry Adams's novel *Democracy* (published in 1880) that corresponds, I think, to Homer's state of mind and explains his change of style. The novel's heroine, Madeline Lee, experienced a crisis of disillusionment with the corruptions of American democracy in the 1870s similar to the one that Homer underwent at the same time. Her reaction to that experience was this: " 'I want to go to Egypt,' she said. 'Democracy has shaken my nerves to pieces. Oh, what a rest it would be to live in the Great Pyramid and look out for ever at the polar star!' "[26]

Homer's reaction, it seems, was the same. It, too, was expressed in a mode of style almost Egyptian in its monumentality, formality, and timelessness, and it, too, after a crisis of faith, sought certainty and tranquillity in abiding stability of form.

NOTES

1. "He does not know what is going on in London, Paris, and New York," a critic said in 1894. He is "the most truly and exclusively national painter ever reared in America," "Some Living American Painters: Critical Conversations by Howe and Torrey [William Howe Downes and Frank Torrey Robinson]. Second Paper," *Art Interchange* 32 (May 1894): 137.

2. Quoted in Lloyd Goodrich, *Winslow Homer* (New York: Whitney Museum of American Art, 1945), 6.

3. George W. Sheldon, quoted in Goodrich (see note 2), 17–18.

4. "Letters on Landscape Painting: Letter I," *The Crayon* 1 (3 January 1855): 2.

5. Samuel Greene Wheeler Benjamin, *Art in America: A Critical and Historical Sketch* (New York: Harper, 1880), 117.

6. For Homer's artist friends at this time, see Goodrich (see note 2), 24.

7. "An Interesting Exhibition of Pictures," *New York Evening Post* (16 November 1866).

8. "Modern French Painting," *Atlantic Monthly* 22 (July 1868): 95.

9. Ibid., 91.

10. *New York Evening Post* (17 May 1869).

11. *New York Evening Post* (12 May 1865).

12. "Literature Truly American," *The Nation* 6 (2 January 1868): 7–8.

13. See Nicolai Cikovsky, Jr., "Winslow Homer's *Prisoners from the Front*," *Metropolitan Museum of Art Journal* 12 (1977): 155–72.

14. See David Park Curry, *Winslow Homer, The Croquet Game*, exh. cat. (New Haven: Yale Univ. Art Gallery, 1984).

15. "Democracy," *The Galaxy* 4 (December 1867): 931.

16. "A Woman Waits for Me" [1856], *Leaves of Grass*, in Mark Van Doren, ed., *The Portable Walt Whitman* (Harmondsworth: Penguin Books, 1977), 406.

17. Olive Logan, "Life at Long Branch," *Harper's New Monthly Magazine* 53 (September 1876): 482.

18. Asher Brown Durand's *Kindred Spirits*, 1849 (New York, New York Public Library), depicting Thomas Cole and William Cullen Bryant in the Catskill Mountains, is probably the most famous example of this communion.

19. "The Little Red Schoolhouse," *Boston Evening Transcript*, 17 January 1873. On Homer and schools, see Nicolai Cikovsky, Jr., "Winslow Homer's *School Time*: 'A Picture Thoroughly National,'" in John Wilmerding, ed., *Essays in Honor of Paul Mellon, Collector and Benefactor* (Washington, D.C.: National Gallery of Art, 1986), 47–69.

20. "The fault we are constrained to find with his pictures in general is the coarseness of their execution," "Fine Arts: National Academy of Design – Fifty-first Annual Exhibition," *The New York Daily Tribune* (1 April 1876). "Mr. Homer was never more careless and capricious and trying," *The Nation* 24 (15 February 1877): 108. "We do not like to think how long it is since Mr. Homer showed us a finished picture," "Fine Arts: The American Society of Painters in Water-Colors – Eighth Annual Exhibition," *New York Tribune* (22 February 1875).

21. "The Academy Exhibition," *The Art Journal* 3 (1877): 159.

22. Benjamin (see note 5), 117.

23. Charles Baudelaire, *The Painter of Modern Life, and Other Essays*, ed. and trans. Jonathan Mayne (London: Phaidon, 1964), 13.

24. George Arnold, "The Academy Exhibition: Second Article," *New York Leader* (30 April 1864).

25. On Homer and Impressionism, see Henry Adams, "Winslow Homer's 'Impressionism' and Its Relation to His Trip to France," in Nicolai Cikovsky, Jr., ed., *Winslow Homer: A Symposium* (Washington, D.C.: National Gallery of Art, 1990), 61–89.

26. Henry Adams, *Democracy: An American Novel* (New York: Holt, 1880; reprint, New York: New American Library, 1961), 189.

1. John Haberle (American),
The Changes of Time, 1888,
oil on canvas, 62.5 x 51.9 cm.
Taylor, Mich., Manoogian collection.

Olaf Hansen

THE SENSES OF ILLUSION

It is true, that which I have revealed to you: there is no God,
no universe, no human race, no earthly life, no heaven no hell.
It is all a Dream, a grotesque and foolish dream. Nothing exists
but You. And you are but a Thought – a vagrant Thought, a
useless Thought, a homeless Thought, wandering forlorn
among the empty eternities!

 – Mark Twain

Unfortunately, William James never wrote a book (*The Many and the One*)
in which "A World of Pure Experience" would have been the decisive chap-
ter, but how can one resist the invitation to follow his lines of thought when
looking at the paintings of a group of artists we commonly refer to as the
Trompe l'Oeil school in American still-life painting?[1] So much is seen and
so much is absent in a painting such as John Frederick Peto's *Lincoln and the
Star of David*, 1904 (private collection), that we are forced, or rather bound
by tradition, to account for the meaning of time. History will follow and, as
the painting so visibly dramatizes, vast segments of history will also disap-
pear. Our history depends upon responsible reconstruction, a responsibil-
ity not made easier by the fact that we have so little with which to start.
This brings to mind Ralph Waldo Emerson's statement that facts sit for us
for their portrait, but Emerson was not naive where the stability of facts
was concerned, nor was Peto, nor James. "Of every would be describer of
the universe," James claimed, "one has a right to ask immediately two gen-
eral questions. The first is: 'What are the materials of your universe's com-
position?' And the second: 'In what manner or manners do you represent

267

them to be connected?' "[2] We are already somewhat ahead of our own argument, a forgivable prolepsis, because we want to understand Peto and the group of painters to which he belongs in their American setting. So while looking occasionally at Peto's painting — at Lincoln's image, at a piece of string, at the Star of David, at two matches, at a burning cigarette, to leave it at that for now — we may follow William James's argument from the point where he calls the materials of the universe *experiences* only to make his second statement, namely, "that the relations that connect the experiences must *themselves be experienced relations*."[3] So the experience of experienced relations is the central issue of the argument, and if we look at the world of objects that we find in the paintings of the Trompe l'Oeil school, we must account for their meaning within experienced relations. The voice of William James leads us straight to Martin Heidegger's statement about man's relationship to things, in which Heidegger wants us to know:

1. that we must always move in the *between*, between man and thing;
2. that this *between* exists only while we move in it;
3. that this *between* is not like a rope stretching from the thing to man, but that this *between* as an anticipation (*Vorgriff*) reaches beyond the thing and similarly back behind us. Reaching-before (*Vor-griff*) means thrown back (*Rück-wurf*).[4]

To these ideas, which no pragmatist and no Transcendentalist would have expressed differently, James adds two more nuances. In his deliberations about how the mind moves from one object to another without the help of intervening terms (remember Heidegger's *betweenness*), James comes to the conclusion that we experience the lack of a "tertium quid" essentially as one "of an absence."

As a counterpoint James introduces the idea of "virtual existence." "When an event that is not yet actual is nevertheless *certain to occur* in the future, it is more than a bare possibility. We speak of its enjoying even now a *virtual or potential* existence."[5] There is a delightful tone of pleasure in James's manuscript, due, perhaps, to the fact that he himself enjoyed the distance to the tragic side of the experience of absence, which his highly technical, academic text allowed him to keep. Illusion, especially when posited against the burden of manifest historical and social facts, can sometimes be a great promise, but hardly all the time. For something is always there, like the image of Lincoln reminding us of the past and of what history might have

been if he had not been assassinated, or the Star of David representing history as a promise yet to be fulfilled — long senses of time in contrast to the counterimages of the two matches telling us the story of a brief intense moment, to be counted against what time span, we wonder. The viewer must make his choice, being bound to assess potential fates, such kinds of fate at least as he occasionally shares, is allowed to share, with what the work of art reveals.

The fate might be one of scale only. Henry Adams points out such a possibility in the preface to his highly stylized autobiography, *The Education of Henry Adams*, when he informs his reader about the fate of the ego in modern times: "The Ego has steadily tended to efface itself, and, for purposes of model, to become a manikin on which the toilet of education is to be draped in order to show the fit or misfit of the clothes."[6]

The object of study is the garment, not the figure. What Adams meant by "the toilet of education" was nothing less than the meaning of life itself, its purpose, its hidden sense. Henry Adams, the grimmest pessimist of his day, failed to see what he had so artfully searched for: above all, of course, any aesthetically and intellectually satisfying order. Adams wanted higher laws, and he constantly had to admit that only as ideas in essence could he construct the order he had in mind. *Mont-Saint-Michel and Chartres*, his other great book on the idea of historical and aesthetic unity, is a reflection of whatever kind of hardship reality had to offer. For Adams, the fragility of life and the experience of its tragedies led to the conclusion that the loss of the ego could make sense after all, when he points out that the manikin "has the same value as any other geometrical figure of three or more dimensions, which is used for the study of relation. For that purpose it cannot be spared; it is the only measure of motion, of proportion, of human condition; it must have the air of reality; must be taken for real; must be treated as though it had life. Who knows? Possibly it had!"[7]

Starting all over again was one of Adams's favorite positions in life; it allowed for deep skepticism without abandoning the idea that a modicum of originality could still be claimed as one's own. It all seemed a matter of balance: science and art brought successfully together would help to control the envisaged chaos. Like so many of his contemporaries, Henry Adams felt drawn toward the Middle Ages, but he did not romanticize them. What he saw was an affinity to crisis and a similar way of overcoming it. To him, the great periods in the history of mankind were those when the builders

were at work creating order with a sense of illusion in mind. Thus Henry Adams, like his friends Clarence King and John LaFarge, created his own specific style of expression. Without going into detail and without undue generalization, some of the characteristics of this style can be named.

The ground configuration of the mentality at work was a highly developed sense of paradox. History is never what it seems to be. Everything has to be viewed from a distance; there is no such thing as a shelter against one's own self. The difference between the private world and the public sphere is constantly diminishing. Ever since the debate — or should one call it the quarrel — between Calvinists, Transcendentalists, and Unitarians, the great *querelle* of the American nineteenth century, these ground metaphors had, both in literature and philosophy and eventually in painting, created their own form of expression. We might therefore surmise that the matrix of the invention of such ground figuration was fundamentally religious.

I hope that by now a certain clarity has been achieved as to what is meant by the American setting of the Trompe l'Oeil painters: it is not the social setting and the economically disastrous ups and downs of the late nineteenth century in America nor the more or less crisis-ridden existence of the individual artist at that time. Rather, still-life painting created its American setting by questioning its own nature in the very same way in which Transcendentalism had made its inquiries into the riddle of language, and pragmatism into the problems of epistemology.

Questioning was itself a way of self-invention, or to put it differently, a way of offering an alternative to the dominant tradition by taking its own dynamics seriously. Emerson had warned against reading too many books, for the sense of what the act of reading might be all about could easily be lost; Henry David Thoreau did the same for the act of writing; and the Trompe l'Oeil painters made you wonder what art is all about. The paintings seriously query the sense of self-reflection, and they answer by reenforcing the ancient question of why matter and form exist and for what purpose, rather than not existing at all. Since this argument began in a Jamesian mood, it seems fitting to point out that the manuscript of the book that he never wrote ends with a line taken from a student's exam paper informing us that "the activity of the mind is that it holds itself firm to suffer." Perhaps the most enigmatic among the trompe l'oeil paintings try to tell us the same thing or something like it about art.

Still life is the chamber music of painting: a singularly pure and refined form
of artistic expression. It manifests the intrinsic values of art, very little
diluted by incidental elements. For that reason the study of still life is no less
rewarding as an aesthetic experience than as an historical discipline.[8]

Still life is perhaps the most artificial of all artistic subjects and the one most
concerned with the making of art.[9]

Art, nature, history, and the quest for order: the historian of culture
frequently has to interpret the obscure, the small signature of minor art-
ists, in order to catch a sense of the larger design of meaningful relations
between art and society. From its very beginning American still-life paint-
ing has undergone so many significant changes that it is extremely diffi-
cult to justify the specific choice to discuss the Trompe l'Oeil painters unless
one is willing to assume an intimate relationship between the works of
William Michael Harnett, John Frederick Peto, and John Haberle as a par-
ticular form of artistic representation and the social context that shaped
their style of enigmatically playing on our sense of illusion and reality.
The fact that we still know very little about the individual artists' lives and
careers, despite the work of critics such as Alfred Frankenstein and John
Wilmerding, should not intimidate our discussion or invite random specu-
lation but instead give us a chance to see the American Trompe l'Oeil school
of the late nineteenth century firmly within its cultural matrix. This also
means that for the sake of bringing to light the genuinely American idiom
that we detect in the work of Harnett, and especially in that of Peto and
Haberle, we have to neglect the Dutch influence as exemplified in the
paintings of Wallerant Vaillant and Norbert Gybrecht. The following brief
discourse is not a study of influences, but it will try to concentrate on the
American trompe l'oeil as an authentic expression of, and comment on,
the American social and cultural landscape. Alfred Frankenstein, there-
fore, invites a kind of qualified contradiction if in his seminal book *After
the Hunt* he emphasizes a continuity where we would argue for distinction.

Place a Harnett still life of the middle 1870's next to a Raphaelle Peale of 1815
and it is impossible to believe that they are separated by two generations,
that the one belongs to the era of James Madison and the other to that of
U. S. Grant. To be sure, there are differences in subject matter (so far as any-

271

one knows, Harnett was the first to paint pictures of beer mugs, pipes, and newspapers), but for the rest, the two artists are nearly identical — in their glossy technique, their crisp, objective drawing, their composition, and their psychology.[10]

Certainly there are similarities, but to the extent that we see the still life as an extremely self-conscious mode of representation, we have to look for the distinctive feature rather than stress aspects of similarity. It is the conscious ordering of objects in the individual paintings that turns them into singular statements. In this sense it is only a matter of convenience even to speak of a Trompe l'Oeil school. To be more accurate, one should approach the work of each individual painter by discussing the paintings as autonomous records in their own right. The fact of thematic and iconographical repetition is quite deceptive where the individual appeal of the painting to our perception of illusion and reality is concerned. Illusion and reality in this sense refer not so much to the painterly effect of the trompe l'oeil as to the language that the painting creates with its assemblage of related details. As individual details they each occupy their own place in history and time; as related objects they transcend their own existential space only to return to the structure of meaningful expression. The ideal complementary viewer of this expression, in the phrase of William James, would be the "inclusive mind," a monistic hypothesis that of course, like all ideal types, does not exist in reality.[11] The sense of illusion, therefore, is to serve as a reminder both of the flux of reality as historical time and of the timelessness of the self-contained object.

The viewer of John Haberle's painting *The Changes of Time* (fig. 1) will necessarily have to read it both as a comment on a society that increasingly defied capture in a unified image and as a statement about time and history. Posted against a wooden cupboard door are overlapping notes of various currencies, stamps, and a newspaper clipping, the whole assemblage being framed by miniature portraits of American presidents. The upper left corner holds a carte-de-visite picture of a woman, the lower right corner is covered by an envelope addressed to John Haberle, in part covered by a tintype photograph of the artist. The historically significant and the mundane and trivial are ordered into a composition of extreme irony. Presidents Lincoln and Washington appear on the picture frame *and* on banknotes in the center of the painting. History is represented as a surface and as a transitory

phenomenon. The viewer who is drawn in by these emblematic qualities of the painting will be tantalized by the key to the cupboard door, dangling from a string, which seems to insinuate that the door can be opened: there is something behind the surface, just as there is something behind the surface of history. The fragments are not history — they represent aspects of it. The melancholy theme is the victory of time over history, and however close the viewer gets to the surface, the distance to what is *behind* increases. This includes the Emersonian fear that once we leave all the layers of appearances behind us, we might discover that there is *nothing* behind them. The viewer, to be sure, can always withdraw from the vexing problems of illusion and reality, or from the dialectics of an emphasized surface and its relationship to something behind it, by relying on the title of the painting. Such a withdrawal exploits the didactic element of the allegorical expression and leaves aside the work of the artist and the meaning of the making of the painting.

The Changes of Time is an idea, a concept with which, in an abstract sense, any viewer is familiar. The painting itself, once taken seriously as a singular statement, destroys the abstract quality of this familiarity. It does this in two ways, both related to the status of the work of art in a cultural context. On one level the typical trompe l'oeil draws attention to the artist as an individual. *He* collected, arranged, and composed; he selected the fragments; and it is his particular choice that the viewer has to confront. Against the change of time, the artist asserts himself as an individual. The painting itself reflects the basically democratic stance of this assertion. Consider the carte-de-visite-like image of the woman in the upper left corner and the artist's tintype self-portrait in the lower right corner. The anonymous and the highly individual form a diagonal line across the portraits of presidents on banknotes, leveling the historical distinction. The objects on the canvas are all of equal importance, the equality being one of chance, not of political principle. As a political statement the painting functions primarily by a declaration of artistic intention. Every object, once chosen by the artist, could potentially have become part of the work of art as a whole — and the viewer, wondering what would happen if the cupboard door were opened, harbors the suspicion that a whole world of invisible objects, hidden behind the given surface, might burst out.

The common object, within the context of the finished and autonomous work of art, had become the common denominator, sometimes functioning

273

by way of contrast, as in Haberle's *Torn in Transit* (fig. 2), and sometimes assuming a kind of naive, magical power of pure iconographical delight, as in his *Chinese Firecrackers* (fig. 3), or even more so in *A Bachelor's Drawer* (fig. 4). The latter's assemblage of mass-produced images and their theatricality demonstrate that the artist was at home in a world of material mass production and chose his role as a collector and observer. The celebration of the profane object is, however, not only an act of acceptance but also a gesture of resistance. The objects are taken out of context, or to put it somewhat more accurately, they are given a "second reality" beyond the sphere for which they had been intended. The postcard, the coin, the advertisement, the matchboxes, and the photograph are being derealized by the artists' arrangements. That the objects of industrial capitalism become the objects of still-life painting, given the history of the genre, points out the forces of nature within a sphere of dominant functionalism. If we look at all those assembled objects of a modern, progressive age as they are arranged by the artist, we immediately realize how the very new, as if by metamorphosis, becomes a representation of an archetype. The letter, the image, numbers, and objects are transformed into symbols of original immediacy. The products of mass culture are restored as objects in their own right and dignity. The illusion of reality is unveiled by the quality of the still life to articulate self-reference: *nature morte*.

The language of art criticism is not very flexible, especially in a case where the process of discovery is still ongoing. Ever since Wolfgang Born's early statement about Haberle's "whimsical" qualities, this attribute has been repeated in the literature describing his paintings. Far from being quaint and capricious, however, the whim in the paintings of Haberle and Peto literally represents imagination at work. It is an imagination that tries to restore a lost innocence, and there is also — most explicitly in Haberle's *Torn in Transit* (see fig. 2) — a trace of nostalgia that cannot be overlooked. The torn wrapping reveals part of a landscape painting, and the viewer who compares these paintings with those that display the objects of modern, everyday life is forced to wonder about the direction of the transit in question. The painted landscape, it seems, only survives as an element of the past; we get a glimpse of it by accident.

If, against such nostalgic reminiscences, we read most of the Trompe l'Oeil painter's work as succinct comments on a changing society, we have to admit that the power of the comment lies in the anticipatory art of quo-

tation, which means that both history and society can only be understood as series of chaotically related fragments.

Societies produce versions of the past, and the closer we examine the overlapping layers of historical projections, the more we tend to see them as a kind of palimpsest. The same troubled society that produced the White City found its values expressed in the kind of still-life painting that seems to transcend time only in order to create its own language about history. The question of whether the name "Trompe l'Oeil painters" adequately describes the essence of the work of John Frederick Peto, William Michael Harnett, and John Haberle remains to be answered. Their preoccupation was with objects, and the problem of representing illusion and reality seems to make sense only if we allow the painted object to become a statement within a specific version of history.

The first and most important part of this statement is the element of self-reflection that Peto's ordering of objects on a table or at an office board assumes. The nature of such self-reflection fulfills a twofold purpose. First, it creates allegorical distance by emphasizing the painter's intention. The ordering of a painted segment of reality aggressively reveals itself as a conscious act. And second, it establishes a mode of ambiguity. Painterly qualities are almost immediately translated into a formal discourse about history, time, and the transitory nature of reality. At the same time, the assembled objects invite a discussion about the language of redemption. The objects in the still life of a Peto or a Harnett defy history — even if they help to define it by powerfully appealing to memory. The objects, in other words, have been used (abused, just as often) and served a purpose in the past, and yet they maintain a timeless dignity. At no time, however, are we led to forget that it is the work of the artist that achieves this kind of Platonic vision that allows a recollection of the past and that provokes, at the same time, the projection of the innate quality of the object into the future. For the beholder of the individual painting this structuring of time is at once exhilarating and a melancholic experience.

The melancholic reaction is provoked by the passing of time and often by emblems of death and decay, as in the case of Peto's paintings that incorporate the image of Lincoln, a knife, the Star of David, and the dates of Lincoln's birth and death. In his *Office Board for Eli Keen's Sons*, painted in 1888 (present location unknown), Peto juxtaposes the photographs of Keen *père* and his three sons with a calendar as the wider time frame, with a pic-

2. John Haberle (American),
 Torn in Transit, 1890–1895,
 oil on canvas, 34.3 x 43.2 cm.
 Chadds Ford, Pa., Brandywine River Museum,
 Gift of Amanda K. Berls, no. 80.3.12.

3. John Haberle (American),
 Chinese Firecrackers, ca. 1890,
 oil on canvas, 54.3 x 67 cm.
 Hartford, Wadsworth Atheneum, The Ella
 Gallup Sumner and Mary Catlin Sumner
 Collection.

4. John Haberle (American),
 A Bachelor's Drawer, 1890–1894,
 oil on canvas, 50.8 x 91.4 cm.
 New York, The Metropolitan Museum of
 Art, Purchase, 1970, Henry R. Luce Gift,
 no. 1970.193. All Rights Reserved,
 The Metropolitan Museum of Art.

277

ture of the store and a newspaper clipping – the effect being an overall tension between actuality and its constant loss. Frequently, paintings of letter racks represent not only the tangible past in a metaphor, such as an old letter that has been read, but they also represent, in the remainders of cards that have been torn off the board, the disappearance of reality or the destructive force of time. If we look at these paintings only for their stylistic achievement, we miss the point that the allegorical quality of many of the so-called trompe l'oeil paintings by Harnett, Peto, and Haberle lies in their epic aspiration: they do tell an unfinished story, relying for narrative strength on the powerful fragment of quotation.

One would hardly do justice to Harnett, Peto, and Haberle by treating them as a group, overlooking the distinctions between the individual painters. Harnett's precisionism is as clearly his hallmark as a sense of loss is Peto's. Historically, Harnett seems to be closer to the mainstream of American still-life painting of the nineteenth century, while Peto's vision of history turned many of his paintings into tragic comments on the reality they represent within the context of their own contemporary historical matrix. If Barbara Novak can place Harnett in the tradition of conceptual realism, then Peto clearly goes beyond the strictures of the conceptual. In this sense John I. H. Baur's remarks in his essay "Peto and the American Trompe L'Oeil Tradition" need some consideration:

> From early in his career, however, Peto was sensitive to the new impressionist vision which was gradually seeping into American painting at about this time. We do not know what contacts he may have had with this, but its influence is quite apparent in most of his work, as several critics have already pointed out. It caused him to relax that intensity of observation which the *trompe l'oeil* group had used to create a sense of preternatural significance, and to abandon the exact description of texture, weight and density. The object, with Peto, is no longer paramount; it is bathed in palpable light and atmosphere, half lost in shadow and wholly transformed by the conditions of seeing.[12]

Rather than concluding from this observation that Peto's technique led him away from the object and its reality, one should follow Baur's further remarks and their implications that by design Peto was above all preoccupied with the object's reality within the wider historical reality.

278

> But it was in respect to design, space and color that Peto departed most
> radically from the tradition in which he had been raised. His instinctive feel-
> ing for strongly marked, abstract patterns of simple volumes, subtly related,
> has been remarked by everyone who has had an opportunity to study his work
> as a whole. While he was uneven in this, as in most other respects, his best
> work has a closely knit architectural quality quite unusual for its time...they
> show Peto's abiding preference for asymetrical [sic] arrangements brought
> into balance by an innate feeling for the poetry of intervals and formal
> relations. Doubtless it was his fascination with this kind of flat design that
> led him to paint so many "rack" and "patch" pictures.[13]

What Baur identifies as an "innate feeling" is in fact the conscious and mean-
ingful construction of objects related to one another so as to create histori-
cal space. The object, to pursue Barbara Novak's argument, does not lose
its realism but gains a new dimension by becoming an object of a double
contemplation. The composition creates a tension between the object's Pla-
tonic qualities and its place in actual history. Peto's vision, therefore, is struc-
tured by an unresolved paradox. The object can only be saved by being
represented as an artifact of individual perception. Only by appealing to
the intellect of the viewer can the idea of the object be saved from the attacks
made on it by actual history.

Composition and design are the means to persuade the viewer to share
the vision of an alternative history as a history of undecaying ideas. This
redemptive vision is reserved not only for great historical events, as paint-
ings such as *Lincoln and the Star of David* and *Reminiscences of 1865* (fig. 5)
might suggest. A picture such as *Ordinary Objects in the Artist's Creative
Mind* (fig. 6) demonstrates that the artist's redemptive vision also includes
the trivial, leveling by way of self-quotation the difference between the
painted work of art and the objet trouvé. The reverence for the thing seen
is democratic and allows no real focus on any object of primary importance.

In an essay that was written long after his book *After the Hunt* had be-
come a classic, Alfred Frankenstein categorizes the three major Trompe
l'Oeil painters in the following manner, setting them apart from other still-
life artists that he had discovered in the course of his work: "The leaders
were Harnett himself, a flawless precisionist and great composer of forms;
John Frederick Peto, a magnificent colorist and the first artist in history to
make still life a genuinely tragic form; and John Haberle, visual comedian,

5. John Frederick Peto (American),
 Reminiscences of 1865, 1897,
 oil on canvas, 76.9 x 56.4 cm.
 Hartford, Wadsworth Atheneum, The Ella
 Gallup Sumner and Mary Catlin Sumner
 Collection.

6. John Frederick Peto (American),
 *Ordinary Objects in the Artist's Creative
 Mind*, 1887,
 oil on canvas, 143.6 x 84.6 cm.
 Shelburne, Vt., Shelburne Museum,
 no. 27.1.3-19. Photo: Ken Burris.

satirist, and prophet of Pop Art."[14]

Even if some of these attributes help to characterize the individual paint-
ers, they also blur the common quality of the allegorical in the bulk of the
work of the Trompe l'Oeil painters that we are talking about. What they have
in common is a transformation of the traditional *vanitas* motif into a state-
ment about the contemporary world. The modern world of the 1880s was
constantly producing its own past, at an accelerating speed, which in the
eyes of someone like Peto propelled the very new back into a state of origi-
nal innocence. History as an ongoing, functional process became a threat
from which the artist withdrew into the mythical world of objects. One of
the finest examples of the process of derealization at work is Peto's *The Poor
Man's Store* (fig. 7). John Wilmerding in *Important Information Inside* quotes
a contemporary notice about this painting from a Philadelphia newspaper:

> Mr. John F. Peto contributes to the present annual exhibition of the Pennsyl-
> vania Academy of the Fine Arts a study of still life, entitled the "Poor Man's
> Store," which cleverly illustrates a familiar phase of our street life, and pre-
> sents upon canvas one of the most prominent of Philadelphia's distinctive
> features. A rough, ill-constructed board shelf holds the "Poor Man's Store" —
> a half dozen rosy-cheeked apples, some antique gingerbread, a few jars of
> cheap confectionery "Gibraltars" and the like.[15]

The point about this comment is, of course, that it takes things for granted
that are not part of the painting. The familiarity that the critic claims is the
result of having added to the still life exactly those elements that it leaves
out: *pars pro toto*, the "street life."

The meaning of the painting lies in the fact that it is not part of a func-
tioning process in operation. The poor man's store is taken out of its con-
text, of which it reminds the viewer by showing the opposite; its meaning, in
other words, lies elsewhere. As a result, we are not directly confronted with
a social situation of poverty and the fight against it; we are not, in other
words, invited to examine a document that intends to criticize a social con-
dition. In the end, of course, we cannot avoid *thinking* about the realistic
situation behind the painting, but far more important is what we see and
the fact that we have to take a detour in order to reintegrate the segment of
reality into its social context. Isolating the objects from the context of their
use means representing a miniature utopian world where the direct sense

7. John Frederick Peto (American),
 The Poor Man's Store, 1885,
 oil on canvas and wood, 91.4 x 64.8 cm.
 Boston, Museum of Fine Arts, Gift of Maxim
 Karolik to the Karolik Collection of Ameri-
 can Paintings, 1815–1865, no. 62.278.

impression counts and a childlike awe is provoked by the single object that for a brief moment is not a commodity but a representation of achieved form. The gingerbread horse, the apples, and the candy could just as well be gifts under a Christmas tree. Poverty remains the dominant note, but the aesthetic dignity of the arranged objects reflects upon the absent owner of the shop. John Wilmerding makes a formidable point when he emphasizes the similarity between the vision of Peto and that of Walker Evans, the photographer of the 1930s.

> Peto's image of this gentle corner of humanity, with its casual yet careful record of individual presence, calls to mind strikingly similar arrangements isolated by the camera of Walker Evans in the 1930s.... Like Peto, Evans brought an eye to his subject matter that cared as much for the reality of things as for the aesthetics of abstract form. Instead of store shelves, a crude table and shallow mantle serve the same effect of turning this plain Alabama fireplace into a secular altar. With reverence objects of use are placed on these boards; the mantlepiece is given simple decoration by the cut paper strip; and on the nearby wall planking are affixed the visual signs of peoples' [sic] passing lives.[16]

The similarity that Wilmerding points out is not one of mere chance, and neither is the iconographical style in question the result of a specific social condition, namely that of poverty. Both the celebration of the common object by the still-life painters of the 1880s and Walker Evans's obsession with road signs, billboards, and interiors of country stores are part of a more general current in American culture. This current kept on grappling with the development of an artistic idiom that tried to resist the effects of socialization — in other words, it was still obsessed by the presence of the sacred within the profane. This Puritan tradition went through many changes as the social and cultural context within which it was expressed changed. But the problem remained the same, and transformed into the language of allegory it would repeat in an industrial capitalist environment the old quest for the clues to radical innocence.

The sense of illusion, then, is to remind the viewer of history's eternal fragility and preserve a sense of the absolute and concrete. The metaphysical materialism, which has so often inspired the anthropological imagination of critics of culture and which equally often has been delegated to the

niche of folk art, is, to a much larger degree than modern, diversified criticism allows itself to realize, a remnant of the Puritan ethos that everyday experience contains, potentially, the sudden revelation of something hidden, not *behind* but *within* the surface of appearance. The religious and aesthetic dimensions of this Puritan legacy had near the end of the nineteenth century become inextricably interwoven and would become even more so as the process of secularization continued. Both the quest for experience in the work of Henry Adams and William James and their view of the individual's role within the context of the historical and social process demonstrate the vitality of the Puritan legacy. At the same time, when the still-life painters of the late nineteenth century were, for a brief period, just as puzzlingly modern as they were part of a tradition, Henry Adams, in his own hyperbolic rhetoric was once again outlining the full drama of the errand, when he wrote: "Indeed, the American people had no idea at all; they were wandering in a wilderness much more sandy than the Hebrews had ever trodden about Sinai; they had neither serpents nor golden calves to worship. They had lost the sense of worship; for the idea that they worshipped money seemed a delusion."[17]

Could one think of a better expression of this sense of bewilderment than John Haberle's stark allegory, probably painted in the mid-1890s, adequately titled *Time and Eternity* (fig. 8)? And should one not perhaps pursue the suppressed kenotic element in both Puritanism, Transcendentalism, and pragmatism as the path toward Modernism, the kind of Modernism that Irving Howe meant when he described it as something that is dialectically defined as a phenomenon that must struggle for its success but is doomed to find its *meaning* in the struggle and not in the achievement of success?

The idea of the kenotic tradition in American intellectual history needs some explaining, especially when applied to painting. Originally an inherent part of Christianity's beginning, kenosis became a central point of theological discussion within the Puritan debate about the whole issue of conversion. Dominant as the theology of conversion might have been, the question came up, whether the ritual of conversion was really essential for salvation. The deviant (but exegetically not unreasonable) point of view was that the total and absolute acceptance of man's difference from God was not the *only* way to see God as the supreme being. This being the premise, man and things justified and testified to the existence of God by being exactly what they appeared to be, or to put it metaphorically, *there is no*

8. John Haberle (American),
Time and Eternity, ca. 1890,
oil on canvas, 35.9 x 25.6 cm.
New Britain, Conn., New Britain Museum of
American Art, Stephen Lawrence Fund, no.
1952.1. Photo: E. Irving Blomstrann.

important information inside. Thus, what Herman Melville tries to tell us in the *The Confidence Man* — namely, that there is no hidden plot or secret character involved, and the world is but an ongoing masquerade — is what the Trompe l'Oeil painters try to express as well. The surface is real, but to make this point you need art.

Notes

1. Roxana Barry, *Plane Truths: American Trompe L'Oeil Painting*, exh. cat. (Katonah, N.Y.: Katonah Gallery, 1980); idem, "Plane Truths: Nineteenth-Century American Trompe l'Oeil Painting," *Art & Antiques* 4, no. 5 (September/October 1981): 100–107; John I. H. Baur, "Peto and the American Trompe l'Oeil Tradition," *Magazine of Art* 43 (May 1950): 182–85; Wolfgang Born, *Still-Life Painting in America* (New York: Oxford Univ. Press, 1947); Alfred Frankenstein, *After the Hunt: William Harnett and Other American Still Life Painters, 1870–1900*, rev. ed. (Berkeley and Los Angeles: Univ. of California Press, 1969); Lloyd Goodrich, "Harnett and Peto: A Note on Style," *The Art Bulletin* 31, no. 1 (March 1949): 57–59; John Wilmerding, *Important Information Inside: The Art of John F. Peto and the Idea of Still-Life Painting in Nineteenth-Century America*, exh. cat. (Washington, D.C.: National Gallery of Art, 1983).

2. William James, *Manuscript Essays and Notes*, The Works of William James (Cambridge, Mass.: Harvard Univ. Press, 1988), 18: 21.

3. Ibid., 22 (emphasis in original).

4. Martin Heidegger, *What Is a Thing* (South Bend: Regnery, 1967), 243 (emphasis in original).

5. James (see note 2), 35 (emphasis in original).

6. *The Education of Henry Adams*, ed. Ernest Samuels (Washington, D.C.: Henry Adams, 1907; reprint, Boston: Houghton Mifflin, 1973), xxx.

7. Ibid.

8. Born (see note 1), 3.

9. Wilmerding (see note 1), 53.

10. Frankenstein (see note 1), 31.

11. James (see note 2), 42–44.

12. Baur (see note 1): 182.

13. Ibid., 183.

14. Alfred Frankenstein, "Illusion and Reality," *Horizon* 22 (July 1979): 27.

15. Wilmerding (see note 1), 95–96.

16. Ibid., 97.

17. Adams (see note 6), 328.

1. Thomas Eakins (American),
 Portrait of Professor William D. Marks, 1886,
 oil on canvas, 195.8 x 138.8 cm.
 Saint Louis, Washington University Gallery
 of Art, University Purchase, Yeatman Fund,
 1936, no. WU 2944.

Kathleen Pyne

Resisting Modernism

American Painting in the Culture of Conflict

Although the volume of literature on Modernism is vast, the enterprise of defining the concept still presents a challenge to students of this phenomenon. For example, in their anthology *The Modern Tradition* Richard Ellman and Charles Feidelson concluded that the task of arriving at any precise understanding of Modernism was a problem still awaiting resolution. To begin an analysis of any element of the problem, however, some conception of the matrix of values that are usually evoked by the term Modernism must be set down. For our purposes, then, a few of the classic formulations of canonical Modernism will be called into play to illustrate the way in which the paradigm of Modernism has been promoted in the middle decades of this century.

To many, Modernism "has come to denote a family of artistic and intellectual movements that have been radically experimental, spiritually turbulent and militant, iconoclastic to the point of nihilism, apocalyptic in their hopes and fantasies, savagely destructive to one another — and often to themselves as well — yet capable of recurrent self-renewal."[1] A second, equally accepted understanding of Modernism, directly bearing on pictorial vision, is that it constitutes a new way of seeing. Modernism is thus a mode that strives "to undermine, to readjust" or to reframe our vision, which in turn denies "validity" to the previous order of human affairs.[2] The modern cosmos is usually construed as a world in which the center no longer holds things together. It is a world that only capriciously reveals its true reality to humankind, with the consequences that human experience is often contradictory and irrational, and uncertainty rules moral and religious life.[3]

If we have been more or less certain about which European painters, as

well as which American and European writers, conformed to these programs, we have been much less comfortable with admitting to the canon American painters of the 1880s and 1890s — with the exception, of course, of Thomas Eakins, Winslow Homer, and Albert Pinkham Ryder. Of late, however, American painters of this period are being judged more frequently in the context of their French contemporaries, with the result that the Americans are usually found lacking in their refusal to employ a sufficiently radical vision. Their technique never approaches the boldness of Claude Monet's, nor is their point of view as iconoclastic as Edouard Manet's.[4] Unquestionably, American art of the 1890s lacks many of the values deemed intrinsic to European Modernism at that historical moment. We should consider, however, that American art might be directed to other issues more central to its own cultural dilemmas. If this is true, then an examination of the special conditions of American life in the 1890s would lead to a better understanding of the particular aesthetic decisions made by the American painters deemed Tonalists and Impressionists. The meaning of certain artistic strategies will become clearer in light of the specific cultural context. This essay will explore the cultural sources of the American resistance to Modernism and how that resistance is embodied in American painting of the 1890s, with special attention given to the relation of American evolutionary thought to Modernism.

Though Americans had ample contact with modernistic European tendencies from the post–Civil War period on, it is difficult to think of instances when they permitted the central myths of Modernism to occupy the powerful realm of the canvas. At the heart of Modernism is the myth of an environment so mechanized and regularized that it mandates a dehumanized experience of the world. To name an obvious example, Gustave Caillebotte's composition *Paris Street; Rainy Day* (see p. 327) embodies the essence of this condition in its picturing of individuals as isolated, anonymous, and passive spectators of the urban scene. Another succinct metaphor for dehumanization was offered in the Baudelairean image of the prostitute whose identity is inseparable from the use of her body as an impersonalized commodity. In contrast to the central place of sexuality and prostitution in the works of Manet and Edgar Degas, few American artists adopted the image of the prostitute.[5] Instead, the female figure in American painting remained an object of beauty, revered by the painter and veiled in her "natural" mystique of fecundity and spirituality.

2. Claude Monet (French),
 Monet's House at Argenteuil
 (*La maison de l'artiste à Argenteuil*), 1873,
 oil on canvas, 60.2 x 73.3 cm.
 Chicago, The Art Institute of Chicago, Mr. and
 Mrs. Martin A. Ryerson Collection, 1933.1153.
 ©1992 The Art Institute of Chicago,
 All Rights Reserved.

3. Childe Hassam (American),
 Gathering Flowers in a French Garden, 1888,
 oil on canvas, 71.8 x 55.4 cm.
 Worcester, Mass., Worcester Art Museum,
 Theodore T. and Mary G. Ellis Collection,
 no. 1940.87.

If Modernism is also a new way of seeing that readjusts or reframes our vision, Monet's art certainly has a claim to the modernist canon by virtue of its experimentation with color and light. One historian, however, has recently found Monet's suburban scenes to exemplify the socially uncritical viewpoint of the average bourgeois (fig. 2).[6] Significantly, the typical strategy of the American painter, such as Childe Hassam or William Merritt Chase, in approaching the modern urban experience, was to follow Monet's lead and turn to the landscape of the *hortus conclusus* (fig. 3). The parklike setting of cityscapes, such as those depicted by Hassam and Chase, served as a middle ground in which the beauty and normative influence of nature could ameliorate the potential dangers of the urban environment.[7] In uncrowded, ordered spaces filled with air and sunshine, individuals could still realize their singularity, yet they were not cut off from the whole and alienated in the sense that Caillebotte's Parisians were.

The reasons for the necessity to maintain this sense of a unified, harmoniously ordered world are deeply rooted in the conditions of American life in this period, as well as in the ideology Americans developed in response to those conditions. Social historians have made us well aware of the problems and events that plagued American life in the period between the Centennial celebration of 1876 and the Chicago World's Columbian Exposition of 1893. For example, the waves of immigrants from the south and east of Europe flooding into the Northeast in the 1880s created new tensions between social classes and ethnic groups. In addition to this, the tens of thousands of strikes in industry, which mounted to a pitch of increasing violence in this period, inspired a national hysteria over the foreign, supposedly anarchist, element in the country. On top of labor unrest, a major economic depression, from 1873 to 1896, seemed to menace the corporate establishment.[8] Put simply, Americans feared that the unity of the nation, so recently preserved, was again being threatened, this time by the possibilities of a class war and a cultural Babel.

In searching for evidence of these tensions, we sift almost in vain through the fine arts of the period. In the late 1880s Jacob Riis designed his photojournalistic essays (fig. 4) to awaken the middle class to the plight of immigrants living in the unconscionable squalor of Lower Manhattan, where half of New York's population was crammed into some thirty-nine thousand tenements, many without indoor toilets or water.[9] Acknowledgment of such dilemmas in paintings, however, is almost nonexistent until the work of The

292

4. Jacob A. Riis (American),
*In the Home of an Italian Rag-picker,
Jersey Street*, n.d., photograph.
New York, Museum of the City of New York,
The Jacob A. Riis Collection, no. 157.

5. James McNeill Whistler (American),
The White Symphony – Three Girls, ca. 1868,
oil on prepared board mounted on wood
panel, 46.4 x 61.6 cm.
Washington, D.C., Freer Gallery of Art,
Smithsonian Institution, no. 02.138.

Eight, and then, with the exception of John Sloan, the approach of Robert Henri and his circle is more celebratory of the vital energy of the lower classes than critical of their living conditions. Indeed, from the evidence of their painted work, American artists strove to avert their gaze from the social ills of large cities. In place of selecting any socially objectionable aspect of the urban scene, they evolved an art of traditional domestic concerns that was subtly prescriptive and even mildly utopian. Harmony, unity, and repose — the shibboleths of critics in this period — were prized in every cultural endeavor, precisely because these values seemed to be imperiled on all fronts.

It is not that these American Impressionist and Tonalist painters were unresponsive to social and political ideologies, but neither were these aesthetic modes merely tools capitalists used as expedient means to display their newly acquired power and wealth, nor were they intended to pacify the underprivileged masses and dazzle consumers into purchases.[10] By and large, American artists responded less to the desires of robber barons and merchant princes than they did to the needs of middle-class, Anglo-Saxon Protestants like themselves. Americans' fears of social discord and economic upheaval seem to offer convincing explanations for the conservatism of upper-middle-class Anglo-American culture. Yet, at this complex moment another facet of the American experience proffers an equally compelling context for its resistance to Modernism, namely the atmosphere of doubt resulting from the attacks that scientists were judged to be mounting on the foundations of liberal Protestant belief. For several recent theorists of nineteenth-century American culture, liberal Protestantism has figured as a whipping post upon which the failings of the culture can be publicly flogged.[11] Nevertheless, in considering the compulsion Americans felt to preserve traditional beliefs in the existence of the human soul and a spiritual dimension in the universe, we begin to approach an important ideological category that helps to explain why the American environment produced a paradigm of Modernism distinct from that of Europe. To the generation that matured in the 1880s and 1890s, the warfare between science and religion was deemed just as disruptive to the social order as the warfare that threatened between "native" Anglo and "foreign" communities.

In the 1860s and 1870s French artists and intellectuals may well have responded to Auguste Comte's agnostic vision of the world in which traditional Christian beliefs were replaced by positivist faith in human knowl-

edge and science. In the same decades a legion of British thinkers converted to a variety of agnostic beliefs under the pressures of biblical criticism and scientific naturalism.[12] Americans, however, refused to give up their historical convictions so quickly. For many, the period of the 1880s and 1890s was an "Age of Pain," as the philosopher Charles Peirce called it, an age in which suicides and nervous collapse became increasingly commonplace phenomena, especially in the Northeast.[13] Americans, however, proved to be extremely industrious in accommodating the new science to the old faith. In this task they received assistance from neither Charles Darwin nor Comte, but from the British philosopher Herbert Spencer. As James R. Moore has shown in his authoritative study *The Post-Darwinian Controversies*, Americans might have invoked Darwin's name, in using the popular term "Darwinism," to denote evolutionary theory in general, but it was Spencer who lent them the strategy by which the new science could be invested with their established beliefs in a spiritual dimension of the universe.[14]

Spencer's ten-volume work, *The System of Synthetic Philosophy* (1862–1896), provided an alternative evolutionary system to Darwin's delineation of cruelty, violence, and waste as the order of nature. Darwin had stressed the mechanism of natural selection — a process that, he was forced to admit, inadvertently produced ugliness, random mutations, and a struggle for survival in which the fittest, not necessarily the good, triumphed. In contrast, Spencer insisted upon adaptation to the environment as the principal mechanism of evolution and envisioned evolutionary change taking place in a spiral of progress upward to higher forms of life, as "incoherent" uniformity gave way to a higher "coherent" complexity. Though Spencer's grand unifying theory struck many of his compatriots as nonsense, it assumed the dimensions of a new gospel for Americans because it was compatible with traditional religious belief. Promising that *Homo sapiens* was different in kind from the lower animals, Spencer's system of evolution presented an optimistic view of human destiny.[15] If change took place through adaptation to the environment, as Spencer maintained, then men and women could shape that environment and the future, as his American followers, such as Lester Frank Ward, were quick to point out.

In America, Spencer's scientific naturalism also had the effect of revitalizing the familiar Transcendentalist credo. As James Turner has shown, at mid-century Ralph Waldo Emerson's radical views had seemed difficult for the public to swallow whole. By the end of the Civil War, however, Ameri-

cans were rapidly assimilating his perception of spiritual influx in nature and mankind into the heart religion of Protestant Evangelicalism.[16] Between Emerson's death in 1882 and the end of the century, faith in Transcendentalism continued to grow in the Northeastern Anglo-American community.[17] While Darwin had limited the scope of his inquiry to establishing a theory of biological science, Spencer's sweeping generalities left the door wide open for theological application. Spencer's American disciples — John Fiske, for example — translated his secularized language into religious terms; "energy" became "divine energy," and "force" became "spiritual force."[18] Emerson's world of unity-in-diversity was thus easily conflated with this pantheistic evolutionary universe pervaded by an underlying spiritual energy, an energy that impelled the spiraling development of life upward, toward higher, more complex and intelligent forms. By the late nineteenth century, a hybrid natural religion, composed of pantheism and Spencer's science, was prevalent in both popular and intellectual discourse, especially around Boston and Cambridge, where aesthetes, such as Bernard Berenson and Ernest Fenollosa, nurtured themselves on the writings of Emerson, Spencer, and Georg Wilhelm Friedrich Hegel.[19]

While Darwin revealed a forbidding picture of nature — "red in tooth and claw" — Spencer, then, at the same moment provided reinforcement for ideologies already in place. By controlling the environment, he counseled, humankind could direct the evolution of civilization toward altruism and pacifism, away from the state of competition and combat endemic to the lower animal kingdom. Prompted by this imperative to shape a more desirable, harmonious environment, a formidable burden now fell upon artists and architects, as well as social theorists and educators. The aesthetic movement, as it grew after the Philadelphia Centennial Exposition of 1876, fostered a new awareness of the psychic comfort — the sense of refuge from the competition of the marketplace — that was to be obtained in the house beautiful. Although premised on a racist hierarchy of cultures, the Chicago World's Columbian Exposition of 1893 similarly led great numbers of Americans to visualize the utopian possibilities of the unified urban environment.[20]

The need to advance a utopian social model must have seemed all the greater in light of the urgency of the moment, warranted by the elevated degree of social unrest. The descendants of the original Anglo-Saxon Protestant settlers, who controlled the nation's cultural institutions, perceived their hegemony to be challenged by immigrants of largely Catholic and

Jewish composition. Brooks Adams, for example, feared that the loss of vital energy within his own patrician class would lead to social anarchy, while other members of New England's elite responded by organizing the Immigration Restriction League.[21] The idea that the American Anglo-Saxon population would achieve world eminence, given its physical energy and moral superiority, had earlier been promoted by Darwin in his *Descent of Man* of 1871.[22] Spencer, on his trip to New York City in 1882, reinforced the American right to claim evolutionary predominance and assured his audience that, in spite of America's current social problems,

> the eventual mixture of the allied varieties of the Aryan race forming the population will produce a finer type of man than has hitherto existed, and a type of man more plastic, more adaptable, more capable of undergoing the modifications needful for complete social life.... Americans may reasonably look forward to a time when they will have produced a civilization grander than any the world has known.[23]

However, Spencer also warned against stressful habits of overwork and the frenetic pace of modern life. Americans, he said, should allow for more repose and relaxation, or competitors would take advantage of their "damaged constitutions" that were bound to "reappear" in the next generation.[24]

Culture, then, had to be instilled with unity, harmony, and repose in order to guide human evolution along an ascending course. This problem could be approached from the standpoint of constructing a desirable external environment, but it could also be redressed, as Spencer submitted, through the means of self-culture, through refining the world within. While French, German, and Viennese scientists, such as Sigmund Freud, were probing the recesses of the unconscious, William James and his colleagues in the Society for Psychical Research were at the same time also avidly pursuing this study — but from a different philosophical position. The atheistic Freud saw the unconscious as the seat of the darker sexual and aggressive instincts, while the agnostic James pushed to discover there a point of contact with some higher spiritual realm.

In attempting to obtain empirical confirmation of a nonmaterial universe, James merely shared in his generation's crisis of faith, as well as the general willingness to embrace beliefs as dubious as Spiritualism. Both his experiments with the medium Mrs. Piper and his efforts to come to terms

PYNE

with his own neuroses through contemporary meditational therapies vividly illustrate the real requirements of Americans — including scientists — at this juncture in history for reassurance in the face of overwhelming change. James wanted Americans to fight the good fight (that is, adopt activist strategies to combat social evils), but like others of his milieu, he was forced to admit the high personal costs exacted by such strenuous intellectual and moral engagement.[25]

Like scientists and clergy, American painters in the 1890s were, consciously or unconsciously, caught up in the issues that signify the resistance to the positivism characteristic of European Modernism. For Americans, the touchstone of this resistance was the Tonalist mode of James Abbott McNeill Whistler. The curator and educator Fenollosa was drawn to Whistler's work because it exemplified the way in which "harmonious spacing" could induce "harmonious living." A student of Spencer and Hegel, Fenollosa awaited an aestheticized American environment that would propel the evolution of civilization toward a new universal order — a "higher" culture that was to be a dialectical synthesis of East and West. Conveniently, for Fenollosa Whistler represented "the meeting-point of the two great continental streams,…the nodule, the universalizer, the interpreter of East to West, and of West to East."[26] Whistler's aesthetic principles, drawn from Japanese and Greek art, Fenellosa thought implicitly embodied a vision of a unified, utopian world. *The White Symphony – Three Girls* (fig. 5) from *The Six Projects*, circa 1868, for example, shows Whistler early in his career, working out this assimilation of East into West in terms of harmonious spacing and formal rhythms.[27] Such principles, according to Fenollosa, could be instrumental in redesigning the industrial urban and domestic environments, in a manner similar to the way in which Whistler's "nocturnes" (fig. 6) demonstrated how harmonious spacing might transform an industrial landscape, that along the Thames, into a sublime vision of a utopian cosmopolis.[28] The foundation of Whistler's art, Fenollosa discerned, was located in the gray chords, which pulsated with "imprisoned colors." These grays suggested the Hegelian dynamic of the many unified into the one, spirit and sense ever resolving into harmonious form.[29] Thus, Whistler's art held out, not only the possibility of transcendent experience for the individual viewer but also ideological instruction for a mode of social and political unity.

Like-minded American critics — Charles Caffin and Sadakichi Hartmann, to name just two of the more obvious — received Whistler's images

298

6. James McNeill Whistler (American),
 *Nocturne in Blue and Gold: Old Battersea
 Bridge*, 1872–1873,
 oil on canvas, 68.6 x 51.3 cm.
 London, Tate Gallery, no. NO 1959.

299

7. Thomas W. Dewing (American),
 The Hermit Thrush, ca. 1893,
 oil on canvas, 88.1 x 117 cm.
 Washington, D.C., National Museum of
 American Art, Smithsonian Institution, Gift
 of John Gellatly, no. 1929.6.39.

and those of his American followers in much the same vein.[30] In the works of Thomas W. Dewing and John Henry Twachtman the aesthetics of Whistler's art, as well as the Japanese print, have been thoroughly internalized. Here, sensuousness is offered as the means of engagement both with nature and with the painting itself. The artful sensuousness of the surface is employed, in reality, not so much for the sake of the insensate art object – which was a rhetoric much voiced by the Americans attuned to Whistler. Rather, beauty is presented for the sake of the viewer; it offers personal delectation and the opportunity for self-culture.

Dewing's New England nature drama *The Hermit Thrush* of circa 1893 (fig. 7) affords a cogent example of this therapeutic use of the Tonalist mode. In the loosely brushed-in foreground various cool and warm opalescent hues shift almost imperceptibly through the long grass, while in the background the highly condensed form of the pine tree shelters the elusive bird. Occupying the middle ground are two young women whose delicate forms speak of the higher consciousness that is to be obtained from the apprehension of melodic sight and sound in concert. In Dewing's world these women represent "what was most civilized," and the "farthest removed from what was animal."[31] The tree's sweeping rhythms rivet our attention and provide a synesthetic metaphor – a "speaking body" – for the thrush's plaintive, oboelike song. It is thus through absorption in the hidden, elusive spirit of nature, through unification with the boundless energy that flows through the world, the painting tells us, that we can gain the transcendent experience for the self-refinement exemplifed by the two women.[32] This therapeutic benefit, however, is also to be received from imaginative absorption in the work of art. The powdery texture and subtly flowing color of the surface elicit the viewer's meditative immersion into its abstract rhythms, just as the women's rapt attention to the bird encourages the observer's empathy with their mystical experience in that dematerialized, dreamlike reality.

This is precisely how Dewing's ideal patron, Charles Lang Freer, used paintings by Whistler, Dewing, Twachtman, and others as well as the Chinese scrolls and Japanese screens in his collection. As he meditated on the rarefied image, Freer believed that its talismanic powers would provide him with emotional and physical restoration.[33] Art, like nature, when approached in quiet, solitary contemplation, could soothe the nerves and take one out of the restricted confines of the self – could unify the beholder

301

with the spiritual effluence of the world.[34]

Both Twachtman's and Dewing's works advance a prescriptive view of the world as peaceful and harmonious, and like Whistler's, they promote a religion of art — a belief in the capacity of art to sustain a transcendent, psychically redemptive experience. Twachtman's dematerialized Connecticut landscapes were likewise conceived for the purpose of psychic comfort. *Winter Harmony*, circa 1890–1900 (fig. 8), is typical of his pictures of this period, which one critic in 1891 judged "not fit for the struggle of life in a contemporary exhibition gallery." In the winter scenes he became known for, Twachtman attempted to summon up the mystery of the unseen, in which only silence can intimate the inexpressible.[35] The empathic merging with the shadow world of *Winter Harmony*, for example, allows the viewer a freedom from the burdens of gravity, a sensation of floating and weightlessness that is posed in the flattened form of the brook and the attenuated shapes of the trees. Such an experience of quiescence restores psychic balance,[36] it was perceived, so that the viewer can go back into the fray with renewed vitality.

Twachtman was exploring Asian philosophy and aesthetic strategies at a time when the vogue for Asian thought and art was at a high point in American culture. Emerson and his circle had earlier immersed themselves in the sacred books of the East, only to find reverberations of their own idealism. Perhaps predictably, this influx of Asian thought now also served to reinforce Transcendentalism.[37] In *Icebound*, 1889–1900 (fig. 9), Twachtman flaunted his familiarity with the Japanese print in the use of conceptual shape and the all-over surface. Emulating the vision of the Asian artist, he thought, could instill his art with an antibourgeois, antimaterialistic expression. Like Dewing, Twachtman worked toward a thin, but complex, surface, washed with iridescent tones that shift into one another. For Freer, Whistler, Dewing, and Twachtman, the ability to discern and appreciate these subtleties of surface, as well as the nuances of nature's aristocratic moods, marked the viewer as a member of an elite order of consciousness.[38]

In recent years, Twachtman's painting has been compared to that of Monet. In some ways the two artists independently approached one another's vision, but only after Monet had left behind his high Impressionist mode, which celebrated an immediate present. In 1887 Monet had stayed with Whistler in London, and in the 1890s Monet resumed his interest in the works of J. M. W. Turner and Jean-Baptiste-Camille Corot and began to focus

on themes of a private, timeless world that was closer to the vision of the Symbolist.[39] In these years he also became more entranced with the mystery of nature in its veiled unity than with the reflections of bright light and the fragmentation of form. In landscapes such as the Morning on the Seine series of 1896–1897 (fig. 10), Monet's reaching for a retrospective mood of mystery and silence recalls a few of Twachtman's images of bodies of water, for example, *Springtime*, circa 1883–1885 (Cincinnati, Cincinnati Art Museum, no. 1908.1218). Twachtman's landscapes of the early 1890s, however, seem to anticipate the purpose Monet conceived for his later *nymphéas*. In 1909 Monet related that he hoped his great watery environments would "offer an asylum of peaceful meditation at the center of a flowery aquarium" and that "nerves overstrained by work would be relaxed there, following the restful example of the still waters."[40]

For Twachtman, winter presented the perfect pictorial motif for the anti-materialistic, inexpressible sentiments he strove to elicit. Time and again in the reiterated image of the brook on his farm, the fluid atmosphere and mantle of snow transform the earth into a reverie. Nature here has entered a state of suspension, not death. And yet how differently the winter landscape could be interpreted at this historical moment is instantly apparent when Winslow Homer's magnificent epic of nature's cruelty, *The Fox Hunt* of 1893 (fig. 11), is contrasted. While Homer's work is also informed by the spatial play of the Japanese print, it, more importantly, represents a view of nature outside of, and even opposite to, Twachtman's Spencerian synthesis and repose. Homer's world exemplifies the Darwinian order, in which nature is beautiful but also cold and impassive to the outcome of the struggle for survival.[41] In his mature works of the 1880s and 1890s, Homer repeatedly proved himself a dissenter from the dominant view of the world as harmony and unity. As in *Eight Bells*, 1886 (Andover, Mass., Addison Gallery of American Art, Phillips Academy, no. 1930.379), and *The Fog Warning*, 1885 (Boston, Museum of Fine Arts, no. 94.72), man is alone in a hostile universe with only his intellect and his skill as a toolmaker to guide himself through crises. In Homer's Darwinian view, nature is now confronted as a secularized sublime force, and man, as he is pitted against this force, attains a regenerate heroic status.[42]

In his perception of life as a contest that exacts a strenuous as opposed to a passive response, Homer's ideological correspondent was, of course, Thomas Eakins. Either physically animated or intellectually engaged, the

303

8. John Henry Twachtman (American),
 Winter Harmony, ca. 1890–1900,
 oil on canvas, 65.3 x 81.2 cm.
 Washington, D.C., National Gallery of Art,
 Gift of the Avalon Foundation, no. 1964.22.1.

9. John Henry Twachtman (American),
 Icebound, 1889–1900,
 oil on canvas, 64.1 x 76.5 cm.
 Chicago, The Art Institute of Chicago,
 Friends of American Art Collection,
 no. 1917.200.
 ©1987 The Art Institute of Chicago,
 All Rights Reserved.

10. Claude Monet (French),
 Morning on the Seine near Giverny,
 1896–1897,
 oil on canvas, 81.6 x 93 cm.
 New York, The Metropolitan Museum of
 Art, Bequest of Julia W. Emmons, 1956,
 no. 56.135.4. All Rights Reserved,
 The Metropolitan Museum of Art.

305

11. Winslow Homer (American),
 The Fox Hunt, 1893,
 oil on canvas, 97.4 x 174.4 cm.
 Philadelphia, The Pennsylvania Academy of
 the Fine Arts, Joseph E. Temple Fund,
 no. 1894.4.

athletes, scientists, and musicians he portrayed (see fig. 1) signify the profound extent to which Eakins's world is man-centered. He revered the human body, and he worshiped the human intellectual power to create transcendent works of art, as well as the human capacity to understand the world through the empirical study of nature. In the late portraits of his heroic Philadelphians, Eakins traced his sitters' individual histories in the lines of their faces and recorded, sometimes even projected, the marks of the hundreds of adverse incidents that would appear over time. Eakins's human race seems worn down by assaults to the body and soul, reflecting, perhaps, his personal sense of defeat and resignation in these years.

As Barbara Weinberg has observed, it was Homer, Eakins, and Ryder whom historians in the 1930s and 1940s singled out as the saving remnant of nineteenth-century painting.[43] In the cases of Homer and Eakins, this reasoning not only reflects the search for a usable past, a nativist tradition, in late nineteenth-century art but also conforms with the shift in worldview that occurred with the outbreak of World War I. The human slaughter on the battlefields of France confirmed the Darwinian model of reality and made the Spencerian ideology no longer tenable or defensible.[44] Both Homer's and Eakins's works implicitly acknowledged the presence of evil in the world, just as Whistler and his followers had optimistically denied it. The pessimism of European naturalist literature, in which humans are caught in the forces of a blind and purposeless universe, seemed to be echoed in the dark vision of Homer and Eakins. And the requisite description of Modernists as disappointed, alienated individuals who cut across the grain of polite Victorian morality and social norms was also satisfied in the grim personal histories of both Eakins and Homer. The third *isolato*, Ryder, harbored an intuition of the world as a place of supernatural mystery (fig. 12) but put forward a sufficiently difficult imagery and hermetic personality to qualify also as a nascent American Modernist.[45]

The tradition of conceiving the world as unified by a mystical force did not meet its end at the turn of the century, however, for this legacy was inherited by the group around Alfred Stieglitz — especially by Arthur Dove and Marsden Hartley, who were responsible for many of the first completely abstract compositions in America. Hartley, Stieglitz, and Edward Steichen all proceeded from a nature mysticism that, directly or indirectly, was inspired by Emerson's writings. During the first decade of the century both Stieglitz and Steichen remained under the spell of Whistler's soulscapes,

306

12. Albert Pinkham Ryder (American),
Moonlit Cove, 1880–1890,
oil on canvas, 35.9 x 43.5 cm.
Washington, D.C., The Phillips Collection,
no. 1708. ©The Phillips Collection.

307

while they came to Emerson's ideas through the writings of the Belgian Symbolist Maurice Maeterlinck, who venerated Emerson and had translated his works.[46] Georgia O'Keeffe and Max Weber inherited Fenollosa's belief in the redemptive experience of sensuous art through the teachings of Arthur Wesley Dow. In the 1880s Dow had first traded his stern Calvinist beliefs for an aesthetic religiosity and then, early in the next decade, while working under Fenollosa at Boston's Museum of Fine Arts, he converted to Fenollosa's faith in a universal artistic mode synthesized from East and West and its power to reform the environment. Presiding over classes at the Teachers' College of Columbia University during the critical period of these artists' first abstractions in 1910–1914, Dow led a generation toward a system of design based on Japanese aesthetic principles that he had set down in print in 1899 in his influential textbook *Composition*.[47]

The simplified rhythmic movements of O'Keeffe's and Dove's abstractions from nature reflect a concern with the unity of the world and imply the presence of a mysterious life-force. Inspired by the mysticism of Twachtman and Ryder — as well as the words of Emerson, John Ruskin, and Maeterlinck — Hartley also translated his religious longings into landscape painting and approached nature as a therapeutic source for the human psyche.[48] The publication in *Camera Work* of Henri-Louis Bergson's ideas on the essential duration of human consciousness acted within the Stieglitz circle to cross-fertilize the Emersonian view of art and nature as twin therapies. The appearance of Wassily Kandinsky's theories from his meditation *On the Spiritual in Art* (1912) in the same journal further abetted the mystical tendency of these artists to locate the immaterial effluence of nature in musical movements of pure colors and abstract forms.[49] Working in New York at the same time as these artists, Arthur B. Davies — the organizer of the Armory Show of 1913 in which European Modernist painting was first unveiled to the American public on an immense scale — maintained decided interests in esoteric Tantric beliefs and Theosophy.[50] Davies's ventures into the occult perhaps partially account for the ethereal presences of his nude female figures, who drift across the surfaces of his canvases. As their undulating movements reciprocate the contours of the landscape, these women seek to reach a higher plane of experience through their dancelike unity with nature.

This tradition of Modernism that is defined through intuitive and mystical experience can be observed to extend even farther into American paint-

ing of the twentieth century. In search of mystical experience in which the self becomes unified with the universe, abstract painters such as Barnett Newman, Mark Rothko, Ad Reinhardt, and Jackson Pollock, probed sources as diverse as the writings of mystics — from Emanuel Swedenborg to Emerson to Mme Blavatsky, William James, and Rudolf Steiner; the ritualistic objects of Native American culture, for example, masks, carvings, and pictographs; or the paintings of Albert Pinkham Ryder. These painters no doubt publicly refuted any overt religious meaning for their art in order to escape attachment to a belief system and didactic verbalization of the image that would in turn rob the image of its power. In place of verbalization, the paintings of Rothko typically call for an atmosphere of silence in their offering the viewer a surrogate spiritual experience, much as the landscapes of John Twachtman do.[51]

These connections thus propose that the relationship between the generation of the 1890s and canonical Modernism is rather complex. Whistler and the American Tonalists displayed the symbolism, the privatism, the self-consciousness, and the obscurity of Modernism, but they refused to lose sight of the eternal invested in the fleeting phenomena of this world. Though they learned technique from the French naturalists and academicians of the 1870s and 1880s, their technique served very different ideological ends. Like the Symbolists, they wanted to instill life and art with a sense of mystery and the infinite; they wanted connection with the past, and even duration in the Bergsonian sense. The historical disruption and discontinuity of the Modernist mode were only impediments to the evolutionary goal. Finally, these Americans were not ironically distanced from their upper-middle-class public. No matter what personal disappointment and neglect artists such as Dewing and Twachtman might have experienced, their works bear no antisocial expression. As a defense against the new social reality of the 1890s, which demanded cultural pluralism, official America promoted a homogeneous, Anglo-Saxon Protestant cultural paradigm into which foreign cultures were to be absorbed.[52] Such a society — unified within itself and impressed with the harmony of its environment — was considered both modern and ideal. Following this course, scientists and clergy alike predicted that Americans would produce a "civilization grander than any the world has known," and artists and architects enlisted to help realize that goal.

NOTES

1. Richard Ellmann and Charles Feidelson, Jr., eds., *The Modern Tradition: Backgrounds of Modern Literature* (New York: Oxford Univ. Press, 1965), v; on p. vi, the editors recapitulate Lionel Trilling's chacterization of Modernism in "The Modern Element in Modern Literature," which is reprinted in Irving Howe, ed., *The Idea of the Modern in Literature and the Arts* (New York: Horizon, 1967), as profoundly anticultural, historically discontinuous, and pervaded by a "sense of loss, alienation, and despair." Marshall Berman, " 'All That Is Solid Melts into Air': Marxism, Modernism, and Modernization," *Dissent* 25 (Winter 1978): 54, distinguishes between modernization that involves a "complex of social, economic, and political processes," and Modernism that has to do with "spiritual upheavals and cultural revolution, the death of God, the theater of cruelty, Dada, jazz, the twelve-tone scale, Existentialism, [and] abstract art," among other themes; on p. 73, Berman includes Marx as "one of the first and greatest of modernists." David A. Hollinger, "The Canon and Its Keepers: Modernism and Mid-Twentieth Century American Intellectuals," in idem, *In the American Province: Studies in the History and Historiography of Ideas* (Bloomington: Indiana Univ. Press, 1985), 74–91, details the shifting definition of Modernism in the twentieth century. It is interesting to note that there is at present a similar lack of consensus regarding the historical point of origin and the ideological basis of the concept of postmodernism. See, for example, the essays in Ingeborg Hoesterey, *Zeitgeist in Babel: The Postmodernist Controversy* (Bloomington and Indianapolis: Indiana Univ. Press, 1991).

2. The literary critic Richard P. Blackmur in "The Great Grasp of Unreason," in *Anni Mirabiles 1921-1925: Reason in the Madness of Letters* (Washington, D.C.: Reference Dept., Library of Congress, 1956), 10, constructed this version in discussing the "expressionism" of the artistic period of the 1920s, especially in the works of James Joyce, T. S. Eliot, Thomas Mann, William Butler Yeats, and André Gide, among others.

3. David A. Hollinger, "The Knower and the Artificer," *American Quarterly* 29 (1987): 38, recounts this scenario as one widely accepted version of the "modern predicament."

4. In the light of this judgment, see Helene Barbara Weinberg, "Renaissance and Renascences in American Art," *Arts Magazine* 54 (November 1979): 172–76; and idem, "American Impressionism in a Cosmopolitan Context," *Arts Magazine* 55 (November 1980): 160–65. Weinberg has argued that the conservatism of American painters should be viewed in the light of their academic training. It is also significant that by the late 1880s, when Theodore Robinson, John Twachtman, and J. Alden Weir are thought to have assimilated Impressionism, the French painters had progressed from their purer naturalistic phase of the 1870s to take up interests affiliated with neoconservative and Symbolist tendencies.

5. It is equally difficult to think of American painters in this period who represented individual reality as isolated and alienated, or as permeated by the strangeness and beauty of Poe's

world, which French artists and intellectuals found so enticing. Christine Buci-Glucksmann, "Catastrophic Utopia: The Feminine as Allegory of the Modern," *Representations* 14 (Spring 1986): 220–29, discusses Walter Benjamin's analysis of the modern urban environment and Baudelaire's "system of feminine fictions that characterize modernity." Timothy J. Clark, *The Painting of Modern Life: Paris in the Art of Manet and His Followers* (New York: Knopf, 1984), chap. 2 and pp. 47–49, expands on this mythology. On Degas's imagery of women, see Eunice Lipton, *Looking into Degas: Uneasy Images of Women and Modern Life* (Berkeley: Univ. of California Press, 1986), 163–86.

6. Clark (see note 5), 71–73, 158.

7. Clark (see note 5), 195, uses the term *hortus conclusus* to evoke a domestic, suburban milieu as a predominant aspect of Monet's painted world in the 1870s. See also Hubert Beck, "Die Ikonographie der Stadt: Das Zögern vor der Stadt-Thematik," in Thomas W. Gaehtgens, ed., *Bilder aus der Neuen Welt: Amerikanische Malerei des 18. und 19. Jahrhunderts*, exh. cat. (Munich: Prestel, 1988), 114–16.

8. Alan Trachtenberg, *The Incorporation of America: Culture and Society in the Gilded Age* (New York: Hill & Wang, 1982), 39–41, and chap. 3, esp. pp. 71–72, 80, 89–90, summarizes much of the recently published social history on the period and offers an engrossing account of the crisis in labor and industry during the late nineteenth century. Reiterating a few of these events helps to evoke this culture of conflict. The period unfolded, for example, with a series of violent railroad strikes that spread across the country in 1877, leaving in their wake one hundred dead and millions of dollars in property destroyed. The year of the Great Upheaval, 1886, in which 700,000 laborers went out on strike, also witnessed the Haymarket Riot in Chicago. Eleven people were killed in this incident and four were executed afterward. Moreover, in 1892 the National Guard was called out in five states to quell labor unrest, and two years later the Pullman Strike seemed to confirm a rising pitch of turmoil and rage among laborers.

9. In the fine arts, Robert Koehler's painting *The Strike*, 1886 (Detroit, collection of Richard A. Manoogian), provides a rare glimpse of the confrontation between labor and capital that was so pervasive in the social landscape of this period. On Riis, see Trachtenberg (see note 8), 128–29. John Higham, *Strangers in the Land: Patterns of American Nativism, 1860–1925* (New Brunswick, N.J.: Rutgers Univ. Press, 1955), 40, has made it clear that Riis's book had an effect opposite to what the photojournalist intended in that it "aroused anti-foreign as well as anti-tenement attitudes."

10. Trachtenberg's (see note 8) generalizations about high culture on pp. 144–45, and about the painting, sculpture, and architecture at the Chicago World's Columbian Exposition of 1893 on pp. 217–28, fail to discriminate between the differing motives and tastes of American capitalists, as well as the various ideologies and conditions governing the production of the fine arts in this period.

11. One can think of Ann Douglas, *The Feminization of American Culture* (New York: Knopf, 1977) and T. J. Jackson Lears, *No Place of Grace: Antimodernism and the Transformation of American Culture, 1880–1920* (New York: Pantheon, 1981), for example, both of whom fault the liberals for their soft-minded response to science and biblical criticism and lament the passing of hard-minded Calvinism in the nineteenth century.

12. Linda Nochlin, *Realism* (Harmondsworth, Middlesex: Penguin, 1978), 23, 25, 41–43; Joel Isaacson, "Observation and Experiment in the Early Work of Monet," in John Rewald and Frances Weitzenhoffer, eds., *Aspects of Monet: A Symposium on the Artist's Life and Times* (New York: Abrams, 1984), 14–35; and Richard Shiff, "The End of Impressionism: A Study in Theories of Artistic Expression," *Art Quarterly* 1 (Autumn 1978): 338–78, have all treated the relationship between various manifestations of pleinairism in the 1860s and 1870s and positivist philosophy. For a discussion of the varieties of English unbelief in the nineteenth century, see Bernard V. Lightman, *The Origins of Agnosticism* (Baltimore: Johns Hopkins Univ. Press, 1987), esp. 6–31. Gertrude Himmelfarb, *Victorian Minds* (New York: Knopf, 1968), 289–92, comments on the way in which moral and ethical values replaced religious belief among the British "intellectual clerisy," as the social ethic "acquired some of the stigmata of the old religion"; she quotes Leslie Stephen, who "after abandoning the effort to derive an ethic from Darwinism, finally confessed: 'I now believe in nothing, but I do not the less believe in morality...I mean to live and die like a gentleman if possible.'" See also Gertrude Himmelfarb, *Marriage and Morals Among the Victorians* (New York: Knopf, 1986).

13. James Turner, *Without God, Without Creed: The Origins of Unbelief in America* (Baltimore: Johns Hopkins Univ. Press, 1985), 206, quotes Peirce on the "Age of Pain." See William James, "Is Life Worth Living?" in idem, *The Will to Believe and Other Essays in Popular Philosophy and Human Immortality: Two Supposed Objections to the Doctrine* (New York: Dover, 1956; reprint of the first edition of *The Will to Believe and Other Essays in Popular Philosophy* [New York: Longmans, Green, 1897]; and the second edition of *Human Immortality* [New York: Houghton Mifflin, 1898]), 32–62. James was so alarmed by the number of suicides in the United States (which he cited as three thousand in 1895) that he felt the need to address the issue of suicide and its causes in religious pessimism at some great length in this and other essays. James was moved to assist Americans in reconciling their traditional Protestant belief in the unity of nature with the contradictory picture of nature revealed by science. George Miller Beard, *American Nervousness, Its Causes and Consequences: A Supplement to Nervous Exhaustion (Neurasthenia)* (New York: Putnam, 1881; reprint, New York: Arno, 1972), 65–70, drawing on Spencer's sociology, noted the rising incidence of nervousness in young American women and defined the condition as an integral part of the American character in this era; in chap. 3 he examined the causes of this neurasthenia as he perceived them to be located in the overwhelming changes and hurried schedules of Americans in this period.

14. See James R. Moore, *The Post-Darwinian Controversies: A Study of the Protestant Struggle to Come to Terms with Darwin in Great Britain and America, 1870–1900* (Cambridge and New York: Cambridge Univ. Press, 1979), chap. 7, "The Vogue of Herbert Spencer"; D. H. Meyer, "American Intellectuals and the Victorian Crisis of Faith," *American Quarterly* 27 (December 1975): 600–601; and John David Yeadon Peel, *Herbert Spencer: The Evolution of a Sociologist* (London: Heinemann Educational, 1971), 2–3, 132–33. Peel (p. 119) also adds that the American pragmatists "were both massively influenced by Spencer and defined themselves against him."

15. See Moore (see note 14), 156, 162, 165–66, 171; and Peel (see note 14), 135, 142–47, 156. Spencer maintained that evolution occurred primarily through adaptation of organisms to the environment and that each generation inherited characteristics acquired by its parents. Darwin disagreed with Spencer on the issues of methodology and the precedence of the role of natural selection over direct inheritance of characteristics, but he deferred to Spencer on the issue of human evolution and praised Spencer as "the great expounder of the principle of Evolution." As another reason for the popularity of Spencer in the United States, Moore (pp. 167–68) also cites the fact that Spencer's philosophy supported American economic and political ideologies of laissez-faire and individualism.

16. Turner (see note 13), 163, 80–81.

17. In a survey of the literature published in 1882 and in the two decades after, Herbert L. Kleinfield, "The Structure of Emerson's Death," in Carl Bode, ed., *Ralph Waldo Emerson: A Profile* (New York: Hill & Wang, 1969), 175–99, demonstrates the preponderance of Emerson's mythology and thought during this period.

18. See Peel (see note 14), 135; Moore (see note 14), 150–54, 168 n. 146, 224–25; John Fiske, *Studies in Religion; Being the Destiny of Man; the Idea of God; Through Nature to God; Life Everlasting* (Boston: Houghton Mifflin, 1902), 80–83; Milton Berman, *John Fiske: The Evolution of a Popularizer* (Cambridge, Mass.: Harvard Univ. Press, 1961), 102. Berman (p. 159) comments that Fiske's language moved closer to traditional Christian terminology after Spencer's visit to America in 1882. Americans also readily substituted the word "God" for Spencer's terms "the Ultimate Reality" and "the Unknown." This quasi-religious terminology was common to other American evolutionists, for example, Joseph LeConte and George Cope, who had based their thought on Lamarckian evolution, as did Spencer.

19. Lawrence W. Chisolm, *Fenollosa: The Far East and American Culture* (New Haven: Yale Univ. Press, 1963), 22–28, 41–42.

20. Robert W. Rydell, "And Was Jerusalem Builded Here?" in idem, *All the World's a Fair: Visions of Empire at American International Expositions, 1876–1916* (Chicago: Univ. of Chicago Press, 1984), 47–48, and Trachtenberg (see note 8), 218–19, cite testimony of fairgoers that shows the fair through their eyes as a "New Jerusalem."

21. On Brooks Adams, see Lears (see note 11), 133–36. Higham (see note 9), 102–105, treats

the formation of the Immigration Restriction League in Boston in 1894; among other Boston blue bloods, Henry Cabot Lodge and John Fiske were both leaders in the movement. Berman (see note 18), 105, notes that Fiske stressed the social conservatism of his evolutionary message; details Fiske's work with the League (p. 251); and comments that Fiske's ideology defended and celebrated preindustrial, small-town life in New England (p. 269).

22. Charles Darwin, *The Descent of Man and Selection in Relation to Sex* (London: J. Murray, 1871; reprint, New York and London: Appleton, 1915), 144–45.

23. Edward Livingstone Youmans, ed., *Herbert Spencer on the Americans and the Americans on Herbert Spencer, Being a Full Report of His Interview and of the Proceedings of the Farewell Banquet of November 9, 1882* (New York: Appleton, 1883; reprint, New York: Appleton, 1887), 19–20.

24. Ibid., 31–32.

25. James (see note 13), 61.

26. Ernest Fenellosa, "The Collection of Mr. Charles L. Freer," *Pacific Era* 1 (November 1907): 61.

27. Chisolm (see note 19), 97, 155–56, 159, 123–24.

28. For Fenollosa's opinions on Whistler and the emergence of a new world civilization, see Fenollosa (see note 26), 57–66; idem, "The Coming Fusion of East and West," *Harper's New Monthly Magazine* 98 (December 1898): 115–22; idem, "The Place in History of Mr. Whistler's Art," *Lotus: In Memoriam, James A. McNeill Whistler* 1 (Special Holiday Number, December 1903): 14–17; and idem, "The Symbolism of the Lotos," *Lotos* 9 (February 1896): 581.

29. Fenollosa (see note 26), 60.

30. For other antimaterialist interpretations, see Charles H. Caffin, *The Story of American Painting: The Evolution of Painting in America from Colonial Times to the Present* (New York: Charles Scribner's Sons, 1907); idem, *American Masters of Painting: Being Brief Appreciations of Some American Painters* (New York: Doubleday, Page, 1902); Sadakichi Hartmann, *A History of American Art* (Boston: L. C. Page, 1902), vol. 2; and Royal Cortissoz, "Egotism in Contemporary Art," *Atlantic Monthly* 73 (May 1894): 162–73. Sarah Burns, "Old Maverick to Old Master: Whistler in the Public Eye in Turn of the Century America," *American Art Journal* 22 (1990): 39, in this same vein also cites critics such as Theodore Child, John C. Van Dyke, and Christian Brinton.

31. Frances Grimes, "Reminiscences" (typescript in the Papers of Augustus Saint-Gaudens, Special Collections Division of the Dartmouth College Library, microfilm roll 3565r #36, frames 350–410), frame 357, relates this expression of Dewing's wife, Maria Dewing, to his female figures.

32. This reading of the painting reflects the Dewings' deep-seated engagement with the Transcendentalist milieu in Boston, where Thomas Dewing was born and raised and where Maria Dewing was related to a member of the Transcendentalist circle. Both Dewings were

known as devotees of Emerson's writings, and Thomas Dewing at several points in his work alluded to Emerson's poetry, for example, in *The Days*, 1887 (Hartford, Conn., Wadsworth Atheneum, no. 1944.328); *Dawn*, circa 1892 (Washington, D.C., National Museum of American Art, Smithsonian Institution, no. 1926.6.27A); and possibly in *Four Sylvan Sounds*, 1896–1897 (Washington, D.C., Freer Gallery of Art, Smithsonian Institution, nos. 06.72 and 06.73). On Maria Dewing's professed devotion to Emerson, see Greville MacDonald, *George MacDonald and His Wife* (London: Allen & Unwin, 1924), 440. Dewing's abstract poetic mode here, his use of a symbolic speaking form in the undulating mass of the tree, calls to mind Eugène Delacroix's longing for an artistic language in which the painting would become a "speaking hieroglyph." The phrase "speaking body" is used by Frank Kermode, *The Romantic Image* (New York: Macmillan, 1957), 58, to denote the expressiveness of the human form in the Symbolist image of the dancer.

33. See Agnes E. Meyer, "The Charles L. Freer Collection," *The Arts* 12 (August 1927): 65, 69, 80; and Aline Bernstein Saarinen, *The Proud Possessors: The Lives, Times, and Tastes of Some Adventurous American Art Collectors* (New York: Random House, 1958), 120.

34. In this regard, Robert Rosenblum, "Painting: 1870–1900," in Robert Rosenblum and Horst Woldenmar Janson, *19th-Century Art* (New York: Abrams, 1984), 456, has interestingly compared Dewing's *Summer*, 1893 (Detroit, The Detroit Institute of Arts, no. 27.316), with Edvard Munch's approach to nature and human sexuality in *Summer Night's Dream (The Voice)*, 1893 (Boston, Museum of Fine Arts, no. 59.301). Rosenblum is essentially correct in this comparison, for both painters in their imagery suggest beliefs in an underlying pantheistic spirit unifying nature with human nature. Munch consciously projected onto his image a quasi-religious reverence for the forces of energy that instinctively linked man to the universe. But the eroticism that Rosenblum detects in Dewing's *Summer* — Dewing's desire to merge with a nature that is literally and figuratively identified with the feminine — remains a repressed subtext that is subordinate to the ostensible Transcendentalist scenario Dewing acknowledges to be taking place. This merging with an oceanic universe was the experience William James would put forth as the very basis of true religious feeling a few years later in the conclusion of his *The Varieties of Religious Experience: A Study in Human Nature* (New York and London: Longmans, Green, 1902; reprint, New York: Collier, 1961).

35. See the *New York Times* review of 12 April 1891, 12; and on Twachtman's quest for a landscape mode of silence and comfort, Kathleen A. Pyne, "John Twachtman and the Therapeutic Landscape," in Deborah Chotner, Lisa N. Peters, and Kathleen A. Pyne, *John Twachtman: Connecticut Landscapes*, exh. cat. (Washington, D.C.: National Gallery of Art, 1989), 53–57.

36. See James (see note 34), 102–111, on the efficacy of quiescence in terms of the popular mind cure movement; also idem, "The Gospel of Relaxation," *Scribner's Monthly* 25 (April 1899): 499–507.

37. Carl T. Jackson, *The Oriental Religions and American Thought: Nineteenth-Century Explorations* (Westport, Conn.: Greenwood, 1981), 151–53, 235, comments on the confluence of Transcendentalism and Buddhism in late nineteenth-century America.

38. Pyne (see note 35), 61.

39. John House, *Monet: Nature into Art* (New Haven: Yale Univ. Press, 1986), 221–25; and Robert Goldwater, *Symbolism* (New York: Harper & Row, 1979), 2.

40. Roger Marx, "Les 'Nymphéas' de M. Claude Monet," *Gazette des Beaux-Arts* 1 (June 1909): 529: *"aurait offert l'asile d'une méditation paisible au centre d'un aquarium fleuri," "les nerfs surmenés par le travail se seraient détendus là, selon l'exemple reposant de ces eaux stagnantes."*

41. On the theme of death in Homer, see Henry Adams, "Mortal Themes: Winslow Homer," *Art in America* 71 (February 1983): 112–26.

42. Here, Homer's vision of humanity's heroic struggle seems to approach James's idea of the moral value of struggle. Thanks to Craig Adcock for his suggestion that Homer's depiction of nature implies a regard for nature as a sublime force.

43. Weinberg, 1979 (see note 4), 175.

44. On the shift in worldviews, see William R. Hutchison, *The Modernist Impulse in American Protestantism* (Cambridge, Mass.: Harvard Univ. Press, 1976), 220–27.

45. In referring to Homer, Eakins, and Ryder, Weinberg, 1979 (see note 4), 175, used this Italian term. Elizabeth Broun, *Albert Pinkham Ryder*, exh. cat. (Washington, D.C.: National Museum of American Art, 1989), 142–45, details how the movement to assimilate Ryder's work into the Modernist canon was led by Roger Fry and the Museum of Modern Art.

46. William Innes Homer, *Alfred Stieglitz and the American Avant-Garde* (Boston: New York Graphic Society, 1977), 20, 33, 68, 148.

47. See Arthur Warren Johnson, *Arthur Wesley Dow: Historian, Artist, Teacher*, Ipswich Historical Society, Ipswich, Mass., Publications (Ipswich: Historical Society, 1934), 28: 20–21, 54–62, 65; Frederick C. Moffatt, *Arthur Wesley Dow, 1857-1927* (Washington, D.C.: Smithsonian Institution Press, 1977), 49–50. Weber studied with Dow at the Pratt Institute in Brooklyn from 1897 to 1901; O'Keeffe enrolled in his class at Columbia in 1914 but had already been introduced to his system in 1912 at the University of Virginia. Dow was also connected to Stieglitz's Photo-Secession group through professional relationships with Gertrude Käsebier at Pratt and with Clarence White at Columbia, as well as with Alvin Langdon Coburn at Pratt and Dow's Ipswich school.

48. Homer (see note 46), 148–50.

49. Charles C. Eldredge, "Nature Symbolized: American Painting from Ryder to Hartley," in Maurice Tuchman, *The Spiritual in Art: Abstract Painting, 1890-1985* (New York: Abbeville, 1986), 114–18, 123–24.

50. On Davies's reading in esoteric Buddhism and Theosophy, see Brooks Wright, *The*

Artist and the Unicorn: The Lives of Arthur B. Davies, 1862-1928 (New York: Historical Society of Rockland County, 1978), 56–57, 72, 78–79, 109–114, 119–21.

51. See Linda Darymple Henderson, "Mysticism, Romanticism, and the Fourth Dimension"; W. Jackson Rushing, "Ritual and Myth: Native American Indian Culture and Abstract Expressionism"; and Donald Kuspit, "Concerning the Spiritual in Contemporary Art," all in Tuchman (see note 49), esp. 233, 278–82, 319–23. Broun (see note 45), 174–78, has commented on Ryder's impact on Pollock and other contemporary artists; on Ryder's influence on Davies (pp. 165–67); and on Hartley's debts to Ryder (pp. 169–72).

52. See Higham (note 9), chaps. 6 and 7.

1. Charles Graham (American),
 The New Building of the New York Times,
 engraving.
 Harper's Weekly, 27 October 1888.
 From John Grafton, *New York in the Nine-
 teenth Century*, 2nd ed. (New York: Dover,
 1980), 219.

Hubert Beck

Urban Iconography in Nineteenth-Century American Painting

From Impressionism to the Ash Can School

I found a love in the heart of the city.
I found a love where there's none to be found.
> — Mink DeVille

The Exclusion of the City

Industrialization and urbanization, the main socioeconomic factors of the nineteenth century, dramatically transformed American civilization and culture. In nineteenth-century painting, however, city themes play hardly more than a marginal role. Predominant as subject matter are landscapes: wilderness and village. On America's way to becoming an urban nation, these images of nature become increasingly nostalgic, for the real historical process leaves nothing untouched, turning the American wilderness into pastures, farms, and towns — into real estate.[1] The city — whose wealthy inhabitants acquire these canvases — dreams of nature and village life and at the same time dissolves their original forms and qualities by its very hegemonic dynamic.[2] It is in this sense that even the painted operas of nature of an Albert Bierstadt contain an urban subtext. On the surface — with regard to what is mainly depicted — the iconography of the city remains an exception; in a deeper sense, however, all of these paintings deal with the problematic relationship between individual self and city — a central concern in the second half of the century.

In American as in European paintings, Impressionism (and Realism) mean the beginning — however hesitant and narrow — of a representation of the city. Barbara Rose declares nineteenth-century America in the sphere

319

of the arts still a European colony.³ Sam Hunter deplores the provincialism and materialism in American culture of that period and emphasizes the heroic struggle for artistic independence and national identity.⁴ Thus both art historians see in American Impressionism primarily the misunderstood and unmatched European prototype. This is not a false conception, for American Impressionism is a derivative rather than a genuine original creation. William Merritt Chase and John Henry Twachtman studied in Munich, while Theodore Robinson's discovery of Claude Monet in Giverny remains a stamp on his work. But this perspective of artistic model, influence, and emancipation in its restricted horizon does not account for the more interesting questions of the specific American cultural experiences and social conditions. Moreover, American Impressionism develops later and incorporates post-Impressionist elements, too. The Impressionists belong to the generation of painters who appear on the stage in the late 1880s and include many expatriates. James McNeill Whistler stays in Europe, John Singer Sargent goes back and forth between Boston and London, but most Impressionists, such as Chase, Twachtman, and Childe Hassam, come back, that is, to New York, the most cosmopolitan American city and the one closest to Europe. In this time of complicated cultural transformations, that element of cosmopolitanism reflects a new, now more ambivalent turn toward Europe with all the insecurity ambivalence entails, not, however, a simple adaptation of foreign artistic achievements.

With the rise of the illustrated press, on which the public's conception of the city increasingly depends, commercial graphics (not the graphic art of artists) — in contrast to High Culture painting — first establish a specific iconography of the city. New York appears in the press as an ideal city of commerce and prosperity, a well-functioning institutional machine, as examples in *Frank Leslie's* and *Harper's Weekly* (fig. 1) indicate. Only after alternative views of the city, such as Jacob Riis's photographs of the Lower East Side (see p. 293), coerce reality out of hiding does the system of exclusions in pictorial representation and eventually in painting disintegrate.

Urban Pastorals

For the American Impressionists, Central Park in New York and Prospect Park in Brooklyn are significant sources of motifs. Chase's *In the Park/*

2. William Merritt Chase (American),
 In the Park/A By-Path, ca. 1890–1891,
 oil on canvas, 35.5 x 49 cm.
 Lugano, Thyssen-Bornemisza Collection.

A By-Path (fig. 2) is also a representative example in terms of content. The strict spatial organization of the composition does not allow any excess in the image's striving for the atmospheric effect — that is, the Impressionist effects of light, air, and color. Chase often uses members of his family for his figures, but in this case we do not know who the two people are. The mother-child theme with its notion of privacy and intimacy is reminiscent of Monet's pictures of his garden. As an urban sphere the big-city park is at once public and private, but Chase stresses the privacy. The figures in the park are not unlike those in more anecdotal paintings. Central to this painting is its cavernous space suggesting refuge. The vegetation and the stone wall shelter mother and child like a building. Typical of American Impressionism, Chase presents the park landscape as an interior, the city as domesticated nature, a pleasure ground for city people. Motif and title of the painting are programmatic. Chase's park represents the idealistic conception of city and country (nature) in organic harmony. Drawing on Frederick Law Olmsted's Park Movement, the same organic vision is applied to the strata of society. The park is meant to be a public space that compensates for the usurpation of the city by private interest — in the hope for a renewal of community through the social uses of leisure.[5] The point made by Chase is that under the sign of familial bonds and at a place of unity between nature and city, society can and shall be one big family. But by focusing on the park as an ersatz interior, he blurs and evades the public function. Unity in the metropolis proves to be fictitious.

For the French Impressionists, Paris is the city of light, atmosphere, and wide, open spaces.[6] Most of all, they paint the light-filled boulevards and streets with trees and passersby, the buildings, urban places, and the Seine. The river appears not only as a haven of leisure but also as a traffic route. The paintings celebrate a picturesque Paris of progress, the architectural and technological feats reveled in by the visitors to the world's fairs. *Artiste démolisseur* Baron Georges-Eugène Haussmann makes a huge construction site out of the city, a permanent world exhibition in its own right. This modern side of the French capital is the Impressionists' source of motifs: railway stations, new apartment houses and hotels on the boulevards, bridges (Pont-Neuf, Pont de l'Europe), and the new arenas of amusement (café concert) with their social mix of patrons.

This emphasis on modernity and technology is not shared by the American Impressionists. If we agree with Timothy J. Clark that in the French

322

3. Childe Hassam (American),
Fifth Avenue at Washington Square, 1891,
oil on canvas, 56 x 40.6 cm.
Lugano, Thyssen-Bornemisza Collection.

323

repertoire of motifs, industry, but not work, has a place, we can add that the Americans in their paintings avoid even industry.[7] Until the twentieth century the representation of the American city of technological progress remains the domain of commercial graphics. There are no significant equivalents in American Impressionism to Monet's, Edouard Manet's, and Gustave Caillebotte's well-known pictures of railway stations and bridges. With the bridge in *Max Schmitt in a Single Scull*, 1871 (New York, The Metropolitan Museum of Art), the "Realist" painter Thomas Eakins comes much closer to those motifs. Twachtman's bridges, for example, *The White Bridge*, circa 1895 (Minneapolis, The Minneapolis Institute of Arts), resemble those of Jean-Baptiste-Camille Corot or Monet's renowned Japanese bridge in his garden in Giverny. In his street scene *Fifth Avenue at Washington Square*, 1891 (fig. 3), Hassam depicts New York as urbanized Arcadia. Only parts of the buildings' front yards are shown. His static figures have nothing in common with the amorphous city crowds of Paris, one of the most important and persistent motifs in French Impressionism. Derived from anecdotal genre, the figure in American Impressionism is more narrative, stereotypically grouped and placed. The street functions mainly as a stage for these personae. The interiors lack the inside-outside ambiguity of the window motif that is so effectively employed, for instance, in Caillebotte's *Man at the Window*, 1875 (Paris, private collection).

A comparison between Hassam's *Rainy Day, Boston* (fig. 4) and Caillebotte's *Paris Street; Rainy Day* (fig. 5) reveals how differently each Impressionism works on the subject of the city. Evidently Hassam's picture is an urban pastoral; his Boston seems almost like a small town. Hassam is striving for formal and conceptual harmonies, while Caillebotte's formal language is full of dissonances, even confrontations radically involving the viewer. Caillebotte's urban spaces are fragmented and ambiguous. In the light of such overt contrasts, it seems questionable whether the American Impressionists had any knowledge at all of those motifs of Manet and his followers that have to do with modernity, urban alienation, and spectacle. Or is this exactly what American Impressionism, whether knowingly or unknowingly, tends to avoid, as if rejecting modernity's very inevitability?

In their landscape subjects, both Impressionisms are very similar. They are preoccupied with the perpetual Sunday at the pleasure grounds of a leisure class outside the city and at the coast. The marriage of country and

city does not imply — on either side of the Atlantic — that the difference
between the two should disappear. On the contrary:

> The environs belonged to Paris, or at least its map of urbanity.... Cities ought
> to have an ending, an outside, an elsewhere one could reach, as if in doing so
> one gave the city back a lost identity. Paris [New York] was a set of constraints
> and formalities, and thus the opposite of nature; from a distance it all seemed
> clear — what the city had to offer and why one had to get away from it; the
> exile was momentary and the crowds came home at evening re-created.[8]

The American pictorial synthesis of country and city neglects urban mo-
dernity and superimposes its metaphors of nature on urbanity. Thus it sub-
scribes much more to the myth of the city as organism. Underlying this
organic vision is the wish for unity and oneness in the face of the fragmen-
tation, complexity, and alienation of the real big city, which is the dispa-
rate, inorganic, and unreal per se. In particular, this is expressed in the
interiors as the "elsewhere" within the city.

The Repression of the City

The significance (not so much in quantity as in quality) assigned to the inte-
rior space in American Impressionism, as opposed to the French model, is
important. The American Impressionists work on the interiorization and
feminization of the city. We notice this in central paintings such as Edmund
C. Tarbell's *Mother and Mary*, 1922 (Washington, D.C., National Gallery of
Art), Chase's *In the Studio*, circa 1880 (Brooklyn, The Brooklyn Museum,
no. 13.50), and his *A Friendly Visit*, 1895 (Washington, D.C., National Gallery
of Art), and in numerous works by Thomas W. Dewing. These bourgeois
rooms packed with the insignia of highly cultured taste and sensibility are
laid out like sanctuaries. The daylight, filtered and diffused by curtains and
mirrors, is kept out — and with it the reality of the city as well. The hyper-
trophy and material preciousness of drapes, pillows, exotica, and parapher-
nalia indicate the interior's function as shelter and private kingdom. As a
female sphere and refuge, these spaces have to compensate for and protect
people from the harsh and indistinct outside world of the laissez-faire
metropolis, where the master of the household has to hold his ground.[9]

325

4. Childe Hassam (American),
 Rainy Day, Boston, 1885,
 oil on canvas, 66.3 x 122 cm.
 Toledo, The Toledo Museum of Art,
 Purchased with funds from the Florence Scott
 Libbey Bequest in Memory of her Father,
 Maurice A. Scott, no. 1956.53.

5. Gustave Caillebotte (French),
 Paris Street; Rainy Day
 (*Rue de Paris; temps de pluie*), 1877,
 oil on canvas, 212.2 x 276.2 cm.
 Chicago, The Art Institute of Chicago,
 Charles H. and Mary F. S. Worcester
 Collection, no. 1964.336.
 ©1992 The Art Institute of Chicago,
 All Rights Reserved.

The interiors of American Impressionism are part and parcel of late nineteenth-century genteel culture. Peter Conrad describes the role of the "interior" — the "holy inwardness" — in the novels of Henry James, Edith Wharton, and William Dean Howells — as if talking of these paintings: "A clean, quiet, patient, meditative stasis, a disoccupied calm. A room, like the city, is a camp set up in an alien world and fortified in fear, placed under the aegis of friendly deities. Decor functions fetishistically, as an offering to these gods. The interior is a shrine, a tabernacle where every surface must be devoutly layered, commemorated by concealment."[10]

The Impressionistic interiors reveal the bourgeois notions of fashion, class, and self at the turn of the century. They build up a system of exclusions. The city street epitomizing vulgarity and chaos is their exact counterpart. James — a friend of Sargent's — decries this "assault of the street" in *The American Scene*. On the one hand, the room's aura of idle privacy and cultural refinement is taken as an antidote to the crowded coarseness of low life. But on the other hand, the interiors suggest art and culture to be "friendly" and elevating forces. Yet the turn to inwardness is deeply problematic. In the interdependent urban marketplace, in the weightless unreality of the city, the sense of self disintegrates. "The urban-industrial transformation stemming from faith in individual autonomy, was undermining that faith at the moment of its triumph."[11] Individual identity becomes fragmented into a series of social roles, autonomous achievement becomes increasingly definable and manipulable by others —as unreal as the city itself.

The reasons for the repression of the city in American Impressionism are to be found in the larger context of Anglo-American Victorianism. It simultaneously associates and represses the concepts of city and sexuality.[12] Both heighten the dualism of free will and determinism. The Victorian sensibility discovers the opaque mechanisms of the urban maelstrom and the unconscious impulses of the psyche at the same time — as threatening forces. Popular literature of the period illustrates the punishments awaiting those who succumb to the manifold lures of the city. The disorienting forces of sex and city call for nothing more than the primacy of the disciplined individual will. The faces in Thomas Eakins's portraits show the "cover of restraints," this intense effort of the Victorian self to control both the own inner psychosexual nature and the outer (second) nature of the metropolis as an overwhelming mass of confusing signs.[13] In the interior both are

328

repressed. To give just one example, Eakins's portrait of *Letitia Wilson Jordan*, 1888 (fig. 6), clearly shows this sense of effort, the young woman's fear of exhaustion of her physical and emotional resources. She is the sister of David Wilson Jordan, Eakins's good friend and former fellow member of the Philadelphia Academy. Since the portrait shows a young woman, it cannot be old age that causes the resignation on her face. The whole posture of the erect figure seems to be laden with and immobilized by an unconscious weight. Although nominally in the older tradition of the portrait genre, the painting also takes up the theme of the young woman in fashionable attire ready to go out that is common in Manet and his followers. But in Eakins's painting the woman's melancholic self-absorption contrasted with the thingness of her allegorical attributes — above all the open fan — enacts the drama of willful concealment and involuntary revelation central to the topos of unauthentic subjectivity.

Another reason the city is repressed in American Impressionism is the lack of an American capital. Washington is merely the symbolic capital of the nation. New York competes with other cultural centers: Boston, Philadelphia, and Chicago. A centrally coordinated and comprehensive intervention like that of Baron Haussmann in Paris cannot take place in America's laissez-faire cities. But it is essentially Haussmann's Paris that furnishes the French Impressionists with their urban subject matter.

The city is nevertheless a new thematic concern for American Impressionism, but it is seen only through atmospheric effect and picturesque filters of dusk, rain, or snow. In their paintings the Impressionists wanted what James called the "element of mystery and wonder." In this sense, Hassam's urban scene *Fifth Avenue at Washington Square* (see fig. 3) and his rural subjects, for example, *Barnyard*, 1885 (New York, Coe-Kerr Gallery), are all landscapes rather than cityscapes. In terms of style as well as psychology, American Impressionism is rooted in familiar traditions. The new city does not yet require forms of representation that in themselves reflect its changing modern features. There is a strong aesthetic connection with Luminism — evident in Hassam's early Boston harbor scenes, for instance. Twachtman's *New York Harbor*, 1879 (Cincinnati, Cincinnati Art Museum), indicates a similar heritage.

The American painters incorporate the new French aesthetic into the quietism and lyricism of their traditional style, excluding the ambivalent modernity of French Impressionism. They present a pastoral city of beauty,

6. Thomas Eakins (American),
Letitia Wilson Jordan, 1888,
oil on canvas, 152.4 x 101.6 cm.
Brooklyn, The Brooklyn Museum, Dick
S. Ramsay Fund, no. 27.50.

although they probably have not experienced the late nineteenth-century American city as such. As the persistent decorative and ornamental elements in their painting suggest, they also believe that aesthetic work can guarantee some sense of (fragile) unity in a world that seems to be falling apart. The late Luminist light — again perhaps most notably in Hassam's work — creates clarity, allows calmness, and makes the objects solid. The tendency in French Impressionism is to dissolve the thingness and leave incorporeal surfaces, particles of paint. Clark has demonstrated that here the light, the pleasure for the eye, implies ambiguity and illegibility, too. The Americans recoil from the dissolution of objects and stick to the illusionistic pictorial space. Due to their cosmopolitanism, however, they do break away from the past as well. Not only a supposedly general American preference for object integrity and "realist" forms of representation make them preserve the academic conventions but also the specific reception of painterly modes on their study tours of Europe. They go to Europe intending to establish a tradition of their own, and yet they learn to draw the human figure in Munich and Paris.[14]

As a consequence, Hassam can in one and the same image render trees and sky Impressionist by any standard and buildings, cabs, and people according to conventional academic formulas, for he is obviously after a pictorial formulation in a language both personal and American. Twachtman's metaphors of nature in his snow landscapes make him seem almost anti-urban, but his color fields anticipate American abstract Modernism of the twentieth century. Only in this century, when the new New York comes to embody the genius loci of America, do the illusionist conventions lose their validity. And only then do the American painters' representations of the city cease to appear primarily as expressions of the artists' detachment and dissociation from it.

Urban Minds

Prepared by Impressionism as well as the big-city press in the last third of the nineteenth century, a modern city consciousness emerges in American art from the turn of the century on. This can be seen in the urban Realism of the Ash Can school no less than in the early American Modernism of artists such as John Marin, Max Weber, and Charles Sheeler. Both groups

try to come to terms with the modernity and singularity of the American metropolis, however different their formal responses to modernity are. Frederick Jackson Turner's frontier thesis and the Chicago World's Columbian Exposition (the so-called White City), both of 1893, basically stood for three developments: the city as a way of life in the process of becoming dominant, the economy becoming corporate, and the nation on its way to becoming an empire. From then on, every theory of modernity overlaps with a vision of the city. American society after 1900 can be seen as the contemporary of nascent mass production and mass consumption. This fundamental shift has far-reaching cultural consequences. The artists and intellectuals of the 1910s (including photographers such as Alfred Stieglitz) seem to be the first to have internalized — not negated — the ambivalence of the relationship between self and city. They experience the new urban environment as at once fascinating and alienating, linking modernity with urbanity. They explore the city's aesthetic (and ethical) potential and represent a new type of self-assertive, if ambivalent, middle-class urbanite.

Robert Henri, John Sloan, and the Ash Can artists (George Bellows, George Luks, Ernest Lawson, Everett Shinn, William Glackens, and Maurice Prendergast) discover the teeming city street around them. It is depicted as a diverse public and social space. Conventional by stylistic standards, The Eight, as they were also called, add the theme of the "social garden" to the conventionality of the picturesque and the exotic, which they have taken over from Impressionism. The private interior of the nineteenth century is penetrated, indicating the dramatic clash of the private and public spheres in the modern metropolis. The Eight make significant use of the window motif as employed, for example, in Sloan's etching *Night Windows*, 1910 (New York, Whitney Museum of American Art), which reflects the heightened inside-outside ambiguity of modernity. Sloan boasts of being a proud "window watcher." Thus, he underscores the role of the artist as "a spectator of life…selecting bits of joy in human life" who "doesn't need to participate in adventures," a role in conflict with his urge to merge into the "milieu" he renders.[15] Sloan's voyeurism is not so much a private obsession as it is a consequence of the dialectic between near and far in the modern city. Urbanites live physically very close together, while emotionally they are worlds apart. The distancing sense of vision is privileged, and seeing each other is spying on each other. Sennett has described this modern paradox of visual (physical) revelation and mental concealment.[16]

The Eight's favorite vantage point is that of the pedestrian. Their street scenes often connote the question of who is in possession of the street. Sloan's *Return from Toil*, 1915 (fig. 7), an etching from his New York Life Series, is a good example. Here the street is a stage for the "human comedy," according to Sloan. "A bevy of boisterous girls with plenty of energy left after a hard day's work," as the caption says, makes a crowd filling the entire picture space. It is not an anonymous crowd, but one of solidarity; a solidarity, however, that is not political – in pursuit of a specific goal – but rather one that is satisfied with the common use of leisure and the celebration of its own relentless youth. The custodians of older culture had been afraid of the crowded tenement street; in their human-interest genre, The Eight ennoble it with their vitalism, representing it as a regenerative urban wilderness. Mindful of street scenes like this – a sketch form served as the cover of an issue of *The Masses* – or interiors such as the etching *Nude Reading*, 1928 (New York, Whitney Museum of American Art), Conrad makes an important point: "In the polymorphous, orgiastic democracy of New York, the proximity and entanglement of bodies defeats [*sic*] social distinction."[17]

The Eight cling to Walt Whitman's organic urban vision of bodily democracy while their New York images – for example, Bellows's sport scenes – revel in the urban spectacle, the raw physical energy in the city, and implicitly express a certain sense of social struggle. The work aspect of life is avoided in these pictures, as is evident in Sloan's example. (More than in pictorial form, the diverse Ash Can school painters gain unity in their collective strategy for admission into the conservative institutions of High Culture.)

The pictorial representation of the new urban themes and motifs in New York Realism – the night spots, the slum streets, the crowd, the Flatiron, the Elevated – is based on nineteenth-century experiences of nature. On the one hand, in their countless snow, rain, and night scenes, The Eight picture the city as domesticated nature, just like their Impressionist predecessors. On the other hand, the new social element is unhesitatingly incorporated into the system of natural metaphors, in spite of also being represented as something artificial in the sense that the street is a stage and the individual an actor. Compared to Hassam's "stage," it is, however, now a different one with more and diverse, less stereotyped "actors" from various social backgrounds. In Shinn's theater scenes, this aspect is so intensified that it approaches the topos of the *theatrum mundi*. The entire New York Life Series

333

7. John Sloan (American),
 Return from Toil, 1915,
 etching, 24.4 x 32.7 cm.
 Philadelphia, Philadelphia Museum of Art,
 Purchased Lessing J. Rosenwald and Farrell
 Fund Income, no. '56-35-99.

can be read as a song to Greenwich Village, where the city is still rural in character and where Sloan finds "organic growth" and "untamed womanhood." "Sloan, for whom the female nude was — in spite of its physical flagrancy — a symbol of the lofty Platonic spirituality of art, anatomizes New York as a plumply appetizing woman's body."[18] Naturalized in the symbol of the female, New York as the urbanized and secularized sublime, like wild nature before, can now be the authentic American place.

This is a modern place, for it is full of contradictions and insecurities. In a way, the city has no "outside" any longer. As in literary Realism slightly earlier, this notion renders the older opposition of country and city obsolete. Here Henri's and Sloan's urbanism coincides with the Romantic cultural nationalism of the contemporary wider culture of which they are part. The Eight are less cosmopolitan than Impressionism before and the avantgarde after them, although Henri had studied in Paris and expounded Manet and Honoré Daumier, Frans Hals and Goya. For Henri and The Eight's supportive critic, Van Wyck Brooks, the artist is an interpreter of the national life of his time, determined to connect art with life.

The Ash Can school develops a differentiated topography of the city. The Eight as environmentalists are convinced that the artist needs close ties to a knowable community in which he can "grow." For Henri, progress in art is synonymous with individual accomplishment. This specific dialectic of individual and environment is important. The Eight's obsessive individualism is inseparable from their myth of the Village, the "community" that resonates with pre-Modern qualities of life. The same is true for Sloan's socialism and progressivism in general: At the center of both lies an idea of untrammeled individual development. And these archindividualists are the first in America to establish a progressive artistic community, even though as painters they stylistically form a very heterogeneous group, as the standard comparison of Henri and Prendergast can undoubtedly show.

The most prominent characteristic of early urban Realism is its vitalism, the mystification of spontaneity and energy. First of all, it is a reaction against the acceleration and circulation of the modern metropolis. As such, it includes a critique of the modern rationalization process, and, more generally, it also stands for the shift in general cultural orientation from Jeffersonian moralism to modern consumptive hedonism: vitalism replaces nineteenth-century stoicism as the wider culture eventually adopts what T. J. Jackson Lears calls "a therapeutic world view." All the international

335

ramifications of the philosophy of life (*Lebensphilosophie*) are based on a conception of becoming and moving: Experience and intuition are more important than logically ordered discursive thought; for the American pre-war rebels that meant, specifically, more important than moralized science and Puritan conscience.

At the heart of Henri-Louis Bergson's theory of the life stream, the élan vital, is the notion of reality as becoming. It is here that more than the literary stream of consciousness has its roots. "In everyone there is a great mystery," claims Robert Henri drawing on a very Emersonian concept.[19] It is in the city that this can best be expressed, and the appropriate form is the sketch. The realm of literature in that period is generally marked by a renaissance of essayistic thought, and Stephen Crane describes his urban experiences around the turn of the century as a mosaic of little worlds — "city sketches."[20] Henri again: "A sketch that is the life of the city and river... Work with great speed. Have your energies alert, up and active. Finish as quickly as you can."[21] Whereas in early New York abstraction, the urban dynamic reflects itself primarily in the pictorial form itself, in early New York Realism it does so instead in the process of selecting a motif and most notably in the act of executing a painting. As a matter of fame or notoriety, Henri probably *was* the fastest brush in the East.

In all city painting there is a more or less articulated psychographic element. Painting for The Eight is only "real" as a physical, earthen act, a kind of soiling. So Brooks says about Sloan: "The lower East Side delighted him, even the doorways, greasy and begrimed, that looked as if hogs, covered with filth, had worn the paint away, going in and out."[22] All members of the Ash Can school (except Henri) began as newspaper artists; they were trained sketchers and chroniclers before they took up painting. Hence they knew from direct experience that the modern city is fragmented into separate spaces of experience and function, "a mystery" — their insistence on its being one large organism notwithstanding. The city's whole identity seems hidden; the metropolis is in any of its moments; it consists of inner and outer distances. In order to try to understand it, it is necessary to change the perspective, to shift from one space and one role to another. The city, it seems, wants to be won over by investigation and intrusion. The urban reform movement of the period depended on the investigation of hidden interests (corruption) and functioning of all sorts.[23]

As Donald Kuspit has emphasized, it is of secondary importance that

336

the early urban Realists were not stylistically equal to the modernity of the city, since the adherence to traditional forms of representation of urban subjects is in itself a response to the city's threatening depersonalizing force. He writes: "The Eight represent a golden moment in New York art (and life), when individual and communal/mass-identity were synonymous."[24] The Eight give recognition to industrial civilization. There are Glackens's and Bellows's docks and harbor scenes with their pockets of smoke everywhere and Sloan's motifs of the Elevated with the construction site scenes — but Greenwich Village is the life center of The Eight.

The Village is the ideological and representational matrix of the prewar cultural insurgency as a whole. In America's first modern bohemia of the Village, precarious and short-lived though it was, the intellectuals and artists who flocked there from other cities, such as Chicago, and from small towns found both an intimate community (individual identity) and an urban anonymity (mass identity). New York in a way is the Village. It is a picturesque place far from being purely Anglo-Saxon. There are immigrant slums, benevolently depicted in Luks's *Hester Street*, 1905 (Washington, D.C., National Gallery of Art), a community devoted to artistic and personal expressiveness. And there is a cause: the struggle against Eastern upperclass monopoly and its genteel culture of "decorum." The attraction of the pre-Modern is evident in Sloan's *Backyards, Greenwich Village*, 1914 (New York, Whitney Museum of American Art), an idyllic scene complete with his favorite attributes: children, cats, snowman, and drying laundry.

The Village had traditionally been somewhat of a backyard. This area of short, narrow streets south of Washington Square had functioned as a refuge from city traffic for the well-to-do in nineteenth-century New York, including, among others, Edgar Allan Poe, Samuel Langhorne Clemens, Edith Wharton, and Winslow Homer. The prewar counterculture makes this the place in the city where, as one of the mostly young rebels of the time rejoices, "we can be as crazy as we like." The way their indulgence in carefree frivolities grated against the Catholic attitudes of the large Italian population that had established itself in the Village since the turn of the century was carefully overlooked in the selective vision of The Eight, a vision that included a strong tendency to sentimentalize the only occasional harsh subjects they depicted. The Ash Can school, like *The Masses*, was particularly sentimental about children in the slums. There were, of course, American bohemias in the nineteenth century, but they had nei-

ther the Village's mass character nor its modern publicity.

In *The City from Greenwich Village* (fig. 8), a late cityscape by Sloan, one can detect, as in his early series of New York etchings, a central ambiguity of The Eight: the contradiction between internalizing the pressure to be modern and trying to humanize the city. Since the big city is a depersonalizing conglomerate, The Eight celebrate the new New York and simultaneously reject its very modernity. Sloan's panoramic winter scene by night is viewed from a Village rooftop. The soft curve of the Sixth Avenue Elevated, reminiscent of an ancient town wall, separates the benignly lit and intimately scaled neighborhood space from the unknowable vastness of the larger metropolis. In the far background the threatening office towers of Lower Manhattan rise in cold artificial light. New York is represented as an ambivalent juncture of opposites reconciled by the strained formula of older landscape painting rather than by an inherent dialectic of the subject. The high vantage point of the viewer, shaky and somewhat tilted, is within the home turf of the painter — an island of shelter from the boundless urban sea. Even in Sloan's rare urban panorama, the Village marks the center (although by now already off to one side), which is clearly defined, recognizable, and idealized in an effort to let it stand as a firm entity against the alien spaces beyond. The compositional structure of the painting reflects a willful and highly ambivalent integration of conflicting concepts. The El-train motif links modern technology with pre-Modern life. It is the boundary that stresses the opposing symbolic contents between water tank and high-rise buildings, between electric light and "Moonshine," the Village's tavern name, and most notably between the office towers alluding to the topos of the radiating city on the hill and "the gathering darkness...of the chopped out towers of modern New York."[25] In a precarious balance, the overall image represents at once the pride and the promise of the city and its annihilating indifference.

We can only make sense of early American Realism by placing it in the context of the prewar cultural insurgency that was centered in New York, by that time already a part of the intellectual life of the Western world. In the early 1910s, this place inaugurated contact between the new ideas of Freud, Bergson, Baudelaire, and Nietzsche, on the one hand, and latent American discontent, on the other. Although the relationship has not yet been analyzed in full detail, there can be little doubt that there are strong ties between the Ash Can painters and the literary rebels. Most explicitly,

8. John Sloan (American),
 The City from Greenwich Village, 1922,
 oil on canvas, 66 x 85.7 cm.
 Washington, D.C., National Gallery of Art,
 Gift of Helen Farr Sloan, no. 1970.1.1.

339

Henri and Sloan stand on the political left. Theodore Dreiser is particularly fond of The Eight's subjects. Magazines such as *The Dial*, the *Seven Arts*, and *The Masses* are the vital center of this New York rebellion. In the case of *The Masses*, it is most obvious that The Eight are wholeheartedly involved in the movement, however strictly they defend their artistic independence when it comes to political agitation. When this kind of one-dimensional propaganda is demanded of him, Sloan withdraws from his close connection with *The Masses*. Daniel Aaron has identified the artistic and literary contributors to *The Masses* as a who's who of early twentieth-century cultural criticism.[26] This and other little magazines depended on the regular contributions of Bellows, Sloan, and others, not to speak of the many ties of friendship between writers and painters, of which the one between Sloan and Brooks is only a more prominent example. In his restaurant scene *Yeats at Petitpas* (fig. 9), Sloan pays tribute to this intellectual community. It shows, among others, Henri, Sloan, Brooks, and the Irish artist John Butler Yeats, father of William Butler Yeats, in conversation. This painting, among many others, reflects the Village's collective sense of itself as the most open and vital community in America. The New York rebellion is part of a societal process, in which circa 1900 the intellectual emerged as a distinctive social type. The rebels are urban intellectuals of a modern fashion in spite of The Eight's anti-intellectual rhetoric.

As such they specifically epitomize the intellectualistic constitution of the modern city dweller's psyche, the inner urbanization, which Georg Simmel has described in terms of the categorical triad of money, modernity, and city. His seminal city essay is also a sort of self-portrait of the modern urban consciousness.[27] The New York intellectuals find themselves estranged from the larger materialistic society, a minority lacking the securities of genteel times. Devoid of a (secure) solid sense of self, they seek spiritual wholeness in the discovery of the Native American and in the very cultural tradition they are criticizing. With their cult of spontaneity and their belief in the regenerative force of literature and art, The Eight revitalize the Romanticism of Whitman and Ralph Waldo Emerson, reinforcing in part the official credo of which particularly the latter was a central pillar. This earlier romantic doctrine of individualism, now heightened by vitalism, can be rearticulated only to the extent that Transcendentalism had not been – contrary to a still-proclaimed interpretation – an antiurban movement.

In a way the New York rebels radicalize the conviction of their nine-

9. John Sloan (American),
Yeats at Petitpas, 1910,
oil on canvas.
Washington, D.C., The Corcoran Gallery of
Art, Museum Purchase, no. 32.9.

341

teenth-century counterparts who did not criticize the city as an institution, "but, rather, as an accumulation of contradictions, as an unrealized aspiration."[28] The Eight come to New York believing in its modernity and uniqueness as a token of the possibility of realizing this aspiration in a renewed form. At a time of an unprecedented wave of industrial consolidation (mergers) and construction of high-rise buildings, this implies a radicalization of contradictions as well. Kuspit's foundation of his New York art essay proves its validity here. For Simmel as for the American Realists, the city as the sphere of abstract networks where all substantiality melts into the relational and functional, as the place of the culture of indifference and the hegemony of the objective, that very city also offers an unprecedented degree of individual freedom, a realm of heightened subjectivity. Although seemingly paradoxical, for Simmel the internalization of the money economy in the city, where human behavior is reduced to a mechanical "shock reaction" performed by disillusioned "masks," is to be interpreted as a positive sign. It helps an understanding of the city's reality as the presupposition of a new synthesis.

This ambivalence is shared by The Eight, whose vision of the city, like Simmel's, therefore lacks the extremes of apocalypse and utopia. This is the main difference between The Eight's urban iconography and that of early European city painters, such as Ernst Ludwig Kirchner, Ludwig Meidner, and the lesser-known ones with whom they otherwise share more than we might expect.[29] Most of these artists on both continents tend to internalize rather than to negate or sublimize the experience of fear and shock in the metropolis. For the modern urban mind, the risk of involvement in the city replaces nineteenth-century aloof detachment from it. Since The Eight seem to have easier access to a usable past of Transcendental individualism as well as to an (optimistic) world city, they can, if only for a moment, reconcile the self to the city to a larger degree than their European counterparts.

Berlin's Expressionists after the turn of the century, for example, are much more shaken by their anticipation of the destruction of Europe's inherited cultural values. Their clash with Prussia's "parvenue" metropolis leads to the disruption of the initial community of the Brücke. And after the shock of "Babylon, the mother of harlots" they return to nature where they had started out. Yet they cannot but pass on the shock of the city. So, for instance, in Kirchner's Davos paintings the nervousness and neuroticism of his earlier urban figures are carried over into the land-

scapes, indicating the depth of the tormenting urban experience.

Although the formal differences between the Berlin Expressionists and the New York Realists are obvious, there are significant similarities. In the context of the European capitals it is Berlin, as a mainly production-oriented laissez-faire city, rather than Paris (national authority) or London (liberalism) that can be compared to New York — if only by way of strong simplifications. Also similar is the new cultural centrality of the two cities within an international process of sociocultural reform. Seen beyond a narrow formal perspective, Henri's "Art Spirit" and the program of the Brücke, on the one hand, and Kirchner's *Street, Dresden* (fig. 10) and some of the New York streets in the paintings of Sloan, Bellows, and Luks, on the other, are not very far apart. It is us, at the end of this catastrophic century, who are far apart from those artists' belief in sociocultural, spiritual renewal, in transcendence at the beginning of it.

"Ever since the Great War broke out in 1914 this world has been a crazy place to live in," remarks Sloan in retrospect.[30] World War I dispels the liberal progressive atmosphere in which early American Realism — with its triumph of The Eight show in 1908 — could thrive. The other reason for the decline of Realism after 1914 lies in the impact of the Armory Show the previous year, which marked the beginning of American Modernism and put the Ash Can painters on the defense. The heyday of the Village was around 1913; its gradual decline is marked by the extension of Seventh Avenue, the commercialism of false bohemians, the war, and later Prohibition, which changed the Village to the point of caricature. Another caricature was, by then, the older moral idealism. Moreover, the war put an end to the Transcendental optimism of the prewar rebellion and to its exuberance and vitalism, which had always been rather fragile — "the village's obsessive pride in its own vitality was a sign of the precariousness of its health."[31] It was altogether "the end of American innocence."[32]

Early American Modernism presents (to say the least) a different, abstract version of the city that belongs to the twentieth century. But it very much depends on the prewar rebels' urban consciousness. The Ash Can school is the relay station, the link, between the nineteenth century and ours. Their human-interest genre is today a utopian hope, dated when World War I broke out, just as Whitman's vision of New York as the place not of industry but of the most faithful lovers and friends had been dated long before. Sloan certainly tries to adapt to the new aesthetic tendencies, and there was

343

10. Ernst Ludwig Kirchner (German),
 Street, Dresden (Straße, Dresden), 1908
 (dated on painting 1907),
 oil on canvas, 150.5 x 200.4 cm.
 The Museum of Modern Art, New York.
 Purchase, no. 12.51.

a continuity of the Ash Can school in a sense.[33] But what is left for him is just nostalgia: "I went on painting and etching the things I saw around me in the city streets and on the rooftops."[34] Only briefly did there seem to be something like innocent modernity. In terms of urban iconography, interpretations of the Brooklyn Bridge (and the skyscraper) indicate the change. Merely an example of Yankee ingenuity before, it enters the realm of High Art in the 1910s and 1920s and reaches its apotheosis in the works of John Marin, Joseph Stella, Walker Evans, and Hart Crane. Like the abstracted city itself, empty of people, it is then symbolized on an existential plane and becomes a dynamic metaphor telling of our hopes and fears.

NOTES

I want to express my gratitude to Virginia Teichmann.

1. See Martin Christadler, "Heilsgeschichte und Offenbarung: Sinnzuschreibungen an Landschaft in der Malerei der amerikanischen Romantik," in Manfred Smuda, ed., *Landschaft* (Frankfurt am Main: Suhrkamp, 1986), 135–58.

2. On the economic and cultural "centrality" of the city, see Alan Trachtenberg, *The Incorporation of America: Culture and Society in the Gilded Age* (New York: Hill & Wang, 1982).

3. Barbara Rose, *Amerikas Weg zur modernen Kunst: Von der Mülltonnenschule zur Minimal Art* (Cologne: DuMont, 1969), 9.

4. Sam Hunter, *Modern American Painting and Sculpture* (New York: Dell, 1959), 13.

5. See Manfredo Tafuri and Francesco Dal Co, *Architektur der Gegenwart* (Stuttgart: Belser, 1976), 24.

6. On the city (not only) in French Impressionism, see Hubert Beck, *Der melancholische Blick: Die Großstadt im Werk des amerikanischen Malers Edward Hopper* (Frankfurt am Main: Peter Lang, 1988), chaps. 1 and 2.

7. See Timothy J. Clark, *The Painting of Modern Life: Paris in the Art of Manet and His Followers* (New York: Knopf, 1985), chap. 3, "The Environs of Paris."

8. Ibid., 199.

9. Benjamin's reflections on the interior come to mind here: "The private person who squares his accounts with reality in his office demands that the interior be maintained in his illusions. This need is all the more pressing since he has no intention of extending his commercial considerations into social ones. In shaping his private environment he represses both. From this spring the phantasmagorias of the interior. For the private individual the private environment represents the universe. In it he gathers remote places and the past." Walter

Benjamin, *Reflections*, ed. Peter Demetz, trans. Edmund Jephcott (New York: Harcourt Brace Jovanovich, 1978), 154.

10. Peter Conrad, *The Art of the City: Views and Versions of New York* (New York: Oxford Univ. Press, 1984), 29.

11. T. J. Jackson Lears, *No Place of Grace: Antimodernism and the Transformation of American Culture, 1880-1920* (New York: Pantheon, 1981), 34.

12. See Steven Marcus, *The Other Victorians: A Study of Sexuality and Pornography in Mid-Nineteenth-Century England* (New York: Basic Books, 1974), chap. 7.

13. See Elizabeth Johns, *Thomas Eakins: The Heroism of Modern Life* (Princeton: Princeton Univ. Press, 1983), 161.

14. See William H. Gerdts, *American Impressionism* (New York: Abbeville, 1984).

15. John Sloan, *Gist of Art* (New York: American Artists Group, 1939; reprint, New York: Dover, 1977), 189. For reproductions of Sloan's city etchings, see Helen Farr Sloan, ed., *John Sloan: New York Etchings (1905-1949)* (New York: Dover, 1978).

16. Richard Sennett, *The Fall of Public Man* (New York: Knopf, 1977). Not unlike Lears, Sennett is concerned with the cultural shift from a Protestant to a therapeutic worldview and the changes of publicity.

17. Conrad (see note 10), 90.

18. Ibid.

19. Robert Henri, *The Art Spirit* (Philadelphia and London: J. B. Lippincott, 1923; reprint, New York: Harper & Row, 1984), 135.

20. See Alan Trachtenberg, "Experiments in Another Country: Stephen Crane's City Sketches," in E. Sundquist, ed., *American Realism: New Essays* (Baltimore: Johns Hopkins Univ. Press, 1982).

21. Henri (see note 19), 127.

22. Van Wyck Brooks, *John Sloan: A Painter's Life* (New York: Dutton, 1955), 64.

23. Therefore, perhaps, the gangster is *the* protagonist of the city's most modern medium, film — he is moving knowingly and gracefully among the crowded dangers of the city.

24. Donald B. Kuspit, "Individual and Mass Identity in Urban Art: The New York Case," *Art in America* 65 (September/October 1977): 67–77, esp. 69.

25. John Sloan (see note 15), xxxvi caption.

26. Daniel Aaron, *Writers on the Left* (Oxford and New York: Oxford Univ. Press, 1977), chap. 1, n. 35.

27. Georg Simmel, "Die Großstädte und das Geistesleben" (1903), in idem, *Das Individuum und die Freiheit: Essais* (Berlin: K. Wagenbach, 1984), 192–204.

28. Francesco Dal Co et al., *The American City from the Civil War to the New Deal*, trans. Barbara Luigia La Penta (Cambridge: MIT Press, 1979), 148.

29. See Eberhard Roters and Bernhard Schulz, eds., *Ich und die Stadt: Mensch und Großstadt in der deutschen Kunst des 20. Jahrhunderts*, exh. cat. (Berlin: Nicolaische Verlagsbuchhandlung, 1987).

30. John Sloan (see note 15), 4.

31. Kenneth Schuyler Lynn, *The Air-Line to Seattle: Studies in Literary and Historical Writing about America* (Chicago: Univ. of Chicago Press, 1983), 84.

32. Henry Farnham May, *The End of American Innocence: A Study of the First Years of Our Own Time, 1912-1917* (Chicago: Quadrangle, 1964).

33. See John Czaplicka, "Engagement für das Leben: Realismus in der amerikanischen Kunst seit der Jahrhundertwende," in Eckhart Gillen and Yvonne Leonard, eds., *Amerika: Traum und Depression, 1920-40*, exh. cat. (Berlin: NGBK, 1980).

34. John Sloan (see note 15), 5.

347

Biographical Notes
on the Authors

Hubert Beck specializes in the study of modern American painters and particularly their depictions of cityscapes. He is the author of *Edward Hopper* (1992) and *Andy Warhol* (forthcoming) and has also written articles on the iconography of the city. Beck is associate curator of the Museum für Moderne Kunst in Frankfurt am Main, and he holds a lectureship in American studies at the Institut für England- und Amerikastudien at the Johann Wolfgang Goethe-Universität, also in Frankfurt.

Werner Busch concentrates his research on Dutch art of the seventeenth century, English art of the eighteenth century, and German art of the nineteenth century. His publications include *Die notwendige Arabeske* (1985), *Joseph Wright of Derby: Das Experiment mit der Luftpumpe* (1986), *Funkkolleg Kunst*, 2 vols. (1987), and recent articles on Goya, Goethe, Chodowiecki, Rembrandt, Longhi, and history painting. Since 1988 he has been chair of the Kunsthistorisches Institut at the Freie Universität, Berlin.

Martin Christadler is professor of American literature at the Johann Wolfgang Goethe-Universität in Frankfurt am Main. His research focuses on eighteenth- through twentieth-century authors. Christadler has published *Natur und Geschichte im Werk von William Faulkner* (1962) and *Der amerikanische Essay, 1720–1820* (1968), as well as numerous essays on topics ranging from the poetry of Edgar Allan Poe to Marxist literary criticism. In recent years he has explored the relationship between history and painting in America.

Nicolai Cikovsky, Jr., has organized exhibitions on the works of Raphaelle Peale, William Merritt Chase, and Sanford Robinson Gifford, which reflect his concentration on the study of nineteenth-century American painting. His publications include *Samuel F. B. Morse's Lectures on the Affinity of Painting with the Other Fine Arts* (1983) and monographs on *Winslow Homer* (1990), *George Inness* (forthcoming), and *Thomas Eakins* (forthcoming). Cikovsky is curator of American and British paintings at the National Gallery of Art, Washington, D.C.

Françoise Forster-Hahn concentrates her research on the interrelationships of art, politics, and popular culture in nineteenth- and twentieth-century Europe. The author of *French and School of Paris Paintings in the Yale University Art Gallery* (1968), she has also published and lectured extensively on the art of Adolph Menzel and the cultural politics of nineteenth-century Berlin and has contributed essays to volumes including *Our*

Faust? Roots and Ramifications of a Modern German Myth (1987), *Bilder aus der Neuen Welt* (1988), and *Kunst um 1800 und die Folgen: Festschrift Werner Hofmann* (1988). Forster-Hahn is professor of the history of art at the University of California, Riverside.

Ursula Frohne focuses her studies on nineteenth- and twentieth-century American and European art. She has contributed to a number of exhibition catalogs, most recently *Bilder aus der Neuen Welt* (1988) and *Markus Lüpertz – Folgen* (1989). Since 1989 Frohne has held a teaching position in the department of art history at the Freie Universität, Berlin.

Barbara Gaehtgens specializes in seventeenth-century Dutch art history. She is the author of *Adriaen van der Werff, 1659–1722: Leben und Werk* (1987) and a number of articles on seventeenth-century Dutch art as well as on modern artists and themes ranging from Expressionism to Abstraction. Gaehtgens teaches the history of art at the Technische Universität, Berlin.

Thomas W. Gaehtgens is an art historian and the author of *Napoleons Arc de Triomphe* (1974), *Versailles als Nationaldenkmal: Die Galerie des batailles im Musée historique von Louis-Philippe* (1984), *Joseph-Marie Vien, peintre du roi, 1716–1809* (with Jacques Lugand, 1988), and *Anton von Werner: Die Proklamierung des Deutschen Kaiserreiches* (1990). In addition he has written numerous articles on eighteenth- through twentieth-century French art and on contemporary art and art criticism. Gaehtgens organized the seminal exhibition of pre-Modern American art *Bilder aus der Neuen Welt* (1988–1989), which was held initially at the Schloß Charlottenburg, Berlin, and then at the Kunsthaus Zürich. He also edited the exhibition's catalog. Since 1979 he has held the position of professor of art history in the Kunsthistorisches Institut at the Freie Universität, Berlin.

Barbara Groseclose divides her research interest between art and literature. Among her publications are *Emanuel Leutze, 1816–1868: Freedom Is the Only King* (1976), *Literature and the Visual Arts in Contemporary Society* (1985), and an essay for *George Caleb Bingham* (1990). She is professor of art history at the Ohio State University, Columbus, and is currently writing a book on British sculpture in India.

Olaf Hansen concentrates his research on nineteenth- and twentieth-century American literature, literary criticism, and theory as well as photography and the visual arts. His writings include *Aesthetic Individualism and Practical Intellect: American Allegory in Ralph Waldo Emerson, Henry David Thoreau, Henry Adams, and William James* (1990), *Marxistische Literaturkritik in Amerika* (with Martin Christadler, 1982), and *Bewußtseinsformen Literarischer Intelligenz: Randolph Bourne, Herbert Croly, Max Eastman, V. F. Calverton, Michael Gold* (1977). In 1977 he edited *The Radical Will: Randolph Bourne, Selected Writings 1911–1918*. Hansen is executive director of the Zentrum für Nordamerika-Forschung and professor of American literature and culture at the Johann Wolfgang Goethe-Universität in Frankfurt am Main.

William Hauptman specializes in nineteenth-century European art with particular interest in Swiss painting. He has also published on the iconography of melancholy, seventeenth-century architecture, and the history of photography. He is the author of *Svizzera meravigliosa: Vedute di artisti stranieri, 1770–1914* (1991) and a two-volume catalogue raisonné of the works of Charles Gleyre (forthcoming). He is presently associated with the Musée Historique de Lausanne.

Heinz Ickstadt has published extensively on American literature of the nineteenth and twentieth centuries; much of his research is centered on questions of class and culture.

He has also studied depictions of the city in literature and painting and westward expansion in nineteenth-century America. His publications include *Dichterische Erfahrung und Metaphernstruktur: Eine Untersuchung der Bildersprache Hart Cranes* (1970), *Ordnung und Entropie: Zum Romanwerk von Thomas Pynchon* (1981), and many journal articles and essays. He also edited the volume *The Thirties: Politics and Culture in a Time of Broken Dreams* (with Rob Kroes and Brian Lee, 1987). Ickstadt is professor of American literature at the John F. Kennedy-Institut für Nordamerikastudien at the Freie Universität, Berlin.

Barbara Novak is a specialist on American painting of the nineteenth century. She is the author of *American Painting of the Nineteenth Century* (2nd ed., 1979), *Nature and Culture: American Landscape and Painting, 1825-1875* (1980), and *Nineteenth Century American Paintings in the Thyssen-Bornemisza*

Collection (1986), as well as numerous essays on American landscape painting and other art-historical topics. She has also published a novel, *Alice's Neck* (1987), and a theater piece. A painter herself, she exhibits at Berry-Hill Galleries in New York. Novak is the Altschul Professor of Art History at Columbia University in New York.

Kathleen Pyne concentrates her research on art in America during the latter half of the nineteenth century, including American Impressionism, the problems of Modernism, and the relationship of belief systems to art. She is the author of papers on a variety of subjects relating to American art and is currently finishing a monographic study of painting and evolutionary thought in late nineteenth-century America. She is assistant professor in the Department of Art, Art History, and Design at the University of Notre Dame.

INDEX